For Reference

Not to be taken from this room

WORLD PAINTING INDEX

FIRST SUPPLEMENT
1973-1980

by
PATRICIA PATE HAVLICE

Volume I:

Bibliography
Paintings by Unknown Artists
Painters and Their Works

The Scarecrow Press, Inc.
Metuchen, N.J., & London
1982

Other Scarecrow books by Havlice:

Art in Time. 350p. (1970)
Index to American Author Bibliographies. 204p. (1971)
Index to Artistic Biography. 2 vols. (1973)
_____. First Supplement. 962p. (1981)
Index to Literary Biography. 2 vols. (1975)
Popular Song Index. 933p. (1975)
_____. First Supplement. 386p. (1978)
World Painting Index. 2 vols. (1977)

Library of Congress Cataloging in Publication Data

Havlice, Patricia Pate.
 World painting index.

 Bibliography: p.
 Includes index.
 1. Painting--Indexes. I. Title.
ND45.H38 Suppl. 750'.16 82-3355
ISBN 0-8108-1531-1 AACR2

CONTENTS

PREFACE

The purpose of this First Supplement is to update the basic set
that was published in 1977. Together they provide the user with
a tool for locating reproductions of paintings in books and catalogs
by artists from around the world. To the 1167 books and catalogs
in the basic set the supplement adds 617, bringing the coverage
down through 1980.

World Painting Index is arranged in four parts: (I) a num-
bered bibliography; (II) a listing by title of work by artists whose
names are unknown; (III) a listing by painter of works appearing in
the indexed volumes; and (IV) a listing by title of paintings giving
the names of the painters.

Part II contains as much information about the date of the
painting and nationality of the painter as could be found. In parts
II and III the titles of the painting are followed by a number code
referring the user to the book in the bibliography which contains
the desired work.

A letter code appended to the bibliography number of each
painting indicates four different types of reproductions:

bc - a reproduction in both black-and-white and color

c - a color reproduction

d - only a black-and-white detail of the painting is reproduced

cd - a color detail

Those numbers with no letters appended are for paintings
reproduced in black-and-white only.

Works entitled simply "Self-portrait" are not listed in Part
IV as separate titles.

v

For purposes of this index, "painting" includes works in oil, tempera, gouache, acrylic, fresco, pastel and watercolor. Some works called "collage" appear because they were considered paintings by the authors of the books in which they were reproduced.

Any user of this book should also be familiar with the three works by Isabel S. and Kate M. Monro. They are: <u>Index to Reproductions of European Painting</u> (1956), and <u>Index to Reproductions of American Paintings</u> (1948) with its <u>Supplement</u> (1964). Titles indexed in these three works appear in this compilation only if they were published in new editions.

I am indebted to Gloria Wells of the Freeman Memorial Branch Library for interlibrary loan services the like of which are rarely obtained in Houston, Tx. The library at the Cleveland Museum of Art and the Fine Arts Department of the Cleveland (Ohio) Public Library headed by Joan Hoagland provided a goodly share of the titles indexed in this supplement. Special thanks and a big hug to Edward, my chief carbon maker.

Part I

BIBLIOGRAPHY*

1 Abbey, Rita Deanin. Rivertrip. Flagstaff, Ariz.: Northland
 Press, 1977.

2 Adams, Eric. Francis Danby: Varieties of Poetic Landscape.
 New Haven: Yale University Press, 1973.

3 Adams, Hugh. Modern Painting. New York: Mayflower
 Books, 1979.

4 Adams, Philip Rhys. Walt Kuhn, Painter: His life and work.
 Columbus: Ohio State University Press, 1978.

5 Albright-Knox Art Gallery. American Painting of the 1970s.
 Buffalo: Gallery, 1978.

6 Albright-Knox Art Gallery. The Armand Hammer Collection:
 Four Centuries of Masterpieces. Buffalo: Gallery, 1978.

7 Aldrich, Lanning. The Western Art of Charles M. Russell.
 New York: Ballantine Books, 1975.

8 Alexandrian. Marcel Duchamp. New York: Crown, 1977.

9 Allen, Janet, and John Holden. The Home Artist. New York:
 Van Nostrand Reinhold, 1979.

10 Alley, Ronald. Portrait of a Primitive: The Art of Henri
 Rousseau. New York: Dutton, 1978.

11 Alloway, Lawrence. Topics in American Art Since 1945.
 New York: Norton, 1975.

12 America the Beautiful: A Bicentennial exhibition; October 5--
 November 16, 1975. Shreveport, La.: R. W. Norton
 Art Gallery, 1975.

13 American Marine Painting: A Loan Exhibition. Richmond,
 Va.: Virginia Museum, 1976.

*An asterisk indicates a juvenile book.

14 America's Great Adventure: The Spirit of Freedom. Fort
 Atkinson, Wisc.: Home Library Publication, 1976.

15 Andrew Crispo Gallery. Edward Hicks: A Gentle Spirit.
 New York: The Author, 1975.

16 Andrew Crispo Gallery. Ten Americans: Masters of Water-
 color. New York: The Author, 1974.

17 Andrus, Lisa Fellows. Measure and Design in American
 Painting 1760-1860. New York: Garland, 1977.

18 Apollonio, Umberto, ed. Futurist Manifestos. New York:
 Viking, 1973.

19 Apraxine, Pierre. Haitian Painting: The Native Tradition.
 New York: American Federation of Arts, 1973.

20 Arcangeli, Francesco. Graham Sutherland. New York:
 Abrams, 1975.

21 Arciniegas, Germán. Fernando Botero. New York: Abrams,
 1977.

22 Art, Inc. American Paintings from Corporate Collections.
 Montgomery, Ala.: Museum of Fine Arts, 1979.

23 Artists/USA 1978. Philadelphia: Artists/USA, 1977.

24 Ashton, Dore. Yes But ... A Critical Study of Philip Guston.
 New York: Viking, 1976.

25 Babbitt, Bruce E. Color and Light: The Southwest Canvases
 of Louis Akin. Flagstaff, Ariz.: Northland Press, 1973.

26 Bacci, Mina. Leonardo. New York: Avenel Books, 1978.

27 Bacon, Francis. Francis Bacon: Recent Paintings 1968-1974.
 New York: Metropolitan Museum of Art, 1975.

28 Baeder, John. Diners. New York: Abrams, 1978.

29 Baigell, Matthew. The American Scene: American Painting
 of the 1930's. New York: Praeger, 1974.

30 Baigell, Matthew. Charles Burchfield. New York: Watson-
 Guptill, 1976.

31 Baigell, Matthew. Thomas Hart Benton. New York: Abrams,
 1974.

32 Balazs, Marianne E. Sheldon Peck. New York: Whitney
 Museum of American Art, 1975?

33 Balcomb, Mary N. Nicolai Fechin. Flagstaff, Ariz.: North-
 land Press, 1975.

34 Bama, James. The Western Art of James Bama. New York:
 Scribner's, 1975.

35 Barbour, Arthur J. Watercolor: The Wet Technique. New
 York: Watson-Guptill, 1978.

36 Barchus, Agnes. Eliza R. Barchus: The Oregon Artist 1857-
 1959. Portland, Ore.: Binford and Mort, 1974.

37 Barnitz, Jacqueline. Abstract Currents in Ecuadorian Art.
 New York: Center for Inter-American Relations, 1977.

38 Barrio-Garay, José Luis. José Gutiérrez Solana: Paintings
 and Writings. Lewisburg, Pa.: Bucknell University
 Press, 1978.

39* Batterberry, Ariane Ruskin. The Pantheon Story of Art for
 Young People. Rev. ed. New York: Pantheon Books,
 1975.

40 Battersby, Martin. Trompe L'Oeil: The Eye Deceived. New
 York: St. Martin's Press, 1974.

41 Baudouin, Frans. Pietro Paulo Rubens. New York: Abrams,
 1977.

42 Beck, James. Leonardo's Rules of Painting: An Unconven-
 tional Approach to Modern Art. New York: Viking, 1979.

43 Beck, James H. Raphael. New York: Abrams, 1976.

44 Berenson, Bernhard. The Study and Criticism of Italian Art.
 Reprint of 1920 ed. New York: AMS Press, 1976.

45 Bermingham, Peter. American Art in the Barbizon Mood.
 Washington, D.C.: Smithsonian Institution Press, 1975.

46 Betts, Edward. Creative Landscape Painting. New York:
 Watson-Guptill, 1978.

47 Betts, Edward. Master Class in Watercolor. New York:
 Watson-Guptill, 1975.

48 Biggers, John, and Carroll Simms with John Edward Weems.
 Black Art in Houston: The Texas Southern University
 Experience. College Station, Tx.: Texas A & M Uni-
 versity Press, 1978.

49 Billcliffe, Roger. Mackintosh watercolours. London: John
 Murray, 1978.

50 Bireline, George. Original Bireline: A Retrospective of the
 Work of George Bireline. Raleigh, N. C. : North Caro-
 lina Museum of Art, 1976.

51 Bisanz, Rudolf M. The René von Schleinitz Collection of the
 Milwaukee Art Center. Madison: University of Wiscon-
 sin Press, 1980.

52 Bishop, Isabel. Isabel Bishop. Tucson, Ariz. : University
 of Arizona Museum of Art, 1974.

53 Blahove, Marcos, and Joe Singer. Painting Children in Oil.
 New York: Watson-Guptill, 1978.

54 Blake, Wendon. Landscape Painting in Oil. New York:
 Watson-Guptill, 1976.

55 Blunden, Maria, and Godfrey Blunden. Impressionists and
 Impressionism. New York: Rizzoli, 1976.

56 Bock, Joanne. Pop Wiener: Naive Painter. Amherst:
 University of Massachusetts, 1974.

57 Boege, Uli. Elsewhere: Collages. New York: Links
 Books, 1974.

58 Börsch-Supan, Helmut. Caspar David Friedrich. New
 York: Braziller, 1974.

59 Bol, Laurens J. Adriaen Coorte: A Unique Late Seven-
 teenth Century Dutch Still Life Painter. Amsterdam:
 Van Gorcum, Assen, 1977.

60 Bolotowsky, Ilya. Ilya Bolotowsky. New York: Solomon
 R. Guggenheim Museum, 1974.

61 Borgo, Ludovico. The Works of Mariotto Albertinelli. New
 York: Garland, 1976.

62 Born, Wolfgang. Still-Life Painting in America. Reissue
 of 1947 ed. New York: Hacker Art Books, 1973.

63 Boyle, Richard J. John Twachtman. New York: Watson-
 Guptill, 1979.

64 Brackett, Ward. When You Paint: A Complete Guide for
 Practicing Artists. New York: McGraw-Hill, 1974.

65 Brandt, Rex. Watercolor Techniques and Methods. New
 York: Van Nostrand Reinhold, 1977.

66 Brion, Marcel. Cézanne. New York: Doubleday, 1974.

67 Broder, Patricia Janis. Hopi Painting: The World of the
 Hopis. New York: Dutton, 1978.

68 Brooklyn Museum. Leaders of American Impressionism.
 Reprint of 1937 ed. New York: Arno Press, 1974.

69 Brown, Jonathan. Francisco de Zurbaran. New York:
 Abrams, 1973.

70 Brown, Jonathan. Images and Ideas in Seventeenth-century
 Spanish Painting. Princeton: Princeton University
 Press, 1978.

71 Brown, Percy. Indian Painting under the Mughals A. D.
 1550 to A. D. 1750. New York: Hacker Art Books,
 1975.

72 Brown, Stephanie. Religious Painting: Christ's Passion and
 Crucifixion. New York: Mayflower Books, 1979.

73 Buchanan, William. Joan Eardley. Edinburgh: Edinburgh
 University Press, 1976.

74 Bugler, Caroline. Dutch Painting in the Seventeenth Century.
 New York: Mayflower Books, 1979.

75 Burkhard, Arthur. Matthias Gruenewald: Personality and
 Accomplishment. New York: Hacker Art Books, 1976.

76 Burns, Paul C. , and Joe Singer. The Portrait Painter's
 Problem Book. New York: Watson-Guptill, 1979.

77 Burnside, Wesley M. Maynard Dixon: Artist of the West.
 Provo, Utah: BYU Press, 1974.

78 Caddell, Foster. Keys to Successful Color: A Guide for
 Landscape Painters in Oil. New York: Watson-Guptill,
 1979.

79 Caddell, Foster. Keys to Successful Landscape Painting.
 New York: Watson-Guptill, 1976.

80 Cahill, James. Hills Beyond a River: Chinese Painting in
 the Yüan Dynasty, 1279-1368. New York: Weatherhill,
 1976.

81 Cahill, James. Parting at the Shore: Chinese Painting of
 the Early and Middle Ming Dynasty, 1368-1580. New
 York: Weatherhill, 1978.

82 Callen, Anthea. Renoir. London: Oresko Books, 1978.

83 Cambridge University. Fitzwilliam Museum. J. M. W.
 Turner, R. A. , 1775-1851. New York: Cambridge Uni-
 versity Press, 1975.

84 Camfield, William A. Francis Picabia: His Art, Life and
 Times. Princeton: Princeton University Press, 1979.

85 Campbell, Malcolm. Pietro da Cortona at the Pitti Palace.
 Princeton: Princeton University Press, 1977.

86 Canaday, Frank H. Triumph in Color: The Life and Art of
 Molly Morpeth Canaday. Canaan, N. H. : Phoenix, 1977.

87 Canaday, John. What Is Art? An Introduction to Painting,
 Sculpture and Architecture. New York: Knopf, 1980.

88 Capon, Edmund. Chinese Painting: 64 Reproductions. Ox-
 ford: Phaidon, 1979.

89 Cardinal, Roger. Primitive Painters. New York: St. Mar-
 tin's, 1979.

90 Carline, Richard. Stanley Spencer at War. London: Faber
 and Faber, 1978.

91 Carluccio, Luigi. Domenico Gnoli. Woodstock, New York:
 Overlook Press, 1975.

92 Carmean, E. A. , Jr. The Great Decade of American Ab-
 straction Modernist Art 1960 to 1970. Houston, Tx. :
 Museum of Fine Arts, 1974.

93 Carsman, Jon. Jon Carsman: Paintings and Watercolors.
 New York: Everson Museum, 1977.

94 Carter, Denny. Henry Farny. New York: Watson-Guptill,
 1978.

95 Cathcart, Linda L. , and Marcia Tucker. Alfred Jensen:
 Paintings and Diagrams from the Years 1957-1977.
 Buffalo, NY: Albright-Knox Art Gallery, 1978.

96 Celebonovič, Aleksa. Some Call It Kitsch: Masterpieces of
 Bourgeois Realism. New York: Abrams, 1974.

97 Chaet, Bernard. An Artist's Notebook: Techniques and
 Materials. New York: Holt, Rinehart and Winston,
 1979.

98 Chicago. Art Institute. The Art Institute of Chicago: 100
 Masterpieces. Chicago: Rand, McNally, 1978.

99 Chicago, Judy. Through the Flower: My Struggle as a Wom-
 an Artist. New York: Doubleday, 1975.

100 Christian, John. Symbolists and Decadents. New York:
 St. Martin's Press, 1978.

101 Christ-Janer, Albert. George Caleb Bingham: Frontier
 Painter of Missouri. New York: Abrams, 1975.

102 Chu, Petro T-D. , ed. Courbet in Perspective. Englewood
 Cliffs, NJ: Prentice-Hall, 1977.

103 Claridge, Elizabeth. The Girls of Mel Ramos. Chicago:
 Playboy Press, 1975.

104 Clark, Kenneth. An Introduction to Rembrandt. New York:
 Harper and Row, 1978.

105 Clifford, Derek. Collecting English Watercolours. 2nd ed.
 New York: St. Martin's, 1976.

106 Cloar, Carroll. Hostile Butterflies and Other Paintings.
 Memphis, Tenn. : Memphis State University Press,
 1977.

107 Cockcroft, Eva, John Weber and Jim Cockcroft. Toward a
 People's Art: The Contemporary Mural Movement.
 New York: Dutton, 1977.

108 Cogniat, Raymond. Pissarro. New York: Crown, 1975.

109 Cogniat, Raymond. Sisley. New York: Crown, 1978.

110 Cogniat, Raymond. Soutine. New York: Crown, 1973.

111 Coke, Van Deren. Andrew Dasburg. Albuquerque: Uni-
 versity of New Mexico Press, 1979.

112 Cole, Bruce. Agnolo Gaddi. Oxford, Clarendon Press,
 1977.

113 Cole, Bruce. Giotto and Florentine Painting 1280-1375.
 New York: Harper and Row, 1976.

114 Comini, Alessandra. The Fantastic Art of Vienna. New
 York: Knopf, 1978.

115 Comini, Alessandra. Gustav Klimt. New York: Braziller,
 1975.

116 Comini, Alessandra. Schiele in Prison. Greenwich, CT:
 New York Graphic Society, 1973.

117 Conil Lacoste, Michel. Kandinsky. New York: Crown,
 1979.

118 Constable, W. G. Canaletto: Giovanni Antonio Canal 1697-
 1768. 2nd ed. rev. Oxford: Clarendon Press, 1976.

119 Constant, Alberta Wilson. Paintbox on the Frontier: The
 Life and Times of George Caleb Bingham. New York:
 Crowell, 1974.

120 Cooke, H. Lester, Jr. Fletcher Martin. New York: Ab-
 rams, 1977.

121 Cordingly, David. Marine Painting in England 1700-1900.
 New York: Clarkson N. Potter, 1973.

122 Country Beautiful. The Story of America. Waukesha,
 Wisc. : Country Beautiful, 1976.

123 Courthion, Pierre. Georges Rouault. New York: Abrams,
 1977.

124 Courthion, Pierre. Impressionism. New York: Abrams,
 1977.

125 Croydon, Michael. Ivan Albright. New York: Abbeville
 Press, 1978.

126 Cummings, Paul. Dictionary of Contemporary American
 Artists. 3rd ed. New York: St. Martin's, 1977.

127 Curtis, Roger W. How to Paint Successful Seascapes:
 Techniques in Oil. New York: Watson-Guptill, 1975.

128 Dallas Collects: Impressionist and Early Modern Masters.
 Dallas: Museum of Fine Arts, 1978.

129 Daniels, Alfred. Enjoying Acrylics. London: William
 Luscombe, 1976.

130 Daulte, Francois. Renoir. New York: Doubleday, 1973.

131 Davidson, Abraham A. The Eccentrics and Other American
 Visionary Painters. New York: Dutton, 1978.

132 Davidson, Harold G. Edward Borein: Cowboy Artist: The
 Life and Works of John Edward Borein 1872-1945. New
 York: Doubleday, 1974.

133 Davidson, Jane P. David Teniers the Younger. Boulder,
 Col. : Westview Press, 1979.

134 Davies, Ken. Ken Davies: Artist at Work. New York:
 Watson-Guptill, 1978.

135 Davies, Ken, and Ellye Bloom. Painting Sharp Focus Still
 Lifes: Trompe l'oeil Oil Techniques. New York:
 Watson-Guptill, 1975.

136 Dawley, Joseph. Painting Western Character Studies:
 Techniques in Oil. New York: Watson-Guptill, 1975.

137 Dawley, Joseph. The Second Painter's Problem Book.
 New York: Watson-Guptill, 1978.

138 Dayez, Anne, et. al. Impressionism: A Centenary Exhi-
 bition. New York: Metropolitan Museum of Art, 1974.

139 Delvaux, Paul. Paul Delvaux. Chicago: J. Philip O'Hara,
 1973.

140 Dennis, James M. Grant Wood: A Study in American Art
 and Culture. New York: Viking, 1975.

141 Descharnes, Robert. Salvador Dali. New York: Abrams,
 1976.

142 Deshazo, Edith. Everett Shinn 1876-1953: A Figure in His
 Time. New York: Clarkson Potter, 1974.

143 Deuchler, Florens, Marcel Roethlesberger, and Hans Lüthy.
 Swiss Painting: From the Middle Ages to the Dawn of
 the Twentieth Century. New York: Rizzoli, 1976.

144 Dhanens, Elisabeth. Van Eyck: The Ghent Altarpiece.
 New York: Viking, 1973.

145 Dickson, T. Elder. W. G. Gillies. Edinburgh: Edinburgh
 University Press, 1974.

146 Diebenkorn, Richard. Richard Diebenkorn: Paintings and
 Drawings, 1943-1976. Buffalo, N.Y.: Albright-Knox
 Art Gallery, 1976.

147 Diehl, Gaston. The Fauves. New York: Abrams, 1975.

148 Di Federico, Frank R. Francesco Trevisani: Eighteenth-
 century Painter in Rome: A Catalogue Raisonée.
 Washington, D.C.: Decatur House, 1977.

149 Dillenberger, John. Benjamin West: The Context of His
 Life's Work with Particular Attention to Paintings with
 Religious Subject Matter. San Antonio, Tx.: Trinity
 University Press, 1977.

150 Dinnerstein, Harvey. Harvey Dinnerstein: Artist at Work.
 New York: Watson-Guptill, 1978.

151 Doi, Tsuguyoshi. <u>Momoyama Decorative Painting.</u> New
 York: Weatherhill/Heibonsha, 1977.

152 Domit, Moussa M. <u>American Impressionist Painting.</u>
 Washington, D. C. : National Gallery of Art, 1973.

153 Doty, Robert. <u>Extraordinary Realities.</u> New York: Whit-
 ney Museum of American Art, 1973.

154 Dumur, Guy. <u>Staël.</u> New York: Crown, 1975.

155 Duncan, David Douglas. <u>Goodbye Picasso.</u> New York:
 Grosset & Dunlap, 1974.

156 Dunstan, Bernard. <u>Painting Methods of the Impressionists.</u>
 New York: Watson-Guptill, 1976.

157 <u>Dutch and Flemish Painting: 110 Illustrations Selected and
 Introduced by Christopher Brown.</u> New York: Dutton,
 1977.

158 Ebert, John, and Katherine Ebert. <u>American Folk Painters.</u>
 New York: Scribner's, 1975.

159 <u>Eighteen Songs of a Nomad Flute: The Story of Lady Wen-
 chi.</u> New York: Metropolitan Museum of Art, 1974.

160 Elderfield, John. <u>European Master Paintings from Swiss
 Collections: Post-impressionism to World War II.</u>
 New York: Museum of Modern Art, 1976.

161 Elderfield, John. <u>The "Wild Beasts": Fauvism and Its Af-
 finities.</u> New York: Museum of Modern Art, 1976.

162 Elgar, Frank. <u>Cézanne.</u> New York: Abrams, 1975.

163 Elgar, Frank. <u>The Post-Impressionists.</u> Oxford: Phaidon,
 1977.

164 Elsen, Albert. <u>Paul Jenkins.</u> New York: Abrams, 1973.

165 Engen, Rodney K. <u>Kate Greenaway.</u> New York: Harmony
 Books, 1976.

166 <u>English Conversation Pictures of the Eighteenth and Early
 Nineteenth Centuries: With Notes by Dr. G. C. Wil-
 liamson.</u> Reprint of 1931 ed. New York: Hacker Art
 Books, 1975.

167 Environmental Communications. <u>Big Art.</u> Philadelphia:
 Running Press, 1977.

168 Ernst, Max. <u>Max Ernst: A Retrospective.</u> New York:
 Solomon R. Guggenheim Museum, 1975.

169 Evers, Carl G. The Marine Paintings of Carl G. Evers.
 New York: Scribner's, 1975.

170 Farmer, John David. Ensor. New York: Braziller, 1976.

171 Feaver, William. The Art of John Martin. London: Ox-
 ford, 1975.

172 Ferber, Linda S. William Trost Richards: American
 Landscape and Marine Painter 1833-1905. New York:
 The Brooklyn Museum, 1973.

173 Ferris, Keith. The Aviation Art of Keith Ferris. New
 York: Peacock Press/Bantam Books, 1978.

174 Finch, Christopher. Norman Rockwell's America. New
 York: Abrams, 1975.

175 Fincke, Ulrich. German Painting from Romanticism to Ex-
 pressionism. Boulder, Col.: Westview Press, 1975.

176 Fink, Lois Marie, and Joshua C. Taylor. Academy: The
 Academic Tradition in American Art. Washington,
 D.C.: Smithsonian Institution Press, 1975.

177 Fiocco, Giuseppe. The Frescoes of Mantegna in the Ere-
 mitani Church, Padua. 2nd ed. Oxford: Phaidon,
 1978.

178 Flexner, James Thomas. The Face of Liberty: Founders
 of the United States. New York: Clarkson Potter,
 1975.

179 Fong, Wen. Summer Mountains: The Timeless Landscape.
 New York: Metropolitan Museum of Art, 1975.

180 Foucart, Bruno. G. Courbet. New York: Crown, 1977.

181 Fouchet, Max-Pol. Wilfredo Lam. New York: Rizzoli,
 1976.

182 Frankenstein, Alfred. William Sidney Mount. New York:
 Abrams, 1975.

183 Frary, Michael. Impressions of the Texas Panhandle.
 College Station: Texas A & M University Press, 1977.

184 French Painting 1774-1830: The Age of Revolution. De-
 troit: Detroit Institute of Arts, 1975.

185 Freundlich, August L. Richard Florsheim. New York:
 A. S. Barnes, 1976.

186 Friedman, Martin. Charles Sheeler. New York: Watson-Guptill, 1975.

187 Friend, David. Composition: A Painter's Guide to Basic Problems and Solutions. New York: Watson-Guptill, 1975.

188 Fu, Marilyn, and Shen Fu. Studies in Connoisseurship: Chinese Paintings from the Arthur M. Sackler Collection in New York and Princeton. Rev. ed. Princeton: Princeton University Press, 1976.

189 Fuchs, R. H. Dutch Painting. New York: Oxford University Press, 1978.

190 Gadney, Reg. Constable and His World. New York: Norton, 1976.

191 Gállego, Julián. Zurbaran 1598-1664. New York: Rizzoli, 1977.

192 Gallwitz, Klaus. Botero. New York: Rizzoli, 1976.

193 Garman, Ed. The Art of Raymond Johnson, Painter. Albuquerque: University of New Mexico Press, 1976.

194 Gaunt, William. The Great Century of British Painting: Hogarth to Turner. 2nd ed. New York: Dutton, 1978.

195 Gaunt, William. The Restless Century: Painting in Britain 1800-1900. 2nd ed. New York: Dutton, 1978.

196 Gaunt, William. Stubbs. Oxford: Phaidon, 1977.

197 Gay, Peter. Art and Act: On Causes in History--Manet, Gropius, Mondrian. New York: Harper and Row, 1976.

198 Gaya-Nuño, Juan Antonio. Juan Gris. Boston: New York Graphic Society, 1975.

199 Geelhaar, Christian. Paul Klee and the Bauhaus. Greenwich, CT: New York Graphic Society, 1973.

200 Genauer, Emily. Rufino Tamayo. New York: Abrams, 1974.

201 Gérard, Max. Dali... Dali... Dali.... Abridged ed. New York: Abrams, 1974.

202 Gerhardus, Maly, and Dielfried Gerhardus. Cubism and Futurism: The Evolution of the Self-sufficient Picture. Oxford: Phaidon, 1979.

203 Gerhardus, Maly, and Dietfried Gerhardus. Expressionism
 from Artistic Commitment to the Beginning of a New
 Era. New York: Dutton, 1976.

204 Gibson, Robin. Flower Painting. New York: Dutton, 1976.

205 Gilbert, Creighton. History of Renaissance Art Throughout
 Europe: Painting, Sculpture, Architecture. New York:
 Abrams, n. d.

206 Goddard, Ruth. Porfirio Salinas. Austin, Tx: Rock
 House Press, 1975.

207 Gogh, Vincent van. Van Gogh: Paintings, Drawings and
 Prints. New York: Phaidon, 1074.

208 Goldberg, Norman L. John Crome the Elder. New York:
 New York University Press, 1978.

209 Goldsborough, Robert, ed. Great Railroad Paintings. New
 York: Peacock Press/Bantam, 1976.

210 Goldstein, Nathan. Painting: Visual and Technical Funda-
 mentals. Englewood Cliffs, N. J.: Prentice-Hall, 1979.

211 Goodman, John K. Ross Stefan: An Impressionistic Painter
 of the Contemporary Southwest. Flagstaff, Ariz.:
 Northland Press, 1977.

212 Goodrich, Lloyd. Edward Hopper. New Concise ed. New
 York: Abrams, 1976.

213 Gould, Cecil. Leonardo: The Artist and the Non-artist.
 Boston: New York Graphic Society, 1975.

214 Gould, Cecil. The Paintings of Correggio. London: Faber
 and Faber, 1976.

215 Gowing, Lawrence. Matisse. New York: Oxford Univer-
 sity Press, 1979.

216 Granick, Arthur. Jennings Tofel. New York: Abrams,
 1976.

217 Green, Christopher. Léger and the Avant-garde. New
 Haven: Yale University Press, 1976.

218 Greer, Germaine. The Obstacle Race: The Fortunes of
 Women Painters and Their Work. New York: Farrar,
 Straus, Giroux, 1979.

219 Grossmann, F. Pieter Bruegel [the Elder]: Complete Edi-
 tion of the Paintings. 3rd rev. ed. New York:
 Phaidon, 1973.

220 Gruppé, Emile A. Gruppé on Color: Using Expressive
 Color to Paint Nature. New York: Watson-Guptill,
 1979.

221 Gruppé, Emile A. Gruppé on Painting: Direct Techniques
 in Oil. New York: Watson-Guptill, 1976.

222 Gudiol, José. Velázquez 1599-1660. New York: Viking,
 1974.

223 Hale, John. Italian Renaissance painting from Masaccio to
 Titian. New York: Dutton, 1977.

224 Hale, Robert Beverly, and Niké Hale. The Art of Balcomb
 Greene. New York: Horizon Press, 1977.

225 Hall, Douglas. Klee. Oxford: Phaidon, 1977.

226 Hamblett, Theora. Theora Hamblett Paintings. Jackson:
 University Press of Mississippi, 1975.

227 Hammacher, A. M. René Magritte. New York: Abrams,
 1974.

228 Hannaway, Patti. Winslow Homer in the Tropics. Rich-
 mond, Va. : Westover, n. d.

229 Hanson, Anne Coffin. Manet and the Modern Tradition.
 New Haven: Yale University Press, 1977.

230 Harada, Minoru. Meiji Western Painting. New York:
 Weatherhill/Shibundo, 1974.

231 Hardie, William. Scottish Painting 1837-1939. London:
 Studio Vista, 1976.

232 Harding, James. The Pre-Raphaelites. New York: Riz-
 zoli, 1977.

233 Harmsen, Dorothy. American Western Art: A Collection
 of 125 Western Paintings and Sculpture with Biographies
 of the Artists. Denver: Harmsen, 1977.

234 Harper, J. Russell. Painting in Canada: A History. 2nd
 ed. Toronto: University of Toronto Press, 1977.

235 Harper, J. Russell. A People's Art: Primitive, Naïve,
 Provincial and Folk Painting in Canada. Toronto: Uni-
 versity of Toronto Press, 1974.

236 Harris, Ann Sutherland, and Linda Nochlin. Women artists:
 1550-1950. New York: Knopf, 1976.

237 Harris, Nathaniel. Great Masters of World Painting: Bot-
 ticelli, Canaletto, Watteau, Cézanne, Titian. New
 York: Spring Books, 1974.

238 Hassrick, Royal B. The George Catlin Book of American
 Indians. New York: Watson-Guptill, 1977.

239 Hatfield, Rab. Botticelli's Uffizi "Adoration": A Study in
 Pictorial Content. Princeton: Princeton University
 Press, 1976.

240 Hayes, John. Gainsborough: Paintings and Drawings.
 London: Phaidon, 1975.

241 Hedgpeth, Don. Bettina: Portraying Life in Art. Flag-
 staff, Ariz. : Northland Press, 1978.

242 Heller, Nancy, and Julia Williams. The Regionalists.
 New York: Watson-Guptill, 1976.

243 Hemphill, Herbert W. , Jr. , and Julia Weissman. Twen-
 tieth-century American Folk Art and Artists. New
 York: Dutton, 1974.

244 Hendricks, Gordon. The Life and Works of Thomas Eakins.
 New York: Grossman, 1974.

245 Hendricks, Gordon. The Life and Work of Winslow Homer.
 New York: Abrams, 1979.

246 Henkes, Robert. Eight American Women Painters. New
 York: Gordon Press, 1977.

247 Herrmann, Luke. British Landscape Painting of the Eight-
 eenth Century. New York: Oxford University Press,
 1974.

248 Herrmann, Luke. Turner: Paintings, Watercolors, Prints
 & Drawings. Boston: New York Graphic Society, 1975.

249 Hess, Hans. George Grosz. New York: Macmillan, 1974.

250 Hess, Hans. How Pictures Mean. New York: Pantheon
 Books, 1974.

251 Hess, Thomas B. Cleve Gray; Paintings 1966-1977. Buf-
 falo: Albright-Knox Art Gallery, 1976.

252 Hicks, Edward. A Peaceable Season. Princeton, N. J. :
 Pyne Press, 1973.

253 Highwater, Jamake. Song from the Earth. Boston: New
 York Graphic Society, 1976.

254 Hill, Tom. Color for the Watercolor Painter. New York:
 Watson-Guptill, 1975.

255 Hill, Tom. The Watercolor Painter's Problem Book. New
 York: Watson-Guptill, 1979.

256 Hillcourt, William. Norman Rockwell's World of Scouting.
 New York: Abrams, 1977.

257 Hills, Patricia. The Painters' America: Rural and Urban
 Life, 1810-1910. New York: Praeger, 1974.

258 Hilton, Timothy. Picasso. New York: Praeger, 1975.

259 Hobbs, Robert Carleton, and Gail Levin. Abstract Expres-
 sionism: The Formative Years. New York: Whitney
 Museum of Art, 1978.

260 Hochmann, Shirley. Invitation to Art. New York: Ster-
 ling, 1974.

261 Hofmann, Werner. Hundertwasser. New York: Rizzoli,
 1976.

262* Hollmann, Eckhard, and Helmar Penndorf. Looking at
 Landscapes Through Artists' Eyes. New York: St.
 Martin's, 1976.

263 Holmes, Steward W., and Chimyo Horioka. Zen Art for
 Meditation. Rutland, Vt.: Charles E. Tuttle, 1973.

264 Hood, Graham. Charles Bridges and William Dering: Two
 Virginia Painters 1735-1750. Williamsburg, Va.:
 Colonial Williamsburg Foundation, 1978.

265 Hoog, Michel. R. Delaunay. Paris: Flammarion, 1976.

266 Hoopes, Donelson F. American Narrative Painting. Los
 Angeles: Los Angeles County Museum of Art, 1974.

267 Hoopes, Donelson F. American Watercolor Painting. New
 York: Watson-Guptill, 1977.

268 Hoopes, Donelson F. Childe Hassam. New York: Watson-
 Guptill, 1979.

269 Horwitz, Sylvia L. Francisco Goya: Painter of Kings and
 Demons. New York: Harper and Row, 1974.

270 House, John. Monet. New York: Dutton, 1977.

271 Houston. Museum of Fine Arts. The Collection of John A.
 and Audrey Jones Beck. Houston: The Museum, 1974.

272 Hoving, Thomas. Two Worlds of Andrew Wyeth: A Con-
 versation with Andrew Wyeth. Boston: Houghton Mif-
 flin, 1978.

273 Hütt, Wolfgang. The Living Countryside. New York: St.
 Martin's Press, 1973.

274 Huisman, Philippe, and M. G. Dortu. Toulouse Lautrec.
 Garden City, N. Y.: Doubleday, 1973.

275 Hulings, Clark. Hulings: A Collection of Oil Paintings.
 Kansas City, Mo.: Lowell Press, 1976.

276 Hurley, Wilson. Wilson Hurley: An Exhibition of Oil
 Paintings. Kansas City, Mo.: Lowell Press, 1977.

277 Hyslop, Francis E. Henri Evenepoel: Belgian Painter in
 Paris, 1892-1899. University Park: Pennsylvania
 State University Press, 1975.

278 Ienaga, Saburo. Japanese Art: A Cultural Appreciation.
 New York: Weatherhill, 1979.

279 Irwin, David, and Francina Irwin. Scottish Painters: At
 Home and Abroad 1700-1900. London: Faber and
 Faber, 1975.

280 Isaacson, Joel. Observation and Reflection: Claude Monet.
 Oxford: Phaidon, 1978.

281 Isabella Stewart Gardner Museum, Boston. A Selection of
 Paintings, Drawings, and Watercolors. [N. B.: All
 illustrations on microfiche.] Chicago: University of
 Chicago Press, 1976.

282 Jacobs, Alan. 17th Century Dutch and Flemish Painters:
 A Collector's Guide. New York: McGraw-Hill, 1976.

283 Jacobs, Jay. The Color Encyclopedia of World Art. New
 York: Crown, 1975.

284 Jacobs, Michael. Mythological Painting. New York: May-
 flower Books, 1979.

285 Jacobs, Michael. Nude Painting. New York: Mayflower
 Books, 1979.

286 Jacobus, John. Henri Matisse. New York: Abrams, 1973.

287 Jaffe, Irma B. John Trumbull: Patriot-Artist of the Amer-
 ican Revolution. Boston: New York Graphic Society,
 1975.

288 Jaffé, Michael. Rubens and Italy. Ithaca: Cornell University Press, 1977.

289 Jakovsky, Anatole. Naïve Painting. Oxford: Phaidon, 1979.

290 Jameson, Kenneth. Painting: A Complete Guide. New York: Viking, 1975.

291 Janson, H. W., and Dora Jane Janson. The Story of Painting from Cave Painting to Modern Times. Rev. and updated. New York: Abrams, 1977.

292 Janssens, Jacques. James Ensor. New York: Crown, 1978.

293 Jaques, Florence Page. Francis Lee Jaques: Artist of the Wilderness World. New York: Doubleday, 1973.

294 Jeffares, Bo. Landscape Painting. New York: Mayflower Books, 1979.

295 Johnson, May. Burne-Jones: All Colour Paperback. New York: Rizzoli, 1979.

296 Johnson, William Weber. Kelly Blue. Reprint of 1960 ed. College Station: Texas A & M University Press, 1979.

297 Johnstone, Christopher. John Martin. New York: St. Martin's Press, 1974.

298 Jones, Arthur F. The Art of Paul Sawyier. Lexington: University Press of Kentucky, 1976.

299 Jones, Franklin. Painting Nature: Solving Landscape Problems. Westport, Ct.: North Light, 1978.

300 Jones, Franklin. The Pleasure of Painting: Three Mediums, Oil, Watercolor, Acrylic. Westport, Ct.: North Light, 1975.

301 Joyes, Claire. Monet at Giverny. New York: Two Continents, 1975.

302 Jullian, Philippe. The Orientalists: European Painters of Eastern Scenes. Oxford: Phaidon, 1977.

303 Kahr, Madlyn Millner. Dutch Painting in the Seventeenth Century. New York: Harper and Row, 1978.

304 Kahr, Madlyn Millner. Velázquez: The Art of Painting. New York: Harper and Row, 1976.

305 Kan, Diana. The How and Why of Chinese Painting. New
 York: Van Nostrand Reinhold, 1974.

306 Kaplan, Julius. Gustave Moreau. Los Angeles: Los Ange-
 les County Museum of Art, 1974.

307 Kapp, Helen. Enjoying Pictures. London: Routledge,
 Kegan Paul, 1975.

308 Karlstrom, Paul J. Louis Michel Eilshemius. New York:
 Abrams, 1978.

309 Keay, Carolyn. Henri Rousseau Le Douanier. New York:
 Rizzoli, 1976.

310 Kelder, Diane. Great Masters of French Impressionism.
 New York: Crown, n. d.

311 Kelley, Ramon, and Mary Carroll Nelson. Ramon Kelley
 Paints Portraits and Figures. New York: Watson-
 Guptill, 1977.

312 Kendall, Dorothy Steinbomer. Gentilz: Artist of the Old
 Southwest. Austin: University of Texas Press, 1974.

313 Kennedy Galleries, Inc., New York. Recently Acquired
 American Masterpieces of the 19th and 20th Centuries.
 New York, The Gallery: 1974.

314 Kirschenbaum, Baruch D. The Religious and Historical
 Paintings of Jan Steen. New York: Allanhead and
 Schram, 1977.

315 Klee, Paul. Paul Klee: The Late Years 1930-1940. New
 York: Serge Sabarsky Gallery, 1977.

316 Kortlander, William. Painting with Acrylics. New York:
 Van Nostrand Reinhold, 1973.

317 Koschatzky, Walter. Albrecht Dürer: The Landscape
 Watercolours. New York: St. Martin's, 1973.

318 Kozloff, Max. Cubism/Futurism. New York: Charter-
 house, 1973.

319 Kramer, Hilton. Richard Lindner. Boston: New York
 Graphic Society, 1975.

320 Kultermann, Udo. The New Painting. Rev. and updated
 ed. Boulder, Col.: Westview Press, 1977.

321 Kurelek, William. Kurelek Country. Boston: Houghton
 Mifflin, 1975.

322 Kurelek, William. The Last of the Arctic. Toronto:
 Pagurian Press, 1976.

323 Kuretsky, Susan Donahue. The Paintings of Jacob Ochter-
 velt (1634-1682). Montclair, N. J.: Allanheld and
 Schram, 1979.

324 Lackner, Stephan. Max Beckmann. New York: Abrams.
 1977.

325 Lai, T. C. Three Contemporary Chinese Painters: Chang
 Da-chien, Ting Yin-yung, Ch'eng Shih-fa. Seattle:
 University of Washington Press, 1975.

326 Lane, John R. Stuart Davis: Art and Art Theory. New
 York: Brooklyn Museum, 1978.

327 Langdon, Helen. Holbein. New York: Dutton, 1976.

328 Larkin, David. Innocent Art. New York: Ballatine Books,
 1974.

329 Larkin, David. The Marine Paintings of Chris Mayger.
 New York: Peacock Press/Bantam, 1976.

330 Larkin, David, ed. The Paintings of Carl Larsson. New
 York: Peacock Press, 1976.

331 Larkin, David, ed. Temptation. New York: Peacock/
 Bantam, 1975.

332 Lassaigne, Jacques. El Greco. London: Thames and
 Hudson, 1973.

333 Lassiter, Barbara Babcock. American Wilderness: The
 Hudson River School of Painting. Garden City, N. Y.:
 Doubleday, 1978.

334 Laurence, Jeanne. My Life with Sydney Laurence. Seattle,
 Wash.: Salisbury Press, 1974.

335 Lawrence, Mary. Mother and Child. New York: Crowell,
 1975.

336 Lee, Arthur T. Fort Davis and the Texas Frontier. Col-
 lege Station: Texas A & M University Press, 1976.

337 Lee, Sherman E. The Colors of Ink: Chinese Paintings
 and Related Ceramics from the Cleveland Museum of
 Art. New York: Asia Society, 1974.

338 Leepa, Allen. Abraham Rattner. New York: Abrams,
 n. d.

339 Legouix, Susan. Botticelli. London: Oresko Books, Ltd.,
 1977.

340 Lehmann, Geoffrey. Australian Primitive Painters. St.
 Lucia: University of Queensland Press, 1977.

341 Leningrad. Ermitazhe. Western European Painting in the
 Hermitage. New York: Abrams, 1978.

342 Levin, Gail. Synchromism and American Color Abstraction
 1910-1925. New York: Braziller, 1978.

343 Levine, Frederick S. The Apocalyptic Vision: The Art of
 Franz Marc as German Expressionism. New York:
 Harper and Row, 1070.

344 Levitine, George. The Dawn of Bohemianism: The Barbu
 Rebellion and Primitivism in Neoclassical France.
 University Park: Pennsylvania State University Press,
 1978.

345 Leymarie, Jean. Van Gogh. New York: Rizzoli, 1977.

346 Licht, Fred. Goya: The Modern Temper in Art. New
 York: Universe Books, 1979.

347 Lindsay, Maurice. Robin Philipson. Edinburgh: Edinburgh
 University Press, 1976.

348 Lipman, Jean, and Helen M. Franc. Bright Stars: Amer-
 ican Painting and Sculpture Since 1776. New York:
 Dutton, 1976.

349 Little, Nina Fletcher. Asahel Powers: Painter of Vermont
 Faces. Williamsburg, Va.: The Colonial Williamsburg
 Foundation, 1973.

350 Longman, Lester D., and Maurice Bloch. Joyce Treiman.
 Los Angeles: Hennessey and Ingalls, 1978.

351 Looney, Ben Earl. Watercolors of Dixie. Baton Rouge,
 La.: Claitor's, 1974.

352 Lucie-Smith, Edward. Henri Fantin-Latour. New York:
 Rizzoli, 1977.

353 Lucie-Smith, Edward, and Celestine Dars. How the Rich
 Lived: The Painter as Witness 1870-1914. New York:
 Paddington Press, 1976.

354 Lucie-Smith, Edward, and Celestine Dars. Work and
 Struggle: The Painter as Witness, 1870-1914. New
 York: Paddington Press, 1977.

355 Lunde, Karl. Anuszkiewicz. New York: Abrams, 1977.

356 McAdoo, Donald and Carol McAdoo. Reflections of the Out-
 er Banks. Manteo, N. C. : Island Publishing House,
 1976.

357 McClure, David. John Maxwell. Edinburgh: Edinburgh
 University Press, 1976.

358 McCracken, Harold. The Frank Tenney Johnson Book: A
 Master Painter of the Old West. Garden City, N. Y. :
 Doubleday, 1974.

359 McDermott, John Francis. Seth Eastman's Mississippi: A
 Lost Portfolio Recovered. Urbana: University of Illi-
 nois Press, 1973.

360 McGrew, Ralph Brownell. R. Brownell McGrew. Kansas
 City, Mo. : Lowell Press, 1978.

361 McMullen, Roy. Mona Lisa: The Picture and the Myth.
 Boston: Houghton Mifflin, 1975.

362 Magritte, René. Secret Affinities: Words and Images.
 Houston, Tx. : Rice Institute for the Arts, 1976.

363 Mallalieu, Huon. The Norwich School: Crome, Cotman and
 Their Followers. New York: St. Martin's, 1974.

364 Mann, Maybelle. Francis William Edmonds. New York:
 Garland, 1977.

364a Manners, Lady Victoria, and Dr. G. C. Williamson.
 Angelica Kauffman, R. A. : Her Life and Her Works.
 Reprint of 1924 ed. New York: Hacker Art Books,
 1976.

365 Marden, Brice. Brice Marden. New York: Solomon R.
 Guggenheim Foundation, 1975.

366 Marsh, Winifred Petchey. People of the Willow: The Pad-
 limiut Tribe of the Caribou Eskimo. Toronto: Oxford
 University Press, 1976.

367 Marshall, Richard. New Image Painting. New York:
 Whitney Museum of American Art, 1978.

368 Martin, Gregory. Bruegel. New York: St. Martin's
 Press, 1978.

369 Martini, Alberto. Renoir. New York: Avenel Books,
 1978.

370 Mathey, Francois. American Realism: A Pictorial Survey
 from the Early Eighteenth Century to the 1970's. New
 York: Rizzoli, 1978.

371 Mason, Penelope E. Japanese Literati Painters: The
 Third Generation. New York: Brooklyn Museum,
 1977.

372 Matsushita, Takaaki. Ink Painting. New York: Weather-
 hill, 1974.

373 Mauner, George. Manet: Peintre-Philosophe--A Study of
 the Painter's Themes. University Park: Pennsylvania
 State University Press, 1975.

374 Mayer, Ralph. The Painter's Craft: An Introduction to
 Artists' Methods and Materials. 3rd ed. New York:
 Viking, 1975.

375 Meiss, Millard. The Painter's Choice: Problems in the
 Interpretation of Renaissance Art. New York: Harper
 and Row, 1976.

376* Mendoza, George. Norman Rockwell's Americana ABC.
 New York: Dell, 1975.

377 Messum, David. The Life and Work of Lucy Kemp-Welch.
 Woodbridge, Suffolk: Antique Collectors' Club, 1976.

378 Meyer, Susan E. 40 Watercolorists and How They Work.
 New York: Watson-Guptill, 1976.

379 Meyer, Susan E. 20 Landscape Painters and How They
 Work. New York: Watson-Guptill, 1977.

380 Meyer, Susan E. 20 Oil Painters and How They Work.
 New York: Watson-Guptill, 1978.

381 Miles, Ellen, ed. Portrait Painting in America: The
 Nineteenth Century. New York: Main Street/Universe
 Books, 1977.

382 Millar, Oliver. The Queen's Pictures. New York: Mac-
 millan, 1977.

383 Miller, Alfred J. Braves and Buffalo: Plains Indian Life
 in 1837. Toronto: University of Toronto Press, 1973.

384 Minnesota University. University Gallery. The Art and
 Mind of Victorian England: Paintings from the Forbes
 Magazine Collection. Minneapolis: Gallery, 1974.

385 Mitchell, Lucy B. The Paintings of James Sanford Ells-
 worth: Itinerant Folk Artist 1802-1873. Williamsburg,
 Va.: Colonial Williamsburg Foundation, 1974.

386 Mitsch, Erwin. The Art of Egon Schiele. London: Phaid-
 on, 1975.

387 The Moderns, 1945-1975. New York: Dutton, 1976.

388 Moffett, Kenworth. Kenneth Noland. New York: Abrams,
 1977.

389 Moffitt, John F. Spanish Painting. New York: Dutton,
 1973.

390 Montgomery Museum of Fine Arts. Corporate Collections
 in Montgomery. Montgomery, Ala.: Museum, 1976.

391 Moxey, Keith P. F. Pieter Aertsen, Joachim Beuckelaer
 and the Rise of Secular Painting in the Context of the
 Reformation. New York: Garland, 1977.

392 Muller, Joseph Emile. Velázquez. London: Thames and
 Hudson, 1976.

393 Mygatt, Emmie D., and Roberta Cheney. Hans Kleiber:
 Artist of the Big Horn Mountains. Caldwell, Id.:
 Caxton, 1975.

394 Naïve Art. Oxford: Phaidon, 1977.

395 Nathanson, Melvyn B. ed. Komar/Melamid: Two Soviet
 Dissident Artists. Carbondale: Southern Illinois Uni-
 versity Press, 1979.

396 Nemser, Cindy. Art Talk: Conversations with 12 Women
 Artists. New York: Scribner, 1975.

397 Ness, June L. Lyonel Feininger. New York: Praeger,
 1974.

398 New York (City) Metropolitan Museum of Art. Italian Paint-
 ings: A Catalogue of the Collection of the Metropolitan
 Museum of Art: Venetian School. New York: Museum,
 1973.

399 New York (City) Metropolitan Museum of Art. Life in
 America. Reprint of 1939 ed. New York: Arno, 1974.

400 New York. Museum of Modern Art. Art of the Twenties.
 New York: Museum, 1979.

401 New York. Museum of Modern Art. The Masterworks of
 Edvard Munch. New York, Museum, 1979.

402 New York. Museum of Modern Art. The Natural Paradise:
 Painting in America 1800-1950. New York: Museum,
 1976.

403 Newcomb, William W. , Jr. German Artist on the Texas
 Frontier: Friedrich Richard Petri. Austin: Univer-
 sity of Texas Press, 1978.

404 Nicholson, Ben. Ben Nicholson: Fifty Years of His Art.
 Buffalo, N. Y. : Albright-Knox Art Gallery, 1978.

405 Nicoll, John. Dante Gabriel Rossetti. New York: Mac-
 millan, 1975.

406 Nicolson, Benedict and Christopher Wright. Georges de la
 Tour. New York: Phaidon, 1974.

407 Noël, Bernard. Magritte. New York: Crown, 1977.

408 Norelli, Martina R. American Wildlife Painting. New
 York: Watson-Guptill, 1975.

409 Norman, Geraldine. Nineteenth-century Painters and Paint-
 ing: A Dictionary. Berkeley: University of California
 Press, 1977.

410 Norton, R. W. , Art Gallery. The Hudson River School:
 American Landscape Paintings from 1821 to 1907.
 Shreveport, La. : Gallery, 1973.

411 Norwood, Malcolm M. , Virginia McGehee Elias, and Wil-
 liam S. Haynie. The Art of Marie Hull. Jackson:
 University of Mississippi Press, 1975.

412 Novak, Barbara. Nature and Culture: American Landscape
 and Painting 1825-1875. New York: Oxford University
 Press, 1980.

413 O'Doherty, Brain. American Masters: The Voice and the
 Myth. New York: Random House, 1974.

414 O'Keeffe, Georgia. Georgia O'Keeffe. New York: Viking,
 1976.

415 Oklahoma Museum of Art. 100 Years of Native American
 Painting. Oklahoma City: Museum, 1978.

416 Oppenheim, Moritz Daniel. Pictures of Traditional Jewish
 Family Life. New York: KTAV Publishing, 1976.

417 Ormond, Leonée, and Richard Ormond. Lord Leighton.
 New Haven: Yale University Press, 1975.

418 Osborne, Harold. Abstraction and Artifice in Twentieth-
 century Art. Oxford: Clarendon Press, 1979.

419 Owens, Gwendolyn. Watercolors by Maurice Prendergast
 from New England Collections. Williamstown, Mass. :
 Sterling and Francine Clark Art Institute, 1978.

420 Parry, Ellwood. The Image of the Indian and the Black
 Man in American Art 1590-1900. New York: Braziller,
 1974.

421 Pataky, Dénes, and Imre Marjai. Ships in Art. N. P. :
 Corvina Press, 1973.

422 Pearsall, Derek, and Elizabeth Salter. Landscapes and
 Seasons of the Medieval World. Toronto: University
 of Toronto Press, 1973.

423 Pellew, John C. John Pellew Paints Watercolors. New
 York: Watson-Guptill, 1979.

424 Peppin, Anthea, and William Vaughan. Flemish Painting.
 Oxford: Phaidon, 1977.

425 Perry, Gillian. Paula Modersohn-Becker; Her Life and
 Work. New York: Harper and Row, 1979.

426* Peter, Adeline, and Ernest Raboff. Frederic Remington.
 Garden City, N. Y. : Doubleday, 1974?

427* Peter, Adeline, and Ernest Raboff. Paul Gauguin. Garden
 City, N. Y. : Doubleday, 1974.

428* Peter, Adeline and Ernest Raboff. Vincent Van Gogh.
 Garden City, N. Y. : Doubleday, 1974.

429 Picasso, Pablo. Picasso. New York: Acquavella Gal-
 leries, Inc. , 1975.

430 Picon, Gäeton. Modern Painting from 1800 to the Present.
 New York: Newsweek Books, 1974.

431 Pieyre de Mandiargues, André. Arcimboldo the Marvelous.
 New York: Abrams, 1978.

432 Pignatti, Terisio. The Golden Century of Venetian Paint-
 ing. New York: Braziller, 1979.

433 Pike, John. John Pike Paints Watercolors. New York:
 Watson-Guptill, 1978.

434 Piper, David, ed. The Genius of British Painting. New
 York: Morrow, 1975.

435 Pisano, Ronald G. William Merritt Chase. New York:
 Watson-Guptill, 1979.

436 Pittsburgh. Museum of Art, Carnegie Institute. Catalogue
 of Painting Collection. Pittsburgh: Museum, 1973.

437 Pitz, Henry C. Howard Pyle: Writer, Illustrator, Founder
 of the Brandywine School. New York: Clarkson Potter,
 1975.

438 Pohribny, Arsén. Abstract Painting. New York: Dutton,
 1979.

439 Pomeroy, Ralph. Stamos. New York: Abrams, 1977.

440 Pope-Hennessy, John. Fra Angelico. 2nd ed. Ithaca,
 N. Y. : Cornell University Press, 1974.

441 Porzio, Domenico and Marco Valsecchi. Understanding
 Picasso. New York: Newsweek Books, 1974.

442 Potterton, Homan. The National Gallery, London: A Com-
 plete Catalogue of the Paintings. London: Thames and
 Hudson, 1977.

443 Poulet, Anne L. Corot to Braque: French Paintings from
 the Museum of Fine Arts, Boston. Boston: Museum,
 1979.

444 Powell, Nowland Van. The American Navies of the Revo-
 lutionary War. New York: Putnam, 1974.

445 Prown, Jules David, and Barbara Rose. American Painting:
 From the Colonial Period to the Present. New updated
 ed. New York: Skira, 1977.

446 Pyle, Howard. Howard Pyle. New York: Scribner's, 1975.

447 Quignon-Fleuret, Dominique. Georges Mathieu. New York:
 Crown, 1977.

448 Quinn, Wayne. The Art of Wayne Quinn. San Francisco:
 David Charlsen/New Glide, 1977.

449 Read, Herbert. A Concise History of Modern Painting.
 Enlarged and updated 3rd ed. New York: Praeger,
 1974.

450 Reed, Walt. John Clymer: An Artist's Rendezvous with
 the Frontier West. Flagstaff, Ariz. : Northland Press,
 1976.

451 Reff, Theodore. Degas: The Artist's Mind. New York:
 Harper and Row, 1976.

452 Reff, Theodore. Manet: Olympia. New York: Viking, 1977.

453 Reid, Charles. Flower Painting in Oil. New York: Watson-Guptill, 1976.

454 Reiss, Stephen. Aelbert Cuyp. Boston: New York Graphic Society, 1975.

455 Rice, David Talbot and Tamara Talbot Rice. Icons and Their History. Woodstock, N.Y.: Overlook Press, 1974.

456 Richardson, Brenda. Frank Stella: The Black Paintings. Baltimore: Museum of Art, 1976.

457 Richmond, Leonard. Fundamentals of Oil Painting. New York: Watson-Guptill, 1977.

458 Rinaldis, Aldo. Neapolitan Painting in the Seicento. Reprint of 1929 ed. New York: Hacker Art Books, 1976.

459 Roberts, Keith. Italian Renaissance Painting. New York: Dutton, 1976.

460 Roberts, Keith. Painters of Light: The World of Impressionism. New York: Dutton, 1978.

461 Roberts, Keith. Rubens. New York: Dutton, 1977.

462 Roberts-Jones, Philippe. Beyond Time and Place: Non-realist Painting in the Nineteenth Century. New York: Oxford University Press, 1978.

463 Robinson, Duncan. Stanley Spencer: Visions from a Berkshire Village. Oxford: Phaidon, 1979.

464 Robinson, E. John. Marine Painting in Oil. New York: Watson-Guptill, 1973.

465 Robinson, E. John. The Seascape Problem Painter's Book. New York: Watson-Guptill, 1976.

466 Robinson, Franklin W. Gabriel Metsu (1629-1667): A Study of His Place in Dutch Genre Painting of the Golden Age. New York: Abner Schram, 1974.

467 Rodrigue, George. The Cajuns of George Rodrigue. Birmingham, Ala.: Oxmoor House, 1976.

468 Rogers, Mondel. Old Ranches of the Texas Plains. College Station: Texas A & M University Press, 1976.

469 Ronen, Abraham. The Peter and Paul Altarpiece and Fried-
 rich Pacher. New York: Humanities Press, 1974.

470 Rosand, David. Titian. New York: Abrams, 1978.

471 Rose, Andrea. The Pre-Raphaelites. Oxford: Phaidon,
 1977.

472 Rose, Barbara. American Art Since 1900. Rev. and ex-
 panded ed. New York: Praeger, 1975.

473 Rosenberg, Harold. de Kooning. New York: Abrams,
 1974.

474 Rosenblum, Robert. Andy Warhol: Portraits of the 70s.
 New York: Random House, 1979.

475 Rosenblum, Robert. Modern Painting and the Northern
 Romantic Tradition: Friedrich to Rothko. New York:
 Harper and Row, 1975.

476 Rosenzweig, Phyllis D. The Thomas Eakins Collection of
 the Hirshhorn Museum and Sculpture Garden. Washing-
 ton, D. C. : Smithsonian Institution Press, 1977.

477 Rothenstein, John. Augustus John. Reprint of 1945 ed.
 Oxford: Phaidon, 1976.

478 Rothenstein, John. Modern English Painters. New York:
 St. Martin's, 1974-76.

479 Rothschild, Lincoln. To Keep Art Alive: The Effort of
 Kenneth Hayes Miller, American Painter (1876-1952).
 Philadelphia, Pa. : Art Alliance Press, 1974.

480 Rubin, William, ed. Cézanne: The Late Work. New York:
 Museum of Modern Art, 1977.

481 Rubin, William. The Paintings of Gerald Murphy. New
 York: Museum of Modern Art, 1974.

482 Russell, John. Francis Bacon. Rev. ed. New York:
 Oxford University Press, 1979.

483 Sanden, John Howard. Painting the Head in Oil. New
 York: Watson-Guptill, 1976.

484 Sapp, Allen. A Cree Life: The Art of Allen Sapp. Van-
 couver: J. J. Douglas Ltd. , 1977.

485 Schaefer, Rudolph J. J. E. Buttersworth; 19th Century
 Marine Painter. Mystic, Conn. : Mystic Seaport,
 1975.

486* Scheader, Catherine. Mary Cassatt. Chicago: Childrens
 Press, 1977.

487 Schiff, Gert. Picasso in Perspective. Englewood Cliffs,
 N. J. : Prentice-Hall, 1976.

488 Schiwetz, E. M. Buck Schiwetz' Memories: Paintings and
 Drawings. College Station: Texas A & M Press, 1978.

489 Schlemm, Betty L. Painting with Light. New York: Wat-
 son-Guptill, 1978.

490 Schmalenbach, Werner. Fernand Léger. New York: Ab-
 rams, 1976.

491 Schmalz, Carl. Watercolor Lessons from Eliot O'Hara.
 New York: Watson-Guptill, 1974.

492 Schmalz, Carl. Watercolor Your Way. New York: Watson-
 Guptill, 1978.

493 Schmid, Richard. Richard Schmid Paints Landscapes. New
 York: Watson-Guptill, 1975.

494 Schrade, Hubert. German Romantic Painting. New York:
 Abrams, 1977.

495 Schwarz, Arturo. Marcel Duchamp. New York: Abrams,
 1975.

496 Schweizer, Paul D. Edward Moran (1829-1901) American
 Marine and Landscape Painter. Wilmington: Delaware
 Art Museum, 1979.

497 Scott, David. John Sloan. New York: Watson-Guptill,
 1975.

498 Scrase, David. Drawings and Watercolours by Peter de
 Wint. New York: Cambridge University Press, 1979.

499* Sedgwick, Kate and Rebecca Frischkorn. Children in Art.
 New York: Holt, Rinehart & Winston, 1978.

500 Selz, Jean. E. Munch. New York: Crown, 1974.

501 Selz, Jean. Gustave Moreau. New York: Crown, 1979.

502 Selz, Jean. Turner. New York: Crown, 1975.

503 Selz, Peter. German Expressionist Painting. Berkeley:
 University of California Press, 1974.

504 Selz, Peter. Sam Francis with an Essay on His Prints by
 Susan Einstein. New York: Abrams, 1975.

505 Serra, Francesc and J. M. Parramon. Painting the Nude.
 Hertfordshire, England: Fountain Press, 1976.

506 Sérullaz, Maurice. Phaidon Encyclopedia of Impressionism.
 Oxford: Phaidon, 1978.

507 Shadbolt, Doris. The Art of Emily Carr. Seattle: Univer-
 sity of Washington Press, 1979.

508 Sharon, Mary Bruce. Scenes from Childhood. New York:
 Dutton, 1978.

509 Shepler, Dwight. An Artist's Horizons. Weston, Mass. :
 Fairfield House, 1973.

510 Shimizu, Yoshiaki, and Carolyn Wheelwright, eds. Japanese
 Ink Paintings from American Collections. Princeton:
 Princeton University Press, 1976.

511 Shone, Richard. The Century of Change: British Painting
 Since 1900. New York: Dutton, 1977.

512 Shone, Richard. Manet. New York: St. Martin's, 1979.

513 Shone, Richard. The Post-Impressionists. London: Octo-
 pus, 1979.

514 Shone, Richard. Vincent Van Gogh. New York: St. Mar-
 tin's, 1978.

515 Shuptrine, Hubert, and James Dickey. Jericho: The South
 Beheld. Birmingham, Ala. : Oxmoor House, 1974.

516 Silverman, Burt. Painting People. New York: Watson-
 Guptill, 1977.

517 Simbari, Nicola. Simbari: Commentary by Stuart Preston.
 New York: Simon & Schuster, 1975.

518 Sinclair, Lester, and Jack Pollock. The Art of Norval
 Morrisseau. New York: Methuen, 1979.

519 Singer, Joe. Charles Pfahl: Artist at Work. New York:
 Watson-Guptill, 1977.

520 Singer, Joe. Painting Men's Portraits. New York: Wat-
 son-Guptill, 1977.

521 Singer, Joe. Painting Women's Portraits. New York:
 Watson-Guptill, 1977.

522 Smart, Alastair. The Dawn of Italian Painting 1250-1400.
 Ithaca, N. Y. : Cornell University Press, 1978.

523 Spalding, Frances. Magnificent Dreams: Burne-Jones and the Late Victorians. New York: Dutton, 1978.

524 Sparrow, Walter Shaw, ed. Women Painters of the World from the Time of Caterina Vigri 1413-1463 to Rosa Bonheur and the Present Day. Reprint of 1905 ed. New York: Hacker Art Books, 1976.

525 Spate, Virginia. Orphism: The Evolution of Non-figurative Painting in Paris 1910-1914. Oxford: Clarendon, 1979.

526 Spear, Richard E. Caravaggio and His Followers. Rev. ed. New York: Harper and Row, 1975.

527 Stangos, Nikos. David Hockney. New York: Abrams, 1976.

528 Stebbins, Theodore E., Jr. American Master Drawings and Watercolors. New York: Harper and Row, 1976.

529 Stebbins, Theodore E., Jr. Close Observation: Selected Oil Sketches by Frederic E. Church. Washington, D.C.: Smithsonian Institution Press, 1978.

530 Stebbins, Theodore E., Jr. The Life and Works of Martin Johnson Heade. New Haven: Yale University Press, 1975.

531 Stein, Roger B. Seascape and the American Imagination. New York: Clarkson N. Potter, 1975.

532 Stettheimer, Florine. Florine Stettheimer: An Exhibition of Paintings, Watercolors, Drawings. New York: Columbia University Press, 1973.

533 Stirton, Paul. Renaissance Painting. New York: Mayflower Books, 1979.

534 Stokes, Hugh. Benozzo Gozzoli. Reprint of 1904 ed. New York: AMS Press, 1976.

535 Storz, Frank. The Western Paintings of Frank C. McCarthy. New York: Ballantine Books, 1974.

536 Stravinsky, Vera. Fantastic Cities and Other Paintings. Boston: David R. Godine, 1979.

537 Strong, Roy. And When Did You Last See Your Father? The Victorian Painter and British History. London: Thames and Hudson, 1978.

538 Strong, Roy. Recreating the Past: British History and the Victorian Painter. London: Thames and Hudson, 1978.

539 Sullivan, Michael. The Three Perfections: Chinese Painting, Poetry and Calligraphy. London: Thames and Hudson, 1974.

540 Swanson, Vern G. Alma-Tadema: The Painter of the Victorian Vision of the Ancient World. New York: Scribner, 1977.

541 Sylvester, David. Francis Bacon. New York: Pantheon Books, 1975.

542 Szabo, Zoltan. Zoltan Szabo Paints Landscapes. New York: Watson-Guptill, 1977.

543 Takeda, Tsuneo. Kano Eitoku. Tokyo: Kodansha International, 1977.

544 Tamayo, Rufino. Rufino Tamayo: Myth and Magic. New York: Solomon R. Guggenheim Foundation, 1979.

545 Tashjian, Diekran. Skyscraper Primitives: Dada and the American Avant-garde 1910-1925. Middletown, Conn.: Wesleyan University Press, 1975.

546 Taylor, Basil. Constable: Paintings, Drawings and Watercolours. New York: Phaidon, 1973.

547 Taylor, John. Icon Painting. New York: Mayflower Books, 1979.

548 Terrasse, Antoine. Degas. Garden City, N.Y.: Doubleday, 1974.

549 Thomas, Denis. Abstract Painting. New York: Dutton, 1976.

550 Thomson, Duncan. The Life and Art of George Jamesone. Oxford: Clarendon Press, 1974.

551 Timberlake, Bob. Bob Timberlake: Paintings, and Watercolors. Shreveport, La.: R. W. Norton Art Gallery, 1974.

552 Tobey, Mark. Tribute to Mark Tobey. Washington, D.C.: Smithsonian Institution Press, 1974.

553 Toledo. Museum of Art. European Paintings. Toledo: Museum, 1976.

554 Tomašević, Nebojša. The Magic World of Ivan Generalić. New York: Rizzoli, 1976.

555 Tomlinson, Juliette, ed. The Paintings and the Journal of
 Joseph Whiting Stock. Middletown, Conn. : Wesleyan
 University Press, 1976.

556 Tomory, Peter. Catalogue of Italian Paintings Before 1800.
 Sarasota, Fla. : John and Mable Ringling Museum of
 Art, 1976.

557 Torczyner, Harry. Magritte: Ideas and Images. New
 York: Abrams, 1977.

558 Trucchi, Lorenza. Francis Bacon. New York: Abrams,
 1975.

559 United Nations Educational, Social and Cultural Organization.
 An Illustrated Inventory of Famous Dismembered Works
 of Art: European Painting. Paris: Unesco, 1974.

560 U. S. National Gallery of Art. Small French Paintings
 from the Bequest of Ailsa Mellon Bruce. Washington,
 D. C. : 1978.

561 Valkenier, Elizabeth. Russian Realist Art: The State and
 Society: The Peredvizhniki and Their Tradition. Ann
 Arbor, Mich. : Ardis, 1977.

562 Vallier, Dora. Henri Rousseau. New York: Crown, 1979.

563 Van Eyck. Van Eyck. London: Abbey Library, 1973.

564 Vassos, John. Contempo, Phobia and Other Graphic Inter-
 pretations. New York: Dover, 1976.

565 Vaughan, William. William Blake. New York: St. Mar-
 tin's, 1978.

566 Venturi, Lionello. Cézanne. New York: Rizzoli, 1978.

567 Venturi, Lionello. Renaissance Painting from Leonardo to
 Dürer. New York: Rizzoli, 1979.

568 Vergo, Peter. The Blue Rider. Oxford: Phaidon, 1977.

569 Verrier, Michelle. Fantin-Latour. New York: Harmony
 Books, 1978.

570 Verrier, Michelle. The Orientalists: All Colour Paperback.
 New York: Rizzoli, 1979.

571 Vickrey, Robert. Robert Vickrey: Artist at Work. New
 York: Watson-Guptill, 1979.

572 Viola, Herman J. The Indian Legacy of Charles Bird King.
 Washington, D. C. : Smithsonian Institution Press and
 Doubleday, 1976.

573 Virginia. Museum of Fine Arts, Richmond. Twelve Amer-
 ican Painters. Richmond, Va. : The Museum, 1974.

574 Vishny, Michele. Mordecai Ardon. New York: Abrams,
 1974.

575 Visions. Corte Madera, Cal. : Pomegranate, 1977.

576 Visual Dictionary of Art. Greenwich, Connn. : New York
 Graphic Society, 1974.

577 Von Schmidt, Harold. The Western Art of Harold Von
 Schmidt. New York: Peacock Press, 1976.

578 Wakefield, David. Fragonard. London: Oresko Books,
 1976.

579 Waldman, Diane. Mark Rothko, 1903-1970: A Retrospec-
 tive. New York: Abrams, 1978.

580 Walker, John. John Constable. New York: Abrams, 1978.

581 Walker, John. Joseph Mallord William Turner. New York:
 Abrams, 1976.

582 Wall, Donald. Gene Davis. New York: Praeger, 1975.

583 Warner, Malcolm. Portrait Painting. New York: May-
 flower Books, 1979.

584 Warnod, Jeanine, Georges Huisman, and Jean Cassou.
 Adolphe Milich: His Life and Art. New York: Diplo-
 matic Press, 1974.

585 Washington, M. Bunch. The Art of Romare Bearden: The
 Prevalence of Ritual. New York: Abrams, n. d.

586 Wasserman, Jack. Leonardo da Vinci. New York: Ab-
 rams, 1975.

587 Waterhouse, Ellis. Painting in Britain 1530 to 1790. 4th
 ed. New York: Penguin, 1978.

588 Watney, Simon. Fantastic Painters. New York: St. Mar-
 tin's, 1977.

589 Waugh, Coulton. Landscape Painting with a Knife. New
 York: Watson-Guptill, 1974.

590 Wechsler, Judith, ed. Cézanne in Perspective. Englewood
 Cliffs, N. J. : Prentice-Hall, 1975.

591 Wedgwood, C. V. The Political Career of Peter Paul
 Rubens. London: Thames and Hudson, 1975.

592 Weigelt, Curt H. Sienese Painting of the Trecento. New
 York: Hacker Art Books, 1974.

593 Weiss, Peg. Kandinsky in Munich: The Formative Jugend-
 stil Years. Princeton: Princeton University Press,
 1979.

594 Welsh-Ovcharov, Bogomila, ed. Van Gogh in Perspective.
 Englewood Cliffs, N. J. : Prentice-Hall, 1974.

595 Werner, Alfred. Chaim Soutine. New York: Abrams,
 1977.

596 Werner, Alfred. Max Weber. New York: Abrams, 1975.

597 White, Barbara Ehrlich, ed. Impressionism in Perspective.
 Englewood Cliffs, N. J. : Prentice-Hall, 1978.

598 Whitney, Edgar A. Complete Guide to Watercolor Painting.
 New, enl. ed. New York: Watson-Guptill, 1974.

599 Wilkinson, Sarah. Reuven Rubin. New York: Abrams,
 1974.

600 Wilton, Andrew. British Watercolours; 1750 to 1850. Ox-
 ford: Phaidon, 1977.

601 Winchester, Alice. Versatile Yankee: The Art of Jonathan
 Fisher, 1768-1847. Princeton, N. J. : Pyne Press,
 1973.

602 Wolfe, Karl. Mississippi Artist: A Self-portrait. Jackson:
 University of Mississippi Press, 1979.

603 Wong, Frederick. Oriental Watercolor Techniques. New
 York: Watson-Guptill, 1977.

604 Wood, Christopher. The Dictionary of Victorian Painters.
 2nd ed. rev. and enl. Woodbridge, Suffolk: Antique
 Collectors' Club, 1978.

605 Wood, Christopher. Victorian Panorama: Paintings of Vic-
 torian Life. London: Faber & Faber Ltd. , 1976.

606 Wood, Robert E. , and Mary Carroll Nelson. Watercolor
 Workshop. New York: Watson-Guptill, 1974.

607 Worth, Leslie. The Practice of Watercolour Painting.
 London: Pitman, 1977.

608 Wright, Christopher. The Dutch Painters: 100 Seventeenth
 Century Masters. Woodbury, N. Y. : Barron's, 1978.

609 Wright, Christopher. Frans Hals. London: Phaidon, 1977.

610 Wright, Christopher. French Painting. New York: May-
 flower Books, 1979.

611 Wright, Christopher. Georges de la Tour. Oxford:
 Phaidon, 1977.

612 Wyeth, Betsy James, Wyeth at Kuerners. Boston: Hough-
 ton Mifflin, 1976.

613 Wyeth, Carolyn. Carolyn Wyeth: A Retrospective Exhibi-
 tion. Shreveport, La. : R. W. Norton Art Gallery,
 1976.

614 Yeo, Wilma, and Helen K. Cook. Maverick with a Paint-
 brush: Thomas Hart Benton. New York: Doubleday,
 1977.

615 Yonezawa, Yshiho, and Chu Yoshizawa. Japanese Painting
 in the Literati Style. New York: Weatherhill/Heibon-
 sha, 1974.

616 Young, Mahonri Sharp. American Realists. New York:
 Watson-Guptill, 1977.

617 Young, Mahonri Sharp. Early American Moderns: Painters
 of the Stieglitz Group. New York: Watson-Guptill,
 1974.

Part II

PAINTINGS BY UNKNOWN ARTISTS

Part III

PAINTERS AND THEIR WORKS

AACHEN, Hans von, 1552-1615
Victory of truth; 576

ABBATE, Niccolo dell, 1512-71
Boiardo, Matteo Maria, writes
 L'Orlando in Love; 283c
Card players; 205
Story of Aristaeus; 442c

ABBATI, Giuseppe, 1836-68
The cloister; 576

ABBEMA, Louise, 1858-1927
Luncheon in the conservatory; 96,
 353
Winter; 524

ABBEY, Edwin Austin, 1852-1911
A concert; 267c
An old song; 528
The Queen in Hamlet; 176
Richard, Duke of Gloucester and
 Lady Anne; 604

ABBEY, Rita Deanin, 1930-
Anonymity; 1c
By the river; 1c
Canyon wall; 1c
Closed space; 1c
Confluence; 1c
Dark silence; 1c
Darkness; 1c
Diving bats; 1c
Drifting siennas; 1c
Fusion; 1c
Hidden canyons; 1c
Images; 1c
Inner voice; 1c
La Sal Mountain; 1c
Ledges; 1c
May flies; 1c
Motion; 1c
Rapids; 1c
Rediscovery; 1c
Serpentine forms; 1c

Stripe; 1c
Textures; 1c

ABBOTT, J.
A sleigh ride; 235

ABDUS SAMAD, 16th century
Princes of the house of Timur; 71

ABEL, Meyer, 1904-
Flowers on blue cloth; 457

ABEL de PUJOL, Alexandre D.,
 1785-1861
Self-portrait; 184

ABILDGAARD, Nikolai Abraham,
 1742/43-1809
The Spirit of Culmin appears to
 his mother; 462c

ABRAMOFSKY----
Canaday, Molly Morpeth; 86cd

ABRAMS, Isaac
Cosmic orchard; 320c

ABRAN, Mme. ----
Study of tigers; 524

ABSOLON, John, 1815-95
Opie, when a boy, reproved by his
 mother; 604

ABU'L HASAN
Jahangir shooting at the severed
 head of Malik Ambar; 576
Jahangir's dream of Shah Abbas
 I's visit; 576

ACCARDI, Carla, 1924-
Pittura; 320c

ACHEN, Hans von see Aachen,
 Hans von

AGASSE, Jacques Laurent, 1767-
 1846/49
The Nubias giraffe; 382
The playground; 143c, 409

AGATE, Alfred T., 1812-46
Fiji Islands; 176

AGATE, Frederick Style, 1803-44
The dead child; 176

AGNEESSENS, Edouard, 1842-85
The Colard children; 96

AIDE-CREQUY, Jean Antoine,
 1746-80
St. Louis tenant la couronne
 d'épines; 234

AIKMAN, William, 1682-1731
Manners, Lady Frances; 279
Marchmont, Patrick, Earl of; 279
Self-portrait; 587

AILES, Curtis A.
Eternal Spring; 23

AINSLIE, Henry F., 1803-79
Ganonoque Mills, Upper Canada; 235

AINSLIE, John, 1750-1834
Florance, Joseph, chef; 279

AISEKI, 19th century
Ghostly rocks and a swiftly flowing
 waterfall; 371
A lakeside village and scattered
 boats; 371

AJMONE, Giuseppe, 1923-
Still life, 559

AKAMATSU Rinsaku, 1878-1953
Night train; 230c

AKAWIE, Thomas, 1935-
Cloud mirror; 575c
Osiris; 575c
Pyramid sunset; 575c
Ra; 575c
Ra rising; 575c

AKBAR, 1556-1605
The dervish wondering at the
 Divine Mercy; 576

AKBAR NAMA
The birth of Prince Salim; 576

AKEN, Leo van
Archers; 354

AKIN, Louis, 1868-1913
Bucksin kachina in dance costume;
 25
A Christmas morning; 25c
Grand Canyon; 233c
Hopi snake priest; 25c
Hopi weaver; 25c
In Oraibi Plaza; 25c
Mesa and desert; 25c
Morning--Hermit Canyon; 25c
Mount Akin; 25c
Navajos watching field sports; 25c
Pool in the desert; 25c
The river; 25c
San Francisco Peaks; 25c
Sunset glow; 25c
The temple; 25c

ALBANI, Francesco, 1578-1660
Air; 576
St. John the Baptist kneeling in the
 wilderness; 556

ALBERS, Josef, 1888-1976
Dense--soft; 97c
Floating; 97c
Homage to a square; 3c, 9c, 97c,
 320c
Homage to a square: ascending;
 3c, 576
Homage to the square: apparition;
 388
Homage to the square: delaying;
 283c
Homage to the square: Frislan;
 472c
Homage to the square: green scent;
 403c
Homage to the square: resound;
 22c
Homage to the square: ritardando;
 445c
Study for painting Mirage A; 449
What you want; 97c

ALBERTI, Henri
An opening night at the Folies
 Bergères; 353
Winter morning, collecting the
 homeless; 354

ALBERTINELLI, Mariotto de Bagio,
 1474-1515
Adoration of the Child; 61
Adoration of the Child with angel;

Maine landscape; 125c
Maker of dreams; 125c
Manifestation; 125
Memories of the past; 125c
Mephistopheles; 125c
Nude; 125c
Paper flowers; 125c
Patterson, Alicia; 125
Patterson, Captain Joseph Medill;
125c
The philosopher; 125
The picture of Dorian Gray; 125c
Poor room--there is no time, no
end, no today, no yesterday,
no tomorrow, only the forever,
and forever and forever with-
out end; 125c
Pray for the little ones; 125c
The purist; 125c
Red onion; 125
Roaring Fork, Wyo.; 125c
Rue du Bac, Paris; 125c
The rustlers; 125c
Samson; 125
The Sea of Galilee; 125c
Self-portrait; 125c
Self-portrait in Georgia; 125c
Shore sentinels; 125
Stones at Stonington, Me.; 125
The temptation of St. Anthony;
125c
That which I should have done I
did not do; 98c, 125c, 472,
576
There comes a time; 125c
There were no flowers tonight; 125c
This ichnolite of mine; 125c
Three love birds; 125c
Tin; 125c
To tread between sky and field;
125c
The trees: they murmur so--
like people they murmur--
murmur so; 125c
Troubled waves; 125c
We are gathered here; 125c
When fall winds blow; 125
Wherefore now ariseth the illusion
of a third dimension; 125c
The wild bunch; 125c
Woman; 125c, 400

ALDEN, G.
Woman; 158

ALDEN, Selma
Stern, Sam, tailor; 23c
Victoriana still life; 23c

ALECHINSKY, Pierre, 1927-
Central Park; 430c
Dragon anemone; 449
Luxe, calme et volupté; 436c

ALEKSA, Son of Peter
St. Nicholas the miracle worker;
455

ALEMAGNA, Giovanni d', fl. 1440-
47
Coronation of the Virgin; 576
Sts. Francis and Mark; 442
Sts. Peter and Jerome; 442

ALENZA, Leonardo
The great lord; 38
The puppeteer; 38
Los romanticos; 389
The scales; 38
The soup; 38

ALEXANDER, Cosmo
Dalyell, Captain Sir Robert, of the
Binns; 279

ALEXANDER, Edwin, 1870-1926
Doves and apple blossom; 604

ALEXANDER, Francis, 1800-80
Ralph Wheelock's farm; 370c

ALEXANDER, Henry, 1860-95
The laboratory of Thomas Price;
266, 399

ALEXANDER, John, 1690-
Hamilton, James, 5th Duke of,
with the artist; 279
Modello for the rape of Proser-
pine; 507
The rape of Proserpine; 279

ALEXANDER, John White, 1856-
1915
Isabella and the pot of basil; 96c
June; 176

ALEXANDER, Lawrence E.
Andromeda returns; 48c

ALEXANDER, Norman, 1915-
Work in progress; 553

ALEXANDER, William
An inn; 105

576c
Battle of Alexander and Darius;
 205c
Christ between two thieves; 72c
Crucifixion; 576
Danube landscape near Regens-
 burg; 567c
Entombment; 72c
Kaiserbad frescoes; 559
Madonna and Child in glory; 335cd
St. Florian taking leave of his
 companions; 567c
St. George; 283c, 294c
St. George in a wood; 205
Sarmengstein on the Danube; 576
Susanna and the Elders; 294c

ALTICHIERO----, 1330-95
Crucifixion; 522d
Death of St. Lucy; 522
Martyrdom of St. George; 576
Miracle of St. Lucy; 205

ALVA----, 1901-
Trio; 449

ALVIANI, Getulio, 1939-
Abito; 320
Linee luce; 320
Orecchino; 320
Superficie a testura vibratrice
 circolare; 320

AMAN-JEAN, Edmond Francois,
 1860-1936
Woman in a pink dress; 100c

AMAURY-DUVAL, Eugene E.,
 1808-85
Birth of Venus; 417

AMBERGER, Christoph, 1490/1500-
 1561/63
Portrait of a young man with a
 fur collar; 341

AMERLING, Friedrich von, 1803-
 87
The lute player; 409
Vogelstein, Carl Christian Vogel
 von; 175

AMES, Ezra, 1768-1836
Cortlandt, Philip van, 178c

AMICO di Sandro, 15th century
Adoration of the Magi; 44
Bandinelli, Esmeralda; 44

La Bella Simonetta; 44
Bust of a youth; 44
Coronation of the Virgin; 44
Esther; 44
Madonna and Child; 44
Madonna and Child with St. John;
 44
Medici, Giuliano de'; 44
Story of Esther; 44
Tobias and the archangels; 44
Virgin and child with two angels;
 44

AMIET, Cuno, 1868-1961
Apple harvest; 160
Autumn sun; 147c

AMIGONI, Jacopo (Amiconi), 1675-
 1752
Frederick, Prince of Wales; 382
Martyrdom of a saint; 556
Mercury presenting the head of
 Argus to Juno; 587
Venus and Adonis; 284c

AMIOTTE, Arthur, 1942-
Gathering firewood; 415

AN KYON, 15th century
Dream journey; 372

ANCHER, Anna Kirstine, 1859-1935
Interior with a young girl plaiting
 her hair; 409

ANCHER, Michael Peter, 1849-1927
Lifeboat taken from the dunes; 354

ANCONA, Nicola d'
Madonna and Child with Sts. Leon-
 ard, Jerome, John the Baptist
 and Francis; 436

ANDERSON, John
Royal arms of Scotland; 550

ANDERSON, Sophie, 1823-98?
Elaine; 524
Guess again; 384
No walk today; 604

ANDERSON, William
Greenwich: return of George IV
 in the Royal Yacht, 10 August
 1822; 121
Limehouse Reach; 121

ANDRE, Dietrich Ernst, 1680?-1735
The golden age under George I; 40

ANDRE, O.
Woman at tea; 443c

ANDREA DA FIRENZE (Bonaiuti),
1343?-77
Triumph of St. Thomas Aquinas;
205
Triumph of the Church; 522

ANDREA del CASTAGNO, 1390-
1457
Last Supper; 205c, 223, 576
Nine famous men and women; 205d
St. Jerome with Sts. Paola and
Eustochium below the Trinity;
375
Tolentino, Niccolò da; 223
Victorious David; 291c
The young David; 283c, 459c
Youthful David; 39c

ANDREA del SARTO, 1486-1510/31
Madonna and Child enthroned with
Sts. Francis and John the
Evangelist; 576
Madonna of the sack; 205
Portrait of a young man; 442c
Nativity of the Virgin; 576
Sacrifice of Jsaac; 223
The Virgin and Child with a saint
and an angel; 382
Virgin and Child with St. Eliza-
beth and St. John the Baptist;
223

ANDREA di BARTOLO, 1389-1428
Crucifixion; 553

ANDREA di CIONE see OR-
CAGNA, Andrea

ANDREJEVIC, Milet, 1925-
Fall of Icarus; 320

ANDREU, Mariano, 1888-
Bastinadoes; 553

ANDREWS, E. Benjamin
The rush from the New York
Stock Exchange; 437

ANDREWS, Elephalet F., 1835-1915
Johnson, Andrew; 122

ANDREWS, George Henry, 1816-98
Queen Down Warren, Hartlip; 105

ANDREWS, Henry
Fête champetre; 604

ANDREWS, Michael
All night long; 434, 478
Good and bad at games II; 478
Lights III: the Black Battalion;
478

ANDREY----
Purification of the Virgin; 455

ANDREZ, P., 17th century
Portrait of a woman; 96

ANGEL, M.
The contractor's inspection; 354

ANGELI, Heinrich von, 1840-
Queen Victoria; 302

ANGELICO, Fra Giovanni, 1387-
1455
Adoration of the Magi; 39c, 223,
291c, 440, 459c
Agony in the garden; 440
Annalena altarpiece; 440
Annunciation; 294c, 440, 533c
Annunciatory angel; 440
Apparition of St. Francis at Arles;
440
Assumption of the Virgin; 375
The attempted martyrdom of Sts.
Cosmas and Damian by fire;
440
Birth of St. Dominic; 440
Birth of St. Nicholas: the vocation
of St. Nicholas and St. Nicholas
and the three maidens; 440
A bishop saint; 440
Bosco ai Frati altarpiece; 440c
The burial of Sts. Cosmas and
Damian; 440
Burial of the Virgin; 440
Christ as pilgrim received by two
Dominicans; 440, 576
Christ blessing; 440
Christ crowned with thorns; 440
Christ despatching the Apostles;
440
Christ in glory; 440
Christ on the Cross; 440
Christ on the Cross adored by St.
Dominic; 440
Christ on the Cross adored by St.
Dominic with the Virgin and St.
John; 440
Christ on the Cross adored by Sts.
Nicholas and Francis; 440
Christ on the Cross with the Virgin
and eight saints; 440
Christ on the Cross with the Virgin

ANTROBUS, John, 1837-1907
Plantation burial; 257

ANTWERP Mannerist Artist
Beheading of John the Baptist; 205

ANUSZKIEWICZ, Richard Joseph,
1930-
Afternoon shadows; 355
All things do live in the three;
355c
Apex; 355
Arithmetical red; 355
The artist; 355
Aureole II: 3-unit dimensional;
355c
Back porch; 355
Backyard; 355
Between; 355
Between two houses; 355
Black and white series; 355
Bleached orange; 355c
Blue center; 355
Blue on orange; 355
The blues; 355
Bonfire; 355
Bound vapor; 355c
Bouquet; 355c
Break-up; 355
The bridge; 355
The burning glass; 355
Butterfly boy; 355
The cadmiums; 355c
Celestial; 355
Centum; 355c
Chewing the rag; 355
Church across the street at
Christmas; 355
Complementary fission; 355c
Complementary forces; 355
Composition with red, yellow and
blue; 355
Concave 1; 355
Concave 2; 355
Concentric; 355
Contained; 355
Convex and concave; 355
Convex and concave II; 355c
Convexity; 355c
Corona; 355
Crimson sanctuary; 355c
Dark center; 355
Density; 355
Derived from without; 355
Dissolving the edge of green; 355
Distinctness of red; 355
Divisible; 355
The dual privileges; 355

The edge of all activity; 355c
Eight windows; 355c
Emerald tablet; 355
Entrance to green; 355c
Equilateral; 355
Exact quantity; 355c
Fire ball; 355
Fluorescent complement; 355c
Football; 355c
Force of light; 355
The fourth of the three; 355c
From my kitchen window; 355
Geometric; 355
Glory red; 355c
Gold and green; 355
Grand spectra; 355c
Green and red, figure and ground;
355
Green on red; 355
Heat; 355c
Inflexional II; 355
Injured by green; 355c
Inner dichotomy; 355
Intensity; 355c
Intrinsic harmony; 355
Iridescence; 355c, 387c
Knowledge and disappearance; 355
Kolbe fisheries; 355
Law of diffusion; 355c
Longitudinal--latitudinal; 355
Luminous; 355
Lunar; 355c
Magnetic force; 355c
Mask; 355c
Mercurian in the fire; 355c
Middle of all activity; 355
Monday morning; 355
Moon and sun furnaces; 355
Moonbow; 355c
Negro wedding; 355
Neon game; 355c
On blue; 355
One hundred and twenty-one squares;
355
One quarter; 355
Orange delight; 355c
People leaving; 355
Plus reversed; 355c
Primary contrast; 355c
Prisma; 355c
Progression: in and out; 355
Quadernity of the cross in the
zodiac; 355
Radiant green; 355
Rectilinear; 355
Red and green reversed; 355
Red on silver; 355
Related blue and green; 355c

Rising and descending; 355
Rosafication; 355
Scintillant; 355
Self-portrait; 355
Seventh authority; 355
Six altar boys at sanctus; 355
Sky veils; 355c
Slow center; 355
Sol I; 348c, 355c
Sol II; 355c
Sol III; 355c
Solution and separation; 3c
Sounding of the bell; 355c
Spectral cadmium; 355
Splendor of red; 355c
Splitting the red; 355
Spring--cool; 355c
Spring--warm; 355c
Still life with pears; 355
Stimulus; 355
Structured; 355
Sun game; 355c
Sun garden; 355c
Sunrise chroma; 355c
To Josef Albers II; 355
Tom; 355
Triangular; 355c
Triangular prism; 355c
Tribal; 355c
Trinity; 355c
Triumphal color; 355c
Twelve quadrate; 320
The two equinoxes; 355c
The union of Mercury and sulphur;
 355
Union of the four; 355c
Unit; 355
The vaulted world; 355
Visible state; 355
Warm on cool; 355
Water from the rock; 355
White shapes; 355
Winter recipe; 355
Winter--summer reds; 355c
Woman in white; 355
YWCA Building, New York, ex-
 terior mural; 355c
Yellow on silver; 355

ANZO, Jose Iranzo Almonacid
Aislamiento--29; 320

AOKI MOKUBEI, 1767-1833
Autumn in the mountains; 615c
Chrysanthemums and rocks; 615cd
Clouds at the foot of the mountain;
 615c
The god of longevity rides down

a cloud; 615c
Landscape; 615
Returning home on donkeyback
 through a secluded valley; 615
Sunny morning at Uji; 615

AOKI SHIGERU, 1822-1911
Chikugo landscape; 230
Fish scale palace in the sea; 230c
Harvest of the sea; 230c
Pleasure; 230
Prince Oanamuchi no Mikoto; 230
Prince Yamoto Takera no Mikoto;
 230
Seascape; 230
Self-portrait; 230
Tempyo era; 230
Woman's face; 230
Yomotsu Hirasaka; 230c

APOLLONIO, Marina
Dinamica circolare 5 cn, cp; 320

APOLLONIO di GIOVANNI
Neptune; 375

APPEL, Charles, 1857-1934?
On the Passaic River; 45

APPEL, Karl, 1921-
Amorous dance; 576c
Big animal devours little animal;
 549c
Child and beast II; 189
The red horseman; 430
Two heads; 449
Woman and flowers; 438c

APPIAN, Adolphe, 1818-98
Landscape in Provence; 506c

APPIANI, Andrea, 1754-1817
General Desaix; 409

AQA RIZA, 16th century
Portrait of a young man; 71

ARAI, Tomie
Wall of respect for women; 107

ARAKAWA, Shusaku, 1936-
From mechanism of memory; 449
Untitled; 126

ARCANGELO, Alan d', 1930-
Safety zone; 11
Untitled; 320
US Highway No. 1; 320

ARCANGELO di COLA Style
Coronation of the Virgin; 440

ARCHER, James, 1824-
Playing at being queen; 604

ARCHER, James Wykeham
Turner's birthplace, 21 Maiden
 Lane, Covent Garden; 581
Turner's house at Chelsea; 581

ARCHIPOV, Abraham
Laundry women; 354

ARCIMBOLDO, Giuseppe, 1527-93
Air; 431c
Autumn; 431c
The cellarman; 431c
The cook; 431c
Earth; 431c
Fire; 431c
Flora; 431c
The gardener; 588c
The jurist; 431c
The librarian; 431c
The man and the vegetables; 431c
The man in the plate; 431c
Rudolph II as Vertumnus; 431c
Self-portrait; 431c
Spring; 431c
Summer; 431c, 576
Water; 431c
Winter; 431c

ARDIZZONE, Edward, 1900-79
The life class; 105

ARDON, Mordecai, 1896-
Above the fields in the Emek;
 574c
Above the roofs; 574
Adventures of an Ace of Hearts;
 574
Amulet for a yellow landscape;
 574c
Anakh-Tab's love rug; 574
Anatot; 574
Anywhere; 574c
Arab village; 574
Ascension of the cuckoo clock; 574
At the gates of Jerusalem; 574c
At the Red Sea; 574
At the seashore; 574
Autumn; 574
The awakening; 574c
Betar; 574
Bethlehem; 574c
Big clock; 574

Bird; 574
Bird at yellow wall; 574
Birth of a leaf; 574
Birthday of the blue R; 574c
Bloom and sign; 574
The blue birds; 574
Blue margin; 574
The blue moon; 574
Blue morning; 574
The blue tent; 574
Bright morning; 574
The broken hour; 574
Building plot; 574
Cemetery of hours; 574
Child with cuckoo clock; 574
Chimneys and cloud over Paris; 574
Cloisters; 574
Cloud over Ma'abara; 574
Clown; 574c
Color scale; 574
Composition; 574
Composition in purple; 574
Composition in yellow; 574
Coral reefs on the Red Sea; 574c
Coralline; 574
Crescendo; 574
Dead bird in a snowstorm; 574
Dirge for a dead bird; 574
The drunken scarecrow; 574
Early morning in spring; 574
Eclipse of the sun; 574
Eilat; 574
Ein Karem; 574c
Eucalyptus trees; entrance to Mish-
 mar Ha'Emek; 574
Eve; 574
Eve of Lag Ba' Omer; 574
Faded leaves; 574
A fair morning in Paris; 574
The fall of Icarus; 574
The field; 574
Fields in the Emek; 574
The final dance; 574
Fish and moon; 574c
Flight at dawn; 574c
Flowers; 574
Flowers at the window; 574
For the fallen triptych; 574c
Frenzy of a black horse; 574c
From the old city; 574
Gambit of yellow; 574
The gates of light; 574c
Gilgal; 574
Girl in blue; 574
Girl lying on the grass; 574
Girl No. 109336; 574
The green point; 574
The harbor; 574

ARTHURS, Stanley, 1877-1950
Harrison and Tecumseh at Vin-
cennes; 122c, 437c
Through the long afternoon and
evening the Colonel roasted;
233c

ARTISTS' CO-OPERATIVE
An agricultural co-operative farm
in the Lan-chi district; 88c

ARTSCHWAGER, Richard, 1924-
Interior; 5
Washington Monument; 11

ASAH, Spencer, 1905-54
Asah dancing; 253
Rider with cape; 415

ASAI CHU, 1856-1907
Autumn in Grez; 230c
Harvest; 230
Hong Kong harbor; 230
In Port Arthur after the battle; 230
Poplars in Grez; 230
Setting sun; 230
Sewing; 230c
Spring furrows; 230c
Trees in winter; 230
A washing place; 230

ASCHER, Mary, 1900-
Humanity was diminished; 23

ASHCRAFT, Michael R.
Between illusion and the dream
No. 1; 23c
Between illusion and the dream
No. 2; 23c
Women times 7 No. 3; 23c

ASHIKAGA YOSHIMOCHI, 1386-1428
Daruma; 510

ASHLEY, Clifford, 1881-
Getting fast; 14c, 122c

ASPER, Hans, 1499-1571
Holzhalb, Cleophea; 143c

ASPERTINI, Amico, 1474/75-1522
Miracle of St. Frediano; 205

ASSELYN, Jan (Asselijn), 1610-52
Italian landscape; 189
Nocturnal fishing scene; 608c

AST, Balthasar van der, 1593-1656
Fruit and flowers; 303

Fruit, flowers, and shells; 553
Still life with shells; 189

ATENCIO, Gilbert, 1930-
The San Ildefonso Pueblo corn
dance; 415

ATHERTON, John
Christmas Eve; 29

ATKINS, Rosalie M., 1921-
Torrential storm; 23c

ATKINS, Samuel, fl. 1787-1808
A view of the Pool below London
Bridge; 121

ATKINSON, John Augustus, 1775-
1834
Arresting the smugglers; 105

ATKINSON, Lawrence, 1873-1931
Abstract composition; 511

ATKINSON, W. A., fl. 1849-67
The unturned barrow; 604
The upset flower cart; 195

ATL, Dr., 1873/77-1964
Volcanic landscape; 576

ATTAVANTE, Migliore
Baptism of Christ; 586

ATTIE, Dottie, 1938-
Untitled; 320

AUBLET, Albert
Flower picking; 353
The new piece of music; 353

AUCHIAH, James, 1906-74
Beadwork designs; 253
The drummers; 415

AUDUBON, John James, 1785-1851
American egret; 408c
American flamingo; 408c
Berthoud, Mr. and Mrs. James;
381
Berthoud, Nicholas; 381
Brown rat; 87c
Canada goose; 408
Cat squirrel; 370c
Chinese blue-pie; 576
Chuck-will-widow; 408c
Common goldeneye; 408
Common raven; 408
Double-crested cormorant; 408

AVIGNON School
Pietà; 72c

AVY, J. M.
Tea time; 353
The white ball; 353

AVY, Marius Joseph, 1871-
Bal blanc; 96

AXELRAD, Steve
The Isle of California; 167c

AYERS, Thomas A.
The devil's pulpit; 528

AYLESFORD, Earl of
Tenby; 105

AYLWARD, William James, 1875-
1957?
When American ships were found
in every part of the world; 437

AYRES, Gillian, 1930/32-
I. C. A. screenprint; 449

AZBE, Anton
Half-nude woman; 593
In the harem; 593
Portrait of a Negress; 593
Self-portrait; 593

BABCOCK, Amory L.
Flower basket and fruits; 62

BABCOCK, William P., 1826-99
Landscape with figures; 45

BABUREN, Dirck van, 1594/95-
1624
Backgammon players; 526
The procuress; 303, 323, 526
Roman charity: Cimo and Pero;
608c

BABUREN, H.
St. Sebastian tended by St. Irene;
526

BACA-FLOR, Carlos, 1869-
Morgan, J. Pierpont; 399

BACH, Johann Samuel
Ideal landscape; 494

BACHELDER, John B.
Lincoln, Death of Abraham; 399

BACHELIER, Jean Jacques, 1724-
1806
Cerf dix cors en velours; 40

BACHER, Otto Henry, 1856-1909
Mrs. Bacher; 152
Nude outdoors; 152

BACHIACCA, Francesco, 1494/5-
1557
Gathering of the manna; 223
Lady with a nosegay; 281c

BACK, Sir George, 1796-1878
Winter view of Fort Franklin; 234

BACKHUYSEN, Ludolf, 1631-1708
Dutch vessels in a rough sea; 282
Seascape; 421c
Seascape: boats in a storm; 608

BACON, Francis, 1910-
After Muybridge--woman emptying
bowl of water and paralytic
child on all fours; 482c, 541
Auerbach, Double portrait of Lucien
Freud and Frank; 558
Beard, Three studies for portrait
of Peter; 482c
Belcher, Muriel; 482, 558
Belcher, Three studies of Muriel;
558c
Chimpanzee; 482, 558c
Chopping, Two studies for portrait
of Richard; 482c
Crucifixion; 482, 541, 558c
Dog; 558c
Dyer, George and Lucien Freud;
482, 511, 558c
Dyer, George, crouching; 482, 558
Dyer, George, in a mirror; 27c,
482, 558c
Dyer, In memory of George; 558c
Dyer, George, on a bicycle; 482,
558c
Dyer, George, starting at blind
cord; 482, 558c
Dyer, Studies of George, and Isa-
bel Rawsthorne; 27c
Dyer, Study of George; 27c, 558
Dyer, George, talking; 558
Dyer, Three studies for portrait of
George; 558c
Dyer, Three studies of George;
482

BACON, John Henry, 1868-1914
A wedding morning; 96, 195, 605

BACON, Sir Nathaniel, 1546-1615
Self-portrait; 550, 587

BADAMI, Andrea, 1913-
Adam and Eve in the sight of God;
 243c
Queen Elizabeth's Canadian tour;
 243

BADGER, Joseph, 1708-65
Badger, James; 399
Bowdoin, James I; 13
Edwards, Mrs. John; 348
Foster, Mrs. Isaac; 158
Portrait of two children; 499

BADGER, S. F. M. , fl. 1890
Schooner John W. Dana; 158

BAEDER, John, 1938-
Air Line Diner; 28
Alice and the Hat Diner; 28c
Ambassador II; 28
American Grille; 28c
Apple Tree; 28c
Ashtray; 28
Blissville Diner; 28c
Blue Sky Diner; 28c
Bus; 28
C & C Restaurant; 28c
Casey's; 28c
Chadwick Square; 28
Chappy's Diner; 28
Charlie's; 28
Chateau Diner; 28c
Curley's Diner; 28c
Day and night; 28c
Diner; 28c
Diner, Camp Hill, Pa. ; 28c
Diner--eat; 28c
Doggie Diner; 28c
Dutch Diner; 28c
Empire Diner; 28c
Epicure Diner; 28c
Ever Ready; 28
Grand Canyon Trading Post; 28
Hi Hat Diner; 28
Hightstown Diner; 28c
Highway Diner; 28
Holt's Cafe; 28
Houtz Hi-way Drug; 28
Jamie's Diner; 28c
Jimmy's Diner; 28
King's Chef; 28
Lisi's Pittsfield Diner; 28c

The Little House Cafe; 28
The Little Nell Diner; 28
The Magic Chef; 28c
Majestic; 28c
Malaga Diner; 28
Maple Diner; 28c
Market Diner; 28c
Max's Grill; 28c
Midwest Cafe; 28
Modern Diner; 28
The Modern Grill Inc. matchbook;
 28c
Muncy's Diner; 28c
O'Connors Diner; 28c
Omar Diner; 28
Owl Diner; 28
Prout's Diner; 28c
The Pullman; 28c
Reading Diner; 28
Royal Diner; 28c
Royal Diner bas-relief; 28
Royal Diner interior; 28
Sally's Diner; 28c
Sam's Diner; 28
Sandwich Grill; 28c
Sandwiches; 28
Schanaker's Diner; 28
Scott's Bridge Diner; 28c
Silver Top Diner; 28c
Sisson's; 28c
Skyline Diner; 28c
Star Diner; 28
Stella's; 28
Steve's Diner; 28c
Street scene in Klamath, Cal. ; 28
Sunset Diner; 28
Super Diner; 28c
Super Duper Weenie; 28c
Ted's Diner; 28
Terhune's Palace Cafe; 28
10th Ave. Diner; 20
Tick Tock; 28c
Time to eat good food; 28
Town Square Diner; 28
Twin Diner--floor; 28
Uncle Wally's; 28c
Vincentown Diner; 28
White Castle; 28c
White Manna Hamburgers; 28c
White Palace; 28c
White Tower, Camden, N. J. ; 28
White Tower, Chicago, Ill. ; 28
White Tower, Collingswood, N. J. ;
 28
White Tower, Philadelphia, Pa. ;
 28
Whitey's Diner; 28
Winged clock; 28c
Yankee Clipper; 28c

BAER, Jo, 1929-
Untitled; 5
V. speculum; 472

BAGDATOPOULOS, William Spencer,
1888-
Borein, John Edward; 132c

BAGLIONE, Giovanni, 1573?-1644
The ecstacy of St. Francis; 526
St. John the Baptist; 526
Victorious earthly love; 526

BAIL, Antoine Jean
The wind band; 354

BAIL, Joseph Claude, 1826-1921
Servants lunching; 553

BAILEY, William
Nude; 320
Still life--table with ochre wall; 97
Still life with kitchen objects; 126

BAILLIE, Louis Eugene
Happy memories of soldiering; 354

BAIN, Emily Johnston
Carolyn; 23c
Texas cannas; 23c

BAINES, Harry
Mother and child, Bombay; 129

BAIRD, Edward
Birth of Venus; 231

BAITUP, H. C.
Timber hauling by the White Horse;
9c

BAKER, Samuel Colwell, 1874-
1964
The Alexander McKenzie going
up the Mississippi River; 243
Christ in the manger; 243

BAKER, Thomas
The park at Chesterton, War-
wickshire; 604

BAKER, William Bliss, 1859-86
Lake Luzerne; 410c

BAKHUYZEN, G. J. van de
Sande, 1826-95
Study of still life: roses in a
basket; 524

BAKKER KORFF, Alexander Hugo,
1824-82
Reading from the Bible; 189

BAKOS, Jozef, 1891-1977
Cottonwood Fall; 233c

BALDOVINETTI, Alesso, 1425/27-
99
Adoration of the shepherds; 205
A lady in yellow; 576
Portrait of a lady; 307
Portrait of a lady in yellow; 223,
442c, 459c
Virgin and Child; 361

BALDUNG-GRIEN, Hans, 1484/85-
1545
Death and the maiden; 285c
Death seizing a woman; 205
Hercules and Antée; 331c
Music; 285c
Nativity; 567c
Portrait of a man; 442c
Three Graces; 285c
Vanitas; 285c, 567c
Witches; 576

BALEN, Hendrik van, 1575-1632/
38
The River Scheldt at Antwerp and
in the foreground a part of the
Vlaams Hoofd; 41c

BALEN, Jan van, 1611-54
Vulcan, Venus and Cupid sur-
rounded by Vulcan's workshop
and exotic birds; 282c

BALINK, Henry, 1882-1963
Soaring eagle; 233c

BALKE, Peder, 1804-87
Landscape study from Nordland;
475

BALLA, Giacomo, 1874-1958
Arc lamp; 18
Atmospheric densities; 18
Automobile and noise; 449
Borghese Park; 318d
A child runs along the balcony;
202c
Dog on a leash; 318, 430
Dynamic depths; 18
Dynamism of a dog on a leash; 18
Futurballa; 18c
Girl running on a balcony; 318

Iridescent interpenetration; 18
Iridescent interpenetration No. 1;
 318
Iridiscent interpenetration No. 4;
 18
Little girl running on a balcony;
 18
Mercurio passa davanti al sole
 visto col cannochiale; 525
Plasticity of lights and speed; 18
Rhythm of a violinist; 318
Saying goodbye; 318
Sketch for 'Woodcutting'; 18
Speed of a motor car; 202c
Speed of a motor car and light and
 sound; 202c
Speeding automobile; 250
The street light--study of light;
 318
Study for 'Iridescent interpene-
 tration'; 18
Study for 'Mercury passing in
 front of the sun'; 18
Study of ongoing lines (swallows);
 18c
The swifts: paths of movement
 and dynamic sequences; 318,
 576
Velocità astratta; 418
The violinist's hands; 18, 283c
Vortex; 18
The worker's day; 318

BALLARD, Thomas, fl. 1865-77
The new governess; 605

BALLING, Ole Peter Hansen,
 1823-
Garfield, James A.; 122
Grant, Ulysses S.; 122

BALTHUS (Balthus Klossowski),
 1908-
La chambre; 331c
The game of patience; 430c
Katia reading; 97c
Miró, Joan and his daughter
 Dolores; 576
Patience; 98c

BAMA, James E., 1926-
Annie Old Crow; 34c
Bama, Lynne, with hat; 34c
Bell in winter; 34c
Bernie Blackstone's old saddle;
 34c
Bezona, Roy; 34c
Bezona, Roy, old man Wyoming;

34c
Bob Rumsey's place; 34c
Bronc rider; 34c
Brown, George Washington, stage-
 coach driver; 34c
Brown, Jack, Southfork Hills; 34c
Chester Medicine Crow in his
 reservation hat; 34c
Chester Medicine Crow with his
 father's flag; 34c
George Medicine Crow with his
 father's peace pipe; 34c
Chuck wagon in the snow; 34c
Cowboy in yellow slicker; 34c
Eddy, Mountain man, Anson; 34c
Edgar, Bob, depicting 1860's
 scout; 34c
1880's still life of saddle and rifle;
 34c
1880's still life with frontier Colt;
 34c
Fales, Gary, outfitter; 34c
Hodson, Jerry, cowboy; 34c
Laird, Tom, prospector; 34c
Lynne and the dogs; 34c
Martin, Tony, hunting guide; 34c
Moore, Dean, descendent of Red
 Cloud; 34c
Myers, Tommy, and Sawdust; 34c
Old buffalo skull; 34c
Old Crow Indian shield; 34c
Old saddle in the snow; 34c
Old time trapping in the Rockies;
 34c
Pinckard, Lee, guide; 34c
The rookie bronc rider; 34c
Rose Plenty Good; 34c
Sheep skull in drift; 34c
Shoshoni chief; 34c
Sims, Joel, high school bronc rid-
 ing champion; 34c
Slim lighting up; 34c
Slim with saddle; 34c
Smith, Bill, No. 1; 34c
Smith, Dee, with saddle bag; 34c
Thompson, Tommy, outfitter; 34c
Thompson's cabin; 34c
Wagons in winter; 34c
Westerman, Henry; 34c
Work shed in winter; 34c

BAMBOCCIO, Il (Pieter van Laer),
 1592-1642
The cake vendor; 576
The quoit seller; 608c

BAMFYLDE, Coplestone Warre,
 1720-91
View over an estuary; 105

BANDINELLI, Baccio, 1493-1560
Self-portrait; 281c

BANKS, J. O.
Showing off; 604

BANNARD, Walter Darby, 1931/34-
Green grip I; 472
Harbor view No. 1; 92
Mandragora No. 3; 92
The tablets; 92
Western air No. 1; 92
Young phenix No. 1; 472c

BANNISTER, Edward Mitchell,
1828-1901
After the shower; 45
Sunrise; 45
Sunset; 45

BANTING, John, 1902-72
Dead gossip; 511

BAÑUELOS, Antonia de
The little fishers; 524
Study of a baby laughing; 524

BAR, Jacob
Pacioli, Fra Luca; 583c

BARABAS, Miklós, 1810-98
The arrival of the bride; 409
Bittó, Mme.; 96

BARACCHIS, Andriola de, fl. 1489
Entombment; 218
Madonna and Child enthroned; 218c

BARATTI, Filippo
The prisoner; 570c

BARBARI, Jacopo de, 1440/50-1516
Dead partridge; 62
Pacioli, Luca; 533c
Partridge and arms; 40
A sparrow hawk; 442
Still life; 205

BARBAULT, Jean, 1705-66
Priest of the law; 302

BARBER, Alice
The ladies' life class; 244

BARBER, Charles Burton, 1845-94
Good friends; 604

BARBER, Joseph, 1757-1811
Figures running; 105

BARBIER, Sister Marie
The Christ Child; 235

BARBIERI, Giovanni Francesco,
1591-1666
Annunciation; 556c

BARBOUR, Arthur J., 1926-
Another time; 35c
Basilica of St. Therese, Lisieux,
France; 35c
Beach at Rockport; 35c
Belle Grove; 35c
Breaking surf; 35c
Burst of autumn; 35c
Buttes in Sedona; 35c
Cape Henelopen dunes; 35c
Capistrano; 35c
Catamount, No. 1; 35
Catamount No. 2; 35
Cathedral of St. James, Santiago,
Spain; 35c
Cooper-Hewitt Museum; 35c
Dance of the winter sunlight; 35c
Edge of the cliff; 35c
Just over the rise; 35c
Left to the elements; 35c
New Jersey farm; 35c
New York farm; 35
Out of the mist; 35c
Shadows of yesterday; 35c
View from the South Rim; 35c
Winter in the hills; 35c
Winter on the farm; 35c

BARCHUS, Eliza R., 1857-1959
California hillside poppies; 36c
Castle Geyser, Yellowstone Na-
tional Park; 36c
Forest giant, Oregon; 36c
Mt. Hood, Ore.; 36c
Mt. Ranier, Wash.; 36c
Mt. Shasta, Cal.; 36c
Mountain sunset; 36c
Multnomah Falls, Columbia River
Highway, Ore.; 36c
Rooster Rock, Columbia River,
Oregon; 36c
Three Brothers, Yosemite Valley,
Cal.; 36c
Three Sisters, Oregon; 36c
Three Witches; 36c
Yosemite Valley; 36c

BARD, James, 1815-97
America; 13
Commonwealth; 158
Isaac Smith; 158c
Minnie Cornell; 158

The sidewheeler Oliver M. Pettit;
 370
Steamboat Metamora; 531
Thomas McManus; 158
Thomas Powell; 158

BARDI ST. FRANCIS MASTER
St. Francis altarpiece; 522

BARENDS, Dirck, 1534-92
Members of a gun club; 205

BARGELLINI, Giulio, 1857-1936
Pygmalion; 96c

BARKA, Nina, 1908-
Wine harvest; 280c

BARKER, Benjamin, 1772-1838
Rocks and waterfall; 105

BARKER, John
The ragged school; 605

BARKER, Thomas of Bath, 1769-
 1847
Landscape; 247
Landscape near Bath; 247

BARKER, Thomas Jones, 1815-82
Queen Victoria presenting a Bible
 in the audience chamber at
 Windsor; 604, 605

BARLAND, Adam
A Highland River scene; 604

BARLOW, Francis, 1626-1702/03
Birds; 105
Ducks and other birds about a
 stream in an Italianate land-
 scape; 434
An owl mocked by small birds; 587

BARNA da Siena, fl. 1330-60
Annunciation; 522
Bearing of the cross; 592
Christ's entry into Jerusalem; 522
Crucifixion; 375, 522, 592d
The kiss of Judas; 205
Last Supper; 522
Marriage at Cana; 592
Massacre of the Innocents; 522
Pact of Judas; 522

BARNABA da MODENA, fl. 1362-
 83
Madonna and Child; 522

BARNARD, Lambert
Henry VIII presenting a charter to
 the Pope; 434

BARNARD, Rev. William Henry,
 1769-1818
Chester from the Gallows Hill; 105

BARNES, E. C.
The seducer; 604

BARNES, Matthew, 1880-1951
High peak; 131

BARNET, Will, 1911-
Pearson, Henry; 64

BAROCCI, Federigo, 1526/35-
 1612/15
Aeneaus fleeing from Troy; 284cd
Circumcision; 223
Descent from the Cross; 576
Nativity; 205c

BARONE, Francis
Lime kiln; 457

BARONZIO, Giovanni, 1300?-52?
Polyptych; 522

BARRAUD, Henry, 1811/12-74
The Beaufort Hunt Lawn Meet at
 Badminton; 604
The Duchess of Kent and her
 daughter, afterwards Queen
 Victoria; 166

BARRAUD, William, 1810-50
The Beaufort Hunt Lawn Meet at
 Badminton; 604
The Duchess of Kent and her
 daughter, afterwards Queen
 Victoria; 166

BARRELL, Theodore
Deed and architectural plans: the
 Barrell house; 528

BARRET, George
Llyn Peris with Dolbadarn Castle;
 247
Powerscourt Waterfall; 475
View of Dalkeith Park with the
 town in the distance; 247

BARRET, George, Sr., 1732-84
Oak tree; 105

BASAN, F.
Venus donnant du Nectar á la
amour; 40

BASANTA, Carlos
Miró fantasy; 167c

BASAWAN, 16th century
Mother and child with a white cat;
335c
Shaikh Abu'l 'Abbas Kassab and
the dervish; 71

BASCHENIS, Evaristo, 1607/17-77
Still life with plates; 556

BASCOM, Ruth Henshaw, 1772-
1848
Davis, Edwin; 158

BASHKIRTSEFF, Marie, 1859-84
The Académie Julian; 218
A meeting; 236, 524
The painter's sister-in-law; 218
Self-portrait; 524
Toulouse, Comtesse de; 524

BASKERVILLE, Charles, 1896-
Baruch, Bernard; 520
Bodyguard in Nepal; 520c
Duke, Mrs. Angier Biddle; 521c
Gabor, Eva; 521
Kelley, Didi; 521
Kustayah, Miss, of Java; 521cd
Olsen, M. S. Richard; 520
Parish, Mrs. R. L. ; 521
Tailer, Fern; 521
Vosler, Tech. Sarg. Forrest L. ;
520

BASOHLI School
Diversion of the Jamuna; 576

BASSA, Ferrer, 1290?-1348
Nativity; 389
The three Marys in front of the
sepulchre; 576

BASSANO, Francesco, 1549-92
Adoration of the shepherds; 556
Allegory of fire; 556
Allegory of water; 556
Christ in the Garden of Olives;
556c
Christ in the house of Mary,
Martha and Lazarus; 432c

BASSANO, Jacopo, 1510?-92
Adoration of the kings; 283c

Adoration of the Magi; 576
Adoration of the shepherds; 205,
382, 432c
Christ carrying the Cross; 382
Christ in the house of Mary,
Martha and Lazarus; 432c
Entombment; 72c
Flight into Egypt; 223, 432c
Pastoral landscape; 432c
Road to Calvary; 72c
St. Valentine baptizing St. Lucilla;
432c

BASSANO, Leandro, 1557-1622
Lute player; 432c
Portrait of a man; 556

BASTIEN-LEPAGE, Jules, 1848-84
Edward VII; 382
Harvesters; 409
Joan of Arc; 63

BASTIN, Henri, 1896-
Self-portrait; 340c
Submerged trees; 340c
Trees with parrots; 340c
A vase of flowers; 340c
The waterfall; 340c

BATES, David, 1840-1921
A reed bed at Arthog near Bar-
mouth; 604

BATES, Maxwell, 1906-
Girls at the Café Congo; 234

BATONI, Pompeo, 1708-87
Gordon, General; 578
Madonna and Child in glory; 553
Time orders Old Age to destroy
Beauty; 412

BATTERSBY, Martin
Boots; 40
Cumberland; 40
Queen Elizabeth II (liner); 40c
Untitled painting; 40

BAUCHANT, André, 1873-1958
Fête de la Libération; 328c
Obsequies of Alexander; 576

BAUCK, Jeanna, 1840-
Portrait; 524
A woodland lake; 524

BAUD-BOVY, Auguste, 1848-99
Morice, Charles; 506

BAUER, Karl
Knight before the battle; 593

BAUERNFEIND, Gustave
Jaffa street scene; 570c

BAUMEISTER, Willy, 1889-1955
Black dragons; 438c
Men and machines; 449
Monteure; 576
Two lanterns; 449c

BAUMGARTNER, Peter, 1834-1911
The trusty sentinel; 51

BAWDEN, Edward, 1903-
The Camore Mountain range; 9c

BAXTER, Charles, 1809-79
The sisters; 604

BAYES, Walter, 1869-1956
The underworld; 511

BAYEU, Francisco, 1734-95
Olympus: the battle of the gods;
389

BAYRLE, Thomas
Objekt Mao; 320

BAZAINE, Jean, 1904-
L'eau; 449
Low tide; 449c

BAZILE, Castera, 1928-
Holy day procession; 19
Self-portrait with corpse; 19

BAZILLE, Frédéric, 1841-70
The artist's studio; 55
The artist's studio, Rue de la
Condamine; 583c
Family reunion; 55c, 506c, 576
Monet after his accident at the
inn in Chailly; 55
Negress arranging flower; 506
Negro girl with peonies; 310c
Renoir; 55, 130c
Scène d'Eté; 124c
Self-portrait; 98c
Sisley, Alfred; 55
Still life with heron; 82, 109c
Summer scene; 513
View of Castelnau; 506c
View of the village; 138c, 460c

BAZIOTES, William, 1912-63
Aquatic; 579

The butterflies of Leonardo da
Vinci; 259
Circus abstraction; 259
Congo; 472c
Dusk; 449
Dwarf; 11
The mannequins; 259
Mirror figure; 259
Night mirror; 259
Pink wall; 259
Primeval landscape; 402, 576
Untitled; 22c
The web; 259c
White bird; 387c

BEAL, Gifford, 1879-1956
After the storm; 13
Armistice Day, 1918; 122c
Farm in Essex; 176
Freight yards; 14c, 122c

BEAL, Jack, 1931-
Drawing; 316
The fisherman; 126

BEALE, Mary Cradock, 1632-97
Cowley, Abraham; 524
King Charles II of England; 524
Self-portrait; 218c

BEALL, Joanna, 1935-
Weldon Cafe; 153

BEARD, James Henry, 1812-93
Goodbye, Ole Virginia; 257
The Ohio land speculator; 257
Taylor, Zachary; 381
Their master's tribute; 266

BEARD, William Holbrook, 1824-1900
Stalking prairie chicken;

BEARDEN, Romare, 1912/14-
The Annunciation; 585c
April green; 585c
Back home from up the country;
585c
Backyard; 585c
Baptism; 585c
Before the first whistle; 585c
Black Manhattan; 585c
The block; 585c
The blue bird; 585c
Blue interior, morning; 22c, 585c
Blue Monday; 585c
Blue snake; 585c
Byzantine dimension; 585c
Circe preparing a banquet for
Ulysses; 585

BEAVER, Fred, 1911-
Creek women preparing sofke; 253
Florida Seminole family; 415
Seminole family; 253c
Seminoles in the Everglades; 415c
Tanning hide; 253

BEAVIS, Richard, 1824-96
Hurley-on-Thames; 604

BECCAFUMI, Domenico, 1485/86-
1551
The appearance of St. Michael on
the Castel Sant' Angelo to Pope
Gregory the Great; 436c
Birth of the Virgin; 205
Miracle of St. Michael on Mt.
Gargano; 436c
St. Michael quelling the rebel
angels; 576

BECHTLE, Robert, 1932-
'71 Buick; 11

BECK, Franz
The council fire; 89c

BECK, Margit
Autumnal complexities; 46

BECKER, August, 1840-1903
Buffaloes drinking at the Yellow-
stone; 233c

BECKER, Carl, 1820-1900
Lady with greyhound; 51

BECKER, G.
Violin hanging on a wall; 40

BECKER, Joseph, 1841-1910
The first transcontinental train
leaving Sacramento; 399

BECKMANN, Max, 1884-1950
Adam and Eve; 324
The Argonauts; 324c
The artist and his wife; 250
The barge; 324
Beckmann-Tube, Minna; 324
Begin the Beguine; 324
Birds' hell; 324c
Black irises; 324c
Brother and sister; 324c
Cabaret artistes; 203c
California park; 324
Carnival in Paris; 324
Carnival: the artist and his wife;

324c
Catfish; 324
Château d'If; 324c
Christ and the woman taken in
adultery; 324c, 503
Christ in limbo; 324
Circus caravan; 449c
City of brass; 324
Conway, Fred; 324c
Costume party; 324
Dancing bear in Baden-Baden;
324c
Death in the family; 324
Demons fishing for souls; 324
The departure; 3c, 324c
The descent from the Cross; 324c
Destruction of Messina: 324
Double portrait of Max and Quappi
Beckmann; 324
The dream; 291c, 324c
Dream of a sculptor; 324
Family picture; 324, 400
Four men around a table; 324
Galleria Umberto; 324c
Girl with mandolin; 324c
The iron bridge; 324
Journey on fishes; 324c
The king; 324c
Lackner, Stephan; 324c
Landscape near Marseille; 324c
Landscape with fishermen; 324c
Leda; 324
The loge; 324c
Man and woman; 324c
Man with fish; 449
May, Morton D.; 324
The mill; 324c
Moonlit night on the Walchensee;
324c
Night; 203c, 324c, 576
North Sea I with thunderstorm;
324c
Odysseus and Calypso; 324c
Odysseus and the sirens; 324
Party in Paris; 324c
Perseus' last duty; 324
Place de la Concorde by night;
324
Place de la Concorde, Paris, with
balloon; 324
Portrait of a girl; 324
The prodigal son; 324c
Pulitzer, Louise V.; 324
Quappi; 324
Quappi with white fur; 324c
The rainbow; 324c
Rathbone, Perry; 324
Reclining woman; 324

Rugby players; 324c
Sacrê-Coeur in Paris; 324c
San Francisco; 324c
Scheveningen, evening on the terrace; 324c
Self-portrait; 98c, 283c, 503, 583c
Self-portrait as a medical corpsman; 324c
Self-portrait before the easel; 203c
Self-portrait in blue jacket; 324c
Self-portrait in Florence; 324c
Self-portrait in sailor hat; 324
Self-portrait in tuxedo; 324c
Self-portrait with horn; 324c
Self-portrait with red scarf; 203c
Self-portrait with saxophone; 324c
Self-portrait with soap bubbles; 324
Siesta; 97
Sinking of the Titanic; 324, 503
The skaters; 324
Snake king and beetle bride; 324
Still life with candles; 324
Still life with candles and mirror; 325c
Still life with cyclamen and bronze bust; 324
Still life with helmet; 324c
Still life with skulls; 210, 324
Still life with studio window; 324c
The street; 503
Street with blooming acacias; 324
Temptation; 324c
Two circus artists; 324c
Two Spanish ladies; 324c
Viareggio; 324c
View of San Francisco; 262c
Windmill; 324
Young men by the sea; 324, 503

BECKWITH, James, 1852-
A marine watercolor; 598c

BEDFORD MASTER
Anne of Burgundy kneeling before the Virgin and Child; 576

BEECHEY, Sir William, 1753-1839
The Dashwood children; 553
Hope, Thomas; 302
Nelson, Horatio Lord; 195c
Princess Augusta; 434
Princess Mary; 587

BEECQ, Jan van
Shipping in a calm; 121

BEELDEMAKER, Adriaen Cornelisz, 1618-1709
The hunter; 608c

BEER, Jan de, 1480?-1520?
Adoration of the Magi; 576

BEERS, Jan van
The fallen star; 354

BEERSTRATEN, Jan Abrahamsz, 1622-66
The castle of Muiden in winter; 576

BEERT, Osias the Elder, 1580?-1624
Large flowerpiece; 204c

BEGAS, Karl Joseph, 1794-1854
Wilhemine Begas, the artist's wife; 175

BEGAY, Harrison, 1917-
Hair washing; 253
Herding the sheep; 415
Navajo weavers; 253c
The weavers; 415

BEHRENS, Peter, 1868-1940
Triumph; 593

BEIGNEUX, Ariane
Pamela; 64

BELKIN, Arnold, 1930-
Against domestic colonialism; 107
Anatomy lesson; 320
Annual anatomy; 320

BELKNAP, Zedekiah, 1781-1858
Brooks, Luther Dana; 381
Brown, Mrs. Lavina; 381
Brown, Phillip; 381
Brown, Sarah Lavinia; 381
Dodge, Abigail Brooks; 381
Girl in white holding a cat; 381
Harrison, Major Thomas; 381
Harrison, Mrs. Thomas; 185, 381
Holman, Rufus; 381
Kirtland, Mary; 381
Lenox, Master; 381
Lenox, Mrs.; 381
Pierce, Anna Kendrick; 381
Pierce, Benjamin; 381
Pierce, Frank H.; 381
Pierce, Kirk; 381
Portrait of a woman; 158

Richardson, Jonathan; 381
Richardson, Mrs. Jonathan; 381
Stedman, Hannah Fisher; 381
Stone, Joseph; 381
Two children holding a basket of
 fruit; 381
Unknown man; 381
Unknown woman; 381
Young girl holding a music book;
 381
Young man with red hair; 381
Young woman with lace shawl; 381

BELL, Charles
Gum ball I; 320

BELL, Graham, 1910-43
Portrait of a lady; 511

BELL, John Zephaniah, 19th cen-
tury
Ceiling fresco; 279
Ogilvie, David, 9th Earl of Airlie
 and his daughter Clementina;
 279

BELL, Leland, 1922-
Self-portrait; 210

BELL, Vanessa, 1879-1961
Abstract; 236
Grant, Duncan, painting; 218c
Hutchinson, Mrs.; 511c
A room at the second Post-Im-
 pressionist exhibition; 513
Street corner conversation; 236
Tree, Iris; 236

BELLECHOSE, Henri, fl. 1415-40
Crucifixion with communion and
 martyrdom of St. Denis; 205

BELLEGARDE, Claude, 1927-
White ecstasy; 449

BELLINI, Gentile, 1426/27-1507
Madonna and Child; 44
Miracle of the True Cross at the
 Ponte San Lorenzo; 294c
Procession in the Piazza di San
 Marco; 576
The reception of the Venetian am-
 bassador in Cairo; 302
A Turkish artist; 281c

BELLINI, Giovanni, 1428?-1516
Agony in the garden; 205, 223,
 459c

Allegory of souls; 294c
Altarpiece; 432d
Blood of the Redeemer; 442
Christ bearing the Cross; 281c
Christ blessing; 432c
Christ carrying the Cross; 553
Coronation of the Virgin; 576
Drunkenness of Noah; 375, 432c
Enthroned Madonna with Child and
 four saints; 61
Enthroned Madonna with Child and
 six saints; 61
Feast of the gods; 205c, 375,
 459c, 470, 576
Fugger, Joerg; 432c
Gethsemane, the agony in the gar-
 den; 422c
Greek Madonna; 533c
Loredan, Doge Leonardo; 223,
 283c, 442c, 459c, 470, 533c,
 583c
Madonna adoring the sleeping
 Child; 398
Madonna and Child; 398, 432c
Madonna and Child in a landscape;
 533c
Madonna and Child with saints;
 398
Madonna and Child with two saints;
 205
Madonna and saints; 205, 375
Madonna of the Greek inscription;
 576
Madonna of the meadow; 294c, 442
Madonna of the trees; 533c
A man with a pair of dividers;
 442
Miracle of the True Cross; 583c
Miracle of the Cross in the canal
 of San Lorenzo; 533c
Pietà; 72c, 533c
Portrait of a young man; 382c
Procession in Piazza San Marco;
 205c
Religious allegory; 223
Resurrection; 72c
Sacred allegory; 205c
St. Dominic; 223, 442
St. Francis in ecstasy; 205, 304,
 422, 470
San Giobbe altarpiece; 470
Transfiguration; 422, 533c
Venus with mirror; 283c
Virgin and Child; 442
Woman at her toilet; 285c
Young woman at her toilet; 223c

BELLINI, Giovanni Workshop
Madonna and Child; 398
Presentation in the Temple; 398

BELLINI, Jacopo, 1400-70/71
Madonna and Child; 398

BELLINIANO, Vittore, fl. 1507-29
Portrait of a young man in a
 black cap; 556

BELLMER, Hans, 1902-75
Lam, Wifredo; 181
Small painting of a doll; 331c

BELLOTTO, Bernardo, 1720/24-80
New Market place in Dresden;
 341
The Ponte della Navi, Verona; 576
Vaprio d'Adda; 398

BELLOWS, Albert Fitch, 1829-83
Landscape; 176

BELLOWS, George Wesley, 1882-
 1925
Anne in white; 616
Blue snow, the Battery; 616c
Both members of this club; 370c,
 445c
Children on the porch; 616
The circus; 472
Cliff dwellers; 399
A day in June; 14c
Dempsey and Firpo; 370c, 472
Forty-two kids; 348c, 616
Golf course, California; 616
The gulls, Monhegan; 13
Henri, Robert; 520
Kids; 257
Love of winter; 14c
Men of the docks; 13
My mother; 616
Nude with white shawl; 176
Pennsylvania Station excavation;
 257
Polo at Lakewood; 616
Portrait of my father; 616
Return of the useless; 266
The sand team; 14c
The sawdust trail; 122c, 616
The sea; 402
Sharkey's; 399
Shipyard society; 13
Stag at Sharkey's; 42, 257, 354,
 472, 576, 616c
Sullivan, Introducing John L. ; 370
Summer night, Riverside Drive;
 616c

BELL-SMITH, Frederic Marlett,
 1846-1923
Lights of a city street; 234

BELLY, Léon Adolph Auguste,
 1827-77
Pilgrims going to Mecca; 302c

BELVEDERE, Andrea, 1646-
 1732
Fruit and flowers; 458

BEMBO, Bonifacio, fl. 1447-77
St. Julian; 533c

BENASSI, Enrico, 1902-
Piazza Milanese; 289c

BENBRIDGE, Henry, 1744-1812
Hartley, Mrs. James and family;
 399
Pinckney, Charles Cotesworth;
 178c

BENCZUR, Gyula, 1844-1920
Hock, Janos; 96
Louis XV and Mme. du Barry; 96

BENDEMANN, Eduard J. F. , 1811-
 89
The Jews in exile; 409

BENDIXEN, Siegfried D. , 1786-
 1864?
River landscape; 409

BENDZ, Wilhelm F. , 1804-32
The blue room; 409

BENEDETTO da MAIANO, 1442-97
Annunciation; 61

BENEDITO, Manuel
Washing after work; 354

BENGLIS, Lynda, 1941-
Video tapes; 320

BENGSTON, Billy Al, 1934-
Boris; 472
McLain, Big Jim; 22c

BENGTSON, Axel, 1905-
Silver wedding; 289c

BENJAMIN, Karl, 1925-
TG # 23; 22c

Landscape with rotunda; 189
A man and a youth ploughing with
 oxen; 576, 580
Mountainous landscape with mule-
 teers; 282
Pastoral landscape; 323, 553
Peasants with cattle by a ruined
 aqueduct; 74c, 442

BERCKHEYDE, Gerrit, 1638-98
The flower market, Amsterdam;
 74c
The market and Town Hall; 576
Market Place and Grote Kerk at
 Haarlem; 282, 303
The Market Place at Haarlem; 442
A street in Haarlem; 303
A view of the Binnenhof at The
 Hague; 282
View of the Grote Market and St.
 Bavo, Haarlem; 189
The west front and north transept
 of the Groote Kerk at Haarlem
 seen from the Colonnade of the
 Town Hall; 608c

BERCK-HEYDE, Job, 1630-93
The letter; 282

BERCZY, William, Jr., 1791-
 1873
Harvest festival; 234

BERCZY, William, Sr., 1744-
 1813
Brant, Joseph; 234
The Woolsey family; 234

BERGANTON, Primo, 1895-
Vision of Turin; 289c

BERGEN, Carl van
Still life; 494

BERGEN, Hendrik .
The welcome; 323

BERGER, Jason, 1924-
The park at Tepozlan; 210

BERGHE, Christoffel van den, fl.
 1617-42
Flowers in a glass vase; 282

BERGOGNONE, Ambrogio da
 (Borgognone), fl. 1481-1522
Agony in the garden; 576
Monk at a window; 40

BERJON, Antoine, 1754-1843
Basket of flowers; 184
Shells and madrepores; 184

BERLINGHIERI, Bonaventura, 1210-
 74
St. Francis altarpiece; 205, 522c
The sermon to the birds; 283c

BERLINGHIERI FAMILY
Crucifix; 576

BERMAN, Eugène, 1899-1972
Lost children of the roads; 40

BERMAN, Steve, 1947-
60 million gumballs with 10 win-
 ners; 153

BERMEJO, Bartolomé, 1405-98
Pietà; 205
The Pietà of Canon Desplà; 389
Santa Engracia; 281c
Santo Domingo de Silos; 389

BERN MASTER of the CARNATION
Angel of the Annunciation; 143

BERNARD, Emile, 1868-1941
Bernard, Madeleine; 100c, 513c
Black wheat; 513
Breton girl with red umbrella;
 271c
Breton women at prayer; 128
Breton women in a meadow; 513
Breton women with parasols; 513
Breton women with umbrellas; 409
Bridge at Pont-Aven; 128
Brothel scene; 513
A harem; 302
Madeleine in the Bois d'Amour;
 513
Portrait of the artist's grand-
 mother; 513
Portrait of the artist's mother;
 163c
Self-portrait; 345
Self-portrait dedicated to Vincent
 van Gogh; 163c
Self-portrait for van Gogh; 513
Still life with bananas; 128
Wheat harvest; 6c
The yellow Christ; 430c
Young African; 513

BERNARD, P.
Pont-Aven; 506c

BERNARDO, Monsù, 1624-87
Itinerant musicians; 556

BERNATH, Aurél, 1895-
Genoa harbor; 421c

BERNDTSON, Gunnar
A rest on the way to the fair; 354

BERNINGHAUS, Charles, 1905-71
Hollyhocks at Ranchos Mission;
 379c
Ranchitos water; 379
Shasta daisies; 379c
Still life with flowers; 379c
Taos Pueblo river; 379c

BERRUGUETE, Alonso, 1488?-
 1561
Birth of Christ; 389
Salome; 389

BERRUGUETE, Pedro, fl. 1477-
 1503
Auto da fé presided over by
 Santo Domingo de Guzmán; 389
King Solomon; 389, 576
Montefeltro, Federico da, Duke
 of Urbino, and his son Guido-
 baldo; 389

BERTHELEMY----
Apollo and Sarpedon; 184
Entry of the French into Paris;
 184

BERTHOLO, René, 1935-
The occasion makes the Gioconda;
 361

BERTHON, George Theodore,
 1806-92
Robinson, Sir John Beverley; 234

BERTHON, Roland
Man with stick; 449

BERTIN----
Italian landscape; 184

BERTIN, E. François, 1797-1871
View of a hermitage in an ancient
 Etruscan excavation; 409

BERTRAM of MINDEN see
 MASTER BERTRAM

BERTRAND, Gaston, 1910-
Italy; 449

BESNARD, Paul Albert, 1849-1934
Fruit merchants in Madura; 302
The happy island; 409

BESSER, Arne, 1935-
Janis; 320
Susan; 320

BEST, Hans, 1874-1942
Character head; 51
The innkeeper; 51
The village schoolteacher; 51

BETTERA, Bartolomeo, 1639-87/
 1700
Still life with musical instruments;
 556

BETTES, John II, 1530?-76
Elizabeth I; 434

BETTS, Anna Whelan
Custis, Nelly, in the Mt. Vernon
 garden; 437

BETTS, Edward, 1920-
After the storm; 47
Beach garden II; 46
Big Sur; 47c
Black ledge; 47c
Black reef; 47
Boulders and pines; 47
Cataract; 47
Coastal cliffs; 47
Coastal fragment #26; 47
Coastal reef; 47
Coastal storm; 47
Country road; 47
Dark cliffs; 46c
Early morning sea; 47
Entrance; 47
Etretat; 47
Fishing shack, Cape Neddick; 47c
Fishing shacks; 47
Forest tangle; 47
Frozen garden; 47c
Frozen landscape; 47
Frozen quarry; 47
Great wave; 47
Grindstone Point; 47
Headland Cove, Point Lobos; 47c
High snow; 47c
Highland Light, North Truro; 47
Hudson River landscape; 47
Island beach; 47
Island memory; 47c
January thaw; 47
Low tide; 47
Low tide, Cape Neddick; 47

BIBBIENA School
Architectural capriccio; 118

BICAT, André, 1909-
Portland Bill; 553

BICCI di LORENZO, 1373-1452
Madonna and Child, Sts. Matthew
and Francis; 281c
Penitent St. Jerome and St. Bene-
dict below the Cross; 375
St. Francis receiving the stigmata;
556

BICHETTAR----
Young prince in a garden with
sages; 576

BIDAULT, Xavier, 1758-1846
Francois I at the fountain of Vau-
cluse; 409
Roman landscape; 184

BIDDLE, George, 1885-1973
Starvation; 29
Sweatshop; 472
Tenement; 29

BIEDERMAN, Charles, 1906-
Structuralist relief; 418

BIEDERMANN, Johann Jakob, 1763-
1830
Lake of Lowerz with shepherds;
143
The Pissevache waterfall in the
Valais; 143c

BIEFVE, Edouard de, 1808-82
Scene of the banquet at the Hôtel
Cuylenborg; 409

BIERLA, Marie Fabienne, 1954-
L'enfant Malheureux; 23

BIERSTADT, Albert, 1830-1902
The ambush; 266
Ascutney Mt. Vt. From Clare-
mont, N.H.; 412
Beach scene; 402
The blue grotto, Capri; 402
The bombardment of Fort Sumter;
399
Buffalo hunt on the prairie; 390
Cloud study: sunset; 402
The conflagration; 402
Domes of Yosemite; 333
The great trees, Mariposa Grove,

Cal.; 402
Lake Tahoe; 445c, 475
Last of the buffalo; 14c, 333c,
370c
Liberty Cap, Yosemite Valley; 22c
Mt. Shasta; 399
Mt. Whitney--grandeur of the
Rockies; 412c
Niagara Falls; 402
The Oregon Trail; 14c, 122c
Rocky Mountains; 333, 409, 412,
420
Rocky Mountains, Lander's Peak;
412
Seal Rock; 531
Snow scene with buffaloes; 399
A storm in the Rocky Mountains--
Mt. Rosalie; 412
Sunset glow; 410
Sunset in the Yosemite Valley;
402c
Turbulent clouds, White Mts.,
N.H.; 412
The wave; 13
Western lake scene; 410c
Western landscape; 370
Wind River Mountain; 14c
Wreck of the Ancon in Loring Bay,
Alaska; 531
Yosemite Valley, Glacier Point
Trail; 412

BIGAUD, Wilson, 1931-
Murder in the jungle; 19
Ra-ra dance; 19
Self-portrait in carnival costume;
19
Women in the shower room; 576

BIGG, William Radmore, 1755-
1828
The charitable lady; 194

BIGGERS, John, 1924-
Birth from the sea; 48c
Dying soldier; 48
Gleaners; 48c
Harvest song; 48
Harvesters; 48
Local 872 Longshoremen; 48cd
Negro woman in American life and
education; 48
Night of the poor; 48
Red barn farm; 48c
Web of life; 48c

BIGOT, Trophime the Younger
Christ in the carpenter's shop;

406d
A doctor examining urine; 526
A man holding a paper; 526
St. Jerome; 406d, 526
St. Luke; 406
St. Sebastian tended by Irene; 406
Vanitas; 406

BIHARI, Sanclar
Before the Justice of the Peace;
354
A speech to the electors; 354

BIHARI, Sandor, 1856-1906
Electoral speech; 96
Sunday afternoon; 96c

BIHZAD, 16th century
Book illustration; 71

BIKANER School
Krishna holding up Mt. Govard-
hana; 576

BILASPUR School
Radha arresting Krishna; 576

BILDERS, Albert Gerard
Landscape near St. Ange; 189

BILITE, Jean
Reunion of painters; 595

BILL, Max, 1908-
Four closed color groups; 438c

BINGHAM, George Caleb, 1811-79
Adams, John Quincy; 122
The belated wayfarers; 101c
Bingham, Mrs. George Caleb; 101
Boatmen on the Missouri: 101c
Boone, Daniel, escorting a band
of pioneers into the Western
Country; 101c, 110, 119c, 399
Boone, The emigration of Daniel;
101cd
Canvassing for a vote; 14c, 101c,
119c, 122c, 257
Captured by Indians; 17, 101c
The checker players; 101c
The concealed enemy; 101c
Cottage scenery; 101c
The county election; 101c, 119c,
122c, 257, 370
Country politician; 101
The dull story; 119
Fishing on the Mississippi; 101c
Fur traders descending to Mis-

souri; 101c, 119c, 291c, 348c,
370c, 399, 409c, 445c, 576
Gentry, General Richard; 101c
In a quandary; 101c
The jolly flatboatmen; 17, 101c,
119c, 266c
Jolly flatboatmen in port; 101c
Lamme, Mrs. David Steele and
son; 17
Landscape with an Indian encamp-
ment; 101c
Landscape with cattle; 101c, 119c
Landscape with deer; 101c
Landscape with fisherman; 101c
Marmaduke, Meredith Miles; 17
Marmaduke, Mrs. Meredith Miles;
17
Martial law; 17, 101c
The mill boy; 101c, 119c
Mississippi boatman; 101c
Mississippi fisherman; 101c
Mountain landscape; 101c
Old field horse: stable scene;
101c
Order No. Eleven; 119
The palm leaf shade; 119
The puzzled witness; 101c
Raftsmen playing cards; 14c, 17,
101c, 119, 257, 399
Ream, Vinnie; 381
Rollins, Major James Sidney; 101,
119
Rollins, Sarah Helen; 17
Rollins, Major Sidney; 101
Sappington, Mrs. John; 101
Self-portrait; 101c, 119
Shooting for the beef; 17, 101c,
119c, 257c, 399
The squatters; 101c
The storm; 101c, 402
Stump speaking; 101c, 110, 400
Trappers' return; 101c
Troost, Dr. Benoist; 101c, 119
The verdict of the people, 101c,
399
A view of the lake in the moun-
tains; 101c
Washington crossing the Delaware;
101c
Watching the cargo; 101c, 399
The wood boat; 101c, 119c
Woodboatmen on a river; 101c

BINOIT, Peter, 1590/95-1632
Bouquet of flowers in a gold
mounted vase with garland and
parakeets; 204c

BIONDO, Giovanni del, 1356-92
Annunciation to the Virgin; 112
Presentation in the Temple; 112

BIONDO, Giovanni del, Studio
Madonna and Child with Sts. Peter,
 Paul, John the Baptist and
 John and two angels; 556

BIRCH, Thomas, 1779-1851
Battle of Lake Erie; 531
The Constitution and the Guer-
 rière; 399
Delaware River front, Philadel-
 phia; 267
Fairmount Water Works; 410
Naval engagement between the
 frigates United States and
 Macedonian; 13
Off the Maine coast; 13
Rider on a snowy day; 410
The ship Ohio; 13
United States and the Macedonian;
 531
View of New York; 399
View of the harbor of Philadel-
 phia from the Delaware River;
 531
The Wasp and the Frolic; 122c

BIRD, John, 1768-1829
Cottage on the moors; 105

BIRELINE, George, 1923-
A. M.; 50
A. M. L.; 50
Alamogordo; 50
American dream series # 1, flag
 and can; 50
American dream series # 2, bag
 and banana peel; 50
Attic; 50
Autumn I; 50
Autumn II; 50
CMCC high; 50
Construction; 50
Corner painting; 50
Crushed cup; 50
DMZ; 50
Dr. Pepper can; 50c
Figure in interior; 50
G. M. M. 1962; 50
Harbor; 50
Harvard Square; 50
Homage to Harnett; 50
J-22; 50
Jan. III; 50
Knightsdale; 50

Landscape; 50
Landscape Eve; 50
Landscape: pastorale; 50c
Magritte's magic works; 50
110 # 20; 50
Painting # 10; 50
Painting # 12; 50
Painting 19A; 50
Painting A62; 50
Painting blue; 50
Painting R. 59; 50
Painting W59; 50
Painting W61; 50
Red book; 50
Red drive; 50
Red shift; 50
San Quentin blues; 50
Sidewalk city; 50
Silverlode; 50
Still life, motion picture, wallpa-
 per, and sky; 50
Still life, wall in three parts; 50
Window; 50c
Winter (damaged); 50

BIRGER, Hugo Pettersen
In the bower; 353

BIRMELIN, Robert, 1933-
Apartment living: a recently
 emptied room; 126

BIROLLI, Renato, 1906-59
Agricultural machine; 449

BIRRELL, Ebenezer, 1801-88
Good friends; 234, 235c

BISCHOFF, Elmer, 1916-
No. 28; 5c
Woman with dark blue sky; 210

BISHOP, Isabel, 1902-
At the noon hour; 52
The bather; 52
Bottles; 52, 246
Campus students # 2; 52
Card game; 52, 267
The club; 52
Coke break; 52
Dante and Virgil in Union Square;
 52, 246
Double date delayed; 52
Encounter; 52
Five women walking # 1; 52c
Five women walking # 2; 52
Getting dressed; 52
Girl reading newspaper; 52

Girl with flowers; 53c
Girl with guitar; 53
Head of a girl; 53
Homework; 53c
Hutton, Christina; 53
June; 53c
Maria; 53
Mark; 53
Music lesson; 53
Paige Marie; 53
Pam; 53
Pamela reading; 53c
Patricia; 53c
Penny; 53c
Penny daydreaming; 53
Penny painting; 53
Pensive girl; 53
Quinn, Mrs. Arthur Lee; 521
Reuter, Diana; 521
Rivera, Graciela; 521
Rogers, Gail; 521
Seated ballerina; 53
Self, Master Smith Winborne; 53
Sheila in blue jeans; 53
Terry; 53
Tying the shoestring; 53c
Valerie and Cecily, the St. John
 Fitzgerald sisters; 53c
Valerie and Cecily, the St. John
 Fitzgerald sisters No. 1; 53
Valerie and Cecily, the St. John
 Fitzgerald sisters No. 2; 53
Young artist; 53
Young ballerina; 53
Young guitarist; 53c
Young violinist; 53

BLAINE, Nell, 1922-
Country room with paper garlands;
 379c
Landscape, Woodside, California;
 379c
Pasture II; 379c
Summer interior, by Gloucester
 Harbor II; 379c

BLAIR, Streeter, 1888-1966
Virginia; 22c

BLAKE, Jane
Self-portrait; 23c

BLAKE, Peter, 1932-
Bo Diddley; 434c
Chanel, Coco; 210
Got a girl; 511c
On the balcony; 387c, 511
Tortur, Doktor K. ; 449
The toy shop; 576

BLAKE, William, 1757-1827
Adam and Eve sleeping; 565c
Adam naming the beasts; 565c
Ancient of days; 475
Bathsheba at the bath; 565c
Beatrice addressing Dante from the
 car; 462c, 565c
Beatrice on the car; 600c
The body of Abel found by Adam
 and Eve; 565c
Book of Job: 'When the morning
 stars sang together'; 565c
The Canterbury pilgrims; 565c
Christ placed on the pinnacle of
 the Temple; 565c
The circle of the lustful--Paolo
 and Francesca; 565c
Dante and Virgil approaching the
 angel who guards the entrance
 of Purgatory; 565c
Dante and Virgil penetrating the
 forest; 565c
Dante running from the wild
 beasts; 565c
Elohim creating Adam; 475
Faerie queen; 565cd
Four and twenty elders; 475
The genius of Shakespeare; 600c
The ghost of a flea; 462, 565c,
 588c
God blessing the seventh day; 565c
The great red dragon and the
 woman clothed with the sun; 565c
The inscription over the gate; 565c
Jacob's ladder; 565c
Joseph making himself known to
 his brethren; 565c
Last Judgment; 565c
The Lazar house; 576
A midsummer night's dream; 283c
Naomi entreating Ruth and Orpah
 to return to the land of Moab;
 600
Oberon, Titania and Puck with
 fairies dancing; 565c
The penance of Jane Shore in St.
 Paul's Church; 565c
Pity; 600
Rest on the flight into Egypt; 475
The resurrection of pious souls;
 600c
Satan smiting Job with sore boils;
 9c
Simoniac pope; 409, 565c
The spiritual form of Nelson guid-
 ing Leviathan; 195, 565c
The wise and foolish virgins; 87
The youthful poet sleeping on a

bank; 565c
Zacharias and the angel; 87

BLAKELOCK, Ralph Albert, 1847-
1919
Afterglow; 410
Blakelock, Mrs. ; 131
The chase; 131
Fifth Avenue at 89th Street in 1868;
399
Flower piece; 62
Indian encampment; 131c
Moonlight; 131c, 436c, 445c
Moonlight, Indian encampment; 576
Moonlight sonata; 131
Out of the deepening shadows; 131
The poetry of moonlight; 402c
Rockaway Beach, Long Island,
N. Y. ; 531
The sun serene, sinks in the
slumbrous sea; 131, 531

BLANCH, Arnold, 1896-1968
Some place in Georgia; 242
Swamp folk; 29
The third mortgage; 29

BLANCHARD, Jacques, 1600-38
Allegory of charity; 553

BLANCHE, Jacques Emile, 1861-
1942
Debussy, Claude; 506c
Gide, André; 506
Portrait of a sculptor; 553
Poulenc, Francis; 506c
Proust, Marcel; 506c
Vasnier, Mme. ; 96

BLANCHET, Louis Gabriel, 1705-
72
Prince Henry Benedict Stuart;
382c

BLARENBERGHE, Louis Nicolas
van, 1716-94
The siege of Yorktown; 178bc
The surrender of Yorktown; 178

BLASHFIELD, Edwin H. , 1848-
1936
Academia; 176
Suspense, the Boston people watch
from the housetops the firing
at Bunker Hill; 266

BLATAS, Arbit, 1908-
Soutine, Chaim; 595

BLATHERWICK, Lily (Hartrick)
Wintry weather; 524

BLAU-LANG, Tina
Springtime in the Prater, Vienna;
524
View in the Prater, Vienna; 524

BLAUVELT, Charles F. , 1824-
1900
The German immigrant inquiring
his way; 257
Waiting for the cars; 257

BLECHEN, Karl, 1798-1840
Girls bathing in the Park of Terni;
494c
Interior of the Palm House on the
Peacock Island; 409
The oriental conservatory at the
Potsdam Palace; 302
Rolling mill near Neustadt-Ebers-
walde; 175
Schadow, Former Studio of Rudolf;
506c
The split tower of Heidelberg
Castle; 494c
Studio of the Sculptor Ridolfo
Schadow in Rome; 175
View of roofs and garden; 175c

BLES, David J. , 1821-99
The conversation; 409

BLES, Herri met de, 1480/1500-
50/84
Adoration of the Magi; 576
Landscape with the flight into
Egypt; 341
Paradise; 422
Story of David and Bathsheba; 281c

BLINKS, Thomas
The York and Ainsty hounds on the
ferry at Newby; 604

BLOCH, Albert, 1882-1961
Harlequin with three Pierrots; 503

BLOEMAERT, Abraham, 1564-1651
Flute player; 303
The flutist; 608c
Head of a saint; 282
John the Baptist preaching; 189
Landscape with Tobias the angel;
341c
The marriage of Cupid and Psyche;
382

Diamond with yellow and orange;
 60c
Double composition; 60
Ellipse red vertical; 60
Elongated diamond; 60
Horizontal or vertical; 60
Large architectural; 60
Large, black, red and white
 diamond; 60
Large blue horizontal; 60
Large cobalt diamond; 60
Large vertical; 60
Large vertical rectangle, red,
 white, yellow; 60
Marine abstraction; 60
Mural for North Central Bronx
 Hospital, New York City; 60c
Mural sketch for Cinema I wall,
 New York; 60
Oil study for mural for Health
 Building Hall of Medical Sci-
 ence, New York World's
 Fair, 1938-39; 60
Opalescent; 60
Opalescent vertical; 60
Painting from collage; 60
Pale blue tondo with dark blue; 60
Portrait of Myrrha; 60
Rectangular space; 60
Red and black tondo; 60c
Red and white; 60
Red keys; 60
Red rectangle; 60
Red tondo; 60c
Rising tondo; 60
Scarlet diamond; 60
Sketch # 1; 60
Sketch # 2; 60
Somber key; 60
Study for mural for North Central
 Bronx Hospital, New York
 City; 60
Tondo; 60
Tondo with blue and violet; 60
Torreon diamond; 60
Two white rectangles; 60
Untitled abstraction; 60
Upright in gold and violet; 60
Variation in red, diamond; 60
Vertical blue; 60
Vertical ellipse, yellow, black
 and red; 60
Vertical lines; 60
Vertical oval; 60c
Vibrant reds; 60
Vibrant yellow diamond; 60
White abstraction; 60, 472
White circle; 60

White on brown; 60
White on white; 60
White vertical with blue, red and
 yellow; 60c
Yellow and gray diamond; 60
Yellow tondo; 60

BOLTRAFFIO, Giovanni Antonio,
 1467-1516
Melzi, Francesco; 361
Virgin and Child; 567c

BOMBERG, David, 1890-1957
In the hold; 511c
Mud bath; 3c, 285c, 434c, 511,
 576

BOMBOIS, Camille, 1883-1970
L'Athète forain; 328
Nu aux bras levés; 328c
The weightlifter; 289c
Woman seen from behind; 250
Wrestlers in the camp; 89c

BONAIUTI, Andrea see ANDREA
 da FIRENZE

BOND, Peter Mason, 1882-1971
Pemabo's garden and Altar of
 Freedom; 243c

BOND, William Joseph J., 1833-
 1926
Raven's Fall, near Hurst Green;
 604

BONDORFF, Sibylla de
St. Francis kneeling in prayer;
 218c

BONFANTI, Arturo
Apparent quiet; 438c

BONGART, Sergei, 1918-
Bill; 520

BONHAM, Horace, 1835-92
Nearing the issue at the cockpit;
 266, 354, 399

BONHEUR, Rosa, 1822-99
Brisco, a shepherd's dog; 524
Gathering for the hunt; 236c
Horse fair; 218c, 236, 409, 524
The king of the desert; 524
Oil sketch for Haymaking in Au-
 vergne; 236
Ploughing in the nivermais; 524

A she-goat; 281c
Shepherd watching his sheep; 524
Study of a bull; 524
Study of rams; 236

BONI, Delmar, 1948-
Great native American dream No.
 1; 253
Portrait; 253

BONINGTON, Richard Parkes,
 1802-28
Boats by the shore; 341
The Château of the Duchesse de
 Berri; 600
Coast of Picardy; 576
Coast scene in Picardy; 121
Coast scene with shipping; 121
Eastern scene; 302
Figures on a Venetian balcony; 600
Fishing boats in a calm; 121c
Fishing on the Normandy coast; 506
François I and Marguerite de
 Navarre; 537, 538
Le Havre harbor; 105c
Henry IV and the Spanish am-
 bassador; 537, 538, 409
Henry VIII and the English am-
 bassador; 537, 538
The interior of the Church of S.
 Ambrogio, Milan; 600c
Meditation; 537, 538
Medora; 570c
An Odalisque; 576
Off the English coast; 421c
On the Adriatic; 434
Page, Anne, and Slender; 537, 538
Riva degli Schiavoni, Venice; 506
Robsart, Amy, and the Earl of
 Leicester; 195
Rouen from the quais; 600c
St. Bertin near St. Omer--transept
 of the Abbey; 195d
Shipping at Rouen; 600
Surrey, The Earl, and the fair
 Geraldine; 538c
Turk reposing; 570c
Two figures in an interior; 600
Venice: the Doges' Palace; 600c
View of Normandy; 283c
The water parterre at Versailles;
 124

BONNARD, Pierre, 1867-1947
Abduction of Europa; 553c
After dinner; 160c
After the bath; 128
The artist's sister and her chil-

dren; 560
At the embroideress's; 513
Avenue Clichy; 128
The beach; 128
Boating on the Seine; 156
Bowl of fruit; 64
Breakfast; 210c
The breakfast room; 400
The cab horse; 560
Children leaving school; 560
Dining room in the country; 124c,
 576
Dining room in the country, Ver-
 non; 156
Dining room on the garden; 156c
Dressing table and mirror; 271c
Early spring; 341c
Evening in Paris; 341c
Flower sellers in the Rue Lepic;
 128
In the painter's studio; 271c
Landscape at Le Cannet; 160
Landscape of the Midi; 64
Landscape with a goods train; 341c
Man and woman; 513c
The Mediterranean; 341c
Morning in Paris; 341c
Nu à contre jour; 9c
Nu dans le bain; 9c
Nude; 156
Nude against the light; 6c, 285c
Nude in bathtub; 436c
Nude in the morning; 160
Nude in yellow; 97
Nude woman; 285c
The palm; 97
The Provençal jug; 160
Rue de Clichy; 140
Seascape, St. Tropez; 156c
Sert, Mme.; 513
Signac on his yacht; 421c
Still life with fruitbowl; 156
Street scene; 6c
The Terrasse family; 409
The three ages of woman; 335c
La toilette; 505c
Two dogs; 64
Two dogs in a deserted street;
 560c
Vase of flowers; 128
The window; 576
Woman in the mirror; 128
Woman with a dog: still life with
 bananas; 156
Woman's torso in a mirror; 124

BONNAT, Leon, 1833-1922/23
Assumption; 244cd

Ferry, Jules; 506
Pasca, Mme. ; 96c

BONNEMAISON, Chevalier Féréol
de, 1770?-1827
Young woman surprised by a
storm; 184

BONVIN, François, 1817-87
The brothers' school; 354
Girls' school; 506
The letter of recommendation; 576
Servant drawing water; 409
Still life; 352
St. Sebastian; 184

BOONEN, Arnold, 1669-1729
Scholar sharpening his pen; 466

BOORAEM, Elizabeth V. , 1919-
Man Full of Trouble Inn, Society
Hill, Philadelphia; 23c

BOOTH, Cameron, 1892-
Iron mines; 29

BOR, Paulus, 1600?-69
A woman as the Magdalen; 608c

BORDONE, Paris, 1500-71
The Child Jesus disputing in the
Temple; 281c
A fisherman consigning a ring
to the Doge; 576
Lady in a green mantle; 432c
Portrait of a knight in armor; 432c
Venus and Cupid; 375

BORDUAS, Paul Emile, 1905-60
Cimetière marin; 234
Froissements délicats; 576
Magnetic silence; 449
3 and 4 and 1; 234

BOREIN, Edward, 1872/73-1945
The Appaloosa; 132c
El bandido; 132c
Blackfoot women, Western Canada;
132c
Bronco; 132c
The buffalo hunt; 132c
Cowboy roping a steer; 132c
Five vaqueros; 132c
Four horsemen; 132c
El Hacendada; 132c
Heading' a steer; 132c
Hinton, Patch; 132c
Horse and rider; 132c

Indian on pinto pony; 132
Indian ponies; 132c
Indian warriors; 132c
Making good time; 132c
Mexican vaquero; 132c
Mounted vaquero; 132c
The mud wagon; 132c
The night rider; 132c
Night trail herd; 132
The pinto colt; 132c
Roped; 132c
Sioux chiefs in Montana; 132
Six place cards; 132c
The stagecoach holdup; 132c
Stone, Fred; 132c
Three buffalo; 132c
Three cowboys; 132c
The trail boss; 132c
Vaquero in courtyard; 132c

BORES, Francisco, 1898-
Beach; 449

BORGIANNI, Orazio, 1578?-1616
Christ disputing with the doctors
in the Temple; 526
Holy Family; 526
Self-portrait; 526

BORGMANN, Paul
Going to America; 354

BORGOGNONE, Ambrogio da see
BERGOGNONE, Ambrogio da

BORGONA, Juan de, fl. 1493-1511
The embrace of Sts. Jochim and
Anne before the Golden Gate;
389

BORIE, Adolphe, 1877 1934
Stone fruit; 62

BORIS----
Biographical icon of the Prophet
Elijah; 455

BORIVOS, Macksimovic
My cow; 328c

BOROZDIN, Semeon
Birth of St. Nicholas and scenes
from his life; 455

BORRANI, Odoardo, 1833-1905
Il Mugnone; 409

BORRASSA, Luis, fl. 1396-1424
Santa Clara altarpiece; 576d

BOS, G. P. van de
Painting in the open air; 353

BOSBOOM, Johannes, 1817-91
The Amstel River, Amsterdam;
553
In Trier Cathedral; 553
Interior of the Pieterskerk, Leiden;
189
Vestry at Nijmegen; 409

BOSCH, Ernst, 1834-1917
Far from home; 51

BOSCH, Hieronymus, 1450-1516
Adoration of the Magi; 576
Ascent to the Empgrean; 422
Calvary; 72c
Christ bearing the Cross; 205
Christ carrying the Cross; 72
Christ mocked; 97, 442
Crowning with thorns; 576
Garden of earthly delights; 87bc,
283cd, 294c, 424cd, 576c
Garden of Eden; 422
The hay wain: 205c, 424c
Last Judgment; 331cd
Marriage at Cana; 189
Mocking of Christ; 189
St. John on Patmos; 294c
Ship of fools; 189, 291c
Temptation of St. Anthony; 205,
588c
Vision de Tondal; 9

BOSCO, Pierre, 1909-
Horse race; 553

BOSHIER, Derek, 1937-
The identi-kit man; 387c, 511

BOSILJ, Ilija
Apocalypse; 394c
Kraljević Marko speaks about the
empire; 394c
Simonida; 394c
Smiling kings; 394c

BOSIN, Blackbear, 1921-
And they moved without him; 253c
Death went riding; 253
Of the Owl's telling; 253c
Prairie fire; 253c
Rain song; 415
Spirit of the plains; 415

BOSS, Homer, 1882-1956
Yellow buffalo; 233cd

BOSSCHAERT, Ambrosius the
Elder, 1573-1621
Flowers in a window niche with
landscape; 204c
Large bouquet in a gilt-mounted
Wan Li vase; 303
Still life: a vase of flowers at a
window; 608c
A vase of flowers; 157c, 189

BOSSCHAERT, Ambrosius the
Younger, 1610?-45
Flowers in a bronze vase; 204c

BOSSE, Bilders van, 1837-1900
A pool near Oosterbeek; 524
A windmill at Heelsum; 524

BOSSERT, Edythe Hoy, 1908-
Summer garden; 23c

BOSSOLI, Carlo, 1815-84
Square of the Tartars at Bahceka;
302c

BOSTOCK, John, 1801?-69?
Bradwardine, Rosa; 384

BOTELLO, David
Dreams of flight; 167c

BOTERO, Fernando, 1932-
Aberbach, Joachim Jean, and his
family; 21
Aberbach, Julian; 21
Adam and Eve; 21
Adam and Eve diptych; 21c
Amparo; 21c
Aurora; 21
Bananas and oranges; 21
The bed; 21c
Bernard, Claude; 21c, 192
Bishop lost in the woods; 21
Bishops bathing in a river; 21
Botero, Bonjour M.; 21c
The Botero exhibition; 21c
Boy eating watermelon; 21c, 192
The butcher's table; 21, 192c
Cat; 21
Chest still life; 192
Chief of police; 21
Child bitten by a dog; 21
Child from Vallescas after Velas-
quez; 192
The coffee break; 21
The collector; 21c
Colombian family; 21
Colombian still life; 21c, 192c

Bathers on the beach at Trouville; 124
The beach; 560
Beach at Trouville; 6c, 55c, 436c, 553, 560
The beach at Trouville: the Empress Eugénie; 460
The beach at Villerville; 310c
Beach scene; 506
Beach scene, Trouville; 442
The coast near Portriux; 138c
The Empress Eugénie on the beach at Trouville; 576
Fishermen's wives at the seaside; 271c
Honfleur, entrance to the harbor; 506
Honfleur: fishing boat leaving the port; 128
Jetty and wharf at Trouville; 409
On the jetty; 560
The pier at Deauville; 506c
Port of Le Havre: looking out to sea; 443c
The quay at Antwerp; 128
Quay at Camaret; 6c
Sailing boats; 506
Sailing ships in port; 6c
St. Mark's Square, Venice, seen from the Grand Canal; 506
A summer's day: coast scene; 9c
Twilight over the Basin of Le Havre; 124c
Venice: Santa Maria della Salute from San Giorgio; 443c
Washerwomen on the beach at Etretat; 560
White clouds over the estuary; 260
Woman with a sunshade; 506
Women on the beach at Berck; 560
Women on the beach at Trouville; 124
Yacht basin at Trouville--Deauville; 560c

BOUGH, Sam, 1822-78
The Royal Volunteer review; 605
The Vale of Teith, Perthshire; 604

BOUGHTON, George Henry, 1833-1905
Pilgrims going to church; 14c, 122c, 266
The road to Camelot; 604
Winter scene; 176

BOUGUEREAU, William A., 1825-1905
The captive; 553
Compassion; 96
Fraternal love; 443c
Nymphs and satyr; 55, 409, 597
The Oreads; 96
Regina angelorum; 96c
Youth and Cupid; 576

BOUHOT, Etienne, 1780-1862
Salle des Pao Perdus, Palais de Justice, Paris; 184

BOUILLIAR, Mlle. ----
Portrait of an actress; 524

BOULANGER, Louis, 1806-67
Avenue of elm trees; 409
Mazeppa; 184, 409

BOULANGER, Gustave R., 1824-88
Ulysses recognized by his nurse Eurycleia; 306

BOULENGER, Hippolyte, 1837-74
The flood; 170

BOULIAR, Marie Geneviève, 1762-1825
Aspasia; 236
Lenoir, Adélaïde Binart; 236c
Lenoir, Chevalier Alexandre Marie; 236

BOUQUET, André, 1897-
View of Villeneuve--St.-Georges; 289c

BOURBON, Infante Doña Paz de
My model; 524
A scene at Comillas; 524
A view of Grottaferrata near Rome; 218

BOURDON, Sébastien, 1616-71
The death of Dido; 341c
Queen Christina of Sweden; 610c
Vauvert, Baron de; 98c

BOURGEOIS, Sir Francis, 1756-1811
View on the seashore; 247

BOURNE, Henrietta P., early 19th century
A mill on the Fowey; 105

BOURNE, James, 1773-1854
Beeston Castle, Cheshire; 105

BOURSSE, Esaias, 1631-72
Old woman asleep over a book;
 466

BOUT, Pieter, 1658-1719
Beach scene; 282

BOUTELLE, De Witt Clinton, 1820-
 84
Grist mill; 410
Locks at New Hope, Pa.; 410
Trenton Falls; 410c

BOUTS, Dirk, 1410/20-75
The appeal of the countess; 205
Entombment; 424c, 442
Gathering of the manna; 205c
John the Baptist as herald of
 Christ; 205
Madonna and Child; 335c
Martyrdom of St. Erasmus; 205
Portrait of a man; 442, 576
St. Christopher; 205
The trail by fire; 576
Visitation; 422

BOWEN, Denis, 1921-
Nocturnal image; 553

BOWER, E.
Charles I at his trial; 382

BOWERS, Edward
Still life with flagon and fruits; 62

BOWES, Betty M.
Corinthian sails; 46
Hunterdon County, N.J.; 46c

BOWKETT, Jane Maria, fl. 1860-
 85
Folkstone; 605
Folkstone beach; 604
Preparing tea; 605

BOWLER, Henry Alexander, 1824-
 1903
The doubt--can these dry bones
 live?; 604, 605

BOXALL, Sir William, 1800-79
Hosmer, Harriet; 604

BOYADJIAN, Micheline E., 1923-
Girl in a room; 289c

The lighthouse of Belle-Ile-en-
 Mer; 289c

BOYCE, George Price, 1826-97
The mill on the Thames at Maple-
 durham; 232

BOYD, Arthur, 1920-
Shearers playing for a bride; 576

BOYLE, Ferdinand Thomas Lee,
 1820-1906
Grant, General Ulysses Simpson;
 399

BOYS, Thomas Shotter, 1803-74
L'Institut de France; 576
A windmill in sunset; 600

BOZE, Joseph, 1745-1825
Mirabeau; 184

BOZNANSKA, Olga de, 1865-1940
Portrait of a lady; 524

BRABAZON, Hercules B., 1821-
 1906
The Bacino, Venice; 604
Homage to Daubigny; 105c

BRACKETT, Ward
Black's beach; 64c
Debbie; 64c
Kathy; 64
Nude study; 64c
Old mill; 64c
Still life; 64c
Still life in red; 64c
View near Lago di Garda; 64c

BRACKMAN, Robert, 1898-
Eilshemius, Louis Michel; 308
Somewhere in America; 176

BRADFORD, William, 1823-92
An arctic summer, boring through
 the pack in Melville Bay; 402,
 412
Clark's Point light, New Bedford;
 13
An English Arctic expedition in
 search of Franklin; 234
Icebergs in the arctic; 531
Muir glacier; 22c
New York Yacht Club regatta at
 New Bedford; 13
Shipwreck off Nantucket; 531

BREENBERGH, Bartholomeus,
 1590/1600-57
Finding of the Infant Moses; 576
Joseph, Mary and the infants
 Jesus and John the Baptist
 resting on the flight into Egypt;
 282c
Landscape with ruins; 303, 553
River landscape with St. Peter and
 St. John; 608c

BREHMER, K. P. , 1938-
Skyline of Berlin; 449

BREITNER, Georg Hendrik, 1857-
 1923
The Dam, Amsterdam; 189
The Damrak in Amsterdam; 197
Ladies on a ferry boat; 576
Paleisstraat, Amsterdam; 189
Rokin in the evening; 409
Warehouses, Amsterdam; 553

BREKELENKAM, Quirin, 1620?-68
The doctor's visit; 466
Fish sellers; 323
Lady choosing fish; 323
Old woman cutting carrots; 466
Old woman with a spindle in a
 niche; 466
The operation; 466
Woman and maidservant; 466

BRELING, Heinrich, 1849-1918
At the inn; 51
The tryst; 51

BRENET, Nicolas Guy, 1728-92
Death of Du Guesclin; 184
The piety and generosity of Roman
 women; 287

BRENTANI, Mário von
Polar sun; 262

BRESCIANINO, Andrea del, fl.
 1507-25
Judgment of Paris; 556
Portrait of a young woman holding
 a book; 556

BRESLAU, Louise
Anais; 524
A portrait group of friends; 524

BREST, Germain Fabius, 1823-
Shores of the Bosphorus, European
 side; 302

BRETON, Jules, 1827-1906
Benediction of the wheat in Artois;
 55
Calling the gleaners home; 409
The shepherd's star; 553
Song of the lark; 45

BRETT, Dorothy, 1883-
My three fates; 111

BRETT, Harold, 1880-
Broadway Limited operating through
 the steel district; 209c

BRETT, John, 1830, 32-1902
Britannia's realm; 121c
The British Channel seen from
 the Dorsetshire cliffs; 412
February in the Isle of Wight; 471c
Florence from Bellosguardo; 232
Lady with a dove: Mme. Loeser;
 232
Landscape, Val d'Aosta; 434
Massa, Bay of Naples; 412
Morants Court in May; 412
Pearly summer; 384
The shipwreck; 121
The stonebreaker; 232c, 471c,
 604, 605

BREU, Jorg the Elder, 1475/76-
 1537
Flight into Egypt; 576

BREWSTER, John, Jr. , 1766-1854
Brewster, Dr. and Mrs. John;
 158
Prince, Sarah; 348c

BREWTON, Denny
Netherland ranch; 23c
Juan Floreztank, Rosewell,
 N. M. ; 23c

BRIANCHON, Maurice, 1899-
Woman with a mirror; 553

BRICE, Bruce, 1942-
Self-portrait; 243c
Treme Wale mural; 243c

BRICE, William, 1921-
Wooden objects; 457

BRICHER, Alfred T. , 1837-1908
At the bridge; 267c
Coast off Grand Manan; 22c
Indian Rock, Narragansett Bay;

402
Monhegan Cliff, Me. ; 13
Morning at Grand Manan; 402
A pensive moment; 528
Summer enchantment; 267
Time and tide; 530c, 531

BRICKDALE, Eleanor F. , 1871-
1945
He married a wife; 524
Justice before her judge; 604
Sleep, that knits up the ravell'd
sleeve of care; 524
Today for me; 524
Youth and the lady; 524

DRIDELL, Frederick Lee, 1831-63
The Temple of Vesta; 604

BRIDGES, C. , 1670?-
Ainsworth, Mr. ; 264
Baker, Rev. Thomas; 264
Bolling, Elizabeth Blair; 264
Boys of the Grymes family; 264
Byrd, Anne; 264
Byrd, William III; 264
Blair, James; 264
Blair, John; 264
Bolling, John, Jr.; 264c
Bolling, Mary Kennon; 264
Carter, Elizabeth Wormeley; 264
Carter, Judith Armistead; 264c
Carter, Robert 'King'; 264
Colonial gentleman; 264
Custis, John IV; 264
Dandridge, Dorothea; 264
Gay, Elizabeth Bolling; 264
Girl of the Ludwell family; 264c
Girls of the Grymes family; 264c
Lee, Hannah Ludwell; 264
Lee, Thomas; 264
Ludwell, Mrs. , and children; 264c
Moore, Augustine; 264c
Moore, Mrs. Augustine, and child;
264
Moore, Thomas; 264
Page, Alice; 264
Page, Mann, II; 264c
Page, Mrs. Mann II and child; 264c
Page, Martha; 264
Randolph, Mrs. William III; 264
Spotswood, Alexander; 264
Two children of the Moore family;
264

BRIDGES, Fidelia, 1834-1923
Milkweeds; 528

BRIDGES, John
Three sisters; 604

BRIDGMAN, Francis
The lawn tennis club; 353

BRIERLY, Sir Oswald Walters,
1817-94
Man overboard; 604

BRIGADA, Ramona Parra
Fabrilana mural; 107

BRIGGS, Austin, 1908-73
Field of lavender, Provence; 64c
On the road to Cavaillon; 64c

BRIGHT, Henry, 1810-73
Beach scene with figures; 363c
Old barn, Kent; 363
The old mill; 604
Throp meadows with Norwich in
the distance; 363
Windmill at Sheringham; 363

BRIL, Paul, 1554/56-1626
A landscape with goatherds; 382
Landscape with the history of
Psyche; 288
Rocky landscape; 576

BRINDESI, Jean, 19th century
Turkish carriage--sweet waters of
Asia; 302

BRINDLE, Melbourne, 1904-
First flight at Kitty Hawk, N.C.,
1903; 122c

BRINNER, George R.
HK/LB landscape; 23c
LB/ self-portrait; 23

BRISPOT, H.
Fifty years of service; 354
The king drinks; 353

BRISSOT, Jacques
The garden of delights; 331c
Hay wain; 331c

BRISTOW, Edmund, 1787-1876
A stag and hind in highland land-
scape; 604

BRITO, José de, 1855-1946
A victim of the Inquisition; 96

BRITTAIN, Miller, 1912-68
Formal party; 234
Market Square, Germantown, Pa. ;
370

BROC, Jean, 1771-1850
Death of General Desaix; 344
Death of Hyacinth; 184, 344
The school of Apelles; 344

BROCKMANN, Elena
Outside a Roman hostelry; 524

BROCQUY, Louis de
Male presence; 449

BRODIE, Gandy, 1924-75
Fallen tree; 475

BRÖCKMANN, Gottfried, 1903-
Crippled lives; 400

BROEDERLAM, Melchior, fl. 1381-
1409
Annunciation; 375
Annunciation and Visitation; 205c,
576
Presentation and flight into Egypt;
205c
Presentation in the Temple and
flight into Egypt; 291c

BROMLEY, William, fl. 1835-88
The schoolroom; 605

BRONCHORST, Jan Gerritsz van,
1603-62
Bean feast; 466

BRONCKHORST, Arnold
Bletso, Oliver, 1st Baron St.
John of; 550
Douglas, James, 4th Earl of
Morton; 550
James VI and I; 382
James VI holding a falcon; 550

BRONTË, Charlotte, 1816-55
The Bay of Glasstown; 9c

BRONTË, Emily, 1818-48
Merlin hawk; 9c

BRONZINO, Agnolo, 1503-72
Allegory; 223, 442c, 459c
Allegory of love and time; 284c,
285c, 533c
Allegory with Venus and Cupid; 470

Eleanora of Toledo and her son;
205, 283c, 335c, 576
Holy Family; 223
Medici, Cosimo I de'; 553
Medici, Giovanni de'; 239, 553
Medici, Giuliano de'; 239
Medici, Lorenzo di Giovanni de';
239
Panciatichi, Bartolomeo; 223
Portrait of a lady in green; 382
Portrait of a young man; 583c
Venus, Cupid, Folly and Time;
505c
Venus disarming Cupid; 205c
Venus, Love and Jealousy; 284c

BRONZINO, Style of
Lady in black and white; 281c

BROODTHAERS, Marcel, 1924-76
The turpitude of Charles Dodgson;
449

BROOK, Alexander, 1898-1980
The barn chair; 457
Georgia jungle; 29c
Siesta; 176
Twentieth century ruin; 242c

BROOKE, Richard Norris, 1847-
1920
Furling the flag; 122c

BROOKE, William Henry, 1772-
1860
Hastings Castle; 105

BROOKER, Bertram, 1888-1955
Alleluiah; 234
Driftwood; 234

BROOKER, Harry, fl. 1876-1910
Making a kite; 604, 605d

BROOKES, Samuel Marsden, 1816-
92
Bad Axe battleground; 381
Martin, Morgan L. ; 381

BROOKING, Charles, 1723-59
Fishing smacks becalmed near a
shore; 121c
Men o'war off a coast; 121
Seascape; 421c
A ship in a light breeze; 194
Shipping in a light breeze; 105
Ships in a light breeze; 121bc
A vice-admiral of the red and a
fleet near a coast; 121

Fight between Carnival and Lent;
 38, 219, 368c, 424c
Flemish proverbs; 87
Flight into Egypt; 219
Gloomy day; 219, 368c
Good Shepherd; 219
Harbor with ships; 283cd
The harvest; 283c
Hay making; 219bc, 294c, 368c
Head of an old peasant woman; 219
Hunters in the snow; 9c, 205c,
 219bc, 294c, 346, 368c, 422,
 424c
Land of Cockaigne; 219, 291c, 368c
Landscape with Christ appearing
 to the Apostles at the Sea of
 Tiberias; 219
Landscape with the fall of Icarus;
 87c, 219, 576c
Landscape with the parable of
 the sower; 219
The lepers; 368c
Magpie on the gallows; 219, 368c
Massacre of the Innocents; 219bc,
 368c, 382
The misanthrope; 219, 368c
Month of July; 368cd
The months; 559
Naples harbor; 421c
Netherlandish proverbs; 219, 368c
Numbering at Bethlehem; 219,
 368c
Parable of the blind; 87c, 219,
 368c, 576
Peasant and the birdnester; 219,
 368c
Peasant dance; 219, 368c, 424c
Peasant wedding; 205, 219bc
Procession to Calvary; 219bc,
 368c
Resurrection of Christ; 219
Return of the herd; 219bc, 368c,
 422
St. John the Baptist preaching
 in the wilderness; 368c
Sermon of St. John the Baptist;
 219
The storm at sea; 219, 368c
Suicide of Saul; 219bc, 368c
Three soldiers; 382
Tower of Babel; 205, 219, 368c,
 424c, 588c
Triumph of death; 38, 219bc,
 331c, 368c
Two monkeys; 219, 368c
View of Naples; 219, 368c
Way to Calvary; 375
The wedding dance; 219

Wedding feast; 368c
Winter landscape with a bird trap;
 553
Winter landscape with skaters and
 a bird trap; 219

BRUEGHEL, Pieter the Younger,
 1564-1638
The village; 294c

BRÜLLOV, Karl, 1799-1852
Last days of Pompeii; 409

BRÜTT, Ferdinand, 1849-
The hope of the countryside; 353

BRUFF, Goldsborough, 1804-
Assorted prints; 62

BRUNE-PAGES, Aimée
Leonardo painting the Mona Lisa;
 361

BRUNET, Jean
The newlyweds return home; 354

BRUNTON, Arthur D.
Extremity; 605

BRUSH, George De Forest, 1855-
 1941
Before the battle; 420
The escape; 420
George, Henry; 399
A memory; 176
The moose chase; 266

BRUTOSKY, Veronica
Peaceful afternoon; 23c

BRUYN, Bartholomaus the Elder,
 1493-1555
Brauweiler, Arnold von; 576
Portrait of a lady with her
 daughter; 341c

BRUYN, Barthel the Younger,
 1530-1610
Father and sons; 553
Mother and daughters; 553
Nude Giaconda; 361
Reidt, Johann von, mayor of
 Cologne; 205

BRYANT, Harold, 1894-1950
The strategy of the wild; 233c

BRYDEN-WILLS, Betty
Looking down; 46

30
Poplar tree and house; 30
Poplar walk; 30
Poplars in June; 30
Promenade; 242
Purple vetch and buttercups; 30
Railroad gantry; 30
Rain and clouds; 30
Rainy day; 242
Rainy night; 14c, 30c, 242c
Red birds and beech trees; 30c
Road in early spring; 30
Rogue's gallery; 30
Scrapped locomotives; 390
September road; 30
Setting sun through the catalapas;
 30c
Six o'clock; 14c, 30, 122c, 242
The sky beyond; 30c
Snow patterns; 30
Snowbank and pool; 30
Snow-covered alley; 30
Snowflakes in October; 30c
Snowstorm in the woods; 30
The song of the katydids on an
 August morning; 30
Song of the red bird; 30c
Song of the spring peepers; 30
Song of the telegraph; 30c
Song of the wood thrush; 30
The Sphinx and the Milky Way; 30c
Spirit of the North Woods; 30
Spring twilight; 30c
Springtime in the pool; 30
Starlit woods; 30c
Storm at sunset; 30
Sulphurous evening; 30c
Summer; 126
Summer solstice; 30c
Sun and rocks; 30c, 267
Sunflower; 30
Sunlight behind two pines; 30
Sunshine and rain; 30
Swamp apparitions; 30
Tall white sun; 30
Three boats in winter; 30
Trees and fields, noon sunlight;
 30c
Weather moon; 30
Wet snow and ice; 313c
White violets and coal mine; 30
Winter, East Liverpool; 30
Winter solstice; 30c, 267c
Winter sun and barnyards; 30c
Winter twilight; 30c
Woman in a doorway; 30
Wood lilies; 30
The woodpecker; 30

BUREN, Daniel, 1938-
Photo/souvenir, London; 449c

BURGESS, John Bagnold, 1829/30-
 97
St. Sevres, Angers; 105
Waiting; 604

BURGKMAIR, Hans the Elder,
 1473-1531
St. John at Patmos; 273, 576

BURKE, Joe
Industrial planning; 29

BURKO, Diane, 1945-
Ama Dablam Peak; 379
Grissom alpine; 379c
Mountain range No. 2, Bernese
 Alps; 379
Northwest ski trails; 379
P. J.'s ridge; 379c

BURLIN, Paul, 1886-1969
Grand Canyon; 233c

BURNE-JONES, Sir Edward Coley,
 1833-98
Adder's tongue; 295c
The angels of creation--the sixth
 day; 320
Annunciation, the flower of God;
 295c
The arming of Perseus; 471c
Atlas turned to stone; 462
The avenging angel of St. Catherine;
 295c
The baleful head; 295c
Beguiling of Merlin; 195d, 232c,
 295c, 409c, 523c
Borke, Clara von; 232, 295c
Borke, Sidonia von; 232, 295c
A challenge in the wilderness;
 295c
Clerk Saunders; 232
Cupid delivering Psyche; 232,
 295c
Dinner party; 295
Fair Rosamund and Queen Eleanor;
 295c
The fifth and sixth day of creation;
 523
Fire tree; 295c
The four seasons: autumn; 295c
The four seasons: spring; 295c
The four seasons: summer; 295c
The four seasons: winter; 295c
The garden court; 232, 295cd

The garden of Pan; 588c
The garland; 295c
Golden shower; 295c
The golden stairs; 232, 576
Horner, Frances Graham; 295c
Interior with figures; 295c
King Cophetua and the beggar maid;
 232, 295c, 576
King Rene's honeymoon; 295c
The king's wedding; 232c, 295c
Ladder of heaven; 295c
Laus Veneris; 295c, 604
The legend of the briar rose: the
 briar wood; 523c
The legend of the briar rose: the
 rose bower; 523c
Love among the ruins; 295c
Love leading the pilgrim; 100c
The madness of Sir Tristram; 295c
The mill; 100c, 295cd, 434
The mirror of Venus; 295c
Morgan Le Fay; 295c
Music; 295c
The passing of Venus; 295c
Perseus and the Graiae; 295c, 523
Perseus receiving the mirror from
 Athena; 295c
Phyllis and Demophoön; 471c
Plymouth, The Countess of; 195
Pygmalion and the image III; 409
The rose bower; 232
The sleeping knights; 295c
The sleeping princess; 462
Sponsa da Libano; 232, 295c
The star of Bethlehem; 295c
Traveller's joy; 295c
Tree of forgiveness; 195, 232c,
 295c
Wake dearest; 295c
The wheel of fortune; 295c
White garden, 295c
Witch's tree; 295c
Zambaco, Maria; 523
Zephyrus and Psyche; 295c

BURNET, James, 1788-1816
Old Chelsea Bridge; 279

BURNET, John, 1784-1868
The trial of Charles I; 279

BURNEY, Edward Francis, 1760-
 1848
Amateurs of tye-wig music; 600

BURNS, Mike
Boarded up; 378
House on Wollochet Bay; 378

Psalms 61:3; 378
Requescat; 378c

BURNS, Paul Callan, 1910-
Adams, Charlotte; 76c, 521
The Allen sisters; 76c
Anderson, Nancy; 76c
Augelli, Judge Anthony T. ; 76c
Bartman, Herbert; 76c
Bicknell, Warren, Jr.; 76c
Bohrer, Mrs. Matthew; 76c
Bohrer, Rhoda; 76c
Brehne, Mary; 76c
Brennan, William J. , Jr. ; 76c
Bruton, Robert; 76c
Burns, Diedré; 76c
Butler, Gordon; 76c, 520
Button, Jack; 76c
Button, Mrs. John Edward; 76c
Church, Frederic C. ; 76c
Cooper, Stuart; 76
Crotta, Biz; 76
Dilger, Monsignor Harold J. ; 76c
Eaton, Barbara; 76c
Faye; 76c
Fisher, Mrs. Benjamin; 76c
Fisher, Lilian; 76c
Flynn, Judge John; 76
Gardner, Catherine; 76
Garven, Chief Justice Pierre; 76,
 520
Gelber, Sheila; 76c
Gibson, Rt. Rev. F. , Jr. ; 76c
Greene, Yolande; 76c
Hattori, Amy; 76c
Hazell, Dr. William, Jr. ; 76c
Heines, Anthony; 76c
Hoffman, Merle; 76
Irene; 521c
Kernan, Dean Alvin; 76c
Kloobor, Kathy; 76c
Macksoud, Mrs. ; 521
Marland, E. W. ; 76c
Mexican woman; 76c
Michèle; 521
Moreland, Raymond Ford; 76
Moreland, Mrs. Raymond; 76
Newby, June; 521c
Oriental woman; 76c
Penney, Lynn; 521
Prestwick, Michele; 76c
Randall, Judge Harry, Sr. ; 76c
Reitmeier, June; 76c
Rockefeller, David; 76c
Schreiber, Kathy; 76c
Simmons, Mildred; 76c
Sletteland, Trygve; 76, 520c
Studio door; 492

Tanzola, James; 76c
Tweedy, Gordon; 76c
Wanamaker, Mrs. John R., and
Beany; 76c
Wanamaker, John Rodman; 76c
Weintraub, Chief Justice Joseph;
76c
Wilde, Reggie; 76c

BURR, Alexander Hohenlohe, 1835-
99
The night stall; 605

BURR, John, 1834-93
The peepshow; 279, 384, 604, 605

BURR, William Henry, fl. 1841-
59
Intelligence office; 257

BURRA, Edward, 1905-76
Dancing skeletons; 307
Deth, John; 478
Forth Road Bridge; 9
Harlem; 9c
It's all boiling up; 478
Peter and the High Priest's ser-
vant; 576
Soldiers at Rye; 511c
Storm in the jungle; 511
Wake; 434

BURRI, Alberto, 1915-
Martedi Grasso; 436c
Sacco; 42c
Sacco 3; 449
Sacco 4; 449c
Sacco e rosso; 387c
Sack No. 5; 438c

BURTON, Charles, fl. 1802-38
View of the Capitol, Washington,
D.C., in 1824; 122c

BURTON, Marie
Celebration of cultures; 107

BURTON, William Shakespeare,
1830-1916
A wounded cavalier; 537, 538, 604

BURY, Pol, 1922-
Ponctuation; 320

BUSA, Peter, 1914-
Demolition; 167c

BUSATTI, Luca Antonio, fl. 1500-
39
Descent from the cross; 556

BUSCH, Wilhelm, 1832-1908
Half-portrait of painter with pal-
ette; 175

BUSH, Jack, 1909-
Cerise band; 92
True and fair; 436c

BUSH, Joseph H., 1794-1865
Bush, Thomas James; 381
Clark, George Rogers; 381
Taylor, Zachary; 122
Woolfolk, Mrs. Joseph Harris; 381

BUSON see YOSA BUSON

BUSSY, Simon
Promenade; 513

BUTINONE, Bernardino, fl. 1484-
1507
Madonna; 375

BUTINONE, Bernardo, Follower
Virgin and Child; 586

BUTLER, Bill
Lil' Valley mural; 107

BUTLER, Lady Elizabeth (Thomp-
son), 1846-1933
Missed!; 524
Quatre Bas; 218, 236c
The remnants of an army; 604,
605d
The roll call; 605d
Scotland forever!; 218c, 236
Steady the drums and fifes; 524

BUTLER, Samuel, 1836-1902
Family prayers; 605

BUTLER, Theodore Earl, 1860-
1936
The apricot orchard, Giverny; 152
Flags; 152
Poplars, Giverny; 152

BUTTERSWORTH, James E., 1817-
94
Aberdeen, Scotland; 485
Albany riverfront with sidewheeler
Albany; 485
America; 485

CALDER, Alexander, 1898-1976
The potato; 22c

CALDERARA, Antonio, 1903-
Orthogonal meetin of yellow with
yellow; 438c

CALDERON, Philip Hermogene,
1838-98
Broken vows; 604, 605d
Going with the stream; 96
The moonlight serenade; 384

CALIARI, Carletto, 1570-96
Hagar in the wilderness; 556

CALLCOTT, Augustus Wall, 1779-
1844
A brisk gale: A Dutch East In-
diaman landing passengers;
121
Cicero's tomb; 604
Diana at the chase; 195
The Pool of London; 121
A sea piece; 121c

CALLET----
Louis XVI; 184
Louis XVIII; 184

CALLINS, Charles
A night of song--self impersonation;
340c
A night of splendor; 340c
Old home and beauty; 340c
Recollections; 340c
View from Barrier Reef, Fitzroy
Island to Double Island; 340c

CALLOW, John, 1822-78
A shipwreck off the Isle of Man;
604

CALLOW, William, 1812-1908
Entrance to the Grand Canal,
Venice; 105
The Neu Münster, Würzburg; 600
Riva degli Schiavoni; 604

CALOUTSIS, Valerios, 1927-
Formation II; 553

CALS, Adolphe Felix, 1810-80
Portrait of a young woman; 506
Sunday at the St. Siméon farm;
124

CALUMET HIGH SCHOOL ART
CLUB
The black athlete arises; 167c

CALVAERT, Dionisio, 1540/45-
1619
Flagellations; 576

CALVERT, Edward, 1799-1883
The primitive city; 434c, 576, 600

CALYO, Nicolino, 1799-1884
View of the city of New York,
Governor's Island, taken from
Brooklyn Hts. on the morning
after the conflagration; 267
View of the great fire in New
York, December 16 and 17,
1835; 528

CAMARO, Alexander, 1901-
Scenic railway; 449

CAMBIASO, Luca, 1527-85
Madonna of the Candle; 205

CAMERON, Sir David Young, 1865-
1945
Old Brussels; 231
Stirling Castle; 604

CAMERON, Hugh, 1835-1918
Gleaners; 279
Responsibility; 604

CAMERON, James, 1817-82
Moccasin Bend, Chattanooga; 381
Nolickucky River; 381
Whiteside, Col. and Mrs. James
A.; 381

CAMERON, Katharine
Hush! Remind not Eros of his
wings; 524

CAMERON, Margaret
After the bullfight; 524
Blair, Mrs., with her dogs; 524

CAMMARANO, Michelel, 1835-1920
The battle of Dogali; 96, 409

CAMOIN, Charles, 1879-1965
Charmay, Emilie, at her easel;
128
Marquet, Albert; 147, 161, 480
Matisse, Mme., doing needlework;
147, 161

Marco; 556
Piazza San Marco towards the
Piazzetta; 556
Piazza S. Marco, Venice, looking
east; 118
Piazzetta, Venice, looking north;
118
Regatta on the Grand Canal, Venice;
118
Riva degli Schiavoni, Venice; 118

CARLILE, Joan
The stag hunt at Lamport; 218

CARLIN, John, 1813-91
After a long cruise; 257c, 531

CARLINE, Richard
Spencer, Stanley; 90

CARLONI, Carlo, 1686-1775
Untitled mural; 40

CARLSEN, Emil, 1853-1931/32
Still life; 62
The white jug; 62

CARLSON, Cynthia, 1942-
Untitled; 153

CARLTON, William T. , 1816-88
Cider mill; 257

CARMICHAEL, Franklin, 1890-
1945
Northern tundra; 234

CARMICHAEL, John Wilson, 1800-
68
Coastal brigs and fishing vessels
off the Bass Rock; 121
HMS St. Vincent in Portsmouth
harbor; 604
Hartlepool; 121

CARNOVALI, Giovanni, 1806-73
Landscape; 409

CARO-DELVAILLE, Henry
The pâtisserie; 353
Tea time; 353

CAROLUS, Jean
The bride's farewell; 353

CAROLUS-DURAN, Emile A. ,
1838-1917
Carolus-Duran, The woman with

the glove, Mme. ; 409
Lady with a glove; 55, 506

CARPACCIO, Vittore, 1455-1525/
26
Apparition of the martyrs of Mt.
Ararat in Sant' Antonio di
Castello; 432c
Burial of Christ; 72c
Cycle of the Legend of St. Ursula;
421cd
Dream of St. Ursula; 533c
Leavetaking of St. Ursula and the
Prince; 205
Meditation on the death of Christ;
223
Meditation on the Passion; 398
Miracle of the Cross; 432
Miracle of the relic of the True
Cross; 223
Miracle of the True Cross; 576
Portrait of a lady; 432c
The reception of the English am-
bassadors and St. Ursula talk-
ing with her father; 470
St. Augustine in his study; 205c
St. Jerome and the lion in the
monastery garden; 576c
Vision of St. Augustine; 223
Vision of St. Ursula; 375
Vision of the prior of Sant' An-
tonio di Castello, Venice; 375

CARPENTER, Francis Bicknell,
1830-1900
Fillmore, Millard; 381

CARPENTER, Margaret G. , 1793-
1872
Donington, Richard Parkes; 524
Gibson, John; 524
Self-portrait; 524
Shuckburgh, Henrietta; 524

CARPENTER, William
Nautch girls in Kashmir; 302

CARPENTIER, Evariste, 1845-
1922
Washing the turnips; 354

CARPENTIER, Madeleine
Les Chandelles; 524

CARR, Emily, 1871-1945
Above the gravel pit; 507c
Above the trees; 507c
Abstract tree forms; 507c

The box at the theatre; 506
Cassatt, The daughter of Alexander; 124c
Cassatt, Lydia, the artist's sister; 616
Child in a straw hat; 310c
Childhood in a garden; 524
Children playing on the beach; 310c
Cordier, Mme.; 486
Cup of tea; 246, 257, 283c, 409, 486, 616
Ellison, Mary; 616
Emmie and her child; 156c
Family group reading; 353
Filette au grand chapeau; 68
Five o'clock tea; 460c
Girl arranging her hair; 156, 246, 310c, 616
In the garden; 246
Lady at the tea table; 246, 486
Little girl in a blue armchair; 310c, 445c
The loge; 310c, 257, 616
Lydia dans la loge; 486
Mlle. C.; 506c
Mother about to wash her sleepy child; 236
Mother and Child; 246, 271c, 430c, 486, 616
Mother and two children; 524
Mother, young daughter and son; 156c
Nurse reading to a little girl; 486
Picking flowers in a field; 152
Portrait of a young girl; 486
Rose et vert; 156c
The sisters; 73
Sleepy baby; 335c
Summertime; 6c, 152
Susan comforting the baby; 616c
Susan on a balcony holding a dog; 152
Two children at the seashore; 236
Two women seated in a landscape; 506c
Woman and child driving; 152, 246, 499, 616
A woman in black at the Opèra; 138c
Woman with a dog; 486, 616
Woman's head; 68
Young mother sewing; 486
Young woman in black; 236c
Young woman sewing; 506
Young women picking fruit; 156, 246, 436c

CASSINARI, Bruno, 1912/17-
Still life; 553

CASSON, Alfred Joseph, 1898-
Housetops in the ward; 234

CASTELLANI, Enrico, 1930-
Bisected white with vertical protuberances; 449

CASTELLANOS, Julio, 1905-47
The dialogue; 576

CASTIGLIONE, Giuseppe see LANG SHIH-NING

CASTILLO, Mario
Metafísica; 107

CASTRO, Lourdes
Beige et beige; 320
Café; 320

CASTROVERDE, Juan de Uceda
Double Trinity; 69

CATENA, Vincenzo, 1480?-1531
Adoration of the Shepherds; 398
Delivery of the keys to St. Peter; 281c
A man with a book; 576
Nativity; 44
Portrait of a Venetian senator; 398

CATLIN, George, 1796-1872
Ambush for flamingoes; 436c
Arikara village of earth-covered lodges; 238
Ball play of the Choctaw--ball up; 238bc
Battle between Sioux and Sac and Fox; 238
Bear's Track; 238
Big Eagle; 230
Big Elk; 238c
Big Sail; 238
Birds-eye view of Mandan village; 238
The Black Coat; 238c
Black Hawk; 238c
Black Rock; 238c
Blue Medicine; 238
Bloody Hand; 238
Bod-a-sin; 238
Both Sides of the River; 238
Bow and Quiver; 238c
Brave Chief; 238c
Bread; 238
Breaking down the wild horse; 238
Buffalo Bull; 238
Buffalo Bull's Back Fat; 238c
Buffalo bulls fighting in running

Girl in a boat; 231c
The head of Loch Lomond; 279
The legend; 231
Portrait; 231
St. Clair, William, of Roslin; 279

CHALON, Alfred Edward, 1780-
1860
Portrait of four sisters; 604

CHALON, John James, 1778-1854
The market and fountain of the
Innocents, Paris; 604

CHAMBERLAIN, Wynn, 1929-
Group portrait; 320
Homage to Manet; 320

CHAMBERS, Charles E.
Henry Engelhard Steinway at his
workbench; 22c

CHAMBERS, George, 1803-40
A boat in distress off a pier; 604
The Britannia entering Ports-
mouth; 121
Coast scene; 105
A Dutch boeier in a fresh breeze;
121c
On the Thames; 121
St. Michael's Mount; 195

CHAMBERS, Thomas, 1808?-66?
The Constitution and the Guer-
riere; 13, 531
The Hudson Valley at sunset; 370c
Looking north to Kingston; 410
Niagara Falls; 89c
Storm-tossed frigate; 370c, 531
Summer house in a river land-
scape; 158
Two hunters in a Hudson River
landscape; 410c
View from Mt. Holyoke; 158c
View of the Hudson River at West
Point; 410

CHAMPAIGNE, Philippe de, 1602-
74
Andilly, Arnaud d'; 40
A councilman of Paris; 553
Ex-voto; 576, 610c
Richelieu, Cardinal; 442
Richelieu, triple portrait of Car-
dinal; 591

CHAMPMARTIN, Charles Emile
Massacre of the Janissaries; 302

CHAMPNEY, Benjamin, 1817-1907
Scene in New Hampshire; 410

CHAMPNEY, James Wells, 1843-
1903
Artist sketching in a park; 267
The wedding gifts; 62

CHANDLER, Dana C., Jr., 1941-
The black worker; 107
Education is power; 107c
Stokeley and Rap: Freedom and
self-defense; 107

CHANDLER, Winthrop, 1747-90
Chandler, Samuel; 178c, 348c
Chandler, Mrs. Samuel; 178c,
348c, 370c
Devotion, Rev. Ebenezer; 178, 348
Devotion, Mrs. Ebenezer; 178, 348
Devotion, Mrs. Ebenezer, and her
daughter Eunice Devotion; 178
Devotion, Eunice Huntington, and
child; 158

CHANDOR, Douglas
Roosevelt, Franklin Delano; 122dc

CHANG CH'IU-KU
Chrysanthemums; 615
Flowering plants; 615

CHANG CHI-SU, fl. 1620-70
Snow-capped peaks; 188

CHANG DAI-CHIEN, 1899/1902-
Bamboo; 305
Cat; 325
The great Yangtze River; 305
An immortal; 325
In the manner of the Shih T'ao;
325
Landscape; 325
Lotus; 305, 325
Pines and waterfall; 325
Recluse and lonesome pine; 325
Self-portrait; 305
Tun Huang mural; 325
Waterfall; 325
Young cowherd reading; 325c
Young girl of Darjeeling; 325

CHANG FANG-JU, 14th century
Ox and herdsman; 510

CHANG HUNG, 1577-1668?
Bird, rock and camellias; 188

A summer afternoon in Holland;
435c
The Tenth Street studio; 436c,
616c
The unknown Dane; 616
Wheeler, Dora; 435c, 616
Whistler, James Abbott McNeill;
435c
The white rose; 435c

CHASSAIGNAC, Mme.
General Lejeune; 218

CHASSERIAU, Théodore, 1819-56
Ali ben Hamed, Caliph of Con-
stantine, followed by his escort;
302
Apollo and Daphne; 417
Arab horseman setting out for a
fantasia; 302c
The caliph of Constantine with
his bodyguard; 576
Chaste Susanna; 409
Esther dressing; 302c
The fisherman's wife; 335c
Harem interior; 302
Mona Lisa; 361
Negress from Algiers; 302c
The two sisters; 430

CHATELAIN, James, 1947-
Untitled; 22c

CHATELAIN, Jean Baptiste
Claude, 1710-71
Classical landscape; 105

CHATILLON, Laure de
A young adolescent; 524

CHAUDET, Jeanne Elisabeth
Gabiou, 1767-1830
Villot, Mme. (Barbier); 524
Young girl mourning the death of
her pigeon; 184

CHAUVIN
La Ruffinella near Rome; 184

CHAVEZ, Felix
Beast and development; 23c
The great mystery; 23c
Illusion; 23c

CHAVEZ MORADO, Jose, 1909-
Hidalgo the liberator; 576

CHELMONSKI, Josef, 1849-1914
On a farm; 409

CHEN, Hilo, 1942-
Beach with polka dots; 320

CH'EN CHAO, 1835?-84?
Landscape; 188

CH'EN CHIA-SUI
Landscape in the style of Ni Tsan;
188

CH'EN HSIEN, -1643
Kuan Yin; 615

CH'EN HUNG-SHOU, 1599-1652
Birds and flowers; 188
Boating on the lake; 88c
Landscape; 576
Mi Fei bowing to a rock; 615d
The mountains of the Five Catar-
acts; 337

CH'EN JUNG, 13th century
Nine dragons scroll; 263

CH'EN JU-YEN
Firewood gatherer of Mt. Lo-fou;
80
Meng-tzu and his mother; 80
The woodcutter of Mt. Lo-fou; 337

CH'EN LIN, fl. 1260-80
Duck on a river bank; 80
River landscape; 80

CH'EN SHU, fl. 1649-87
Old tree by waterfall; 188

CH'EN SHUN, 1483-1544
Chrysanthemum and pine; 188d
Landscape; 81
Peonies; 81

CH'EN TAO-FU
Loquat branches; 615

CHENAVARD, Paul, 1807-95
La Palingénésie Sociale; 373

CH'ENG CHIA-SUI, 1565-1643
Landscapes after Old Masters; 188
Pavilion in an autumn grove; 188

CHENG HSIEH, 1693-1765
Bamboo; 188
Orchids and rocks; 539

CH'ENG SHIH-FA, 1905-
Acupuncture; 325
Chaoshutun surrounded by Nannona's

Mt. Storm; 379c
Nocturne--Canadian cascades; 379
Storm over Napa Valley; 379c
View from Twining; 379c

CHRIST-JANER, Albert, 1910-73
Landforms C-15; 46
Skyforms W-39; 46c

CHRISTMAS, Edward
Wall of Dignity; 107

CHRISTO (Christo Javacheff),
1935?-
Valley curtain; 449c

CHRISTUS, Petrus, 1410-72/73
Madonna; 375
Portrait of a young man; 442
St. Eligius and the lovers; 424c,
576
St. Eligius in his shop; 205

CHRISTY, Howard C., 1873-1952
Signing of the Constitution of the
United States; 122c

CHRYSOLORAS, Spiridion, 17th
century
Baptism of Christ; 553

CHU HO-NIEN
Portrait of Tao-chi; 188

CHU TA (Pa-ta Shan-jen), 1625?-
1705?
Fish and rocks; 88, 337
Landscape; 88c, 576
Lotus; 615
Mouse and melon; 615

CHU TE-JUN, 1294-1365
Playing the ch'in beneath pines;
80

CHU TUAN, fl. 1506-22
River landscape with fishermen;
81

CHUA, Hu, 1929-
Composition II (Manila water-
front); 23
Eiffel Tower; 23c
Old church; 23c

CHUAN SHINKO, 15th century
Landscapes with figures; 372
Li Po viewing a waterfall; 510

Pu-tai; 372
T'ao Yüan-ming; 510

CHÜ CHIEH
Spring in Chiang-nan; 81

CHÜ-JAN, fl. 960-80
Asking for the Tao in autumn
mountains; 576
Buddhist retreat by stream and
mountains; 337
Hsiao I obtaining the Lan-t'ing
Preface by fraud; 615
Hsiao I trying to locate a master-
piece; 88
Road through autumn mountains;
372

CHUMLEY, John, 1928-
Above the fruited plain; 12c
Fort Colvin; 12
Garber's farm; 12
Harper's Ferry; 12c
Mill pond; 12c
Virginia farm, Ovoka; 12

CHUNG LI, fl. 1500
Scholar contemplating a waterfall;
81

CHURCH, Frederic Edwin, 1826-
1900
After twilight, color effects; 529
Alpine valley; 529c
The Andes of Ecuador; 412, 529
Apotheosis to Thomas Cole; 529
At the base of the Falls; 529
The Aurora Borealis; 13, 402
Autumn foliage: five studies; 529
Autumn foliage, Vermont; 529
Base of a capital, Dionysius The-
atre, Athens; 529
Beacon off Mt. Desert; 531
Birch trees in autumn; 529c
Blue Mountains, Jamaica; 412
Broken columns, view from the
Parthenon; 529
Campfire, Maine woods; 529
Cardamum; 412
Castle at Salzburg; 529
Century plant; 529
Chimborazo from the town of
Guaranda; 529
Chimborazo seen thru rising mists
and clouds; 529
Cliffs at Gand Manan; 529
Cloud study, above winter land-
scape; 529c

CITYWIDE MURAL PROJECT
Untitled; 167c

CLAESEN, Sir George, 1852-1944
A spring morning, Haverstock
Hill; 605

CLAESZ, Pieter, 1597/98-1661
Breakfast with ham; 341
Still life; 74c, 576
Still life: bread, fruit and glass;
608c
Still life with drinking vessels;
282
Still life with herring; 189c
Still life with oysters; 553
Still life with skull; 303

CLAESZ, Willem
Breakfast still life; 303

CLAIRIN, Georges, 1843-1919
Ouled nail women; 302
The peacocks; 302

CLARE, Oliver, fl. 1884
Still life of fruit blossom and
birds' nests; 604

CLARK, Joseph see CLARKE,
Joseph

CLARKE, John Clem, 1937-
Abstract 9; 320
Abstract 17; 320
Maids of honor; 320
Primavera; 320
Recâmier, Mme. I; 320

CLARKE, John Heaviside
Lake with sportsmen; 105

CLARKE, Joseph, 1834/35-1912/26
The laborer's welcome; 604, 605
The paddle steamer Iona with the
Comet on the Clyde; 604

CLARKE, William, 1760-1810
Wilson, Nancy Stuart, with twin
daughters; 335c

CLAUDIO, Mlle. ----
Flora; 524

CLAUS, Emile, 1849-1924
The flax field; 354

CLAUSEN, Franciska, 1899-
Vase with pipes; 236

CLAUSEN, Sir George, 1852-1944
Harvesters cutting up sheaves;
511
The shepherdess; 604
A team; 105

CLAVE, Antoni, 1913-
Still life with tablecloth; 449

CLAVEL, Marie Joseph Leon,
1850-1923
La Boresca, Venice; 553

CLAXTON, Marshall, 1811-81
The cove of Sydney; 382

CLEMENT, Marcel
The Place Vendôme; 353

CLENNELL, Luke, 1781-1840
Launching a lifeboat; 105

CLEVE, Joos van, 1495-1540
Boghe, Margaretha; 424c
Crucifixion triptych; 72c
Death of the Virgin; 576
King Francis I; 205
Nude Giaconda; 361
Portrait of a man; 553
Portrait of a woman; 553

CLEVELEY, John the Elder,
1712?-77
A ship floated out at Deptford;
121
A ship on the stocks; 121c
A view of a shipyard on the
Thames; 121

CLEVELEY, John the Younger,
1747-86
Calshot Castle from the Solent;
121
View of New York; 399

CLEVELEY, Robert, 1747-1809
The battle of St. Vincent: the
close of the action; 121

CLIFFORD, Edward, 1844-1907
Israelites gathering manna; 604

CLINCHARD, Marina P.
Pollution; 23

CLINT, Alfred, 1807-83
A view of Poole from the cliffs;
604

CLOAR, Carroll, 1918-
Abandoned railroad station; 106
Acker Drew and the wild canaries;
 106c
After rain; 106
Afternoon of a poet; 106
Alien child; 106c
The ambush; 106
The appleknocker; 106c
Arrival of the Germans in Crit-
 tenden County; 106
Aunt Rhody; 106
Autumn conversation; 106
Autumn meditation; 106
Ball players; 106
Big Fourth at Elm Springs; 106
Black levee; 106
The bobcat that came to town; 106
Boy walking across the field; 106
Brother Hinsley wrestling with
 the angel; 106
The brotherhood; 106
Burned field; 106
Burned over levee; 106
The candidate; 106
Cat sanctuary; 106
Charlie Mae and the racoon tree;
 106
Charlie Mae looking for Little
 Eddie; 106
Charlie Mae practicing for the
 baptising; 106c
Church goers; 106
Clarence; 106
Clifford in front of the seed house;
 106
Collard patch; 106
The congregation; 106
Controversy under the persimmon
 tree; 106
Cora Lee, Willie B., T. Boy,
 Beulah, Lurline Scooder and
 Starvester; 106
Cousin Mattie and her saxophone;
 106
Davis, The late Sis Pearlie Mae;
 106c
Day remembered; 106
Delta Street scene; 106
The draught of fishes; 106
Duet for French harp and mando-
 lin; 106
Easter Sunday; 106
The eclipse; 106
Empty pool; 106
End of autumn; 106
The epitaph; 106
Escape to morning; 106

Faculty and honor students, Lewis
 School; 106
Federal Compress; 106
Final resting place; 106
Fire on the levee; 106c
The garden of love; 106c
Gathering at the river; 106
The ghost; 106
Gibson Bayou anthology; 106
The gooseherder; 106c
Grandpa and the panther tree; 106
The grandparents; 106
Group of people in a woody place,
 a long time ago; 106c
Group posing for a Brownie cam-
 era; 106c
Halloween; 106
Helena Harbor; 106
Helena Hills; 106
Highway 7; 106
Historic encounter between E. H.
 Crump and W. C. Handy on
 Beale St.; 106
Hollyhocks; 106
Horses in the nursery; 106
Howe's Cash Gro; 106
Hurry sundown, let tomorrow
 come; 106
Jesus saves; 106
Joe Goodbody's ordeal; 106
Keelley, Harry, the Parkin Kid;
 106
The ladder; 106
Levee children; 106
The lightning that struck Rufo
 Barcliff; 106
Lonesome mule with love unac-
 quainted; 106
The low road; 106
Lull in the revolution; 390
McLeod, the Happy Hollow photo-
 grapher, who provides free of
 charge the most popular resort
 for outdoor and innocent amuse-
 ment in the South; 106
Mablevale representatives at the
 tournament; 106
Magic in the night; 106
Man on a mule; 106
The mistlehunters; 106
The mule herder; 106
My father was big as a tree; 106
Night horses; 106
The night they heard the heavenly
 music; 106
The night walker; 106c
Old church; 106
Old-fashioned rooster; 106

COOPER, Samuel, 1609-72
Clifford, Thomas, Lord; 434
Cromwell, Oliver; 530, 576
Lemon, Margaret; 434c
May, Hugh; 382c
Stuart, Frances, Duchess of Richmond; 382c
Unknown lady; 576

COOPER, Thomas George, fl.
1857-96
Hop picking in East Kent; 604, 605

COOPER, Thomas Sidney, 1803-1902
Near Canterbury; 604
The Victoria Jersey cow; 382

COOPER, Washington B., 1802-89
Cooper, Anne Litton; 381
Nelson, Anson; 381
Robertson, Dr. Felix; 381
White, Judge James J.; 381

COORTE, Adriaen, fl. 1683-1707
Apricots and cherries; 59c
Asparagus; 59
Asparagus and artichokes; 59c
Asparagus and red currants; 59
Asparagus, gooseberries and strawberries on a stone ledge; 59
Black currants; 59
Bowl with strawberries; 59
Bowl with strawberries, gooseberries and asparagus on a stone ledge with draped velvet cloth; 59
Breakfast piece; 59
Bunch of grapes; 59c
A bundle of asparagus; 59
Exotic birds; 59
Fruit and asparagus in a stone niche; 59
Fruit and asparagus on ledge before arched niche; 59
Fruit on a stone ledge; 59
Fruit still life with grapevine; 59
Gooseberries; 59c
Gooseberries and strawberries; 59
Hazelnuts; 59
Medlars; 59
Orange; 59
Peaches and apricots; 59
Red gooseberries; 59
Shells and flowers; 59
Still life: a bundle of asparagus; 608c

Still life with a hoopoe in front of an open niche; 59
Still life with shells; 59bc
Strawberries; 59
Strawberries in a Wan Li bowl; 59c
Three peaches; 59
Two peaches on a stone ledge; 59
Vanitas on a stone ledge before an arched niche; 59
Vanitas still life; 59

COPE, Charles West, 1811-90
The burial of Charles I; 537, 538
Cardinal Wolsey at the gate of Leicester Abbey; 382
Charles I erecting his standard at Nottingham; 537, 538
The council of the RA selecting pictures for the exhibition; 604
Embarkation of the pilgrim fathers; 537, 538
Speaker Lenthall asserting the privileges of the Commons against Charles I; 537, 538
Still life with apples and watermelons; 62

COPLEY, John Singleton, 1737-1815
Adams, Samuel; 178
Amory, Mrs. John; 178
Ascension; 475
Bourne, Mrs. Sylvanus; 399
Boy with a squirrel; 17
Boylston, Mrs. Thomas; 399
Brine, Midshipman Augustus; 283
Burt, Thaddeus; 445
Charles I demanding in the House of Commons the five impeached members; 537, 538
Colonels Hugo and Schleppengull; 194
Copley family; 39c
Daughters of Isaac Royale, Mary Macintosh and Elizabeth; 399
Death of Major Pierson; 178, 194bc, 287, 445c, 587
Death of the Earl of Chatham; 287
Devereaux, Mrs. Humphrey; 445c
Fort, Mrs. Seymour; 17
Goldthwait, Mrs. Ezekiel; 17
Grey, The offer of the Crown to Lady Jane; 537, 538
Hall, Hugh; 313c
Hancock, John; 17, 178, 399
Head of a Negro; 420
Holyoke, Rev. Edward; 287

Hubbard, Daniel; 178
Hubbard, Mary Greene; 98c, 178c
Hurd, Nathaniel; 178c
Laurens, Henry; 178c
Mann, Mrs. Joseph; 17
Mifflin, Mr. and Mrs. Thomas;
 287, 348, 399, 576c
Murray, Mrs. John; 178
The Nativity; 266
Pelham, Henry; 348
Planck, Daniel Crommelin Ver;
 399
Princess Mary, Princess Sophia,
 and Princess Amelia; 382
Quincy, Dorothy; 178
Return of Neptune; 531
Revere, Paul; 178c, 287, 348,
 430c
Self-portrait; 381, 528c, 576
The siege and relief of Gibraltar;
 194
Siege of Gibraltar; 287
The Sitwell family; 166
Skinner, Mrs. Richard; 178c, 399
The three youngest daughters of
 George III; 194
Trumbull, Jonathan and Mrs.
 Jonathan; 287
Warren, James; 178c
Warren, Mrs. James; 178c
Warren, Joseph; 178
Watson and the shark; 178, 187,
 194, 266, 291, 348c, 409, 434,
 445c, 531c, 587
Young lady with a bird and dog;
 17

COPLEY FIELDING, Anthony
 Vandyke, 1727-1855
Bridlington harbor; 121
Fishing smacks; 121
Rievaux Abbey, Yorkshire; 600c

COPPO di MARCOVALDO, fl.
 1260-74
Crucifix; 113
Madonna; 205
Madonna and Child enthroned; 522

COQUES, Gonzales, 1614-84
Anthoine, The family of Jan Bap-
 tista; 382

CORBAZ, Aloise, 1886-1964
Mysterious temple; 218c
Porteuse de rose avec Napoléon;
 218

CORBETT, Matthew Ridley, 1850-
 1902
A loving Psyche loses sight of
 love; 523c

CORBINO, Jon, 1905-64
Flood of refugees; 242
Stampeding bulls; 29

CORBOULD, Alfred, fl. 1878-
 1910
Fitzwilliam carriage horses; 604

CORBOULD, Edward Henry, 1815-
 1905
The artist's dream; 604

LE CORBUSIER (Charles E. Jean-
 neret), 1887-1965
Nature morte à la pile d'assi-
 ettes; 217
Nature morte aux nonbreuses ob-
 jets; 217
Still life; 160, 400, 576
Still with many objects; 258
Taureaux V; 449

CORCOS, Vittorio, 1859-1933
Daydreams; 96c
Dreams; 353

CORDEY, Frédéric, 1854-1911
A lane at Auvers-sur-Oise; 506

CORINTH, Lovis, 1858-1925
After the bath; 506c
After the swim; 175
Easter at the Walchensee; 503c
Emperor's Day at Hamburg; 506
Keyserling, Graf; 503
Morning sun; 175
Reclining nude; 425, 506c
Self-portrait; 210, 400
Self-portrait with skeleton; 576
View from the studio, Munich;
 506c
Walchensee panorama; 409

CORMON, Fernand, 1845-
Cain; 55

CORNE, Michael
The landing of the Pilgrims at
 Plymouth, December, 21, 1620;
 122c
The Mount Vernon meeting a Brit-
 ish squadron; 13

Woman with marguerites; 610c
Young woman weaving a wreath
of flowers; 443c

CORPORA, Antonio, 1909-
Painting; 449

CORREA, Martin
Trompe l'oeil; 40

CORREGGIO, Antonio Allegri,
1489/94-1534
Adoration of the kings; 214
Adoration of the Magi; 44
Adoration of the shepherds; 205
Agony in the garden; 214bc
Allegory of vice; 214
Allegory of virtue; 214, 382
Antiope; 567c
Ascension; 72c, 223, 567c
Assumption of the Virgin; 214, 576
Camera di S. Paolo; 214
Campori Madonna; 214
A cardinal as St. Jerome and the
saint penitent; 375
Celestial Venus; 375
Christ taking leave of his mother;
44, 214
Danaë; 214, 284c, 285c, 567cd
The dream of Antiope; 284c
Ecce homo; 214cd
Ganymede; 214, 284c
Il giorno; 214
Holy Family; 223, 382
Holy Family with St. Francis; 214
Holy night; 291
Io; 214c, 284c, 285c
Judith with the head of Holofernes;
214
Jupiter and Antiope; 176, 382
Jupiter and Io; 205, 459c
Leda; 214
Leda and the swan; 284c, 285c
Madonna adoring the Child; 214
Madonna and Child and St. John
the Baptist; 98c
Madonna and Child with Giovannino
and St. Elizabeth; 214
Madonna and Child with music
making angels; 214
Madonna and Child with St. George;
214cd
Madonna and Child with St. Joseph
and another male saint; 214
Madonna and Child with St. Joseph
and the Giovannino; 214c
Madonna and Child with Sts.
Francis, Anthony of Padua,

Catherine of Siena, and John the
Baptist; 214
Madonna and Child with Sts. John
the Baptist, Geminian, Peter
Martyr, and George; 214
Madonna and Child with Sts. Sebas-
tian, Geminian, and Roche; 214
Madonna and Child with the Gio-
vannino; 214
Madonna and Child with the Giovan-
nino, Sts. Joseph and Elizabeth;
214
La Madonna del Latte; 214
Madonna della Scala; 214
Madonna della Scodella; 214
Madonna of Casalmaggiore; 214
Madonna of Hellbrunn; 214
Madonna of St. Francis; 44
Madonna of the basket; 294c, 335c,
442
Madonna with the Magdalen and
St. Jerome; 567c
A male saint and a donor; 214
Marriage of St. Catherine; 214
The martyrdom of St. Flacidus
and St. Flavia; 576
Mercury instructing Cupid before
Venus; 214, 442c
The Nativity; 44
Nativity with St. Elizabeth and
the Giovannino; 214
Noli me tangere; 214
La notte; 214
Parma Duomo; 214
Pietà; 214
Portrait of a lady; 214
Portrait of a woman; 341c
St. Anthony Abbott; 214
St. Jerome; 214
St. Mary Magdalen; 214
St. Mary Magdalen reading; 214
Sts. Peter, Martha, Mary Mag-
dalen, and Leonard; 214
S. Giovanni Evangelista frescoes;
214
School of love; 214, 285c, 505c
The sleep of Antiope; 283c
Terrestrial Venus; 375
The veil of St. Veronica; 214
Venus, Cupid, and a satyr; 214
Virgin and Child enthroned with
St. John the Baptist, St.
Geminianus, St. Peter Martyr,
and St. George; 223
Vision of St. John the Evangelist;
205c
Young Christ; 214
La Zingarella; 214

CORRODI, Hermann David Salomon
The bridge of Galata at twilight
 with the Yeni Valide Djani
 Mosque; 302

CORTAZAR, Luis
Bank of America mural; 107d

CORTONA, Pietro da, 1596-1669
Allegory of Divine Providence;
 576c
Hagar and the angel; 556c
Virgin with a Camaldolese saint;
 553

CORWINE, Aaron Houghton, 1802-
 30
Biggs, Zaccheus; 381
Hildreth, Dr. Samuel P.; 381
James, John Hough; 381
James, Mr. and Mrs. Levi;
 381
Longworth, Mrs. Nicholas; 381
Self-portrait; 381

COSIMO, Piero di see
 PIERO DI COSIMO

COSMAS Workshop
Sts. Sava and Simeon; 455

COSS, Robert R.
Cheetah; 23c

COSSA, Francesco del, 1435-
 77/78
Griffoni polyptych; 559
St. John the Baptist; 533c
Triumph of Venus; 576

COSSIO, Felix de
Galbis, Luis; 520
Hackley, Mrs. Sherlock; 521
Maureen; 521
Portrait of a lady; 521
Suarez, Mrs. Blanca; 521
Weber, Dr. Ernst; 520

COSTA, Giovanni, 1826-1903
At the spring; 96c
Women on the beach at Anzio; 409

COSTA, Lorenzo, 1460-1535
A concert; 307
Holy Family; 553
Portrait of a lady with a dog; 382c

COSTANZI, Placido, 1688-1759
The Trinity with Sts. Gregory
 and Romuald; 553

COSWAY, Richard, 1742-1821
Princess Sophia; 382

COT, Pierre Auguste, 1837-83
The storm; 87c

COTES, Francis, 1726-70
Hoare, Sir Richard; 587
Princess Louisa and Princess
 Caroline; 382
Unknown lady; 587

COTMAN, John Joseph, 1814-78
A bagman in a country lane, Au-
 gust, 1875; 363
The gardens at Thorpe; 105
A river landscape; 363

COTMAN, John Sell, 1782-1842
After the storm; 506
Crosby Hall; 363c
Croyland Abbey; 9c, 600
The Devil's Bridge, Cardiganshire;
 607
The dismasted brig; 600c
Dolbadern Castle; 105c
The drop gate, Duncombe Park;
 600
Framlingham Earl Church; 363
From my father's house at Thorpe;
 363
Galliot off Yarmouth; 121
Greta Bridge; 409, 576
Landscape in Whittingham; 600
Llyn Ogwen; 363
The market place, Norwich; 600c
The marl pit; 600c
The Mars riding at anchor off
 Cromer; 121c
Mt. St. Catherine; 363
The Needles; 121
Postwick Grove, Norfolk; 363
Ruin and cottages, North Wales;
 9c
Shipping off shore; 363
Silver birches; 363c
Street scene in Alencon; 600c
A thatched barn with cattle by a
 pond; 363
Travelers crossing a bridge over
 an Alpine gorge; 363
Trees at Harrow; 9c
A young merchant adventurer; 363

Sunset on Lake Geneva; 180c
The trellis; 180c, 204c, 548, 553
The trout; 102, 180c, 595
Valley of the Loue with stormy
 sky; 180c
A view across the river; 281c
The village maidens; 180c
Waterfall at Conches; 180c
The wave; 73, 102, 180c
The winnowers; 180c
Woman in the waves; 180c
Woman with a parrot; 102, 180c,
 452
Wounded man; 180c
The wrestlers; 180
The young bather; 308
Young ladies from the village; 102
Young women on the banks of the
 Seine; 180c, 430c

COUSIN, Jean the Elder, 1490?-
1560
Eva Prima Pandora; 576

COUTAUD, Lucien, 1904-
Allegory with boats; 553

COUTURE, Thomas, 1815-79
Les bulles de savon; 373
Enrollment of volunteers; 576
The falconer; 553
The little bather; 341c
Little Gilles; 229
The miser; 443c
A modern courtesan; 452
L'Orgie romaine; 373
Ozy, Alice; 553
Portrait of a man; 197
Romans of the decadence; 55, 102,
 197, 409, 452
Study of a head; 45
Study of the Romans of the
 decadence; 229
Two soldiers; 443
Woman in white; 443c

COVENTRY, R. M. G.
Reflection; 231

COVERT, John, 1882-1960?
Brass band; 348c, 545
Ex act; 545
Vocalization; 472
Water babies; 545

COWEN, Lionel J.
Sweet memories; 604
Two schoolgirls; 231

COWPER, Frank Cadogan, 1877-
1958
The new learning in England; 604

COX, David, 1783-1859/60
Antwerp--morning; 600
The Brocas, Eton; 600
A windy day; 195

COX, David, Jr., 1809-85
Departure of the wagon; 105
Driving the sheep; 105c
Going to the market; 105, 600
Hay-on-Wye; 600
Lancaster Sands, low tide; 600
A street in Paris, near the Pont
 d'Arcole with the church of St.
 Gervais in the distance; 600

COX, Kenyon, 1856-1917/19
An eclogue; 176c, 308
Saint-Gaudens, Augustus; 399
Science instructing industry; 176
Tradition; 176

COYLE, Carlos Cortes, 1871-1962
Calling all Gods; 243
The transformation; 243c

COYPEL, Antoine, 1661-1722
Gallery of Aeneas; 559

COZENS, Alexander, 1717?-86
Distant view of Greenwich; 600
Landscape; 576
Landscape with a woman seated by
 a dark pool; 600
Mountain peaks; 600

COZENS, John Robert, 1752-97
The Aiguille Verte; 600c
Between Chamonix and Martigny;
 581
Lake Albano; 105
Lake Albano and Castel Gandolfo;
 434
The Lake of Albano and Castel
 Gandolfo; 294c
The Lake of Nemi, looking towards
 Genzano; 247bc, 600c
The Reichenbach between Grindel-
 wald and Oberhaslital; 600
View from Mirabella, the villa of
 Count Algarotti on the Euganean
 Hills; 247
View in the Island of Elba; 576
View on the Galleria di Sopra,
 above the Lake of Albano; 247

CRESWICK, Thomas, 1811-69
Landscape with a footbridge; 604
A summer's afternoon; 195
View in a country town; 105

CRETARA, Domenic, 1946-
Animal skull; 210

CRETE School
Crucifixion; 547c
Head of an old ascetic; 547c
Head of St. John the Baptist; 547c
Hospitality of Abraham; 547c
Prophet Elijah; 547c
St. Eleuthere; 547c
St. John the Theologian; 547c

CRIPPA, Roberta, 1912-72
Assured consistency; 449

CRISTALL, Joshua, 1768-1847
Below Cliff, Hastings; 105
Sunset with fishing boats on Loch
 Fynne, Inverary; 600c

CRITZ, Emmanuel de, -1665
Tradescant, John, and John
 Friend, brewer of Lambeth;
 587
Tradescant, John, the Younger;
 550
Tradescant, John, with a spade;
 587

CRITZ, John de
James I; 587
Wriothesley, Henry, 3d Earl of
 Southampton; 434

CRIVELLI, Carlo, 1430/35-1500
Annunciation; 9c, 576
Annunciation; with St. Emidius;
 442, 459c
Coronation of the Virgin; 576
Madonna and Child; 335, 398c
Pietà; 44, 72c, 398
St. Dominic; 398
St. George; 398
St. George and the dragon; 281c
St. Mary Magdalen; 533c
Virgin and Child enthroned, adored
 by a donor; 223c
Virgin and Child with St. Jerome
 and St. Sebastian; 442c

CROFTS, Ernest, 1847-
A cavalry charge; 604

CROME, John (Old Crome), 1768/
 69-1821
At Honingham; 208
Back of the New Mills; 208
Back of the New Mills, looking
 north; 208
Back of the New Mills, Norwich;
 409
Back river, Norwich; 208
A barge with a wounded soldier;
 208
The beaters; 208
The Bell Inn; 208
The blacksmith's shop, Hingham;
 208
The blasted oaks; 208, 600
A boatload; 208
Boulevard des Italiens; 208, 363
Bruges River--Ostend in the dis-
 tance--moonlight; 208
By the roadside; 208
Carrow Abbey; 208
A cart shed, at Melton, Norfolk;
 208
A castle in ruins, morning; 208,
 363
Catton Lane; 363
Catton Lane scene; 208
Clump of trees near Salhouse;
 208
Composition in the style of Wilson;
 208
Cottage and bridge; 208
Cottage and pigsty; 208
Cottage and sheds; 208
Cottage gable in ruins; 208
Cottage in a wood; 208
Cottage in the trees; 208
A cottage near Lakenham; 208
Cottage near Yarmouth; 208
A cottage on the Yare, 208
Cottages on the Wensum, Norwich;
 363
Cottages with a bird cage; 105
A cow; 208
The cow tower on the Swannery
 Meadow, Norwich; 208
Crome, Stephen; 208
Deepham near Hingham; 363
Dolgelly, North Wales; 208
Early dawn; 208
The edge of a common; 208
The edge of a stream; 208
Egyptian poppy and garden mole;
 363
An entrance to Earlham Park near
 Norwich; 208

201c
St. Anne and St. John; 141c
Santiago el Grande; 141
Seated girl, seen from the back;
 141
Self-portrait; 141, 201c
Self-portrait in the studio, Cada-
 qués; 141
Self-portrait with the neck of
 Raphael; 141c, 201
Sentimental colloquy; 141
Shades of night descending; 42,
 141c
The Sistine Madonna; 141
Six apparitions of Lenin on a
 piano; 141
The skull of Zurbarán; 141
Slave market with disappearing
 bust of Voltaire; 141, 201c
Sleep; 141, 201c
Soft construction with boiled beans;
 201c
Soft construction with boiled beans:
 premonition of Civil War; 87,
 141, 346
Soft self-portrait with fried bacon;
 201d
Soft self-portrait with grilled
 bacon; 141
Solitude; 201d
Spain; 141c
The specter of sex appeal; 141,
 201
Still life by the light of the moon;
 141
The sublime moment; 141
Suburbs of the paranoiac-critical
 town: afternoon on the out-
 skirts of European history; 141
Sun table; 141c
The temptation of St. Anthony;
 141c, 283c
Tristan and Isolde; 141c
The true picture of the Isle of the
 dead by Arnold Böcklin at the
 hour of the Angelus; 141
Tuna fishing; 141c, 201c
Twist in the studio of Velazquez;
 201
Two pieces of bread expressing
 the sentiment of love; 141c
Unsatisfied desires; 141c
Venus and Cupids; 141
The visage of war; 141c
The weaning of furniture-nitrition;
 141, 201
White calm; 141
Young virgin auto-sodomized by

her own chastity; 141, 201,
 331c

DALIND, G. van
The happy cottage; 243c

DALLAIRE, Jean, 1916-65
La tragédie; 234

D'ALMAINE, G., -1893
Wagstaffe, Emma; 235
Wagstaffe, Richard; 235
Wagstaffe, Mrs. Richard; 235

DALMAU, Luis, fl. 1428-60
Madonna of Councilors; 389

DALSGAARD, Christian, 1824-
 1907
Inspecting the gravestone; 354

DAM, Vu Cao, 1908-
Maternité; 390

DAMASKENOS, Michael
Baptism; 455
Eptaphios; 455
Virgin and Child; 455

DAMINI, Vincenzo, fl. 1715-40
Judith with the head of Holofernes;
 556

DAMITZ, Ernst, 1805-83
Bayard Taylor's midnight sun in
 Lapland, Norway; 89c

DAMPIER, Guy M., 1932-
Earthen pot; 23c
Kitchen flowerpiece; 23c
The inheritors; 23c
Wild dominions; 23c

DANBY, Francis, 1793-1861
Adam and Eve in Paradise; 2
Ancient lake with crescent moon;
 2
Anglers by a woodland stream; 2
An attempt to illustrate the opening
 of the sixth seal; 2
The Avon at Ashton Gate; 2
The Avon at Clifton; 2
The Avon from Durdham Down; 2
The Avon Gorge; 2
The Avon Gorge, looking towards
 Clifton; 600
The Baptism of Christ; 2
The Baptism of Clorinda; 2

Boatbuilding near Dinan; 2
A boatbuilding shed; 2
Boy fishing, Stapleton Glen; 2
Boy sailing a little boat; 2
Brydges, Sir Samuel Egerton; 2
Cader Idris; 2
Cascade in Norway; 2
Cavern interior with statue; 2
Cavern scene; 2
Children by a brook; 2
Clifton from Leigh Woods; 2
Clifton rocks from Rownham Fields; 2
Conway Castle; 2
A dark rocky lake; 2
Dark wood above a pool; 2
Dead calm--sunset, at the Bight of Exmouth; 2
The delivery of Israel out of Egypt; 2, 171
The deluge; 2, 171, 195, 409, 434, 462, 588c
Disappointed love; 2c, 195, 475
The enchanted castle--sunset; 2
The end of Lake Geneva; 2
Estuary at sunset; 2
An estuary with shipping; 2
The evening gun; 2
The Frome at Stapleton; 2
The ghost of Patroclus appearing to Achilles; 2, 462
The good Samaritan; 2
Harbor seascape; 2
Henbury cottages (Blaise Hamlet); 2
The Israelites led by the pillar of fire by night; 2
Lake among mountains; 2
Lake at sunset; 2c
Lake in Norway; 2
Lake landscape; 2
Lake scene; 2
Landscape; 2
Landscape near Clifton; 2
Landscape study; 2
Landscape: Ulysses at the court of Alcinous; 2
Landscape with crescent moon; 2
Landscape with heron; 2
Liensfiord Lake in Norway; 2
Llynydwal, North Wales; 2
The merchant of Venice; 2
A mill near Tintern; 2
Moonlight landscape with figures; 2
A mountain chieftain's funeral in olden times; 2
A mountain lake; 600c
Mountainous landscape; 2

Mountainous landscape at sunset; 2
Mountains with afterglow; 2
Norwegian lake with warriors; 2
Norwegian landscape; 2
On the Avon near Bristol; 2
Orlando at the grotto; 2
Pagan rites; 2
The painter's holiday; 2c
Path through a wood with pony rider; 2
Phoebus rising from the sea; 2
The procession of Krishna; 2
Romantic valley scene; 2
Rownham Ferry; 2
St. Michael's mount; 2
St. Vincent's rock; 2
Sark: sunset; 2
Scene from A Midsummer Night's Dream; 2c
A scene in Leigh Woods; 2c
Scenic landscape; 2
Shipwreck; 2
Shipwreck against a setting sun; 2
Shore with breakwater; 2
The Snuff Mill, Stapleton; 2
Stoke cottage; 2
A street in Tintern; 2
Study for Calypso's Grotto; 2
Study for The delivery of Israel out of Egypt; 2
Subject from Revelations; 2, 462
Sunset; 2
Sunset at Exmouth with boats; 2
Sunset over the sea; 2
Sunset through a ruined abbey; 2
Swiss Valley with mountains; 2
The Thames at Greenwich; 2
The three sisters of Phaeton weeping over the tomb of their brother; 2
Tobias and the fish; 2
Two girls by a stream in a wood; 2
Two philosophers in a wood; 2
View from Clifton Hill; 2
View from Hampstead Heath; 2
View from near Shirehampton; 2
View in County Wexford; 2
View of Hotwells, the Avon Gorge; 2
View of the Avon Gorge; 2
View over Bristol from Leigh Woods; 2
View towards the Observatory from Leigh Woods; 2
Villeneuve on Lake Geneva; 2
A waterfall; 2
Wild romantic landscape; 2

Winter--sunset: a slide; 2
The wood-nymph's hymn to the
 rising sun; 2, 604
Wooded landscape with river; 2
Wooded river with boats and
 figures; 2
A woodland pool; 2
Woodland pool with seated figure;
 2

DANCE, Nathaniel (Holland), 1735-
 1811
Northumberland, Hugh, Duke of,
 and his tutor Mr. Lippyatt; 587
The Pratt children; 587
Timon of Athens; 382

DANCE, Robert B., 1934-
Calm wash; 378
Halfway to Wilkesboro; 378
Mr. Handy's gate; 378
Handy's wheel; 378c

DANCKAERTS, Jasper
Labadist general view of New York;
 528

DANDRIDGE, Bartholomew, 1691-
 1754
The Price family; 587

DANHAUSER, Josef, 1805-45
The art critics; 114
Liszt at the grand piano; 409

DANIELL, Rev. Edward Thomas,
 1804-42
Djebel Gerbal; 105
The Ghauts at Benares; 247
Interior of convent, Mt. Sinai,
 June 19 and 21, 1841; 363
The second cataract of the Nile;
 363c
Teignmouth; 363

DANIELL, William, 1769-1837
Durham; 600
Egg-boats off Macao; 121

DANIELS, Alfred
Brighton Beach; 129c
British Road Transport Training
 School mural; 129c
The dry color factory: Winsor
 and Newton; 129c
Wapping Reach; 129

DANIELS, William, 1813-80
Children selling matches at night;

605
The goldfish bowl; 604

DANLOUX, Henri Pierre, 1753-
 1809
The deluge; 184

DANTAN, Edouard, 1848-97
Drying the nets, Villerville; 354
L'entr'acte d'une Première à la
 Comédie Française; 40
An interval at the Cómedie Fran-
 çaise; 353c

DANTON, F., Jr.
Time is money; 40, 62

DAPHNIS, Nassos, 1914-
5-69; 436c

DAPRA, Regine, 1929-
Christmas candle market; 289c

DARET, Jacques, 1404?-68?
Adoration of the Magi; 576

DARLEY, Felix, 1822-88
Bear attack; 233c

DARMESTETER, Arsène
Self-portrait; 524
Study; 524

DARWIN, Sir Robin
Castle Howard; 382

DASBURG, Andrew M., 1887-1979
Afternoon, New Mexico; 111
Angela; 111c
Apples; 111c
Avocados; 111c
Bonnie; 111
Chantet Lane; 111c
Dodge, To Mabel, No. 2; 342
Ficke, Charles Augustus; 111
Finney farm; 111
Freight train; 111
Improvisation; 111c, 342c
Improvisation to form; 111
Landscape; 111
Landscape, New Mexico; 111, 126
Monhegan Island; 111
Mozley, Loren; 111
New Mexican village; 111c
November, New Mexico; 111
Poppies; 111c
Portrait of Alfred; 111
Portrait of Cecil; 111c
Puerto Rican beach; 111

No. 6 at Sturbridge Village; 134c
Old and well used; 135
On 139 near 80; 135c
On Pease's Point Way; 135
One moment, please; 134c
Out back; 134c
Overall crock; 134c
Pantry shelf; 135
Pocusmania; 134
Pop art trompe; 134c
Race Brook barn; 134c
Red and white; 135
Red, white and orange; 134c
Ripe fruit; 135
Scoop and gourd; 135
Sheep shed; 134c
A spot of red; 135c
Strutting bird; 134
Transparencies; 135c
Umbrella stand; 135c
White eggs plus; 135c
White jug; 135c
White silo; 134c
Wild turkey on the rocks; 134
Williamsburg coffee grinder; 135
Window on Dock Street; 135

DAVIES, Thomas, 1737-1812
Niagara Falls from above; 234
A view near Point Levy opposite
 Quebec with an Indian encamp-
 ment; 235
View of bridge on the River La
 Puce; 235
View of the Great Falls on the
 Outavaius River; 234
A view of the River La Puce
 near Quebec; 235

DAVIES, William
Glen Finart, Argyllshire, Scotland;
 604

DAVIN-MIRVAULT, Césarine,
 1773-1844
Bruni, Antonio Bartolomeo; 218
Lefèvre, Marshal, Duke of
 Dantzic; 524

DAVIS, Charles H., 1856-1933
Edge of the forest, twilight; 45

DAVIS, Edward Thomas, 1833-67
Fidler; 105

DAVIS, F.
Flamingo in Barbados; 105

DAVIS, Gene, 1920-
African prince; 582
Anthracite minuet; 582
Bartleby; 582c
Big Ben; 582
Big Bertha; 582
Black and gray stripes; 582
Black flowers; 582
Black-gray beat; 582
Black jack; 582
Black watch; 582
Black Watch series; 582
Black widow; 582
Blue broadjump; 582
Blue mist; 582
Blueprint for riveters; 582
Canary tree; 582
Cannonball; 582
Chalice; 582c
Circle; 582
Color needles; 582c
Crevice; 582
Cross bar; 582
Cross hatch; 582
Curtain; 582
Diagonal reds; 582
Diagonals; 582
Diamond Jim; 582c
Drum roll; 582
Edge stripe; 582
Egg; 582
Fence; 582
Ferris wheel; 582c
Fragile blue; 582
Franklin's footpath; 582
Gate of Kiev; 582
Gothic jab; 582
Green hornet; 582d
Half hot; 582c
Half lemon; 582c
Happy seesaw; 582
Homage to Dubuffet; 582
Homage to Matisse; 582
Ice box; 582
Igloo; 582
Jabberwocky; 582c
Jack knife; 582
Jacob's ladder; 582
Janus; 582
Jasmine sidewinder; 582
Jaywalker; 582
Junkie's curtain; 582
King's bedchamber; 582
Klondike calendar; 582
Legato in red; 582
Licorice stick; 582
Mirrors with red stripe; 582

Model-T; 582
Moondog; 582c
Moroccan wedding; 582
Narcissus; 582
Night flight; 582
Open door; 582
Orchard; 582
Oxford; 582
Peach glow; 582d
Peeping Tom; 582
Peeping wall; 582c
Penny candy; 582
Penrod's perambulator; 582c
Pepper tattoo; 582c
Phantom tattoo; 582
Quiet firecracker; 582
Rain dance I; 582
Rain dance II; 582
Raspberry icicle; 582
Red and green; 582
Red devil; 582
Red frenkant; 320
Red on red; 582
Red rattle; 582
Red square; 582
Revolver; 582
Robin Hood; 582c
Royal veil; 582c
Ruler; 582
Sahara; 582
Salute; 582
Sandbox; 582
Saratoga springboard; 582c
Satan's flag; 472, 582
Satyr; 582
Scorpion; 582
Silver fox; 582
Skywagon; 582
Solar diary; 582c
Spearhead; 582
Stinger; 582
Stockade; 582
Study for Franklin's footpath; 582
Submarine; 582c
Sun god; 582
Sweet hopscotch; 582c
Tel Aviv; 582
Three columns; 582
Three needles; 582
Three witches; 582
Tilt; 582
Tom's furnace; 582
Turkish gate; 582
Wall stripes; 582
Wall stripes No. 3; 582
The water dish; 582
Wheelbarrow; 582cd
Wigwam; 582
Yellow jacket; 582

DAVIS, Henry William Banks,
 1833-1914
Toward evening in the forest; 604

DAVIS, Herndon, 1901-62
Red Hawk in Dakota Bad Lands;
 233c

DAVIS, J. N.
Monroe, Hannah; 381

DAVIS, John Scarlett, 1804-41/45
The British Institution Gallery;
 604
Rue Neuve, Notre Dame; 105

DAVIS, Joseph H., fl. 1832-37
Tuttle, Betsy; 381
Tuttle, Esther; 87c
Tuttle, James and Sarah; 267,
 348c, 381
Van Dame, Bartholomew; 381
The York family at home; 381

DAVIS, Lucien, fl. 1860-93
Fashionable gathering; 105

DAVIS, Richard Barrett, 1782-
 1854
A stable interior; 604

DAVIS, Ronald W., 1937-
Arc fan; 5c
Block frame and beam; 42
Cube III; 22c
Disk; 445c
Radial; 320
Red top; 472
Rings skew; 320
Two-thirds yellow; 388

DAVIS, Stuart, 1894-1964
Abstract vision of New York; 326
Abstraction; 326
Allée; 326
American painting; 326c
American waterfront analogical
 emblem; 326
Apples and jug; 326
Arboretum by flashbulb; 326c
Babe La Tour; 326
Bass rocks No. 1; 29
Breakfast table; 326, 342c
Bull Durham; 326
Cliché; 449
Colonial cubism; 326c, 413c
Combination concrete; 413
Composition; 326
Composition concrete; 326

Consumers coal; 326
Contranuities; 326c
Deuce; 326
Egg beater; 400, 326
Eggbeater No. 1 in tempera; 326
Eggbeater No. 2; 29, 472
Eggbeater No. 3; 326
Eggbeater No. 4; 326c
Eggbeater No. 5; 326
Eye level; 326
Famous firsts; 326
For internal use only; 326
French landscape; 326
G & W; 326
Garage lights; 326
Garden scene; 326
Gloucester wharf; 14c
Havana landscape; 326
Hillside near Gloucester; 326
Hot still-scape for six colors; 472
Hot still-scape for six colors--
 7th Ave. style; 326c
House and street; 29, 326c
International surface # 1; 430c
Iris; 267
Itklsez; 326
Landscape with garage lights;
 370c
Last painting; 326
Lawn and sky; 326
Little giant still life; 326
Lucky Strike; 472, 545
Mandolin and saw; 326
Max No. 2; 326
The mellow pad; 326c
Memo; 326
Mexican girls; 326
Midi; 283c, 326, 413c
Multiple views; 326, 413c
Municipal; 326
Municipal Broadcasting Co.
 WNYC Studio B mural; 326
New York mural; 326
New York--Paris No. 3; 326
New York under gaslight; 326,
 413c
New York waterfront; 29
October landscape; 326c
Odol; 413c
Owh! in San Paó; 3c, 326, 576c
Pad No. 1; 326
Pad No. 2; 326
Pad No. 3; 326
Pad No. 4; 326
The Paris bit; 3, 326, 472c
Percolator; 326
Pochade; 326c
Première; 326

The president; 326, 472
Radio City Music Hall men's
 lounge mural; 326
Ready to wear; 3c
Red cart; 29, 326
Report from Rockport; 326c
Rue Lippe; 326
Sail loft; 326c
Schwitzk's syntax; 326
Shapes of landscape space; 326
Something on the eight ball; 413c
Still life; 413c
Still life with 'Dial'; 326
Summer landscape; 29
Summer twilight; 22c, 313c, 390
Sunrise; 326
Super table; 326c
Swing landscape; 29c, 326, 445c
Tournos; 326
Town square; 326
Trees and El; 29
Tropes de teens; 326
Ultramarine; 326
Unfinished business; 326
Ursine park; 326
Visa; 326c, 348c
Waterfront; 29c
Waterfront forms; 326
Windshield mirror; 29

DAVIS, Vestie, 1904-
The cyclone; 243c
The Plaza; 243

DAVIS, William, 1812-73
At Hale, Lancashire; 471c
Corner of a cornfield; 604

DAVISON, Jeremiah
Mercer, Sir Lawrence, of Adie;
 279
Morton, James, 13th Earl of, and
 his family; 279

DAWANT, Albert Purre
Emigrants ready to embark, Le
 Havre; 354
The Russian emperor and his
 suite received by President
 Lorbet; 353

DAWLEY, Joseph, 1936-
Adjusting the pendulum; 137c
An American king; 136
Arm wrestlers; 136c
Boy eating grapes; 137c
Boy with a pear; 137c
Breaking bread; 137

Women on the terrace of a café;
55c, 124c
Women sitting in a café; 548

DE GREGORIO, Giuseppe, 1920-
Cold light; 553

D'EGVILLE, J. Hervé, 1806?-80
Landscape with castle; 105

DEHN, Adolf, 1895-1968
Dust storm; 242
Spring in Central Park; 14c, 29

DEHODENCQ, Edmé Alexis Alfred,
1822-82
A Jewish bride in Morocco; 302

DEKKERS, Adrian, 1938-74
First phase square to circle; 189

DE KNIGHT, Avel, 1933-
Guardian of the night; 126

DELACROIX, Eugène, 1798-1863
Abduction of Rebecca; 87c
Algerian women in their quarters;
576
Apollo; 610c
Apollo slaying the serpent python;
462
Arab saddling his horse; 341c
The barque of Dante; 197
Basket of flowers in a park; 204c
Battle of Nancy; 548
A bunch of flowers in a stone
vase; 451
Chopin; 9c
Christ in the Garden of Olives;
184
Christ on Lake Gennesaret; 479
Christ on the Cross; 442c
Columbus and his son at La
Rabida; 39c
Columbus, The return of Christ-
topher; 553
Combat between the Giaour and
the pasha; 98c
The Comte de Mornay's apart-
ment; 451
A corner of the artist's studio;
566
Dante and Virgil in the infernal
regions; 462
Death of Ophelia; 506
Death of Sardanapalus; 97, 285c,
291c, 302, 409c, 430d, 570c,
610c

Entrance of the Crusaders into
Constantinople; 187
The fanatics of Tangier; 451
Greece on the ruins of Misso-
longhi; 184
Henry IV giving the regency to
Marie de' Medicis; 548
Horseman attacked by a jaguar;
610c
Jewish wedding in Morocco; 306
Liberty at the barricades; 610c
Liberty leading the people; 87c,
184, 283c, 430d, 576c
Lion hunt; 55c, 341c, 443c
Magyar horseman; 39
Massacre at Chios; 430, 610c
Medea; 306
Mirabeau protesting to Dreux-
Brézé; 451
Moorish conversation piece; 302c
Odalisque; 452
Rose, Mlle. ; 285c
Roses and hortensias; 480
Schwiter, Baron; 442
The sea from the heights of Di-
eppe; 124, 506c
Self-portrait; 430c
Sketch for the Battle of Poitiers;
451
Spartan women practicing for war;
480
Tasso in the madhouse; 184
Vase on a console table; 506
Women of Algiers; 161, 302c,
430cd, 610c

DELAMOTTE, William Alfred,
1775-1863
Beech tree, Windsor Great Park;
105
Waterperry, Oxfordshire; 195

DELANGE, Paul
The miners' roll call; 354

DELANY, Joseph
His last address; 29

DELAROCHE, Paul H., 1797-1856
The children of Edward IV; 184
Cromwell, Oliver, contemplating
the body of Charles I; 537,
538bc
Death of Queen Elizabeth; 537, 538
Edward V and the Duke of York
in the Tower; 537, 538
Grey, Execution of Lady Jane;
537c, 538c, 409c, 442

Orpheus; 409
The treasures of Satan; 462

DEMAREST, Guillaume Albert
Back from Iceland; 354

DEMARNE, Jean Louis, 1752-1829
Hay pitchers' lunch; 184
Landscape with animals; 184

DE MARTINI, Joseph, 1896-
Quarry; 187

DEMING, Edwin, 1860-1942
Osage warrior; 233c

DEMONT-BRETON, Virginie
On the seashore; 524
Stella Maris; 524

DE MORGAN, Evelyn, 1855-1919
Flora; 471c
Hope in the prism of despair;
604

DEMUTH, Charles, 1883-1935
Acrobats; 400
After Sir Christopher Wren; 545
Aucassin and Nicolette; 545, 617c
Box of tricks; 545
Buildings abstraction, Lancaster;
445c
Business; 84
Cabaret interior--purple pup with
Carl Van Vechten; 313c
Church in Province town, No. 2;
16c
The circus; 16, 267c, 617c
Columbia; 617c
Corn and peaches; 16
Cucumbers and white daisies; 313c
Daisies; 62
Daisies and tomatoes; 16c
Distinguished air; 16
The drinkers; 617c
Eggplant and pears; 210
Eggplant and squash; 62
Eggplant and summer squash; 267c
Eggplant and tomatoes; 16, 400
Figures on the beach; 16
Flowers; 16c, 617c
Flora and the governess, from
The Turn of the Screw; 528
Fruit and sunflowers; 16
Green pears; 97
I saw the figure 5 in gold; 348c,
545
Incense of the new church; 472,

617c
Iris; 528
Kiss me over the fence; 16
Landscape, Bermuda; 492c
Lily; 267
Machinery; 472, 545
Modern conveniences; 617c
My Egypt; 3c, 472c, 545, 576
The nut, pre-Volstead days; 617c
Old houses; 528
On stage; 313c
Paquebot Paris; 481, 617c
Pink dress; 16
Poppies; 267
Red and yellow gladioli; 62
Roofs and steeples; 267c
Rooftops and steeples; 16c
Still life No. 1; 16, 617c
Still life: apples and bananas;
528c
Sunflowers; 16c
Three pears; 16c
The tower; 617c
Trees and barns, Bermuda; 472

DENBY, Jillian
Figure caprice 1; 320
Two figures; 320
Vagrant; 320

DENEEN, J. B.
The Great Northern; 209c
Spokane, Seattle and Portland; 209c

DENES, Agnes, 1938-
Introspection III aesthetics; 320
Introspection III aesthetics Picasso;
320

DENIS, Maurice, 1870-1943
April; 163c, 513c
Breton pardon; 513
Cézanne "on the motif"; 480
Danse d'Alcoste; 161
Female figures in a spring; 341c
The flying Eros is struck by the
beauty of Psyche; 341
Homage to Cezanne; 162d, 513, 566
Maternité à la fenêtre; 513
The muses; 100c, 513c
The orchard of the wise virgins;
462
Ranson, Mme. Paul; 513
A visit to Cezanne at Aix; 566

DENNIS, James B., 1778-1885
The battle of Queenston Heights;
235

DESIDERIO, Monsù, 17th century
An explosion in a church; 588c

DES JARLAIT, Patrick, 1921-73
Maple sugar time; 415c

DESMARQUÊTS, Pauline
Marie-Louise takes leave of her
 family; 218

DESORIA
Dunoyer, Elisabeth; 184

DESORMEAUX, Odile
New York; 23c
Regates; 23

DESPORTES, Alexandre François,
 1661-1743
A dish of peaches; 610c
A dog with flowers and dead
 game; 204c, 576
Still life; 352

DESSAR, Louis Paul, 1867-1952
A load of brush; 45
Return to the fold; 45

DETAILLE, Jean Baptiste Edou-
 ard, 1848-1912
The dream; 409
The Prince of Wales and the Duke
 of Connaught; 353
Victims of duty; 354

DEUTSCH, Ludwig
The Nubian guard; 570c
Outside a Moorish coffee shop;
 570c
Outside the palace; 570c
Procession of the Mahmod in
 Cairo; 302c

DEUTSCH, Niklaus M., 1454-1530
Beheading of St. John the Bap-
 tist; 143c, 570
Death as a warrior embracing a
 young woman; 143
Judgment of Paris; 143c, 284c
Pyramus and Thisbe; 143c, 567c
St. Luke painting the Virgin;
 143c

DEVERELL, Walter H., 1827-54
A pet; 232
Twelfth night; 195, 232, 604

DEVERIA, Eugene F., 1805-65
Birth of Henri IV; 409
Young women asleep; 184

DEVIS, Anthony, 1729-1817
Throstle's nest with Manchester in
 the distance; 247
Atherton, William, and his wife
 Lucy; 166, 194, 307, 434, 576
Bull, Mr. and Mrs., of North-
 court; 166
Clavey, Charles, with his wife,
 three children, and brother-in-
 law; 166
A family of anglers: the Swaine
 family of Laverington Hall, in
 the Isle of Ely; 166
Harthals, Mr. and Mrs. Van, and
 their son; 166
An incident in the grounds of Rane-
 lagh during a bal masqué; 166
James family; 583c
Moreton, Richard, Esq., of
 Tackley; 166
Orlebar, Mr.; 166
The Rookes-Leeds family; 194cd
Sergison, One of the, family of
 Cuckfield; 166
Strickland, Sir George and Lady,
 in the grounds of Boynton Hall,
 Bridlington; 240
Two little Miss Edgars; 166
Unknown young man; 587
Walpole, Horace, presenting Kitty
 Clive with a piece of honey-
 suckle; 166
Warden, Miss Mary; 166
Warden, Miss Sarah; 166

DE VITO, Teresa M., 1920-
Thinking; 23

DEVOS, Léon, 1897-
Susanna at the bath; 553

DEWASNE, Jean, 1921-
Don Juan; 438c

DEWING, Thomas Wilmer, 1851-
 1938
The days; 176
A lady in yellow; 281c
La pêche; 131
The piano; 131
The recitation; 131
Summer; 131
The white birch; 402
Woman; 528

DE WINT, Peter, 1784-1849
Eton, twilight; 600
Head of a cow; 105
Landscape with harvesters and a
 stormcloud; 600c
Still life with a ginger jar and
 mushrooms; 600c
Travelers resting outside an inn;
 600c
Westminster Palace, Hall and
 Abbey; 600

DE WITT, Richard V.
The Clermont; 122c

DEY, John
Adam and Eve leave Eden; 243c

DHANRAJ---- 16th century
Babur visiting the palace of Jalal
 Khan near Agra; 71

DHURMER, Lucien Levy
 see LEVY-DHURMER,
 Lucien

DIAZ de la PEÑA, Narcisse V.,
 1807-76
Bohemians going to a fête; 443c
The courtesans; 45
Deep woods; 553
Edge of the wood; 553
Fontainebleau; 553
Forest of Fontainebleau; 553
Gypsies going to a fair; 45
Harem scene; 302
In a Turkish garden; 443c
Jean de Paris Hill, Forest of
 Fontainebleau; 409
Landscape on the edge of the
 Forest of Fontainebleau; 506c
Landscape with pond; 506c
A road in the forest; 341c
Storm in the forest of Fontaine-
 bleau; 576
Turkish assembly; 302
Wood interior; 443c
Woodland scene near Fontaine-
 bleau; 553

DIBBETS, Jan, 1941-
Dutch mountain; 449c
Dutch mountain and sea; 189
The shortest day; 189

DICK, Cecil
Deer hunt; 253c

DICKINSON, Edwin A. , 1891-1978
Composition with still life; 576
The fossil hunter; 472
Shiloh; 22c
Stranded brig; 402
Woodland scene; 131

DICKINSON, John Reed, fl. 1867-
 81
Foreshore; 105

DICKINSON, Preston, 1891-1930
Hillside; 267
Hospitality; 62
Industry II; 472
Plums on a plate; 400
Still life, flowers; 62
Still life with bottle; 62

DICKINSON, Sidney, 1890-
Wilson, Woodrow; 399

DICKSEE, Sir Frank, 1853-1928
Funeral of a Viking; 195
Hillingdon, Lady; 604

DICKSEE, Margaret Isabel, 1858-
 1903
The child Handel; 524
In memoriam; 524

DIEBENKORN, Richard, 1922-
Albuquerque; 146
Berkeley; 146
Berkeley, No. 2; 146c, 449
Berkeley, No. 6; 146
Berkeley, No. 7; 146
Berkeley, No. 23; 146c
Berkeley, No. 32; 146c
Berkeley, No. 37; 436c
Berkeley, No. 54; 146c
Black table; 146
Cane chair outside; 146
A day at the race; 146
Figure on porch; 146c
Girl and three coffee cups; 146
Girl looking at landscape; 146
Girl with flowered background;
 146c
Interior with view of the ocean;
 210
Kitchen interior with door and
 sink; 187
Ocean Park No. 14; 146c
Ocean Park No. 16; 146c
Ocean Park No. 19; 283
Ocean Park No. 21; 146c
Ocean Park No. 27; 146c

Ocean Park No. 28; 146c
Ocean Park No. 29; 146c
Ocean Park No. 30; 146c, 573
Ocean Park No. 31; 22c, 573
Ocean Park No. 34; 46, 573
Ocean Park No. 36; 5c
Ocean Park No. 37; 146c
Ocean Park No. 38; 146c
Ocean Park No. 39; 573c
Ocean Park No. 43; 146c
Ocean Park No. 44; 146c
Ocean Park No. 46; 146c
Ocean Park No. 49; 146c
Ocean Park No. 52; 146c
Ocean Park No. 54; 146c
Ocean Park No. 60; 445c
Ocean Park No. 61; 146c
Ocean Park No. 64; 146c
Ocean Park No. 67; 449
Ocean Park No. 83; 146c
Ocean Park No. 85; 146c
Ocean Park No. 86; 146c
Ocean Park No. 87; 146c
Ocean Park No. 88; 146c
Ocean Park No. 91; 146c
Ocean Park No. 92; 146c
Ocean Park No. 94; 146c
Ocean Park No. 102; 5c
Scissors; 146
Seated nude; 64
Seawall; 146
Still life with book; 146
Urbana No. 3; 146
View from the porch; 146
Woman by a window; 146
Woman wearing a flower; 146c
Woman with newspaper; 576c

DIECKMANN, Henry, 1933-
The lighthouse; 289c

DIEDEREN, Jef, 1920-
Summer; 553

DIEMUDIS----
Initial S; 218

DIEPRAAM, Arent, 1622?-70?
Interior of a tavern: boor smoking
 and drinking; 608c

DIETRICH, Adolf, 1877-1957
Girl with striped apron; 89c
Paysage près de Steckborn; 328c
Self-portrait; 289c

DIETZSCH, Barbara Regina, 1706-
83
Flowers; 218

DIEZ, Wilhelm von, 1839-1907
Ambush; 409
Cavalier with horse; 51
Highwaymen; 51c
Soldiers at rest; 51

DIGHTON, Denis, 1792-1827
Battle of Waterloo: general ad-
 vance of the British lines; 382
Between Houghemont and La Belle
 Alliance; 105

DIJCK, Floris van
Breakfast still life; 303

DIKE, Philip L., 1906-
Harbor configurations; 47c

DILL, Laddie John, 1943-
Untitled; 5c, 22c

DILLER, Burgoyne, 1906-65
First theme; 445c, 472

DILLIS, Johann George von, 1759-
1841
Grotto Ferrata near Rome; 175
Prater Island with view of the
 Gasteig Infirmary; 494c
Triva Castle; 175
View of St. Peter's from the Villa
 Malta in Rome; 175
View of the Quirinal; 409

DINE, Jim, 1935-
Cardinal; 445c
Double isometric self-portrait;
 42c, 348c
My Long Island studio; 11
Self-portrait next to a colored
 window; 449
Twenty hearts; 528c
Walking dream with a four foot
 clamp; 576

DINET, Alphonse Etienne
Moonlight at Lanhouet; 302

DINNERSTEIN, Harvey, 1928-
Burning shack, Washington, D. C.;
 150c
Campo dei Fiori; 150c
Clinton Square, Newburgh; 150c
Confrontation at Fort Dix; 150
Early evening, Rome; 150
Entering Campo dei Fiori; 150c
Fillin, Walter; 150
The flutist; 150
Frank; 150c

G. I. Self-portrait; 150c
Garlic lady; 150c
The gift; 150c
Glass of tea; 150
Green reflectors; 150
Hunger's Wall, Ressurection City;
150c
In the kitchen; 150c
Ladino song; 150c
Linda; 150c
Lois; 150
Lois and Rachel; 150c
Main Street movie; 150c
Meltzer, Mr.; 150
Mercedes; 150c
Michael S; 150c
Michelene; 150c
Mid summer; 150
New Paltz; 150
Nude; 150
Nursing; 150
Osage orange; 150c
Parade; 150bc
The passage; 150c
Pregnant woman; 150c
Prospect Park, Brooklyn; 150
Roman workers; 150c
Sarah; 150c
Self-portrait with Mr. Meltzer;
150c
Shaka; 150c
Spring; 150
Stay amazed; 150c
The studio; 150c
Terrorists; 150c
Traveling; 150
Vigil; 150c
White rat; 150c
Winter; 150

DIOGG, Felix Maria, 1762-1834
The Esslinger family making mu-
sic; 143

DIONYSY---- 1440?-1508?
Christ in glory; 455
Virgin Hodegetria; 455

DIONYSY of GLUSHYTAK
St. Cyril of Belo-ozero; 455

D'ISA, Mary Kay
A brush with winter; 492

DISMORR, Jessica, 1885-1939
Head of a young girl; 511

DI STEFANO, Domenic
Up for repairs; 492

DITEMAN, Hall, 1925-
Autumn in the Tetons; 12c
For purple mountain majesties;
12c
Lingering winter; 12
Lupine time; 12
Spring run-off; 12
Winterset; 12c

DIX, Otto, 1891-1969
The artist's parents; 242
The Hall of Mirrors in Brussels;
283c
Harden, Sylvia von; 203c
Herman, Dr. Mayer; 576
Lange, Frau; 449
Mayer-Hermann, Wilhelm; 400
My parents; 203c

DIXON, Alfred
Forsaken; 604

DIXON, J. F.
The ships off Cape Cod; 243c

DIXON, Maynard, 1875-1946
The ancients; 77
The Apache; 77c
Apache scouts; 77
Apaches; 77
Autumn evening; 77
Beef herd; 77c
Blind Hopi; 77c
Carson, Kit, mural; 77
The cattleman; 77c
Christmas Eve procession; 77c
Cloud world; 77c, 402
Clouds; 77
Corral dust; 77
Descent into Dayton; 77
Desert--southwest; 457
Destination nowhere; 77
Destination unknown; 77
Drought and downpour; 77
Earth knower; 77c
Empty house; 77c
Flathead tepees; 77
Forgotten man; 77c
Fortification Butte; 77c
Free speech; 77c
Fremont's entrance into California;
77
Glacier Park, Mont.; 77
The golden range; 77c
The grim wall; 77c
Hand of God; 77
High in the morning; 77c
Home of the desert rat; 77
Homestead farm; 77

DOUGLAS, Sir William Fettes,
1822-91
The alchemist; 604
On the housetop: Rome; 279
The recusant's concealment dis-
covered; 231
Three children; 279

DOUKE, Daniel, 1943-
Imperial Beach wizard; 320
Makaha Prince; 320

DOVA, Gianni, 1925-
Explosion; 576
Painting; 449

DOVE, Arthur G., 1880-1946
Abstraction; 342
Buildings; 16
Centerport; 16c
Centerport IV; 16
Centerport, May 30th; 16
Centerport, July 10th; 16
Centerport, July 25; 16
Centerport series No. 21; 16c
Cow; 16
Cows in pasture; 617c
A cross in the tree; 126
Dusenberry, Ralph; 472
Ferry boat wreck; 617c
Ferryboat wreck--Oyster Bay; 13
Field of grain seen from train;
16c, 617c
Fog horns; 131, 418, 617c
The hand sewing machine; 267
High noon; 472c, 617c
Holbrook's Bridge, northwest;
402, 445c
House and tree; 16
Long Island; 16c
Moon; 475
Movement, No. 1; 528, 617c
Nature symbolized; 617c
Nature symbolized No. 2; 472
Northport harbor; 16c
Oil drums; 617c
Pagan philosophy; 84
Partly cloudy; 16c
Plant forms; 617c
Rise of the full moon; 449
Sand barge; 348c, 617c
Sunrise III; 402
Switch engine; 16
Thunderstorm; 617c
Tree; 22c, 528c
Tree forms; 436c
Waterfall; 617c
White building; 16
Willows; 402

DOWLING, Robert
Ethan Allen's capture of Fort
Ticonderoga on May 10, 1775;
122c

DOWNARD, Ebenezer Newman,
19th century
Mountain path at Capel Curig,
Wales; 604

DOWNMAN, John, 1750-1824
Edward IV on a visit to the Duch-
ess of Bedford is enamoured of
Lady Elizabeth Grey; 537, 538
Jackson, William; 240
Seymour-Conway, Francis Charles;
576

DOYLE, Charles A., 1832-93
The fairy's lecture; 384

DOYLE, Richard, 1824-83
The fairy tree; 604

DRAHONET, A. J. Dubois
Sergeant Major, 7th Hussars;
Colonel and private 10th Hus-
sars; 382

DRAKE, Doris
Ozark mountain mist; 23

DRAKE, John Poad, 1794-1883
View of Halifax harbor; 234

DRAPER, Herbert James, 1864-
1920
The lament for Icarus; 604
Ulysses and the sirens; 523c

DRAPER, William F., 1012
Amory, Mrs. Harcourt; 521
Belmont, Mrs. August, Jr.; 521c
Bordley, John, M. D.; 520
Cooke, Terence, Cardinal; 520
Draper, Francesca; 521
Eric; 520
Goldberg, Sanda; 521
Hart, Mrs. John; 521
Kennedy, President John F.; 520
Meyner, Governor Robert; 520
Rathbone, Perry T.; 520c
Shah of Iran; 520c

DREBER, Heinrich (Franz-Dreber),
1822-75
Sappho; 175

Tribout, Dr. ; 147
Two nudes; 8c, 495c
Virgin No. 2; 8c
Young man and girl in spring; 8c,
495c
Yvonne and Magdeleine in tatters;
8c, 495c
Yvonne et Magdeleine dechiquetées;
525

DUCHAMP, Suzanne, 1889-
Masterpiece: accordion; 84
One and one menaced; 84

DUCKER, Robert W.
Afternoon; 492

DUDREVILLE, Leonardo, 1885-
Everyday domestic quarrel; 18

DÜNZ, Johannes, 1645-1736
Ott, Elisabeth; 143c

DÜRER, Albrecht, 1471-1528
Adam; 285c
Adoration of the Magi; 567c
Adoration of the Trinity; 567c
Alpine landscape; 317c, 567c
Alpine road; 317c
Castle courtyard, Innsbruck; 294c
Castle courtyard with clouds;
317c
Castle courtyard without clouds;
317c
The castle of Trent; 317c
Cemetery of St. John's Church,
Nuremberg; 317c
Covered bridge at Nuremberg;
317c
The Doss' Trent; 317c
Eve; 285c, 505c
Four Apostles; 75, 205, 567c
The great piece of turf; 9c
Hare; 9c
House on an island in a pond;
317c
An iris; 204c
Jabach altarpiece; 559
Kleberger, Johannes; 583c
Lamentation over the dead Christ;
72c
Large grass study; 273c
A large piece of turf; 272
Lime tree on a bastion; 317c
Madonna of the iris; 307, 335c
A man in a fur coat; 281c
Mills on a river bank; 317c
The painter's father; 442

Pine tree; 317c
Pond in the woods; 317c
Portrait of a man; 382
Portrait of a young man; 567c
Portrait of the artist; 382
Quarry; 317c
Ruined alpine hut; 317c
Ruined castle on a rock; 317c
Segonzano Castle; 317c
Self-portrait; 283c, 291, 567c,
576c, 583c
Steinbruch; 210
Three line trees; 317c
Tree in a quarry; 317c
Trees in a mountain landscape;
317c
Valley near Kalchreuth; 317c
View of Arco; 317c
View of Innsbruck; 317c
View of Nuremberg from the
West; 317c
View of Trent; 205, 317c
Village of Kalchreuth; 317c
Waterwheel in the mountains; 317c
A weierhaus; 576c
Wing of a blue roller; 164
Wire-drawing mill; 317c
A young hare; 272, 273

DUEZ, Ernest A. , 1843-
Wet nurses feeding the sickly in-
fants at the maternity hospital;
354

DUFAU, Mlle. ----
Character in Spain; 524
Impression of a city; 524
Study from a model; 524

DUFFAUT, Prefete, 1923-
Town by the sea; 19

DUFFIELD, William, 1816-63
A still life of fruit with a cocka-
too; 604

DUFFIELD, Mrs. William (Mary
Elizabeth)
Yellow roses; 524

DUFRESNE, Charles, 1876-1938
The Spahi; 576

DUFRESNE, Hilaire L.
Lucas Valley view; 167c

DUFUFE, Claude Marie
Portrait of a man; 553

The Narrows, Lake George; 410
Winter landscape: gathering
 wood; 576
Winter scene; 410

DUSART, Cornelis, 1660-1704
Kermesse; 537, 538d

DU TANT, Charles, 1908-47
Snow mountains; 233cd

DUVENECK, Frank, 1848-1919
Adams, William; 616
The blacksmith; 616
Clark, Major D. H.; 520
Currier, J. Frank; 616
Dock sheds at low tide; 13
Girl with a book; 176
Girl with straw hat; 616
Head of an old man; 176
Löefftz, Professor Ludwig; 63,
 616c
Mills, Mr.; 520
Nude standing; 616
The old professor; 616c
Old town brook, Polling, Bavaria;
 409
Ophelia; 402
Portrait of a woman with a black
 hat; 528
Self-portrait; 616
Still life with watermelon; 62
The Turkish page; 302, 616
Wheelwright, Mary Cabot; 348
Whistling boy; 616c

DUVIVIER, Aimée, 18th century
Portrait of a young pupil of David;
 218c

DUYCKINCK, Gerrit
Duyckinck, Mrs. Gerrit; 576

DUYCKINCK, Gerardus I
Hallett, Joseph; 531

DUYSTER, Willem Cornelisz,
 1598-1635
Interior with a man and a woman
 playing tric trac and three
 other men; 608c
Soldiers fighting over booty in a
 barn; 282, 576

DYCE, William, 1806-64
Baptism of Ethelbert; 279
Christabel; 405
Gethsemane; 231

Herbert, George, at Bremerton;
 232, 471c, 537, 538
Jacob and Rachel; 434
Joash shooting the arrow of deli-
 verance; 279
Madonna and Child; 232, 279, 335,
 382
Man of Sorrows; 279
Neptune resigning to Britannia the
 empire of the sea; 279
Pegwell Bay; 307, 412, 604
Pegwell Bay: a recollection of
 October 5th, 1848; 231, 434,
 471c
A scene in Arran; 231
Titian's first essay in color; 409
Virgin and Child; 405
Woman of Samaria; 195

DYCK, Anthony van, 1599-1641
Castlehaven, Lady; 587
Cattaneo, Clelia, daughter of
 Marchesa Elena Grimaldi; 39c
Chaloner, St. Thomas; 341
Charles I in robes of state; 587
Charles I in three positions;
 382c, 434c, 587
Charles I of England; 41, 434c,
 537, 538, 576, 583c
Charles I of England and Henrietta
 of France; 576c
Charles I on horseback; 587
Charles I on horseback with M.
 St. Antoine; 382
The children of Charles I; 537,
 538
Christ; 559
Christ arrested; 72c
Christ falling under the Cross; 41
The continence of Scipio; 434
Cupid and Psyche; 157c, 302c
Denbigh, First Earl of; 587
Drunken Silenus; 284c
Emperor Theodosius forbidden
 entry to Milan Cathedral; 442
Equestrian portrait of Charles I;
 282, 424c, 442c, 591
Family group; 341c
The five eldest Children of Charles
 I; 382
Geest, Cornelis van der; 41, 210,
 583c
Hammer, Sir Thomas; 434
Hertford, Frances, Marchioness
 of; 587
Killigrew, Thomas, and William,
 Lord Crofts; 382, 587
A lady with a rose; 281c

and Lady Charlotte; 105
A farm near Bushey; 600

EDSON, Allan, 1846-88
Trout stream in the forest; 234

EDWARD, Anthony
Holy Family; 48c

EDWARDS, Genevieve D.
Carmel Mission; 23c
Portrait; 23

EECKHOUT, Gerbrand van den,
1621-74
Four officers of the Amsterdam
Coopers' and Winepackers'
Guild; 282
The infant Samuel brought by
Hannah to Eli; 608c
The magnanimity of Scipio; 553
Virgin and nursing Child; 323

EGEDIUS, Halfdan, 1877-99
The dreamer; 513

EGG, Augustus L., 1816-63
Beatrice knighting Esmond; 576
Cromwell before Naseby; 537, 538
Maintenon, Mme. de and Scarron;
384
Past and present I; 434c, 451, 605
Past and present II; 434, 605
Past and present III; 434, 605
Queen Elizabeth discovers she is
no longer young; 537, 538
Traveling companions; 409, 604,
605

EGGER-LIENZ, Albin, 1868-1926
The cross; 114c

EGLEY, William Maw, 1826/27-
1916
Hullo largess! a harvest scene in
Norfolk; 605
Military aspirations; 605d
Omnibus life in London; 604, 605

EHMSEN, Heinrich
The execution; 341

EHNINGER, John Whetton, 1827-89
October; 257
Turkey shoot; 257
Yankee peddlar; 257, 399

EICHHOLTZ, Jacob, 1776-1842
Biddle, Nicholas; 381
An incident of the Revolution; 266

EIELSON, Jorge
Requiem; 320

EILSHEMIUS, Louis Michel, 1864-
1941
Afternoon rest; 308
Afternoon wind; 308c
Alone with nature; 308
American tragedy: revenge; 308c
Apia, Samoa; 308c
Approaching storm; 308c
Autumn evening, Park Ave., New
York; 308c
Banks of the Hudson at Newburgh;
308
The bathers; 308
Beach at Apia, Samoa; 308c
Biskra; 308c
Biskra, Africa; 308
Blond nude in a forest glade; 308
Boat in inlet; 308
Bridge for fishing; 308
Brittany peasant woman; 308
Cabs for hire; 308c
Canal; 308
Central Park West; 308
Chief's daughter, Samoa; 308
Children on the beach; 308
Christ intervening the dragon of
war; 308
Clearing after storm; 308
Coney Island; 308
The concert singer; 308
Cos Cob; 308
The cove; 308
Croquet, Delaware Water Gap; 308
Dance of Salome; 308c
Dance of the sylphs; 308
Dancing in the sunlight; 308
Dark clouds; 308
Delaware Water Gap; 308
Delaware Water Gap village; 308c
Del Mar, Cal.; 308
The demon of the rocks; 308
Despondent; 308
Diana and the hunt; 308
The dream; 308c
Dream landscape; 308
Dreaming of temptation; 308c
Dressing; 308
Duck shooting; 308
Dunes near East Hampton; 308
Early American story; 308c
East Side, New York; 308c

Two girls by a stream; 308
Two nudes; 308
Village near Delaware Water Gap;
 308c
War; 308
The white horse; 308
Winter; 308
Woman standing by a fence; 308
Women washing clothes, Lake
 Geneva; 308c
Yellow landscape; 308
Yuma, Ariz.; 308
Zeppelin in flames over New Jer-
 sey; 308

EISMANN----
Landscape and ruins; 118

EITOKU, 1543-90
Lion dogs; 576

EKEKIAS, fl. 530 B.C.
Achilles killing Penthesilea; 291

EKELS, Jan
The writer; 189

EKIN----
Scene from Kabuki drama Sendai
 Hagi; 278

ELDER, Edward C.
An Edwardian table; 235c

ELIASON, Birdell
Cascade Mountain cabin; 23c
The old hay rake; 23c
Water jars; 23c
Wine and cheese; 23c

ELK, Ger van
The reality of Morandi; 189

ELKINS, Henry, 1847-84
After the storm; 233c

ELLENRIEDER, Maria, 1791-1863
Baptism of Lydia; 236
St. Felicitas and her seven sons;
 218

ELLICOMBE, Sir Charles Grene,
 1783-1871
Farring spire; 105

ELLIOT, Richard
Bonhomme Richard and the Serapis;
 122c

ELLIOTT, Charles Loring, 1812-
 68
Brady, Matthew B.; 399
Goulding, Mrs. Thomas; 399
Mount, William Sidney; 182c

ELLIOTT, James A.
Force Nine; 492
Winter seas; 492

ELLIOTT, Robinson, 1814-94
Strokes of genius; 604

ELLIS, Edwin, 1841-95
Fishermen with their catch on the
 shore; 604

ELLIS, Fremont, 1897-
Ghost ranch country; 233c

ELLISON, Maurice
Campus life: turmoil of the 60's;
 48c
Ritual; 48

ELLSWORTH, Clarence, 1885-1961
Black track; 233c

ELLSWORTH, James S., 1802-73/
 74
Allis, Hannah Hall; 385
Allis, John; 385
Atkins, Edwin Augustin; 385
Atkins, Elisha; 385
Atkins, Henry Austin; 385
Atkins, Martha Elmina; 385
Atkins, Temperance Claghorn; 385
Avery, William Herrick; 385
Baker, Ella; 385
Baker, Elliott; 385
Bartholf, John L.; 385
Bartholf, Susannah Storms; 385
Bascom, Grandfather; 385
Bascom, Grandmother; 385
Bassett, Eliza; 385
Beach, Alfred; 385
Beers, Middle-aged Deacon, of
 Williamstown, Mass.; 385
Beers, Middle-aged Mrs.; 385
Bidwell, Adonijah; 385
Bidwell, Barnabas; 385
Bidwell, Betsey Curtiss; 385
Bill, Avery; 385
Bill, Betsy Barnes; 385
Bottum, Margaret Douglas; 385
Bottum, Simon; 385
Boy; 385
Bradford, Mary Ford; 385

ENDE, Edgar, 1901-65
Explanation in Apocalypsam; 218

ENGELBRECHTSZ, Cornelius,
1468-1533
Crucifixion; 576
Lamentation; 189, 205

ENGELEN, Louis van, 1856-
The Belgian emigrants; 354

ENGLISH, Marie R.
Bouquet of love; 23c

EN'I, late 13th century
Ippen hijiri emaki; 278cd

ENICHI-BO-JONIN, 13th century
Myoe; 576
Myo-e shonin meditating; 372d

ENNEKING, John Joseph, 1841-
1916
Pond in winter twilight; 45

ENNULAT, Minna, 1901-
Noah's ark; 289c

ENSOR, James, 1860-1949
After the storm; 170c
Afternoon at Ostend; 292c
Angry masks; 292c
The antiquarian; 170c
The artist's mother in death; 170c
The astonishment of the mask
Wouze; 292c
At the conservatory; 170c
Attributes of the studio; 170c, 292c
The breakwater; 170c
Christ calming the storm; 292c,
462
Christ in agony; 292c
Christ tormented by demons; 170c
Christ's entry into Brussels; 409
The consoling Virgin; 100c, 170c
A cross face; 292c
The curious masks; 462c
Demolder, Eugène; 292c
Demolder, Mlle., in bullfighter's
apparel; 292c
Demons teasing me; 170c
The drunkards; 170c, 292c
Ensor and General Léman discuss
painting; 292c
The entry of Christ into Brussels;
170c, 250d, 292c, 430c, 462,
503cd
Finch, Willy; 170, 292c

Finding of Moses; 170c
Fireworks; 170c
Flowers in the sunlight; 170c
Garden of love; 292c
The gendarmes; 170c
Girl with doll; 170c, 292c, 449c
The good judges; 170c
Grotesque singers; 292c
The intrigue; 292c
Judith and Holofernes; 170c
The lamp boy; 292c
Man of Sorrows; 170c
Masks and death; 170c, 283c, 292c
Masks fighting for the body of a
hanged man; 292c
My portrait surrounded by masks;
462
Nymphs in movement; 292c
Old woman with masks; 576
Our two portraits; 292c
Pierrot and skeleton in yellow robe;
170c
Portrait of old woman with masks;
170c, 292c
Portrait of the artist's father;
292c
Portrait of the artist's mother;
292c
Portrait of the artist's niece in
Chinese costume; 170c
The rebel angels struck down; 292c
Red apples and white bowl; 292c
Remorse of the Corsican ogre;
292c
The roofs of Ostend; 292c
The rower; 170c, 292c
Russian music; 170c, 292c
Scandalized masks; 170c
Self-portrait; 170c
Self-portrait in a flowered hat;
170c, 292c
Ship with yellow sail; 170c
The skeleton painter; 462
Skeleton painter in his atelier; 170c
Skeletons fighting for the body of a
hanged man; 100c, 170c
Sketch for Bourgeois salon; 170c
The somber lady; 292c
Still life; 170c
Still life with blue bottle; 170c
Still life with blue jug; 203c
Still life with blue pitcher; 170c,
292c
Still life with fish and shells; 170c
Still life with flowers and butter-
flies; 170c
Still life with peaches; 292c
Still life with ray; 170c, 292c

Strange masks; 203c
The strike in Ostend; 170c
Temptation of St. Anthony; 436c
The terrible musicians; 462
Tower of Lisseweghe; 170c, 292c
Tribulations of St. Anthony; 170c,
 292c, 462
Vase of flowers; 170c, 292c
Vlaanderenstraat in the snow;
 170c, 292c
Woman eating oysters; 292c
Woman in distress; 170c, 292c
Woman on a breakwater; 170c
Woman with turned-up nose; 292c

ENSOR, Mary
Spring flowers and a starling by
 a wall; 218

ENVIRONMENTAL COMMUNICA-
 TIONS
Pink house; 167c

EPPLE, Bruno, 1931-
The burial; 289c
Market woman; 289c

EQUIPO CRONICA
La Antesala; 320
El aquelarre; 320
El intruso; 320
Paseos por Toledo; 320

ERBSLÖH, Adolf, 1881-1947
Tennis court; 503

ERNST, Jimmy, 1902-
Across a wall; 126
A time for fear; 449

ERNST, Max, 1891-1976
After us, motherhood; 168
Air washed in water; 168
All friends together; 168
The almost late romanticism; 475
The angel of earth; 168
The angel of hearth and home;
 168c
The anger of the Red Man; 168
The anti-pope; 588c
At the first clear word; 168
Aurenche, Marie Berthe; 595
Barbarians marching to the West;
 168
Battle of fish; 168
A beautiful day; 168
The beautiful season; 168
The bewildered planet; 168, 579

Black sun; 449c
The Blessed Virgin chastises the
 infant Jesus before three wit-
 nesses, A.B., P.E., and the
 artist; 168
Blind swimmer; 168
Blue and pink doves; 168, 579
The bride of the winds; 449
Caged bird; 168
Carnal delight complicated by visu-
 al representations; 168
Celebration of hunger; 168
The celestial army; 462
Chemical nuptials; 168
Cocktail drinker; 168
Collage and gouache; 283c
The contorted song of earth; 168
The couple; 168
Crucifixion; 168, 475
Dada-Gauguin; 168
Day and night; 168c
Déjeuner sur l'herbe; 168
Design in nature; 168
Edge of a forest; 549c
The elephant of the Celebes; 168,
 250
The entire city; 168c, 475
The equivocal woman; 168
Europe after the rain I; 168
Europe after the rain II; 168
Explosion in a cathedral; 168
Eve, the only remaining one; 168
The eye of silence; 168
Fascinating cypress; 168
Father Rhine; 168
The feast of the gods; 168
Figure; 449
The forest; 168
Forest, black sun and cage; 168
The fragrant forest; 168c
Frogs don't sing red; 168
Fruit of a long experience; 168c
Garden airplane-trap; 168
The garden of France; 168
The great forest; 576
Hat in the hand, hat on the head;
 168
He does not see--he sees; 168
Histoire naturelle; 168c
The horde; 168, 579
The idol; 168
The illustrated maker of dreams;
 168
Immortality; 168
Inside the sight: the egg; 168
Inspired hill; 168
The joy of living; 168, 475
Landscape; 168

Sunday promenade at St. Cloud;
 147, 277
Woman in a green hat; 277
Woman in a white hat; 277
Women with hookah; 277

EVERDINGEN, Allart Pietersz
 van, 1621-75
Norwegian landscape; 608c
Rocky landscape; 576

EVERDINGEN, Cesar Pietersz,
 1617?-78
Woman with a brazier; 608c

EVEREN, Jay Van
Untitled No. 3; 528

EVERETT, Bruce
Doorknob; 320
Towel rack; 320

EVERGOOD, Philip, 1901-73
Cotton from field to mill; 29
Everybody's Christmas; 22c
The jester; 445c
The new Lazarus; 370, 472, 576
The story of Richmond Hill; 29
Toiling hands; 29

EVERS, Carl G.
Arctic delivery; 169c
Brooklyn Navy Yard; 169c
Caribbean surf; 169c
Chesapeake Bay; 169c
Conquerors of Cape Horn; 169c
Desperate voyage; 169c
Doris Moran; 169c
Edmund J. Moran; 169c
Full load of crude; 169c
Gloucester schooners; 169c
HMS Invincible; 169c
Heavy duty; 169c
The joy of sailing; 169c
Key West boatyard; 169c
The last grain race; 169c
The lonely sea and sky; 169c
M. Moran; 169c
Mobile Bay; 169c
Old South Street, 1876; 169c
On the Australia run; 169c
Ordeal of Convoy U.N. 119;
 169c
Palm and surf; 169c
Pride; 169c
Ready to abandon ship; 169
The romantic challenge; 169c
Santa Paula; 169c

Santa Rosa; 169c
Schooner yacht America; 169c
Skipjacks at work; 169c
Skipjacks racing; 169c
Star of Finland; 169c
The strange last voyage of Donald
 Crowhurst; 169c
Tug in Korea; 169c
U.S.C.G. Eagle; 169c
U.S.S. America; 169c
U.S.S. Kennebec; 169c
U.S.S. Massachusetts; 169c
U.S.S. New Jersey; 169c
U.S.S. Texas; 169c
U.S.S. Thresher; 169c
Vickers Voyager; 169c
Weather uncertain; 169c
Yacht Courageous; 169c

EWALD, Ernst, 1836-
The three Norns; 343

EWORTH, Hans, fl. 1540-75
Audley, Margaret, Duchess of
 Norfolk; 434c
Brandon, Frances, Duchess of
 Suffolk and Adrian Stokes; 576
Dacre, Lady; 587
Darnley, Henry, Lord, and his
 brother; 382, 587
Elizabeth I and the three goddesses;
 382
Luttrell, Sir John; 434, 587
Queen Elizabeth confounding Juno,
 Minerva, and Venus; 587
Queen Mary Tudor; 587
Turk on horseback; 587
Unknown lady; 434

EXNER, Johann Julius, 1825-1910
The third-class coach; 354

EXTER, Alexandra, 1882-1949
Grapes in a vase; 236
Still life; 218c

EYCK, Hubert van, 1366-1426
Annunciation; 563
Crucifixion; 291c
Ghent altarpiece; 144bc, 205bc,
 424c
Holy women at Christ's tomb; 563
Last Judgment; 291c
Mystical Lamb altarpiece; 563cb

EYCK, Jan van, 1390-1441
Albergati, Cardinal Niccolo; 283c,
 563

320
Roulette--variable painting; 320

FALCONE, Aniello, 1607-56?
Supper at Emmaus; 526

FALCONER, John M., 1820-1903
Old mill, West Milford; 528

FALKARD, Julia B.
I showed her the ring and implored
 her to marry; 524

FAN CH'I, 1616-94?
Landscapes; 188cb

FAN K'UAN, -1030
Travelers among streams and
 mountains; 179, 576
Traveling amid mountains and
 streams; 372, 539

FANG TS'UNG-I, fl. 1300-78
Cloudy mountains; 80, 305
Divine mountains and luminous
 woods; 80
Retreat in cloudy mountains; 615d

FANGOR, Wojciech, 1922-
Bild No. 35; 320

FANNER, Alice
Riverside landscape; 524
A Yorkshire trout stream; 524

FANTIN-LATOUR, Henri, 1836-
 1904
Anniversary--to Berlioz; 569
Apples and foliage in a pot; 352
Ariadne; 352
Around the piano; 352c, 569
The artist's two sisters; 352
L'Atelier des Batignolles; 352c
Basket of grapes; 569
Basket of grapes and peaches; 569c
The Batignolles studio; 569
Bouquet of flowers; 569c
Bouquet of peonies and iris; 569c
Bouquet of roses; 569
Budget, Miss; 352
Budget, Sarah; 569
Candlestick and matchholder; 352
Cherries; 352
Chrysanthemums; 352c, 569
Corner of the table; 352c, 569
Crowe, Edith; 6c
Cup and saucer; 352
Dahlias; 569c

Damnation of Faust; 569
The dance, salon of 1891; 569
Dawn and night; 100c, 352
Delphinium; 569
The drawing lesson; 569
The drawing lesson in the studio;
 352c
Dubourg, Charlotte; 352, 569
Dubourg, Mlle. Charlotte, and a
 friend; 569
Dubourg family; 352, 569
Dubourg, Mlle. Victoria, and her
 sister Charlotte; 569
Dusk; 362
Edwards, Mr. and Mrs. Edwin;
 352, 569
The embroiderer; 569
Entombment; 352
Fairy roses; 569c
Fairyland; 352c, 569
Fitz-James, Duchess of; 352, 569
Flower and fruit; 352
Flower-piece; 352
Flowers; 352, 530, 569, 576
Flowers and fruit; 283c, 352, 553
Flowers and grapes; 128
Flowers in a bowl; 569c
Flowers in a vase; 569
Fruit and flowers; 352, 569
Gladioli; 352c
The grail; 569
Grapes and pomegranates; 352
Grapes in a bowl with carnation;
 352
Gravier, Mme.; 352
Head of a girl; 352c
Head of a woman; 569
Head of a young girl; 509
Hollyhocks; 569bc
Homage to Delacroix; 352c, 569
Immortality; 352, 569
Japanese anemones; 352
Kitchen still life; 352c
Large bouquet or roses; 569
Large vase of dahlias; 352
Lerolle, Mme.; 352, 569
Le Lever; 352
Maître, León; 352
Maître, Mme. León; 569
Manet, Edouard; 197, 352, 452,
 569
Manet in his studio; 352
Marriage at Cana; 352
A mixed bunch; 569
Mixed flowers; 352
Nasturtiums; 204c, 352c
The night; 352, 569
Oranges, strawberries and flowers;

352
Pansies; 569c
Pansies and daisies; 352, 569
Peaches; 352
Peonies; 352
Peonies and Guelder roses; 569c
Peonies in a blue and white vase;
 6c, 569
A plate of apples; 352
Plate of peaches; 443c
Poppies; 352
Portrait of his sister Marie; 352
Portrait of the artist; 569
Portrait of the artist's fiancée; 352
Portrait of the artist's sister; 553
Primulas, pomegranates and pears;
 352
Reading; 352, 569
Reclining nude; 352
Rembrandt in a night cap; 352
The Rhine maidens; 409
Rose-trees--white roses; 569c
Roses; 6c, 352c, 569c
Roses and a glass jug; 352c
Roses and larkspur; 569
Roses in a vase; 569c
Roses in a stemmed glass; 569c
Sara the bather; 569
Scene from Tannhäuser; 569
Self-portrait; 352, 569
Sonia; 310c, 352c
Spring flowers; 352, 569
Still life; 310c, 352, 569
Still life--alms bowl and book; 352
Still life: roses in a glass vase;
 569
Still life with apples; 352c
Still life with flowers and fruit;
 352
Still life with roses and torso; 352
Still life with strawberries and
 oranges; 352
Still life with vase of hydrangeas
 and raunuculus; 204c
The studio in the Batignolles
 quarter; 55c, 124, 283c, 506,
 583c
Study of a nude woman; 569
Sweet peas in a glass; 569
Tannhäuser on the Venusberg; 352
Temptation of St. Anthony; 569
The toilet of Venus; 569c
La toilette; 443c
The Trojans at Carthage; 569
The trysting place; 352
Twilight of the gods; Siegfried and
 the Rhine maidens; 569
The two sisters; 569

Vase of roses and nasturtiums; 341
Venus and amour; 569
Whistler; 352c
White lilies; 352, 569
White narcissi, hyacinths, and
 tulips; 569
Yellow rose in a tall glass; 569
Zinnias; 569c

FARDOULYS, James
Animal devotion down Sydney Town;
 340c
Blue roses; 340c
A day of play on the Barcoo; 340c
The embarrassed model; 340c
Four ghost horses; 340c
The village smithies; 340c

FARINGTON, Joseph, 1747-1821
The oak tree; 247
The Ouse Bridge, York; 600

FARMER, Mrs. Alexander, fl.
 1855-82
An anxious hour; 604, 605
Reading Punch; 605

FARNBOROUGH, Lady Amelia Hume
 Long, 1762/72-1837
Piccadilly from Green Park; 105

FARNY, Henry François, 1847-
 1916
After the evening meal; 94c
After the hunt; 94
Alchisaye, Apache; 94c
Ambushcade; 94
An Apache ambush; 94c
Apache Indians in the mountains; 94
As it was in the beginning; 94
Bad Lands; 94
Beside his mount; 94
Big game in sight; 94
The boys' breakfast; 94
Breaking camp; 94
The broken twig; 94
Buffalo on the range; 94
The buffalo trail; 94
Call of the moose; 94
The campfire; 94c
The captive; 94c, 370
Carrying firewood; 94
Cheyenne camp; 94c
Chief Ogallala Fire; 94
The chief's tent; 94c
Coming home; 94
The coming of the 'fire horse'; 94
Conspiracy; 94

Viaduct; 397, 400
Victory of the sloop Maria; 65
Village; 449
Village Neppermin; 397c
Zirchow V; 397
Zirchow VI; 503

FEITELSON, Lorser, 1898-1978
Cobalt with red; 22c

FEJES, Emerik, 1904/09-64
Basle; 394c
The Duomo in Milan; 394c
Milan Cathedral; 89c
The Parliament Building in Buda-
 pest; 394c
Rheims Cathedral; 394c
Subotica; 394c

FEKE, Robert, 1705?-51
Bowdoin, James, II; 178c
Bowdoin, Mrs. James; 17, 178c
Francis, Tench; 399
Royall, Isaac and his family; 399,
 445c
Self-portrait; 399
Waldo, Brigadier General Samuel;
 531

FELDMAN, Irving, 1930-
The beach; 23c
Open road landscape; 23c
Reclining figure in garden; 23c

FELLINI, William, -1965?
Lily in boat; 243c

FELSKI, Albina
The circus; 243c
Logging operation; 243c

FENDI, Peter, 1796-1842
The poor officer's widow; 409

FERGUSSON, John Duncan, 1874-
 1961
Damaged destroyers; 231, 511
A lowland church; 231

FERNANDEZ, Juan (El Labrador)
Still life; 382

FERNELEY, John E., Sr., 1781/
 82-1860
Two hunters with riders in a
 landscape; 604

FERNHOUT, Edgar, 1912-76
In spring; 189

FERNYHOUGH, William, fl. 1804-
 15
Holme Abbey, Cumberland; 105

FERRAGUTI, Arnaldo, 1862-1923
Digging; 354c

FERRARA, Bona da, fl. 1450-61
St. Christopher carrying the Christ
 Child across the ford; 177

FERRARI, Gaudenzio, 1480-1546
Holy Family with a donor; 556c

FERREN, John, 1905-70
Eucalyptus; 126
Multiplicity; 472

FERRETTI, Giovanni Domenico,
 1692-1766/68
Harlequin as cook; 556
Harlequin as painter; 556
Harlequin attacked; 556

FERREZZI, Luigi
Complimenti! Complementi!; 354

FERRIS, Keith, 1929-
Air superiority, blue; 173c
Atlas Centaur space launch vehicle;
 173c
Bad news for Uncle Ho; 173c
Battle of Britain Spitfire; 173c
Bell 47G; 173c
Big brass ones; 173c
Black cats; 173c
Boeing P-12; 173c
Bull's-eye at Avon Park; 173c
Doumer Bridge; 173c
F-111; 173c
Fiat C.R. 42; 173c
First swept-wing encounter; 173c
Forewarned is forearmed; 173c
Fortresses under fire; 173c
Gallant beginning; 173c
The good old T-bird; 173c
Grumman F-14 tomcat; 173c
The Handley Page 0/400; 173c
High country call; 173c
The Loening amphibian; 173c
Mig sweep; 173c
Mighty big shoes to fill; 173c
The 19th hour; 173c
Palmgren, Cooley and Harvest
 reaper; 173c
Prudoe Bay; 173c
Pursuit section instructors, Kelly
 Field, 1932; 173c
Republic P-47D Thunderbolt; 173c

Retirement party for old Thunder-
bird; 173c
Rolling thunder; 173c
Samurai!; 173c
Skylab; 173c
Sunset refueling; 173c
Thud ridge; 173c
Thunderbird take-off; 173c
The U.S. Air Force Thunderbirds;
173c
View from the Slot; 173c
Wild weasel; 173c

FESTA, Tano, 1938-
La grande odalisca; 320

FETHEROLF, James, 1925-
After the rain; 12
America! America!; 12c
Big Sur; 12c
Near sundown; 12c
Sedona sunset; 12
Winter in the Grand Canyon; 12

FETI, Domenico (Fetti), 1588/89-
1623
Hero and Leander; 283c
Parable of the lost piece of silver;
576
Portrait of an actor; 341c
The vision of St. Peter; 382

FETTI, Lucrina, fl. 1614?-51?
St. Barbara; 236

FEUERBACH, Anselm, 1829-80
Allgeyer, The engraver Julius;
175
Family portrait; 576
Iphegenia; 409
La Nanna; 417
Roses; 204c

FIASELLA, Domenico, 1589-1669
Christ healing the blind; 556
Christ raising the son of the widow
of Nain; 556

FICHEL, Eugene, 1826-95
Two ladies and a boy on a terrace;
353

FICHEL, Jeanne Samson
The bouquet; 524

FIELD, Erastus Salisbury, 1805-
1900
Ashley, Elizabeth Billings; 158

Field, Thankful; 158
Garden of Eden; 370
He turned the waters to blood; 266
Historical monument of the Amer-
ican Republic; 131c, 158, 462
Hollister, Mr. and Mrs. John, of
Glastonbury, Ct.; 158
Israelites crossing the Red Sea;
131c, 348c
Lincoln with Washington and his
generals; 158
Portrait of a young girl; 158

FIELD, Robert, 1794-1819
Inglis, Charles, first bishop of
Nova Scotia; 234

FIELDING, Anthony V. see
COPLEY FIELDING, Anthony
V.

FIELDING, Thales, 1793-1837
The gypsy encampment; 105

FIFE, Phyllis
Two buffalo chips; 253

FIGARI, Pedro, 1861-1938
Federal ladies; 576

FIGONE, Fortunato V.
Assisi, Italy, La Rocca; 23c
Dante's inferno; 23c
Flower picker; 23c
Self-portrait; 23c

FILATIEV, Tikhon
St. John the Forerunner in the
wilderness with scenes from his
life; 455

FILDES, Sir Luke, 1844-1927
An alfresco toilet; 96c
Applicants for admission to a
casual ward; 354, 434, 604,
605d
Betty; 384
The doctor; 409, 576, 605d
The widower; 605

FILIPOVIC, Franjo, 1930-
Tomato; 394c

FILLA, Emil, 1882-1953
The children in a garden; 147

FILLEUL, Mme. (Bocquet), -1794
Angouleme, Duc d', son of Charles

I; 524
The sons of Charles X of France;
524

FIMMERS, H.
Le voleur de cerises puni; 40

FINCH, Alfred William, 1854-
1930
Orchard at Louvière; 513

FINCH, Rev. Daniel, 1757-1840
The old bridge; 105

FINI, Leonor, 1908-
The angel of anatomy; 236
The two skulls; 236

FINOGLIO, Paolo, fl. 1640-56
Adoration of the shepherds; 526
Circumcision; 526
Funeral of St. Martin; 458
St. Bruno with the Virgin; 526
Scenes from the life of St. Martin;
458

FINSON, Hildred A., 1910-
Above Lynx Lake; 23c

FINSON, Louis, 1580-1632
The Magdalen; 526
San Gennaro; 526

FIORENTINO, Rosso see ROSSO
FIORENTINO

FIRMIN-GIRARD, Claude
The artist at the mill; 353

FISCHER, J. G. P., 1786-1875
Princess Victoria; 382

FISCHER, Mark
Boys bathing; 45

FISH, Janet, 1938-
Painted water glasses; 126

FISHER, Captain, fl. 1756-75
Near Gorleston; 105

FISHER, Alvan, 1792-1863
American Eclipse; 399
Corn husking frolic; 122c, 257
Lakes and mountains; 410
Sugar Loaf Mountain; 410
View of Harvard College; 399
View of Springfield; 555

FISHER, Harrison, 1875-1934
Yosemite, near Half Dome; 233cd

FISHER, Jonathan, 1768-1847
The apple service, apples on a
plate; 601c
Ash colored hawk with brown
lizard; 601c
Baltimore oriole, birds of Para-
dise; 601c
The bear, the catamount; 601c
The black and white butcher bird;
601c
Black horse at Blue Hill; 601c
The black macaque; 601c
Brazilian macaw; 601c
Cacque minor; 601c
Carrot; 601c
The crown'd eagle; 601c
An early peach; 601c
Elephant, rhinoceros; 601c
Flies, butterflies, bug; 601c
Floral spray; 601c
Four birds; 601c
The fox and the otter; 601c
Garden pea, strawberries; 601c
The great horned owl from Athens;
601c
Hand of a boy with distempered
skin, and a branch of the com-
mon service tree; 601c
Harvard College; 601c
The latter harvest; 601c
Larkspur; 601c
The lion, the lioness; 601c
The little ant eater; 601c
The little owl; 601c
London pride; 601c
Male and female zebra; 601c
The man of the woods; 601c
The mongoose, the gerbil; 601c
Navigation--the mariner's com-
pass; 601c
A north west prospect of Nassau
Hall with a front view of the
President's house in New Jer-
sey; 601c
The plain scale; 601c
The pole cat, the squirrel, the
guinea pig; 601c
The red cow; 601c
The St. Jago monkey; 601c
Shell fish; 601c
Spring; 601c
Sunflower, opening poppy, cox-
comb; 601c
View of Dedham, Mass.; 601c
View along the Maine coast; 158

FISHER, S. M.
The chess players; 353

FISHER, Thomas, 1782-1836
West Wickham Church, Cambs.;
105

FISHER, William Mark, 1841-1923
The dyke at Basing; 604

FITZ GERALD, Edmond J., 1912-
Beach combings; 378
East wind; 378
Golden afternoon; 378c
Start of the race; 378
Surf; 378

FITZGERALD, Edward
Black boots; 380c
The collector; 380
Kodak; 380
Late edition; 380
Peonies; 380
Potato and candy kiss; 380
The prizewinner; 380
Summermoon; 380
The telephone; 380c
Warm corner; 380

FITZGERALD, John Anster, 1832-
1906
Fairies in a nest; 588c

FITZGERALD, John Austen
The stuff that dreams are made of;
604

FITZ GERALD, Lionel L., 1890-
1956
Farm yard; 234
The little flower; 234

FITZPATRICK, J. Kelly, 1888-
1953
Bream fisherman--Old camp
Dixie; 390

FJAESTAD, Gustav Adolf, 1868-
1948
Silence: winter; 553

FLACK, Audrey, 1931-
Bounty; 5c
David; 320
The Farb family; 396
Jolie Madame; 396
Kennedy motorcade--November 22,
1963; 396

Leonardo's lady; 210
Macarena Esperanza; 396
Michelangelo's David; 396
Piazza of miracles; 316
Royal flush; 396
Self-portrait; 396
Strawberry tart; 396
Truman's, Harry, teachers; 396
Wheel of fortune; 97

FLAGG, Charles Noël, 1848-1916
Twain, Mark; 399

FLAGG, George Whiting, 1816-97
Huger, Alfred; 381
The murder of the princes; 176

FLAGG, James Montgomery, 1877-
1960
First in the fight; 122c

FLANAGAN, Barry, 1941-
Hanging canvas; 449c

FLANDES, Juan de, -1519
Christ crowned with thorns; 576
Magdalen at the feet of Jesus;
205

FLANDRIN, Hippolyte J., 1809-64
Figure study; 417
Tower of Babel; 409

FLAVIN, Dan, 1933-
10 alternating cool white/warm
white; 449

FLAXMAN, John, 1755-1826
Chatterton, Thomas, taking the
bowl of poison from the spirit
of despair; 434

FLECK, Joseph, 1893-
Peaceful hunt; 233c

FLEGEL, Georg, 1563-1638
Still life with flowers and refresh-
ments; 341c

FLEISCHER, Ernst Philipp
Digging the St. Gotthard Tunnel;
354

FLEURY, Fanny
The pathway to the village church;
524

FLICKE, Gerlach, fl. 1545-88
Cranmer; 434

Landscape near Rocco Canterano
 in the Sabine Hills; 175
Mountain landscape; 494cd

FOLKINS, Wentworth
Canadian Pacific No. 29; 209c
The Newfie Bullet; 209c

FONSECA, Apollinare
Still life; 62

FONTAINEBLEAU School
Diana as a huntress; 284c, 285c,
 610c
Diana the huntress; 610c
Poitiers, Diane de; 610c
Poitiers, Diane de, as Diana the
 Huntress; 583c
Villars, Duchess of, and Gabrielle
 d'Estrées at their bath; 285c,
 610c

FONTANA, Lavinia (Zappi), 1552-
 1614
Birth of the Virgin; 218
Jesus Christ talking with the woman
 of Samaria; 524
Noli me tangere; 236c
Orsini, Senator; 236
Portrait of a noblewoman; 236
Queen Luisa of France presenting
 Francis I her son to St. Francis
 of Paola; 236
Self-portrait; 99, 218, 524
Venus and Cupid; 218
The visit of the Queen of Sheba;
 218c

FONTANA, Lucio, 1899-1968
Concetto spaziale; 320, 438c
Spatial concept pause; 576

FONTANESI, Antonio, 1818-82
Grazing cattle; 230
Shinobazu pond; 230

THE FOOL
The Aquarius Theater; 167c

FOPPA, Vincenzo, 1428?-1515?
Madonna and Child with angels;
 576
St. Jerome; 205

FORAIN, Jean Louis, 1852-1931
Gentleman presenting a bouquet to
 a ballerina; 271c
Tribunal scene; 576

FORBES, Edwin, 1839-95
Drummer boy cooling his coffee;
 257

FORBES, Mrs. E. Stanhope
Cuckoo; 524
The fisher wife; 524
In with you!; 524
May evening; 524

FORBES, Elizabeth Stanhope, 1859-
Jean, Jeanine, Jeanette; 604

FORBES, Stanhope A., 1857-1948
By order of the court; 354
The health of the bride; 96, 354c,
 434, 604, 605
Lighting-up time; 354

FORBES-ROBERTSON, Eric
Great expectations; 513

FORBORA, Antonio
The artist's easel; 40

FORREST, Charles Remus, fl.
 1821-23
A dignitary's canoe on the French
 River; 235

FORSBERG, Nils, 1842-1934
Auditioning for the circus director;
 354
Death of a hero; 96
Potter at St. Amand; 553

FORT, Jose Soriano
Hopeless; 354

FORTE, Luca, fl. 1640-70
Still life with fruit; 556

FORTIN, Marc-Aurèle, 1888-1970
Paysage, Ahuntsic; 234

FORTUNY y CARBO, Mariano,
 1838-74
The Moroccan executioner; 302
The Spanish wedding; 409
The vicarage; 389, 576

FOSTER, Myles Birket, 1825-99
Children fishing in a punt; 604
Driving home the cattle; 600

FOSTER, William Harnden
As the centuries pass in the night;
 209c
The sunshine special; 209c

Coronation of the Virgin; 112d
Coronation of the Virgin with angels;
 112
Crucified Christ with the Virgin
 and St. John the Evangelist; 112
Crucifixion; 112
Death of Adam; 112
Death of Michele Dragomari and
 the carrying of the Cintola to
 the Duomo of Prato; 112
Discovery and testing of the True
 Cross; 112
Expulsion of Joachim; 112d
Feast of Herod; 112
Flagellation; 112
Flight of Chosroes; 112
Hermogenes before St. James the
 Greater and the beheading of
 St. James the Greater; 112
Madonna and Child; 112
Madonna and Child enthroned with
 angels; 112d
Madonna and Child enthroned with
 angels and Saints Andrew, Bene-
 dict, Bernard and Catherine;
 112
Madonna and Child enthroned with
 angels and Sts. James the
 Greater, John the Baptist,
 Luke and Philip; 112
Madonna and Child enthroned with
 angels and Sts. John Gualbert,
 Peter, John the Baptist and
 Minias; 112
Madonna and Child enthroned with
 angels and Sts. John the
 Evangelist, John the Baptist,
 James the Greater and Barthol-
 omew; 112
Madonna and Child with four saints
 and angels; 113
Madonna of Humility with angels;
 112
Marriage of the Virgin; 112
Meeting at the Golden Gate; 112
The meeting of Sts. Anthony and
 Paul; 112
Presentation of the Virgin; 112
Resurrection; 112
St. Anthony beaten by devils and
 Christ appearing to St. Anthony;
 112
St. Anthony hearing the Gospel
 and St. Anthony distributing his
 fortune in alms; 112
St. Bartholomew; 112
St. Helena returning the Cross to
 Jerusalem; 112

St. John Gualbert; 112
St. John the Baptist going into the
 wilderness; 112
St. John the Evangelist; 112
St. John the Evangelist on Patmos;
 112
St. Julian helping a pilgrim across
 a stream; 112
St. Julian killing his parents; 112
St. Minias; 112
St. Nicholas and the three maidens;
 112
St. Nicholas rescues the drowned
 child; 112
St. Nicholas saving a ship; 112
St. Nicholas saving the three
 maidens; 112
St. Nicholas stopping an execution;
 112
St. Thomas consigning the Cintola
 to a priest and the marriage of
 Michele Dragomari; 112
St. Ursula; 112
Sts. Augustine, Peter, Paul and
 Stephen; 112
Sts. Mary Magdalen, Benedict,
 Bernard, and Catherine; 112
Sts. Nicholas and Julian; 112
Stigmatization of St. Francis; 112
Story of the bad debtor; 112
Trinity; 112
Voyage of Michele Dragomari; 112
The wood being pulled from the
 Piscina and the making of the
 Cross; 112

GADDI, Taddeo, 1300-66
Annunciation to the shepherds; 113,
 205, 522
Christmas crib at Greccio; 522
David; 375
Madonna and Child; 113
Madonna and Child with saints; 522
Nativity; 283cd
Scenes from the life of the Virgin;
 522

GADSBY, William Hippon, 1844-
 1924
A girl with toys; 604

GAERTNER, Carl, 1898-
Studio party; 457

GAGNEREAUX, Bénigne, 1756-95
Spirit of peace halting of horses
 of Mars; 184

Wooded landscape with figures,
animals and distant village; 240
Wooded landscape with gypsies;
600
Wooded landscape with horseman
and flock of sheep; 240
Wooded landscape with milkmaid
and drover; 240bc
Wooded landscape with seated
figure; 240
Wooded landscape with shepherd
and sheep and distant village;
240
Wooded lane with horses; 105
Wooded slope with cattle and felled
timber; 240d
Wooded stream with pastoral
figures and distant bridge; 240
Wollaston, William; 240, 587
Young Hobbinol and Ganderetta;
240
A young lady seated in a land-
scape; 166

GAISSER, Jakob Emanuel, 1825-99
The faulty memory; 51

GAISSER, Max, 1857-1922
The Dutch interior; 51
Interrupted card game; 51
The scholar; 51

GAKU'O, 15-16th centuries
Landscape; 510
Mountain village; 510

GAKUO ZOKYU
Landscape; 372
Water and moon kannon; 372

GALE, William, 1823-1909
The confidante; 604
The convalescent; 195, 605d

GALIZIA, Fede, 1578-1630
Basket of peaches; 236
Judith with the head of Holofernes;
218, 556
Morigia, Paolo; 236
Still life with peaches and jas-
mine; 218
Still life with quinces; 236

GALLAGHER, Barbara, 1933-
Beethoven's Fifth; 390

GALLAIT, Louis, 1810-87
Abdication of Charles V; 409

GALLE, Hieronymus, 1626-79?
Pink and white flowers in a glass
vase; 204c

GALLEGO, Fernando, 1440-1507?
Adoration of the Magi; 553
Pietà; 72c, 389

GALLEN, Alex
The fight for the Sampo; 593
Lemminkainen's mother; 593

GALLEN-KALLELA, Akseli, 1865-
1931
The sauna; 354
Symposion; 409

GALLI, Giacomo (Lo Spadarino),
1580?-1649?
Santa Francesca Romana; 526

GALLON, Robert
The departing day; 604

GALVAN, Jesus Guerrero, 1910-
Children; 576

GAMBA, Enrico, 1831-83
Funeral of Titian; 417

GAMELIN----, 1738-1803
The deluge; 184

GANDY, Joseph Michael, 1771-
1843
Near Campistrello; 105

GANKU, 1756-1838
Deer; 576

GANSEVOORT LIMNER, fl. 1730-
45
Wandelaer, Pau de; 13

GANSWORTH, George
Island tree house; 378c
Morning sunshine; 378
No longer needed; 378
The widow's watch; 378

GARBO, Raffaellino del, 1466-1524
The Mass of St. Gregory; 556

GARD, Judy Richardson
The covey; 492

GARDINER, Pauline S.
Morafic; 23

St. John the Baptist in the wilder-
ness; 422c, 424c, 576
Tree of Jesse; 335c

GEHRTS, Karl, 1853-98
The court jester; 96

GEIAMI, 1431-85
Jittoku laughing at the moon; 263
Viewing a waterfall; 372, 510

GEIGER, Rupprecht, 1908-
OE 247; 449

GEIKIE, Walter, 1795-1837
Daft Jimmie; 279

GEISER, Lucile
Seams, OK; 492

GELDER, Aert de, 1645-1727
Esther adorned by her maids;
608c
Hermanus Boerhaave with his wife
and daughter; 303
Holy family; 189
Jacob's dream; 303

GELDORP, George, 1580?-1660?
Salisbury, William, 2nd Earl of;
434

GENCHU, 16th century
Lotus; 510

GENELLI, Bonaventura, 1798-1868
Bacchus among the Muses; 175

GENERALIC, Ivan, 1914-
Adam and Eve; 554c
Apples; 554c
At the table; 554c
The barn in flames; 554c
The beggar; 554c
Bird in flight; 554c
The blue bird; 554c
Boy studying; 554c
Boy with cat; 554c
Brawl on a feast day; 554c
Carnival; 554c
Cat and candle; 554c
The circus; 554c
Cock on branch; 554c
The corpse; 554c
Cows in front of the Eiffel Tower;
554c
Crucified cockerel; 394c
The crucified rooster; 89c

Crucifixion; 554c
Dancing in the farmyard; 554c
The death of Virius; 394c, 554
Double portrait; 554c
A fable for children; 554c
Fair at Novigrad Podravski; 554c
The feast of the grape harvest;
554c
Festivities in the vineyard; 554c
Fire; 394cd, 554c
Fish in the air; 554c
Flood; 554c
For taxes; 554c
Frogs; 554c
Gathering the leaves; 554c
Girl with cat; 554c
Girl with rooster; 554c
Going through the countryside;
554c
The grape harvest; 554c
Gypsy feast; 554c
Gypsy wedding; 394c, 554c
Halacek's, Stef, funeral; 394c, 554c
Hanged rooster; 554c
Hlebine Mona Lisa; 554c
Horses at play; 394c
In front of the church; 554c
Indian summer; 554c
The island; 554cd
Killing the pig; 554c
Mask of death in the night; 394c
Mona Lisa; 394c
My studio; 394c
Old bull; 554c
Old gypsy woman; 554c
Old woman at the stove; 554c
Plucked rooster; 554c
Portrait of an old man; 554c
Prayer for rain; 554c
Red flowers; 554c
The red horse; 554c
Revolt in Djelekovac; 554c
The rooster's portrait; 554c
The scarecrow; 554c
Self-portrait; 289c, 394c, 554c
Stacking the hay; 554c
The stag's wedding; 554c
Still life; 394c, 554c
Sunflowers; 554c
Sweeping leaves; 394c
Swineherd; 554c
Taking a nap; 554c
Three trees; 554c
The threshing floor; 554c
Two horses in the woods; 554c
The two peacocks; 554c
Under arrest; 554c
Under the pear tree; 394c

Sassetti, Francesco, and his son
 Teodoro; 87c
Tornabuoni, Giovanna; 223c, 459c

GHIRLANDAIO, Domenico, Style
Caetani, Costanza; 442

GHIRLANDAIO, Ridolfo del, 1482-
 1561
Resuscitation of a youth by St.
 Zenobius; 61
Translation of the body of St.
 Zenobius; 61

GHIZZARDI, Pietro, 1906-
Self-portrait; 289c

GHULAM, 17th century
Elephants; 71

GIACALONE, Pippo, 1953-
Entering old church; 23
Lovers; 23
A newsboy; 23c
Tempest; 23c
Three puppies; 23c

GIACOMETTI, Alberto, 1901-66
Annette; 160
Chromatic fantasy; 160
Seated man; 449
Yanaihara, Isaku; 3c

GIACOMOTTI, Félix Henri, 1828-
 1909
The rape of Amymone; 96

GIAMBONO, Michele, fl. 1420-62
Man of Sorrows; 398

GIANNATTASIO, Ugo
The turnstile; 18

GIBB, Robert, 1845-1932
The retreat from Moscow; 604

GIERYMSKI, Aleksander, 1849-
 1901
The arbor; 96
The child is dead; 354
Jewish feast; 409
Jewish religious celebration,
 Warsaw; 354

GIFFORD, Robert Swain, 1840-
 1905
Boat on a beach; 531
Near the coast; 45

GIFFORD, Sanford Robinson, 1823/
 24-80
In the wilderness; 45
Kauterskill Falls; 333c, 402
Long Island beach; 531
Mt. Hayes; 410c, 412
Mt. Mansfield; 409
Mountain lake; 410
Sandy Hook; 531
The 7th Regiment encamped near
 Washington; 399
Summer afternoon; 410
Sunset on the Hudson; 410
Tivoli; 412
A twilight in the Adirondacks; 410c
Twilight on Hunter Mountain; 412

GIFFORD, Stephen P.
Valentine; 158c

GIGANTE, Giacinto, 1806-76
Storm on the Gulf of Amalfi; 409

GIGNOUX, Francois Régis, 1816-
 82
American landscape; 410
Winter scene in New Jersey; 410

GIL MASTER
Crucifixion; 436c

GILARDI, Pier Celestino, 1837-
 1905
Bad news; 353

GILBERT, Araceli
Diagonal No. 2; 37c
Diagonales No. 3; 37
Variations in red No. 2; 37

GILBERT, Arthur
Near Maidenhead, Berkshire; 604

GILBERT, Sir John, 1817-97
Ego at Rex Meus; 604
The eviction of the peasants; 105

GILBERT, Victor Gabriel
The flower market, Paris; 353
The song pedlar; 354

GILBERT & GEORGE (Gilbert
 Proesch and George Passmore)
Morning gin on the Abercorn Bar
 autumn 1972: a drinking sculp-
 ture; 449

GIUDICI, Rinaldo, 1856-
Betrayed; 96

GIULIANO da RIMINI, 14th century
Polyptych; 522

GIULIO ROMANO, 1492/99-1546
Este, Isabella d'; 382
Fall of the giants; 223, 576
Hall of the giants; 588c
Mythological erotic scene; 331c
The room of the giants; 40d
Transfiguration; 205
The triumph of Titus and Ves-
pasian; 382

GLACKENS, William J., 1870-
1938
At the beach; 616
Bathing near the bay; 616
Beach umbrellas at Blue Point; 176
The captain's pier; 152c
Central Park, winter; 14c, 257, 370
Chez Mouquin; 472, 616c
Curb Exchange, No. 2; 528
The drive, Central Park; 497, 616
Family group; 472
Fête de Suquet; 616
Flowers in a sugar bowl; 62
Girl in black and white; 616
Hammerstein's roof garden; 257,
445c, 616c
Maypole, Central Park; 257
Nude with apple; 472
Pier at Blue Point; 616
Raising the flag over the Royal
Palace in Santiago on July 17th,
1898; 267
Portrait of the artist's wife; 616
The shoppers; 472
The soda fountain; 616
Temple Gold Medal nude; 152
Under the trees, Luxembourg Gar-
dens; 616c
La Villette; 616

GLAIZE, Auguste Barthélemy,
1807-93
Spectacle on human folly; 96

GLARNER, Fritz, 1899-1972
Relational painting; 449
Relational painting tondo #43; 472c
Relational painting, tondo #56; 22c

GLAZIER, Hal
December days; 23c
The thirties; 23

GLEHN, Oswald von, 1858-
Boreas and Orithyia; 384

GLEIZES, Albert, 1881-1953
The bathers; 576
Chartres Cathedral; 475
La femme au phlox; 217
The football players; 318
The kitchen; 318
Landscape near Montreuil; 202c
Man on a balcony; 318

GLENDENNING, Alfred Augustus,
Sr., 1861-1907
The cornfield; 604

GLEYRE, Marc Gabriel Charles,
1808-74
Egyptian modesty; 302
Evening; 55, 409
The Queen of Sheba; 302c
Two women and a bunch of flowers;
143c

GLOFF, George
Hell Gate express; 209c

GLOVER, John, 1767-1849
The Bowder Stone, Borrowdale;
105
Landscape with cattle; 600

GNOLI, Dominico, 1933-70
Absence; 91
Acconciatura; 91
Apple; 91c
Arm chair; 91
Arm of a sofa; 91
Autoportrait; 91
Black view; 91
Bagnarola; 91
Bathing huts; 91
Battistero Toscano; 91
The big fleet; 91c
Black hair; 91
La bonne tranche; 91
Bouton No. 4; 91
Bow tie; 91c
Boy resting at a table; 91
Braid; 91
Branche de cactus; 91
Buste en vert; 91
Buste robe grise; 91
Buste rose; 91
Busto di donna di dietro; 91
Camicetta verde; 91
Canapé bleu; 91c
La casa vuota; 91

Wheat field with a lark; 207c
Wheat field with a reaper; 189c,
 207c
Wheat field with cypresses; 64,
 207c, 345c
Wheat field with mower; 345
Wheat fields with crows; 189, 345
Wheatsheaves; 207c
Window of Vincent's studio at St.
 Paul's Hospital; 475
Woman at the Tambourin Café;
 345, 513c, 514c
Woman sitting in a cafe; 207c
Woman with a cradle; 207c
Working girl; 210
The yellow books; 345
The yellow house; 345, 514c
The yellow house on the Place
 Lamartine, Arles; 594
A Zouave; 207c, 428c

GOINGS, Ralph, 1928-
Airstream; 9, 320, 449
Burger Chef Chevy; 320
Hot fudge sundae; 387c
Interior; 320c
Jeep 40809B; 11
McDonald's reck-lep; 320
Market; 126

GOITIA, Francisco, 1884-1960
Tata Jesucristo; 576

GOLDEN, Daan van
Composition with blue; 189

GOLDEN, Jane
Untitled; 167c

GOLDSMITH, Deborah, 1808-36
Boon, Sanford; 381
Noble, Catherine; 381
The Talcott family; 218, 381, 528
Throop, George Addison; 381
Throop, Cordelia; 381
Throop, Sarah Stanton Mason; 381
Unidentified man; 381

GOLDSMITH, Lawrence, 1916-
Autumn grasses; 378
Copa de oro; 378
Fir against sky; 378
Rolling sea; 378
Spring festival; 378c

GOLDSTEIN, Nathan, 1927-
Fiona; 210

GOLDTHWAITE, Anne
Weary waiting on 10th St., New
 York; 399

GOLTZIUS, Hendrick, 1558-1616
Juno receiving the eyes of Argus;
 189
Venus and Adonis; 608c

GOLUB, Leon, 1922-
Assassins II; 210d
Franco; 210
Napalm; 370c

GONCALVES, Nuno, fl. 1450-72
Retable of St. Vincent; 576d
St. Vincent venerated by the royal
 family; 205

GONCHAROVA, Natalia, 1881-1962
The bathers; 218c
Cats; 418, 576
The clock; 481
Electric lamps; 202c, 236, 568c
Fishing; 236
Larionov; 236c
The laundry; 449

GONSKE, Walter, 1942-
Abandoned adobe church; 378
Arroyo seco wagon; 378
Forgotten hotel in Madrid; 378
New Mexico landscape; 378
Valdez Valley; 378c

GONZALES, Eva, 1849-83
A box at the Théâtre des Italiens;
 460, 506
The fruit girl; 524
The little soldier; 236
Portrait of a lady seated; 524

GOOD, Thomas Sword, 1789-1872
The morning paper; 604

GOODALL, Edward Angelo, 1795-
 1870
Pont de Gudet at Angers; 105

GOODALL, Frederick, 1822-1904
Early morning in the wilderness of
 Schur; 604
An episode of the happier days of
 Charles I; 537c, 538c
The happier days of Charles I; 195
Jessie's dream; 605
A new light in the harem; 570c

Nubian leading a laden camel along
the banks of the Nile; 570c

GOODBEAR, Paul, 1913-54
Animal dance; 415

GOODBRED, Ray, 1929-
Elizabeth; 521
Farrow, Mrs. Patricia; 521
Holmes, Grace; 521
Lackey, Madeline; 521
Solomon, Melvin; 520

GOODE, Joe, 1937-
Torn cloud; 5c

GOODING, William T.
New London Light from the north-
east; 158

GOODMAN, Maude, fl. 1860-1900
Hush!; 524

GOODMAN, Sidney, 1936-
Eileen reading; 492
Portrait of five figures; 126
Toward the Perrys'; 492

GOODRIDGE, Eliza, 1798-1882
Salisbury, Stephen III; 381

GOODRIDGE, Sarah, 1788-1853
Stuart, Gilbert; 381

GOODWIN, Albert, 1845-1932
Ilfracombe; 105
Sunset over the sea, Venice; 604

GOODWIN, Arthur Clifton, 1866-
1929
Flowers; 62

GOODWIN, Edmund
A lane near Bromley, Kent; 105

GOODWIN, Philip, 1881-1935
A chance shot; 233c

GOODWIN, Richard La Barre,
1840-1910
The cabin door; 40c
Theodore Roosevelt's cabin door;
62

GORDON, Lady
After Girtin; 105

GORDON, Erma
Awakening; 48c
Self-portrait; 48c

GORDON, Sir John W., 1790-1864
Campbell, Mrs. Elizabeth, of
Stonefield; 279

GORDON, John Watson
Dalhousie, George, 9th Earl of;
279
Hopetoun, John, 4th Earl of; 279

GORDON, L. T.
Cotton pickers; 48c

GORDON, Russell, 1933-
Hot dog landscape; 153

GORDY, Robert, 1933-
Tortola stomp; 153c

GORE, Charles, 1729-1807
Vessel in a choppy sea; 105

GORE, Ken
Beeches on the Agawam; 379c
Bend in the stream; 379
A footbridge in Mexico; 379
Heavy laden; 379
Morning at the cove; 379
Sugar house; 379c
Sugaring time; 379
Symphony of autumn; 379

GORE, Spencer F., 1878-1914
Gauguins and connoisseurs at the
Stafford Gallery; 434, 513
Gilman's, Harold, house, Letch-
worth; 511c
The mad Pierrot ballet, the Al-
hambra; 511
Mornington Crescent; 553, 576
North London girl; 478
Nude female figure on a bed; 511

GORIN, Jean, 1899-
Composition No. 9; 438c

GORKY, Arshile, 1905-48
Agony; 131c, 438c, 449c, 472
The artist and his mother; 472
Aviation: evolution of forms under
aerodynamic limitations; 472
The betrothal; 348c
The betrothal II; 259c, 445c, 449
Composition; 3c

Garden in Sochi; 131, 472
Golden brown painting; 549c
Landscape table; 430c
The limit; 259
The liver is the cock's comb;
 259, 438c, 472c, 579
One year the milkweed; 259
Organization; 472
The plough and the song; 402
Plumage landscape; 576c
Self-portrait; 445c
Water of the flowery mill; 64,
 259, 402
Waterfall; 259, 387c

GORMAN, R.C., 1933-
Kneeling woman; 253
Mother and child; 253
Navajo woman; 253

GORTER, Arnold Marc, 1866-1933
Apple blossoms; 553

GOSEDA YOSHIMATSU, 1855-1915
Cormorant fishing on the Nagara
 River; 230
Marionette show; 230c
View of Mt. Fuji from Shimizu;
 230
View of Port Victoria, Canada;
 230

GOSHUN, 1752-1811
Landscape; 576

GOSSAERT, Jan see MABUSE,
 Jan

GOSSE, Sylvia, 1881-1968
The printer; 218, 511

GOTCH, Thomas Cooper, 1854-
1931
The child enthroned; 604

GOTHARDT-NEITHARDT, Mathis
Crucifixion; 576c
Resurrection; 576

GOTTLIEB, Adolph, 1903-74
Alchemist; 259
Asterisk on red; 22c
Black hand; 259
Blast I; 3c, 64, 210
Blast II; 449
Counterpoise; 387c, 472c
Dialogue I; 92c
Expanding; 92

Eyes of Oedipus; 11, 259, 579
Flotsam at noon; 402
Forgotten dream; 259
The frozen sounds, No. 1; 472
Persephone; 259c
Pictograph; 259, 579
Pictograph No. 4; 259
Pink smash; 445c
Rape of Persephone; 579
Return of the mariner; 11
The sea chest; 259, 579
Still life--dry cactus; 579
Sundeck; 472, 579
Thrust; 475
Voyager's return; 131, 472

GOTTLIEB, Harry, 1895-
Their only roof; 29

GOUBIE, Richard, 1842-
A country party; 353
The kill: the stag-hunt; 353
A meeting; 353

GOULD, John
Glaucis Fraseri; 530

GOURGUE, Enguerrand Jean, 1930-
Black magic symbols; 19
Magic table; 19

GOURSE, Hippolyte Casmir
Pig market in the Pyrenees; 354

GOUWELOOS, Jean
Success; 353

GOVARDHAN, 17th century
Emperor Jahangir celebrating the
 festival of Ab-pashi; 71c

GOW, Andrew Carrick, 1848-1920
Cromwell at Dunbar; 604
St. Paul's Cathedral, the Queen's
 Diamond Jubilee, 22 June 1897;
 605d

GOW, Mary L., 1851-1929
Mother and child; 524

GOWER, George, 1540-96
Elizabeth I; 434
Kytson, Sir Thomas; 434, 576
Self-portrait; 587

GOWING, Lawrence, 1918-
Strachey, Julia; 511

Kaaz, Karl Ludwig; 175
Reuss, Count Henry XIII of; 175
Reuss, Prince; 143
Self-portrait; 583c

GRAFSTROM, Olaf, 1855-1933
Chippewa encampment at the con-
 fluence of the Mississippi and
 St. Croix Rivers; 233cd

GRAHAM, John
Anschluss; 472
The escape of Mary Queen of Scots
 from Lochleven Castle; 279

GRAHAM, Peter, 1836-1921
The mist wreath hath the mountain
 crest, the stag his lair, the
 crue her nest; 279
Seascape; 604

GRAHAM, Thomas
Alone in London; 231, 279
The landing stage; 231, 353, 604

GRAHAM-GILBERT, John, 1794-
 1866
Scott, Anne; 279

GRAMMATICA, Antiveduto, 1571-
 1626
Judith with the head of Holofernes;
 526
St. Cecilia; 526
Theorbo player; 526

GRAMS, Erich, 1924-
Bears in a field of flowers; 289c

GRANACCI, Francesco, 1469-1543
Assumption of the Virgin; 556c

GRANDIN, Jacques Louis Michel,
 1780-
Blinding of Daphnis; 344

GRANDJEAN, Edmond
The horse market in Paris; 354

GRANDPIERRE-DEVERZY, Adrienne
 Marie Louise, 1799-1855?
Pujol, The atelier of Abel; 218
Pujol, The studio of Abel, in
 1822; 236

GRANET, François Marius, 1775-
 1849
The Capuchin chapel; 409

Stella in prison; 184
Terrace of the artist's country
 house at Le Malvalat near Aix;
 566

GRANGES, David des, 1613-75
Saltonstall, The family of Sir
 Richard; 587

GRANT, Duncan, 1846-1924
Bathing; 576
Fry, Pamela; 513
Green tree with dark pool; 478
Holland, Miss; 478
Nymph and satyr; 511
Pour vous-portrai; 478
The Queen of Sheba; 511
The sharaku scarf; 511
A Sussex farm; 553
The white jug; 511c

GRANT, Sir Francis, 1803/05-78
Champagne, General Sir Josiah,
 G. C. H.; 384
Fraser, Master James Keith, on
 his pony; 231
Hick, Mrs. John; 195
The hunt breakfast; 279
Manners, Portrait of a lady of the,
 family, out riding; 604
Queen Victoria riding at Windsor
 Castle with her gentlemen; 279
Queen Victoria with Lord Mel-
 bourne, the Marquess of
 Conyngham and other; 382

GRANT, William James
The requiem--Mozart on his death-
 bed; 604
Vallombrosa near Florence; 184

GRAVEL, A.
House with mansard roof; 235c

GRAVES, Morris, 1910-
Bird in spirit; 472, 528c
Bird singing in the moonlight; 576
Han bronze with moon; 22c
Joyous young pine; 402
Little-known bird of the inner eye;
 402
Moon-mad crow in the surf; 131
Owl of the inner eye; 210
Snake and moon; 402
Spring; 449
Wheelbarrow; 29
Wounded gull; 370
Wounded scoter No. 2; 267

GRAVES, Nancy, 1940-
A B C; 445c
Camouflage No. 3; 320c
Grafeit; 5c
Indian Ocean floor I; 472
Paleo-Indian painting, southwestern
 Arizona; 449

GRAY, Cleve, 1918-
After; 251
Arachnid; 251c
Black limb; 251c
Cardinal; 251c
Ceres I; 251
Citrine; 251
Conjugation first triptych; 251
Conjunction 151; 251c
Conjunction 199; 251
Conjunction 200; 251
Cortez; 251
Erebus; 251c
Grey triptych; 251
Hansa; 251c
Hera No. 2; 251
Hera No. 3; 251
Hiilawe; 251
Homage to Jacques Villon; 251c
Jonquil; 251c
Li Po; 251
London ruins: spiral staircase
 No. 1; 251
Mont St. Michel; 251
Oklahoma; 251
Paired; 251
Phoebus; 251c
Plum; 251c
Radiance; 251
Reprise; 251
Self-portrait; 251
Shan Shui; 251c
Sheba No. 4; 251
Sheba No. 6; 251c
Silver diver; 251
Sounding; 251c
Spider; 251
Thaw; 251
Thebes; 251
Three; 251c
Threnody; 251
Two; 251
Two circles No. 2; 251
Walden II; 251
Which was and is and is to come;
 251
White passage through green; 251c
Woman tree No. 2; 251

GRAY, Henry Peters, 1819-77
The birth of our flag; 176

GRAZIANI, Rev.
Church of the Assumption, Syra-
 cuse; 158c

GRAZIANI, Sante, 1920-
Rainbow over Inness-Kakavanna
 Valley; 320
Red, white and blue; 320

GRAZIANO, Florence
The monopoly game; 23

GREAVES, Walter, 1846-1930
Chelsea regatta; 604
Old Battersea Bridge; 195
Whistler, James Abbott McNeill;
 553

GREBBER, Pieter Fransz de, 1600-
52/53
Lamentation over the dead Christ;
 608c

GRECO, El (Domenikos Theotoco-
 puli), 1541-1614
Adoration of the kings; 332
Adoration of the shepherds; 332
Agony in the garden; 9c, 87, 332,
 389, 553c
Allegory of the Holy League; 332c
Allegory of the Order of the Camal-
 dolesi; 332
Annunciation; 332c, 553
Appearance of the resurrected
 Christ to the Virgin; 332
Apparition of the Virgin and Child
 to St. Hyacinth; 332
Assumption; 332
Assumption of the Virgin; 98c, 205,
 291c
Azañas, Julián Romero de las, and
 St. Julian; 332c
Baptism; 332c
Benavente, Duke of; 332
Boy lighting a candle; 332c
Cevallos, Jerónimo de; 332c
Christ and the woman taken in
 adultery; 332
Christ carrying the Cross; 332c
Christ driving the traders from
 the Temple; 97d, 442
Christ healing the blind; 332c, 432c
Christ in the house of Mary and
 Martha; 332
Christ in the house of Simon; 332
Christ on the Cross; 332
Christ on the cross with landscape;
 87c
Christ stripped of his garments;

The fisherman; 198
Flask and glass; 198
The flask of milk; 198
Flower on a table; 198
Flute player; 198
Fork and spoon; 198
Fruit; 198
Fruit and knife; 198
Fruit with book; 198
Fruit with bowl; 198c
Fruit with jug; 198
The fruitbowl; 198
Fruitbowl and bottle; 198
Fruitbowl and carafe; 198, 283c
Fruitbowl and glass; 198
Fruitbowl and guitar; 198
Fruitbowl and knife; 198
Fruitbowl and newspaper; 198
Fruitbowl, book and newspaper; 198c
Fruitbowl, glass and basket; 198
Fruitbowl, glass and newspaper; 198
Fruitbowl, newspaper, pears and grapes; 198
The fruitbowl on the cloth; 198
Fruitbowl, pipe and newspaper; 198c
Fruitbowl, pipe and packet of tobacco; 198
Fruitbowl with book; 198
Fruitbowl with bottle; 198c
Fruitbowl with carafe; 198
Fruitbowl with newspaper; 198
Fruitbowl with pears; 198
Girl; 108c
Glass; 198
Glass and bottle; 198
Glass and carafe; 198
Glass and flask; 198
Glass and pipe; 198
The glass of absinthe; 198
Glass with fruit; 198
Glass with packet of tobacco; 198
Glass with playing cards; 198
Glasses on a table; 198
The grapes; 198c
Grapes and book; 198
The green cloth; 198
Gris, Mme.; 198
Guitar; 198
Guitar and bottle; 198
Guitar and flask; 198
Guitar and flowers; 3c
Guitar and fruit; 198
Guitar and fruitbowl; 198
Guitar and fruitbowl on a table; 198c

Guitar and glass; 198
Guitar and music scores; 198
Guitar and newspaper; 198
Guitar and pipe; 128
Guitar and T-square; 198
Guitar, apples and bottle; 198c
Guitar, bottle and fruitbowl; 198
Guitar, bottle and glass; 198
Guitar on a chair; 198
The guitar on the table; 198c
Guitar with bottle; 198
Guitar with bowl; 198
Guitar with clarinet; 198c
Guitar with fruitbowl; 198
Guitar with glass; 198
Guitar with glasses; 198
Guitar with incrustations; 198
Guitar with the sea behind it; 198
Guitar with wineglass; 198
Guitare et compotier; 217
The handbasin; 198
Harlequin; 198
Harlequin and Pierrot; 198
Harlequin in front of a table; 198
Harlequin standing before a table; 198
Harlequin with guitar; 198c, 449
Harlequin with hands clasped; 198
Harlequin's head; 198
Houses; 198
Houses in Céret; 198c
Houses in Paris; 198c
In front of the bath; 198
In front of the cupboard; 198
In the lamp light; 198
L'Intransigeant; 198
The jar; 198
Le Journal; 198
The jug; 198
Jug and carafe; 198
Jug with bowl; 198
Jug with fruit; 198
Jug with fruitbowl; 198
The knife; 108
The lamp; 198
Landscape at Beaulieu; 198c
Landscape near Céret; 198
Legua; 198
The lemon; 198
Lemon and grapes; 198
Lemon with playing card; 198
The letter; 198
Lily of the valley; 198
The little house; 198
Man at table; 198
Man from Touraine; 198c
Man in front of a window; 198
Man sitting in an armchair; 198

Three masks; 198c
Three playing cards; 198
Townscape, Paris; 198
The two Pierrots; 198c
The vase of flowers; 198
The Venetian blind; 198
View of the bay; 198c
The village; 198c
Vin rosé; 198
The violin; 198c
Violin and book; 198
Violin and clarinet; 198
Violin and guitar; 198c
Violin hanging on wall; 198
Violin with draftboard; 198
Violin with engraving hanging on
 wall; 198
Violin with fruit; 198c
Violin with fruitbowl; 198
Violin with guitar; 198
Violin with newspaper; 198
Violin with score paper; 198
Violin with wine glass; 198c
Virgin and Child; 198
Watch with sherry bottle; 198c
The white napkin; 198
Window and hills; 198
Wineglass with box of cigars; 198
Woman; 198
Woman before the window; 198
Woman in a hat; 198
Woman in classical attire; 198
Woman playing the guitar; 198
Woman sitting in an armchair; 198
Woman with a basket; 198c
Woman with a book; 198
Woman with a guitar; 198
Woman with a kerchief; 198
Woman with a mandolin; 198
Woman with a picture; 198
Woman with hands clasped; 198
The woman with the mandolin; 198c
Woman's head; 198
The yellow guitar; 198

GRISET, Ernest Henry, 1844-1907
Cattle near Maidstone; 105

GRISI, Laura
East Village; 320

GRITTS, Franklin, 1941-
Cherokee corn stalk shoot; 415

GROLL, Albert, 1866-1952
Mesa No. 2; 233c

GROOMS, Red, 1937-
I nailed wooden suns to wooden
 skys; 153

GROPPER, William, 1897-
The hunt; 14c
The speaker; 29

GROS, Antoine Jean, 1771-1835
The battle of Aboukir; 302d
Battle of Eylau; 184
Battle of Nazareth; 184
Bonaparte as First Consul; 344
Bonaparte at the battle of Arcola;
 576
The capitulation of Madrid, Decem-
 ber 4, 1808; 420
Chaptal, Comte; 184
Legrand, Second Lt.; 184
Napoleon among the plague-stricken
 at Jaffa; 430d
Napoleon at Arcole; 341c, 430cd
Napoleon at the battle of Eylau;
 610c
Napoleon Bonaparte; 184
Napoleon visiting the victims of the
 plague at Jaffa; 409
The pesthouse at Jaffa; 184
The plague hospital at Jaffa; 583c
Sappho at Leucadia; 184

GROSZ, George, 1893-1959
The adventurer; 249
The ambassador of good will; 249
Americans; 249
Apocalyptic landscape; 249
Approaching storm; 3c
Artist and model; 249
Attacked by stickmen; 249
Ballroom; 249
Bar du Dingo; 249
Bar in Pointe Rouge; 249
The Bataillon of the Hole; 249
Beauty, I shall praise thee; 203c
Beauty, thee I praise; 249
Before the bath; 249
Bericht Marc ... in sunem atelier;
 249c
Berlin C; 249
The best years of their lives; 249
Brecht, The Bert, story; 249
Brindisi; 249
Broadway; 249
The brothers; 249
Burlesque, 42nd St., New York; 249
Cain; 249c
Cassis; 249

Resurrection; 291c
Basle crucifixion; 75
Christ bearing the Cross; 75
Christ mocked; 72c
Christ on the Cross with the three
 Maries, St. John and Longinus;
 72c
Crucifixion; 205c, 283c, 567
The founding of Santa Maria Mag-
 giore; 75
Isenheim altar; 75, 475d, 503d
Karlsruhe Crucifixion; 75
Lindenhardt altar; 75
Maria Schnee altar; 559
Mocking of Christ; 75
Mourning over the body of Christ;
 75
Nativity; 205
The resurrection; 97c, 205c, 567cd
St. Cyriac; 75
St. Lawrence; 75
St. Maurice and St. Erasmus in
 conversation; 75
Small crucifixion; 72c, 75
Stuppach Madonna; 75, 204cd
Temptation of St. Anthony; 588c
Virgin adored by angels; 567c

GRÜTZNER, Edward, 1846-1925
After the meal; 51
The card players; 51
The cardinal; 51
The catastrophe; 51
Falstaff; 51
Falstaff mustering recruits; 51c
Monk at desk; 51
Monk smoking cigar; 51
Monk pouring wine; 51
Prosit; 51
Shaving day at the monastery; 51cb
Siesta; 51
Still life of poppies; 51
Wine sampling in the cloister
 cellar; 51

GRUPPE, Emile Albert, 1896-
 1978
After lumbering; 221
After the rain; 220c
After the snow storm; 220c, 221
After the storm; 220, 221
Afternoon light; 221
Afternoon sycamores; 221
Along the stream; 220c
Angry surf; 221
The arch; 220
Art students; 220c
At Rocky Neck; 220

The back porch; 379
The back shore; 220c
The barn; 220
Bass rocks; 220c
Beech in winter; 220
Beeches in snow; 220, 221
Beeches in the woods; 221
Beginning of winter; 221
Birches; 221c
Birches along the river; 220, 221c
Birches: gray day; 220
Birches in the fall; 221c
Boats at dock; 220
Breaking ice; 221
The bridge to Long Boat Key; 220
Building composition; 220
Buildings; 220c
Busy day at the docks; 221
Busy street, Portugal; 220c
Chores; 221c
Church in Rockport; 220
Church in Woodstock; 220
Cleaning fish; 221
Clear day; 221
Cloud shadows; 220c
Coming for scraps; 221c
Coming home; 220c
Covered bridge; 220c
Covered bridge, Waterville; 220c
Crowded harbor; 220c, 221
Crowded harbor, morning light;
 221
Cumulus clouds; 221
The draggers; 221
Dramatic evening; 221
Drying sail; 221c
Drying sail: foggy day; 221
Drying the sails; 220, 221
The dunes; 220c
Dusk; 221
Early morning; 220c
Edge of the forest; 221
End of fall; 221
Evening light; 221
The fair; 220c
Fall in Vermont; 220, 221c
The farm; 220c
Farm in the snow; 220
The farmhouse; 220c
Field stream; 221
Fishermen; 220
Foggy day; 221
Gill netters; 221c
Gloucester; 221c
Gloucester docks; 221
Gloucester fog; 220
Gloucester harbor; 220
Gloucester schooner; 221

White birches; 221
The white boat; 221
White water; 220c
Windblown snow; 221c
Wingaersheek Beach; 220c
Wood interior; 220, 221
Woodstock; 220
The Yankee at dock; 220c
The yellow house; 220c

GUALTEROTTI, Raffaello, 1543-
1639
Giuoco del Calcio-Piazza Santa
Croce, Florence; 556

GUARANA, Jacopo, 1720-1808
Crowning with thorns; 398

GUARDI, Francesco, 1712-93
Architectural caprice; 442
Ascent of the balloon over the
Giudecca; 346
Bucentaure departure for the As-
cension Day Ceremony; 283c
Fantastic landscape; 398
The Grand Canal, Venice; 98c
Holy Family; 553
Hope, Abundance and Fortitude;
556c
Isola di San Giorgio in Venice;
421c
Laguna Grigia; 97c
Landscape; 341, 398
San Giorgio Maggiore, Venice; 553
Still life; 398
Venice across the Basin of San
Marco; 281c
Venice from the sea; 398
Venice: Piazza San Marco; 398
Venice: Punta della Dogana with
S. Maria della Salute; 442
Venice: Santa Maria della Salute;
398
Venice: the Grand Canal above
the Rialto; 398
View of a town; 341c
View of the Grand Canal; 294c
View of Venice with Sta Maria
della Salute and the Dogana;
576

GUARIENTO----
The three children in the fiery
furnace; 205
Vision of St. Augustine; 522

GUARINO, Francesco, 1611/12-
51/54

Sacrifice of Abraham; 458
St. Cecilia; 458

GUAYASAMIN, Oswaldo, 1919-
The cry; 576

GUDE, Hans F., 1825-1903
Norwegian mountain landscape; 409

GUDIN, Théodore, 1802-79
The body of Napoleon being shipped
to France from the Island of
St. Helena; 341
Devotion of Captain Desse; 184c

GUELDRY, Ferdinand Joseph
The rolling mill; 354

GUERCINO, (G. F. Barbieri),
1591-1666
Entombment of Christ; 98c
Incredulity of St. Thomas; 442,
576
Libyan sibyl; 382

GUERIN, Pierre Narcisse, 1774-
1833
Death of Cato; 184
Iris and Morpheus; 184, 341
La Rochejaquelein, Henri de; 184
The return of Marcus Sextus; 409

GUERRIERI, Giovanni F., 1598-
1656
Salome with the head of the Bap-
tist; 526

GÜTERSLOH, Albert Paris, von,
1887-1973
Self-portrait at the easel; 114

GUEVARA, Alvaro, 1894-1951
Fast swim; 511

GUIDO da SIENA, 13th century
Madonna and Child enthroned; 522c

GUIDOTTI, Johannes S.
Gazana; 23c

GUIELERNO, Rudilo
Tower of power; 167c

GUIGOU, Paul, 1834-71
Landscape in Provence: view of
St. Saturnin-lès-Apt; 566
La route de la Gineste; 506

Porch II; 24
Red painting; 24
Red picture; 24
The return; 387c
Riding around; 24
The room; 24, 576
Sanctuary; 24
Self-portrait; 24
The studio; 24
Sunday interior; 24
To B. W. T.; 24
To Fellini; 24
Tormentors; 24
Voyage; 24
Wall; 24
Wharf; 5c
White painting; 24
Zone; 24

GUTHRIE, Sir James, 1859-1930
Causerie; 231, 279
Hard at it; 279
A hind's daughter; 231, 279

GUTHRIE, Marion B.
January 16th; 23c

GUTTUSO, Renato, 1912-
The beach; 576
Rocco and his son; 341c
The sleeping fisherman; 449

GUY, Francis, 1760-1820
Tontine Coffee House; 17
Winter scene in Brooklyn; 17, 257,
 348c

GUY, Seymour Joseph, 1824-1910
Making a train; 176, 257
The story of Golden Locks; 266c

GUYARD, Mme. (Labille de Ver-
 tus; Vincent)
Elisabeth of France, Duchess of
 Parma; 524
France, Mme. Victoire de; 524

GUYS, Constantin, 1802-92
The café; 197
The Champs-Elysées; 409

GUYSAERTS, Gautier
Weert, Blessed Jan van, in a
 flower garland; 133

GWATHMEY, Robert, 1903-
The painting of a smile; 576

GYOKUDO, Kawai, 1873-1957
Forbidden to the vulgar; 576

GYOKUEN BOMPO, 1348-1420?
Orchids; 510, 615
Orchids, bamboo and thorns; 510
Wild orchids; 372

GYOYOKU REISAI
The Bodhisattva Manjusri; 615

GYSBRECHTS, Cornelis, 1643?-
 75?
After the hunt; 40
The cupboard; 40
Letter rack with curtain; 40
Reversed canvas; 40

GYSBRECHTS, Franciscus, fl.
 1674-77
Cupboard with open doors; 40

HA-SO-DE (Narciso Abeyta), 1918-
The wolf man; 415

HAAG, Carl, 1820-1915
The camel; 302
Danger in the desert; 604

HAAN, Isaac Meyer de, 1852-95
Farmyard at Le Pouldu; 163c
Peasant women beating hemp; 513

HAARLEM, Cornelis van, 1562-
 1638
Covaertsen, An allegorical portrait
 of the Haarlem conchologist
 Jan; 608c
Bath of Bathsheba; 74c
Bathsheba; 285c
The corruption of the world before
 the Flood; 608c
Marriage of Peleus and Thetis; 608

HAAS, Richard J., 1936-
Untitled; 167c

HABERLE, John, 1853-1933
Cigar box and pipe; 62
Dead canary; 528c
Grandma's hearthstone; 370c
Night; 40
Slate; 40
Torn in transit; 40c
Twenty dollar bill; 62

HALLAM, Beverly, 1923-
Cleft; 46

HALLE----
Cornelia, mother of the Gracchi;
184

HALLE, Charles Edward
Love's guidance; 604

HALLIDAY, Michael Frederick,
-1869
The measure for the wedding ring;
604

HALLSTRÖM, Eric, fl, 1893-1946
On the island; 289c

HALS, Dirck, 1591/1600-56
The fête in the park; 608c
Woman tearing up a letter; 576

HALS, Frans, 1581/85-1666
Banquet of the officers of the
Civic Guard Company of St.
George; 609c
Banquet of the officers of the
Company of St. Hadrian; 189,
609c
Banquet of the officers of the
St. George Militia Company;
303, 608c
Boy with a flute; 303
Boy with a skull; 609c
Broecke, Pieter van den; 609cd
Chambre, Jean de la; 609c
The Civic Guards of St. George;
345
Claesdochter, Cornelis Vooght;
303
A couple in a garden; 609c
Coymans, Isabella; 609c
Croes, Willem; 74c, 210
Descartes; 303
A family group in a landscape;
442, 609c
Family group with a Negro servant
in a landscape; 609c
Female Regents of the Old Men's
Home; 303
Governors of the St. Elizabeth
Hospital; 187
The gypsy; 283c
Gypsy girl; 74c, 608c, 699c
Heythuyzen, Willem van; 74c,
576c, 583c, 608c
Laughing cavalier; 189, 303, 608c,
609c

Laughing fisherboy; 609c
Male Regents of the Old Men's
Home; 303
Malle Babbe; 74c
Man with a herring; 436c
Married couple; 74c, 583c
A married couple in a garden;
157c
Massa, Isaac and his wife; 189,
303, 609c
The Meager company; 197
The merry drinker; 74c, 97, 609c
Nurse and child; 74c, 609c
Officers and sergeants of the Civic
Guard Company of St. Hadrian;
609c
Portrait of a gentleman; 189
Portrait of a lady; 98c
Portrait of a man; 157c, 210, 583c,
609c
Portrait of a man in a slouch hat;
609c
Portrait of a man in his 30's; 609c
Portrait of a man with folded
arms; 609c
Portrait of a seated woman; 157,
609c
Portrait of a woman; 609cd
Portrait of a young man holding a
glove; 341c
Portrait of a young woman; 283cd
Portrait of an officer; 39c, 583
Portrait of an unknown man; 382c,
609c
Portrait of an unknown woman;
609c
Ramp, Yonker, and his sweetheart;
291c
Regentesses of the Almshouse at
Haarlem; 576, 609c
The Regentesses of the Old Men's
Almshouse, Haarlem; 608c
Regents of St. Elizabeth's Hospital;
303
Regents of the Old Men's Alms-
house, Haarlem; 609c
The St. George Militia Company;
303
Steenkiste, Freyntje van; 189
Two laughing boys; 609cd
Westrum, Jasper Schade van; 74c
Young man holding a skull; 157c
A young man with his sweetheart;
303

HALS, Frans, Follower
Flute player; 553

HALSMAN, Philippe
Dali as Mona Lisa; 361

HALSWELLE, Keeley, 1832-91
The haunt of the will o' the wisp;
604

HAMANN, Marilyn D., 1945-
Untitled; 153

HAMBLEN, Sturtevant, fl. 1837-56
Jewett, Mr. and Mrs. Aaron; 381
Jewett, Hannah M.; 158

HAMBLET, Margaret Wooldridge
Rising sun lane; 23c

HAMBLETT, Theora, 1895-
Angel's request; 226c
Ascension; 226c
Banner school; 226c
Bear in the cage; 226c
Blackberries; 226c
Calamus vine; 226c
Carrying a bale of cotton to mar-
ket; 226c
Caught; 226c
Christmas trees; 226c
Chronicles I 21: 15-16; 226c
Chrysanthemum; 226c
Cotton picker; 226c
Cotton pickers; 226c
Cotton weighing-up time; 226c
Crosses; 226c
Day's work is over; 226c
The devil jumping from the cliff;
226c
A dream--irises; 226c
Exploded butterfly; 226c
Feeding chickens; 226c
First cotton gin at Paris Spring;
226c
From life to eternity; 226c
God calling the soldier boys; 226c
God's cavalry; 226c
The Golden Gate; 226c
Grandmother Cobb's dream; 226c
Hansel and Gretel; 226c
A hayride and a tragedy; 226
He is risen; 226c
Heaven's descent to earth; 226c,
243
Hickory tree and slide; 226c
Home; 226c
Horse block; 226c
Hot pepper; 226c
Let the feet go tramp, tramp,
tramp; 226c

Life's highway; 226c
Little red shoe; 226c
Long step Hamblett Hill; 226c
Madonna; 226c
Memphis bridge; 226c
Moses and the burning bush; 226c
Mushrooms; 226c
My old home; 226c
O'Tuckoola Consolidated School;
226c
Our fireplace on hog-killing day;
226c
The pasture at our old home; 226c
Peter's release from prison; 226c
Playing Indian; 226c
Playing tennis; 226c
Resting at a spring; 226c
Saturday's chores; 226c
Shadrach, Meshach and Abed-Nego;
226c
Sorghum making day; 226c
Spring cleaning; 226c
Star of Bethlehem; 226c
Stiff starch; 226c
Still life; 226c
Symbols of faith; 226c
Swimming geese and wash day;
226c
Temple in the sky; 226c
A tiskit, a taskit; 226c
Toys; 226c
Trinity; 226c
Wagon carrying cotton to the gin;
226c
A wish, a vision, a fulfillment;
226c
Working time; 226c

HAMEL, Théophile, 1817-70
Laterrière, Mme. Marc Pascal de
Sales; 234
Self-portrait; 234

HAMILTON, Gavin, 1723-98
The abdication: Mary Queen of
Scots resigning her crown; 279
Gunning, Elizabeth, Duchess of
Hamilton; 279
Hector's farewell to Andromache;
587
Mary, Queen of Scots resigning her
crown; 537, 538
Oath of Brutus; 287
Priam redeems the dead body of
Hector; 576
The rape of Helen; 279

HAMILTON, Gawan, 1698-1737
An artist's club in London; 194,
 434, 587

HAMILTON, James, 1819-78
Burning oil well at night near
 Titusville, Pa.; 402
The capture of the Serapis by
 John Paul Jones; 496
Foundering; 402
Last days of Pompeii; 131, 402
London, Canada West; 234
Marine; 267
Naval engagement between the
 Monitor and the Merrimac; 266
What are the wild waves saying;
 13, 530

HAMILTON, Richard, 1922-
I'm dreaming of a white Christ-
 mas; 511
Interior II; 576
Just what is it that makes today's
 home so different, so appeal-
 ing?; 449, 511c
Kent State; 449
Knight, Patricia; 434
People; 449
$he; 387c, 511
Swingeing [sic] London; 449
Towards a definitive statement on
 the coming trends in men's
 wear and accessories; 9c

HAMILTON, Russ A., 1932-
Deserted elevator [grain]--Sheldon,
 Neb.; 23
The last run; 23

HAMMERSHOI, Vilhelm, 1864-1916
Nude female model; 409

HAMMOND, Gertrude Demain,
 1862-1953
Memories; 524

HAMMOND, John, 1843-1939
St. John harbor; 234

HAN KAN, fl. 720-60
Horse; 88
The night shining white steed; 576
Shining light of the night; 80

HANDELL, Albert G., 1937-
Portrait of a young man; 520

HANNAH, Jay
Apples; 380

Morning and afternoon light; 380
New London harbor; 380
Pemaquid Point Light; 380c
Peter; 380
Round table and apples; 380c
Round table from above; 380
Studio light with flowers; 380
The Tiffany vase; 380c

HANNEMAN, Adriaen, 1601-71
William III when Prince of Orange;
 382

HANSEN, Carl C.C., 1804-80
Danish artists in Rome; 409

HANSON, Duane, 1925-
Woman with suitcases; 348

HANSON, Paula
Abandoned; 23
Coral arch; 23
God's splendor; 23c
Industrious; 23

HANSON, Philip, 1943-
I have been there; 153

HARA BUSHO, 1866-1912
Portrait of the artist Henry; 230

HARADA NAOJIRO, 1863-99
German girl; 230
Kannon riding on a dragon; 230c
Landscape by the sea; 230
Shoemaker; 230c

HARARI, Hananiah, 1912-
Hatfield, William; 520

HARBURGER, Edmund
The seamstress; 354

HARDIN, Helen, 1943-
Winter awakening of the O-khoo-wah;
 415

HARDING, Chester, 1792-1866
Boone, Daniel; 381, 399
Smith, John Speed, family; 381

HARDING, George
Monterail--Chateau-Thierry Road;
 122c

HARDING, J.H., 1777?-1846
Faggot-gatherers; 105

HARRIS, Robert
A meeting of the school trustees;
234

HARRIS, Thomas, 1908-
Almond trees, Majorca; 553

HARRISON, Birge L., 1854-1911
Woodstock meadows in winter; 111

HART, Emily
The end of a story; 524

HART, George O., 1868-1933
The Bahamas; 267

HART, James M., 1828-1901
A bit of Lake Placid; 410
In the Adirondacks; 410
The mill; 410c
The old schoolhouse; 399

HART, Solomon Alexander, 1806-81
Lessons from the rabbi; 604

HART, William M., 1823-94
After the storm; 410
Chocorus Mountain, N.H.; 410
Conway Valley, N.H.; 410c
Interior of a stable; 399
Seashore--morning; 14c
Sunset on Long Island; 176

HARTAL, Paul Z.
Chateau de Ramezay; 23
The room; 23c

HARTIGAN, Grace, 1922-
Barbi; 396
Black crows, poem painting; 396
City life; 396
The Creeks: interior; 449c
Essex and Hester Red; 396
Grand Street brides; 396
The year of the cicada; 396

HARTLEY, Marsden, 1878-1943
Abstraction; 342c
Abstraction blue, yellow and green;
342
Berlin ante-war; 617c
Bowl with fruit; 617c
Color analogy; 617c
Composition; 342, 617c
Crow with ribbons; 348c
Desertion; 617c
Eight bells folly: Memorial for
Hart Crane; 13

Evening storm, Schoodic, Me.;
402c
Fishermen's last supper--Nova
Scotia; 472
Landscape, New Mexico; 402
Lilies in a vase; 617c
Mt. Katahdin; 210
The mountain, autumn; 617c
Mountain lake, autumn; 472
The mountains; 617c
Movement No. 2; 472
Movements; 3c, 111
New Mexico recollection No. 6;
233c
New Mexico recollections; 617c
Northern seascape; 14c
Northern seascape--off the banks;
402
Off to the banks; 402
Painting No. 5; 472c
Painting No. 6; 342
Peaches and lemons; 528
Portrait arrangement No. 2; 342
Portrait of a German officer; 348,
370c, 445c, 579
Smelt Brook falls; 576
Still life No. 1; 617c
Still life No. 3; 283c
The window; 617c

HARTMANN, Ludwig, 1835-1902
Two horses on the Inn River; 51

HARTUNG, Hans, 1904-
Painting; 283c
T. 1947, 25; 549c
T 1951/I; 430c
T 1963 - R6; 418
T 1063 - R40; 3c
T 1974. E15'; 438c
Tableau; 576

HARTWELL, G. G.
Man; 158

HARUNOBU, Suzuki, 1724-70
The gathering of flowers; 283c

HARVEY, George, 1800/01-78?
Afternoon--Hastings Landing, Pali-
sade rocks in shadow, N.Y.;
528c
Boys on a beach; 410c
The Covenanter's preaching; 231
Kenyon College, Gambier, O.; 410
Spring--burning up fallen trees--a
girdled clearing--Canada; 14c,
122c, 267

A sultry calm, Pittsford on the
 Erie Canal; 410
View on the Hudson; 122cd

HARVEY, Sir George, 1806-76
The curlers; 231
Holy Isle, Arran; 231
Morning on Loch Awe; 604
The mountain mirror; 604
A schule skailin'; 279

HASEGAWA KYUZO
Cherry tree; 151bc

HASEGAWA School
Autumn flowers; 151c
Tiger and bamboo; 151
Willow; 151c

HASEGAWA TOHAKU, 1539-1610
Ancient pine tree; 615
Four beloved flowers; 151
Hsien Tzu and Chu T'ou; 151d
Landscape; 151c
Maple tree; 515bc
Monkey trying to catch the reflec-
 tion of the moon; 151
Monkeys in a bamboo grove; 372
Monkeys in an old tree; 151
Pine grove; 372cd
Pine tree and cherry blossoms;
 151c
Pine tree and flowers; 151cd
Pine trees; 151
Pine trees in fog; 278
Pines and cedars; 151c
Rocks and waves; 151d
Sixteen arhats; 151d
Willow; 151
Zen patriarchs; 151d

HASEGAWA TOIN
Sixteen arhats; 151d

HASELTINE, William Stanley,
 1835-1900
Rocks at Nahant; 412
Rocks at Nantucket; 531
Seal Harbor, Mt. Desert, Me.;
 267
Vahrn in Tyrol near Brixen; 528

HASENCLEVER, Johann Peter,
 1810-53
Atelier; 409

HASLUND, Otto, 1842-1917
A concert: the artist's children
 and their playmates; 353

HASSAM, Childe, 1859-1935
Afternoon; 268c
Afternoon sky, Harney Desert; 268c
Against the light; 68
Allies Day, May, 1917; 152
Apples; 62
Au Grand Prix de Paris; 268c
Bedford Hills; 268c
Boston Common at twilight; 268c
Bridge at Old Lyme; 268c
Broadway, Newburgh, N. Y.; 492
The Chinese merchants; 268c
Church at Old Lyme; 268c
Coast scene, Isles of Shoals; 268c
Le Crépuscule; 152
Crystal Palace, Chicago Exposition;
 268c
Duck Island; 152
The Electricity Building, World's
 Columbian Exposition, of 1893;
 122c
Fifth Avenue; 152
Fifth Avenue in winter; 436c
The French tea garden; 268c
Giant magnolias; 268c
Gloucester; 268c
Grand Prix Day; 152
Hassam, Mrs., in their garden;
 268c
Headlands; 531
The hovel and the skyscraper; 152,
 268c
Headlands; 531
The hovel and the skyscraper; 152,
 268c
In the rain; 210
The island garden; 528c
Isle of Shoals garden; 267c
Le Jour du Grand Prix; 152, 257,
 268c
July night; 268c
Late afternoon, winter, New York;
 268c
The messenger boy; 268c
Montauk; 68
New England headlands; 13
A New York blizzard; 281c
The New York window; 268c
Newfields, N. H.; 267c
Old house, Dorchester; 22c
Old Long Island landscape; 268c
Place Centrale and Fort Cabanas,
 Havana; 268c
Pomona; 176
Pont Royal, Paris; 268c
Rainy day, Boston; 268c
Rainy day, Rue Bonaparte, Paris;
 445c
The room of flowers; 268c

South ledges, Appledore; 268c
The Spanish Stairs, Rome; 268c
Spring in West 78th St. , New
 York; 399
Summer sunlight; 68
Sunset at sea; 152
Tuileries Gardens; 268c
Une Averse, Rue Bonaparte; 268c
Union Jack, New York, April morn;
 268c
Union Square in spring; 268c, 576
Union Square, New York; 399
View of London; 267
Washington Arch in spring; 268c,
 460c

HASSAN, Mohammed, 19th century
Mother and child with cat; 335c

HATHAWAY, Rufus, 1770-1822
Lady with her pets; 17, 348c,
 370c

HAUDEBOURT-LESCOT, Antoinette
Cecile, 1784-1845
Self-portrait; 184, 236

HAUSNER, Rudolf, 1914-
Adam vis à vis; 114c
Ark of Odysseus; 114c

HAVELL, Charles Richards, fl.
 1858-66
The thatchers, cutting reeds; 605

HAVELL, Edmund, 1819-94
Weston Sands in 1864; 195, 605

HAVELL, Robert, Jr. , 1793-1878
Tarrytown, old Dutch church and
 Beekman Manor House; 410c
Two artists in a landscape; 412
View of the Hudson River; 410

HAVELL, William, 1782-1857
Coolies resting; 105
A road under trees in Knole Park,
 Kent; 600

HAVERMAN, Margareta, fl. 1716-
 50
Still life; 218
Vase of flowers; 236

HAVERS, Alice, 1850-90
Blanchisseuses; 524

HAVERTY, Joseph Patrick, 1794-
 1864
Father Matthew receiving a re-
 pentant pledge-breaker; 605

HAWKER, Susan
Meadows, Steeple Aston; 607

HAWKSWORTH, William T. M. ,
 1853-1935
A timber ship, Great Yarmouth;
 105

HAWORTH, John
Severini, spherical expansion of
 light; 320

HAWTHORNE, Charles Webster,
 1872-1930
Fisher children; 176
Three women of Provincetown; 29

HAY, George Austen, 1915-
Covered bridge; 23c
Portrait study in winter light; 23c

HAY, William M. , fl. 1852-81
A funny story; 605

HAYDEN, Henri, 1883-1970
The factory; 66
Still life; 449

HAYDON, Benjamin Robert, 1786-
 1846
Christ's entry into Jerusalem; 409
Judgment of Solomon; 187
The mock election; 382
Punch and Judy; 434
Punch or May Day; 195

HAYES, Edwin, 1820-1904
Alabama vs. the Kearsage; 122c
Dutch fishing boats entering Calais
 harbor; 604

HAYES, George A.
Mahantangs Valley farm; 370

HAYES, Matilda, fl. 1821
Male partridge; 105

HAYET, Louis, 1864-1940
Vegetable market; 124, 513

HAYEZ, Francisco, 1791-1881/82
Bathsheba; 285c

Sunset on the rocks, Newport; 530
Sunset on the Rowley marshes;
530
Sunset over a wooded bay; 530
Sunset over Lake Champlain; 530
Sunset over the marshes; 530
Sunset: tropical marshes; 530
Susanna; 530
Thimble Island; 530
Thimble Islands near New Haven;
530
Thunderstorm at the shore; 530
Thunderstorm, Narragansett Bay;
436c
Tropical bird in a mountainous
landscape; 530
Tropical harbor: moonlight; 530
Tropical landscape; 530
Tropical orchid; 530
Tropical plums; 530
Tropical scene; 530
Tropical sunset: Florida marsh
with cattle; 530
Tropical uplands; 530
Twilight; 530
Twilight on the Plum Island River;
530
Twilight, salt marshes; 402
Twilight, Spouting Rock Beach;
412, 530
Two blue crest hummingbirds; 530
Two branches of green leaves; 530
Two Brazilian fairy hummingbirds
beneath large leaves; 530
Two Cherokee roses on red velvet;
530
Two fighting hummingbirds with
two orchids; 408, 530
Two fishermen in the marsh at
sunset; 530
Two green-breasted hummingbirds;
530
Two hummingbirds at a nest; 530
Two hummingbirds: copper-tailed
amazile; 530
Two hummingbirds guarding an
egg; 530
Two hummingbirds: sappho
comets; 530
Two hummingbirds: tufted coquettes;
530
Two hummingbirds with a nest and
fledgling; 408
Two hummingbirds with their young;
530
Two hummingbirds with two vari-
eties of orchids; 530
Two hunters in a landscape; 530

Two magnolia blossoms in a glass
vase; 530
Two oranges with orange blossoms;
530
Two owls at sunset; 530
Two puff-legged hummingbirds with
a nest and fruit; 530
Two red roses; 530
Two small hummingbirds above an
orchid; 530
Two swallow-tail hummingbirds
with fledglings; 530
Two thorn tails; 530
A vase of corn lilies and helio-
trope; 530
Vase of mixed flowers; 530
Vase of mixed flowers with a dove;
530
Vase of red roses; 530
View at Southport, Conn.; 530
View from Fern Tree Walk,
Jamaica; 402, 530
Waterlily; 530
Wheaton, Henry; 530
Whipple, Abraham; 530
White Brazilian orchid; 530
White Mountain landscape; 530
The white rose; 530
White wild roses; 530
Wilderness sunset; 410, 530
Wildflowers in a brown vase; 530
Winding River, sunset; 530
Woodland scene; 530
Woodland sketch; 530
Yellow daisies in a bowl; 530
Yellow jasmine; 530
Yellow orchid and two humming-
birds; 402, 530

HEALY, George P. Alexander,
1813-94
Beauregard, Pierre Gustave Tou-
tant; 381
Buchanan, James; 122
Calhoun, John Caldwell; 381, 399
Franklin urging the claims of the
American colonies before Louis
XVI; 266
Lincoln, Abraham; 122cd, 381
The peacemakers; 122c
Pierce, Franklin; 122
Polk, James Knox; 122
Tyler, John; 122
Van Buren, Martin; 122
Webster, Daniel; 399

HEALY, Wayne
Ghosts of the barrio; 167c

HENNINGSEN, Erik, 1850-1908
The changing of the guard; 354
A wounded workman; 354

HENNINGSEN, Frans, 1851-1915
Evicted tenants; 354
The pawnshop; 354

HENRI, Robert, 1865-1929
The art student; 212
Betalo; 176
Blind Spanish singer; 616
Cafferty, Tom; 616c
Girl seated by the sea; 531
Herself; 616
Laughing boy; 472
The man who posed at Richelieu;
 616
Maria y Consuelo; 616c
Mary; 576
Painter and his model; 528c
Southrn, Frank L., M.D.; 616
Storm tide; 616
Thammy; 616
West 57th St., New York; 257
Woman in cloak; 616
The young girl; 616c
Young woman in white; 497, 616

HENRY, Edward Lamson, 1841-
 1919
The Camden and Amboy Railroad
 with the engine Planet in 1834;
 266c
City Point, Va., headquarters of
 General Grant; 399
Country school; 399
Entering the lock; 267
The 9:45 accommodation, Strat-
 ford, Ct.; 14c, 122c, 399
Old Dutch church, New York; 399
The station on the Morris and
 Essex Railroad; 257

HENRY, George, 1859?-1943
The apple orchard; 604
The Druids: bringing in the
 mistletoe; 231, 279
Galloway landscape; 231, 279
Girl gathering mushrooms; 231
A Japanese lady with a fan; 279
Poppies; 231c
River landscape by moonlight;
 231c

HENSCHE, Henry, 1901-
Ada reading; 380
August garden; 380

Blue still life in sunlight; 380c
Dominic in the winter light; 380
Lavender harmony; 380
Nancy in sunlight; 380
October glory; 380c
Pamela in sunlight; 380
The slave; 380c
Teddy; 380

HENSELER, Ernst
A parliamentary party; 353

HENSHALL, John Henry, 1856-
 1928
The public bar; 604, 605

HENSHAW, Frederick Henry, 1807-
 91
A forest glade, Arden, Warwick-
 shire; 604

HENZELL, Isaak
Fisherfolk on a beach; 604

HERALD, James W., 1859-1914
The portico; 231

HERBERT, John Rogers, 1810-90
Children of the painter; 195
Cordelia disinherited; 195
The monastery in the 14th century
 --boar hunters refreshed at St.
 Augustine's monastery, Canter-
 bury; 384
Our Savior subject to his parents;
 604
The youth of our Lord; 434

HERBIN, Auguste, 1882-1960
Composition; 481
Nest; 449
Peinture; 217
Rain; 438c

HERDMAN, Robert, 1829-88
The execution of Mary, Queen of
 Scots; 537, 538
The fern gatherer; 279
Landless and homeless--farewell
 to the glen; 605
Mary, Queen of Scots, returning to
 Scotland; 537, 538

HERFORD, Mrs. John
Landscape at Kenilworth; 524

HERING, George Edward, 1805-79
A lakeside village in the Alps; 604

HILL, David O. , 1802-70
Chalmers, Miss, and her brother;
279

HILL, James John
Going home; 604

HILL, Joan, 1930-
The pecan gatherers; 415
Wars and rumors of wars; 253

HILL, John Henry, 1839-1922
Coblentz after Turner; 412
Sunnyside, Tarrytown, New York;
267, 528
Sea coast, Maine; 531

HILL, John William, 1812-79
Apples and plums; 528c
Broadway and Trinity Church; 267
Dead blue jay; 528
Erie Canal; 528

HILL, Thomas
Strangeways, Susanna; 587

HILL, Tom, 1922-
Afternoon glow; 254
Behind the chutes; 254c
Bisbee; 254
El cargador; 254
Cerrillos cottonwood; 255
Chrysanthemums; 254c
Church at San Antonio Aguas Cali-
entos; 254c
Church façade, Mexico; 255
Coconut lady, San Blas; 254
The corral; 254
Deserted ranch, winter day; 254
Evening in Taxco; 254
Familiaçao, Portugal; 255
Fishing village, Portugal; 254
Flores, Juan Padilla de las; 255
High noon, Albufeira; 254
High noon, Dolores Hidalgo; 254
Iglesia San Antonio, San Miguel;
254
In front of the church; 254
In Port Antonio; 254
In the flower market; 254
Late afternoon near Sonoita; 254c
Laurel; 254c
Manzanillo; 254c
Manzanillo afternoon; 254
Market day, Chichicastenango; 254
Market in Patzcuaro; 254
Mexican balcony; 254
Mexican doorway; 254

Mexican lady with chicken; 254
Mexican market; 255
The mission at Carmel; 255
Nazare, Portugal; 254
Old adobe; 254c
Old Arizona windmill; 254
Old wagon; 254
On Pila Seca Street; 254
Paper flower vendors; 254
Prickly pear and cholla; 254
Rio Hondo Mountains; 254
Rural farm, Mexico; 254
Rural Jamaica; 254
The steps to Las Monjas; 254
Street in San Miguel; 254c
Summertime, Arizona; 254
Sunday morning in the market;
254c
Taxco awnings; 254c
Taxco couple; 254
Three Mexican women; 254
Waist-loom weaver, Guatemala;
254
Water in the river; 254
Watermelon stand; 254
Yalapa; 254c

HILLIARD, Nicholas, 1547?-1619
Clifford, George, Earl of Cumber-
land; 587
Henry, Prince of Wales; 382
Northumberland, The 9th Earl of;
434
Portrait of a young man; 583c
Portrait of the artist, aged 30;
434c
Queen Elizabeth I; 283c, 434, 576
Raleigh, Sir Walter; 9c
Young man among roses; 434c,
576c
A youth leaning on a tree; 205, 607

HILLIER, Tristram, 1905-
Harness; 478
La route des Alpes; 511
Viseu; 478

HILLINGFORD, Robert Alexander,
1828-
The surrender of the French at
Blenheim; 604

HILLS, Robert, 1769-1844
A village in snow; 600

HILTON, Roger, 1911-75
Dancing woman; 511
February; 511

June; 449
Oi yoi yoi; 434c
October, 1956; 387c
September, 1961; 576

HINCKLEY, Thomas, 1813-96
Windgap; 233c

HIND, William G.R., 1833-89
Bar in mining camp; 234
Oxen with Red River cart; 234

HINE TAIZAN, 1813-69
Rainy day in autumn; 371
White sands, green bamboo; 371

HINEY, Harlen
In the Black Canyon; 209c
Vancouver Island; 209c

HINZ, George, fl. 1670
Cabinet of curiosities; 40c
Treasure cabinet; 40

HIROSHIGE, 1797-1858
Snow landscape; 307

HIRSCH, Joseph, 1910-81
Amalgamated mural; 242d
Editorial; 29

HIRSCHFIELD, Emil
Blessing of the new boat; 354
Procession of Our Lady of the Sea;
354

HIRSHFIELD, Morris, 1872-1946
The artist and the model; 243c
Girl in a mirror; 328c
Girl with angora cat; 289c
Girl with dog; 89c, 243c
Girl with pigeons; 89c
Nude at the window; 348c
Woman on couch; 250
The young patriot; 370c

HIRST, Claude Raguet, 1855-1942
Still life; 267c

HIRT, Heinrich
Children with kitten; 51

HISHIKAWA MORONOBU, 1618-94
Beauty looking over her shoulder;
278

HITCHCOCK, David Howard, 1861-
1943
Hawaiian volcano; 402

HITCHENS, Ivon, 1893-
Arched trees; 553
A boat and foliage in five channels;
576
Damp autumn; 449
Firwood Ride, gentle spring; 382
Flower group; 511
Hut in woodland; 553
Winter walk No. 3; 434
Woodland, vertical and horizontal;
387c

HITCHINS, Joseph, 1838-93
The birches; 233c

HITTELL, Charles, 1861-1938
Signal of peace; 233c

HITZ, Dora
Motherhood; 524
Portrait of a little girl; 524

HNAT, Adaline
The flock; 492

HOARE, William, 1707-92
Gainsborough at about 40; 240

HOBBEMA, Meindert, 1638-1709
The avenue, Middleharnis; 64, 74c,
283c, 303, 442c, 576, 608c
Road to Middelharnis; 294c
Ruins of Brederode Castle; 303
A stormy landscape; 303
View of the Haarlem Lock, Am-
sterdam; 189
A view of the Haarlem lock and
the Herringpackers' Tower,
Amsterdam; 282
The watermill; 74c, 294c, 553
A watermill by a woody lane; 382
The watermill with a great red
roof; 98c
Wooded landscape; 189, 608c
A woody landscape with a cottage;
157c
A woody landscape with a cottage
on the right; 576

HOBSON, Alice M., 1860-
Room at Leicester; 524

HOCKENHULL, James L., 1939-
Block signal; 153

HOCKNEY, David, 1937-
Accident caused by a flaw in the
canvas; 527
The actor; 527

Rimbaud; 167c
Two girls; 167c

HOLYOAKE, William
In the front row at the Opera;
 604, 605

HOMER, Henrietta Benson, 1809-84
Two blackbirds on a blackberry
 cane; 245c
Wood thrush on a willow branch;
 245c

HOMER, Irvine
Awaiting the milk truck; 340c
The birthday party; 340c
Evening worship; 340c
The flood; 340c
Manhunt near my home; 340c
Summer by the Hawkesbury; 340c

HOMER, Winslow, 1836-1910
Adirondack lake; 245
Adirondack guide; 245
Adirondack scene; 245
After the hunt; 245
After the hurricane; 228c, 616c
After the tornado; 16c, 245
An afterglow; 245
Amateur musicians; 245, 257, 399
Army boots; 245
Arrival of the fishing boats; 245
The artist's studio in an afternoon
 fog; 245c
At Tampa; 228c, 245
At the cabin door; 245
Autumn; 245d
Autumn foliage with two youths
 fishing; 245
Autumn treetops; 245c
Backrush; 245
Bahama boatmen; 245
Balcony in Cuba; 228
Banana tree, Nassau; 245
Barnyard with boy feeding chickens;
 245
Bass; 245
Bass fishing, Florida; 245
The bather; 245
Beach, late afternoon; 245
Beach scene, Tynemouth; 245, 528
The bean picker; 245
Bear and canoe; 245
Bear hunting, Prospect Rock; 245
Beaver Mountain, Adirondacks,
 Minerva, N.Y.; 245
Below zero; 245c
Bermuda; 228c, 245, 374c

Bermuda settlers; 228c, 245
The birch swing; 245
Blackboard; 245
Blossom time in Virginia; 245
Blown away; 245c
The blue boat; 245c
Blue Spring, Fla.; 228, 245
The boat builders; 245
The boatman; 245
Bo-Peep; 245
Boy and fallen tree; 245
Boy and girl in a field with sheep;
 245
Boy and horse ploughing; 245
Boy holding logs; 245
Boy in a boatyard; 245
Boy on the rocks; 245
Boy with anchor; 245
Boys and kitten; 245
Boys beaching a dory; 245
Boys in a pasture; 245
Boys in dory; 245
Boys wading; 531
Breaking storm, Maine coast; 245
Breaking wave; 245
Breezing up; 13, 39c, 445c
The briarwood pipe; 245
The bridle path, White Mts.; 245
Bridlington Quay; 245
The bright side; 245, 399
The brush harrow; 245
The buccaneers; 245
The busy bee; 245
The butterfly; 245
The butterfly girl; 245
Cabins, Nassau; 16
Call to dinner; 245
Calling the pilot; 245
Camp fire, Adirondacks; 245
Campfire; 245
Canadian boy; 245
Cannon Rock; 245
Canoe in the rapids; 245
The carnival; 245, 399
Casting; 245
Casting, number 2; 245
Casting for a rise; 245
Casting in the falls; 245
The cellist; 245
Cernay la Ville--French farm; 245
Channel bass; 16, 245
Children playing under a Gloucester
 wharf; 245
Children sitting on a fence; 245
Civil War trooper, soldier meditat-
 ing beside a grave; 245
The clambake; 245
Clamming; 245

Clear sailing; 245
Cloud shadows; 245
Coast in winter; 245
Coast of Maine; 245
Coastal scene with boats, women
 and children; 245
Cocoanut palms; 245
The coming away of the gale; 187
The coming storm; 228, 245
The conch divers; 228c, 245
Contraband; 245
Coral formation; 228c, 245
Corn husking; 245
Cotton pickers; 245, 420
A country lad; 245
Country school; 14c, 122c, 245c,
 370
The country store; 245, 354
Coursing the hare; 245
Crab fishing off Yarmouth, Eng-
 land; 245
The croquet match; 412
Croquet player; 176, 245
Croquet players; 245, 257
Croquet scene; 98c, 124c, 245c,
 399, 348c
Crossing the pasture; 245
Dad's coming; 245
Dance of the woodsmen; 245
Day is done; 245
Deck passengers; 245
Deer drinking; 245c, 528c
Defiance: inviting a shot before
 Petersburg, Va.; 245, 616
de Kay, Helena; 245
Diamond shoal; 228c, 245, 267c
The dinner horn; 245
Dog on a log; 245
The dory; 245
Driftwood; 245
Driving the cows to pasture; 245
The dunes; 245
Early evening; 245c
Early morning after a storm at
 sea; 245
Eastern Point Light; 245
Eastern Point, Prout's Neck; 245
Eight bells; 14c, 245c, 616c
End of the day, Adirondacks; 245
The end of the hunt; 245, 492
Evening on the beach; 245
A fair wind; 245c
The fallen deer; 245
Farm scene; 245
Farmer in field; 140
Farmyard scene; 245
Farmyard with duck and chickens;
 245

Feeding time; 245
Fiction; 245
Fish and butterflies; 245
Fisher folk in dory; 245
Fisherfolk on the beach, Tyne-
 mouth; 245
Fisherfolk, Tynemouth; 245
The fisher girl; 245, 267
A fishergirl sewing; 245
Fishergirls on the beach, Tyne-
 mouth; 245
Fisherman's day; 245
Fisherman's family; 245
The fisherman's wife; 245
Fishermen at sundown; 245
Fishermen in dories; 245
Fisherwomen; 245
Fishing; 245
Fishing boats, Key West; 228c,
 245
Fishing in the Adirondacks; 245c,
 267
Fishwives; 245
Flirt; 245
Florida palms; 16
Flower garden and bungalow, Ber-
 muda; 228c, 245c
The fog warning; 245, 445c
For to be a farmer's boy; 245c
Foreboding; 245
The fountains at night, Chicago;
 245
Four boys bathing; 245
Four fisher girls on the beach at
 Tynemouth; 245
Four fishwives; 245
Four rowboats with children; 245
The four-leaf clover; 245
The fox hunt; 245c, 348c
French farmyard; 245
Fresh air; 16, 245
Fresh eggs; 245
The gale; 14c, 187, 245c
A game of croquet; 245
Garrison House, York, Me.; 245
Gathering autumn leaves; 245
Girl and daisies; 245
Girl at garden wall; 245
Girl at the fence; 245
Girl by the seacoast; 124, 245
Girl carrying a basket; 245
Girl in a garden; 245
A girl in a punt; 245
Girl in an orchard; 245, 616
Girl kneeling in a field; 245
Girl on a garden seat; 245
Girl on a garden wall; 245
Girl picking apple blossoms; 245

The turtle pond; 228c, 245
Twilight at Leeds, N.Y.; 245
Two boys in a cart; 245
Two boys rowing; 245
Two children in a field; 245
Two figures by the sea; 13, 245
Two girls in a rowboat; 245
Two girls looking at a book; 245
Two girls on a cliff; 245
Two girls with sunbonnets in field; 45, 245
Two guides; 245c
Two ladies; 16, 245
Two-masted schooner with dory; 245
Two men in a canoe; 528
Two men rowing on a lake; 245
Two sailboats; 245
Two schooners, Gloucester; 245
Tynemouth Priory, England; 245
Tynemouth Sands; 245
Under a palm tree; 245
Under the cliff, Tynemouth; 245
Under the coco palm; 228c
Under the cocoanut palm; 245
Under the palm tree; 228c
Undertow; 245c
Upland cotton; 22c, 245, 390
Valentine, Almira Houghton, and Mary Chamberlain; 245
Valley and hillside; 245
The veteran; 399
The veteran in a new field; 245
View of Santiago de Cuba; 245
View from Cape Diamond, Lewis, Québec; 245
View of street, Santiago de Cuba; 228c, 245
A visit from the old mistress; 245, 420
A voice from the cliffs; 245
Volante; 245
Waiting an answer; 245
Waiting for a bite; 245
Waiting for dad; 245
Waiting for the start; 245
A wall, Nassau; 228c, 245c
Wash day, Virginia; 245
The watcher, Tynemouth; 245
Watching from the cliffs; 245
Watching the breakers; 245
Watching the tempest; 245
The water fan; 228c, 245
Waterfall in the Adirondacks; 245
Watering plants; 245
The watermelon boys; 245, 499
Waverley Oaks; 245
Waves on a rocky coast; 245

Weaning the calf; 245
Weighing anchor; 228
West Indian divers; 228c, 245
West Point, Prout's Neck; 245c, 348, 576c
The west wind; 245c
White house in Bermuda; 245
White mare; 245
White rowboat, St. John's River; 228c, 245
Whittling boy; 245
Winding line; 245
Winter coast; 245c, 402
Winter, Prout's Neck, Me.; 245
Wolf's Cove, Province of Québec; 245
Woman and elephant; 245
Woman driving geese; 245
Woman in autumn woods; 245
Woman on the beach, Marshfield; 245
Woman peeling a lemon; 245
Woman sewing; 245
Woman with a rose; 245
Women in autumn woods; 245
Women on the sand; 245
The woodchopper; 267
Woodsman and fallen tree; 14c, 245
The wreck; 245c, 436c
Wreck near Gloucester; 245
The wreck of the Iron Crown; 245
The wrecked schooner; 228c, 245, 402
The yellow jacket; 245
Young girl at the window; 245
Young lady in woods; 245
Young woman; 245

HOMITZKY, Peter, 1942-
Connecticut binderleaf; 379c
Fairlawn; 379c
Passaic River near Fairlawn; 379
San Luis Obisbo waterworks; 379
Sonoma flower farm; 379
Staten Island III; 379
Staten Island rooftop; 379c

HOMONAI, Pal
My native country; 394c

HONANIE, Delbridge; 1946-
Awatovi; 67
Awatovi women's ceremony; 67
Corn and rain clan symbols; 67
Corn spirits; 67
Flute player; 67
Flute society; 67c

Hopi ceremony; 67c
Hopi kachina face design; 67
Hopi life; 67c
Hopi pottery design; 67
Initiation of the children; 67
Kachinas and mudhead; 67
Navajo kachina faces; 67
Petroglyph--Water Clan; 67
Snow Clan kachina; 67
Spirits of dead lifted by clouds; 67
Symbols of Powamu; 67
Symbols of war god; 67
Two Uncle Star kachinas; 67c
Warriors; 67
The whippers of Old Shungopovi; 67
Women's Society; 67

HONCKGEEST, G.
Interior of old church, Delft; 40

HONDECOETER, Melchior, de, 1636-95
Birds, butterflies and a frog among plants and fungi; 282
A chicken run; 273
The dead cock; 62
Hens, chickens, peacocks, and a turkey; 608c
Poultry in a landscape; 553
Still life with birds; 553

HONDIUS, Gerrit, 1891-
The lovers; 187c

HONE, Nathaniel, 1718-84
The conjuror; 434
Fisher, Kitty; 587

HONTHORST, Gerrit van, 1590-1656
Adoration of the shepherds; 283c, 303
Boy blowing on a charcoal stick; 406
Charles I; 591
The children of King and Queen of Bohemia; 382
Christ before the High priest; 189, 303, 442, 591
The concert; 608c
The family of the 1st Duke of Buckingham; 382
A flea catcher; 406
Merry fiddler; 40
Merry toper; 526
Merry violinist; 526

Nativity; 74c, 608c
The procuress; 189, 303
Samson and Delilah; 303, 526
The stadholder Willem II and his wife Mary Stuart; 608
Supper party; 576
Venus punishing Cupid; 526

HONTHORST, Gerrit van, Follower
A musical party; 553

HOOCH, Pieter de, 1629-84?
A boy bringing pomegranates; 303
The card players; 382
Courtyard, Delft; 553
Courtyard of a house in Delft; 303, 442c
Interior; 553, 576c
Interior of a Dutch house; 97
An interior with a woman drinking with two men and a maidservant; 282
The letter; 323
The linen cupboard; 608c
Mistress and maid; 341c
The mother; 189, 210
Mother by a cradle; 74c
The pantry; 74c, 608c
Tric-trac players; 323
A woman and her maid in a court-yard; 74c, 157c, 608c

HOOD, Rance, 1941-
Fire dance; 253
Indian bar; 253
Morning song; 415
A prayer; 253
Sioux rainmakers; 253c

HOOD, Robert, 1796-1821
A canoe of the Northern Land Expedition chasing reindeer, Little Martin Lake, Northwest Terr.; 234

HOOGSTRAETEN, Samuel van, 1627-78
Man at a window; 40
Perspective box of a Dutch interior with still life; 62
Perspective view down a corridor; 608c
Still life; 303
A view down a corridor; 40c

HOOK, James Clarke, 1819-1907
Word from the missing; 604

Office at night; 212c
Office in a small city; 212c
El Palacio; 16, 212c
Palms at Saltillo; 212c
Pennsylvanian coal town; 212c,
 616
Railroad sunset; 402, 475
Railroad train; 212
Road and houses, Cape Cod; 212c
Road and trees; 212c
Roofs of Washington Square; 212c
Roofs, Saltillo; 9, 212c
Room in Brooklyn; 212c, 283c
Room in New York; 212
Rooms by the sea; 212
Rooms for tourists; 212c
Sailing; 13, 212
St. Francis Towers, Santa Fe,
 N. M.; 267
Saltillo mansion; 212
Saltillo rooftops; 16, 212c
Sea watchers; 212c
Second story sunlight; 97, 212c,
 413c, 472
Self-portrait; 212c
Shoshone Cliffs; 16, 212c, 616
Solitude; 212
Strout's, Captain, house; 212c,
 616
Sun in an empty room; 212c,
 413c
Sunlight in a cafeteria; 212c
Sunlight on brownstones; 212c
Tables for ladies; 212c, 242,
 445c
Talbot's house; 212c
Le terrassier; 212
Two comedians; 212
Two on the aisle; 212c
Universalist Church, Gloucester;
 16, 492
Upton's, Captain, house; 212
Vermont hillside; 212c
Vermont meadow; 16
Western motel; 212c
White River at Royalton; 212c
White River at Sharon; 16c, 212c,
 267, 492
A woman in the sun; 212c, 413c
Yawl riding a swell; 16, 528c

HOPPNER, John, 1758-1810
Beaumont, Sir George; 190
Gale, Mrs. Henry Richmond; 553
Nelson, Horatio, Viscount; 382
Princess Mary; 434, 587
The Sackville children; 73
Townshend, A lady of the, family;

553
Williams, Mrs.; 583c

HORNEL, Ernest A., 1864-1933
The bell ringer; 231
The dance of spring; 231c
The Druids: bringing in the mistle-
 toe; 231, 279
Flower pickers; 604
Summer; 279
Young girl; 231c

HORSLEY, John Callcott, 1817-
 1903
Blossom time; 605
Madame se chauffe; 384
Showing a preference; 604, 605

HORST, Gerrit, 1612?-52
Esther and Ahasuerus; 282

HORWOOD, H., fl. 1876-85
The Wiser garden; 235

HOSCHEDE, Blanche
The house of Sorel-Moussel; 218

HOSFORD, Ray, 1902-
The blacksmith; 12
The coleus; 12
For amber waves of grain; 12c
The Lord is my shepherd; 12c
The mailman; 12
This is goodbye; 12c

HOSKINS, John, 1595-1664/65
Charles I; 382c
Montague, Sir Willaam; 434
Queen Henrietta Maria; 382c
Unknown woman; 434

HOTCHKISS, Thomas H.
Italian landscape; 412
Theatre at Taormina; 412

HOTHAM, Amelia, -1812
River scene; 218
Riverside landscape with a castle
 in the distance; 524

HOU MOU-KUNG
Landscape; 81

HOUCKGEEST, Gerard, 1600-61
Interior of the New Church in
 Delft; 303
The interior of the Old church at
 Delft; 74c

HOUDON, Marguerite J. A., 1771-95
Self-portrait; 524

HOUEL, Jean Pierre, 1735-1813
View of the entrance to a cave; 184

HOUGHTON, Arthur Boyd, 1836-75
Holborn in 1861; 605
Punch and Judy; 604, 605
Ramsgate Sands; 605
Volunteers; 605

HOUNTALAS, John M., 1949-
The race horse; 23c
Victorian; 23c

HOUSER, Allan, 1914-
Apache crown dance; 415
Ill-fated war party returns; 253c

HOUSSAY, Joséphine
The lesson; 524

HOUTEN, Barbara van
Portrait study of a girl; 524

HOUTEN, Mesdag van
A bleak pastoral scene; 524

HOUTHUESEN, Albert, 1903-
A tout à heure; 478
Rocks and sea spray II; 478

HOVENDEN, Thomas, 1840-95
Breaking home ties; 14c, 87, 122c
Brown, The last moments of John; 370, 399
Sunday morning; 257

HOW, Beatrice
In a Dutch cottage; 524
Le repas; 524

HOWARD, Luke
Cloud study; 412

HOWE, Oscar, 1915-
Cunka wakan dance; 415
Dakota duck hunt; 253c
Dance of the mourners; 253
Death of the double woman; 253
Victory dance; 253c, 415c

HOWE, William Henry, 1846-1929
Monarch of the farm; 45

My day at home; 45
Study for Monarch on the farm; 45

HOYLAND, John, 1934-
Green with two reds and violet; 576
10. 3. 71; 449
17. 3. 69; 387c
22. 11. 61; 449

HOYO-MARA GANG
Unity among young Chicanos; 107cd

HSI-CHIN CHÜ-SHIH
Arhat; 372

HSIA KUEI, fl. 1190-1225
Bamboo grove and mountain landscape; 372
Boat; 283c
Landscape; 510, 576
Mountain vista; 372
A pure and remote view of rivers and mountains; 80
Twelve views from a thatched cottage; 9cd
Viewing a waterfall; 510

HSIANG SHENG-MO, 1597-1658
Meditative visit to a mountain retreat; 337

HSIAO YUN-TS'UNG, 1596-1673
Landscape; 576
Landscape in the style of Wu Chen; 337

HSIEH HUAN, 1370-1440
A literary gathering in the apricot garden; 81c

HSIEH SHIH-CH'EN, fl. 1500
Clearing after snow in a mountain pass; 81
Landscape after rain; 81
Misty trees by a level lake; 81

HSÜ LIN, fl. 1506
Winter landscape with a man arriving at a house; 81

HSÜ PEI-HUNG, 1895-1953
Running horse; 88

HSÜ PEN, fl. 1380
Streams and mountains; 80

HSÜ TAO-NING, 11th century
Fishing boats on the autumn river;

179
Fishing in a mountain stream; 88d,
576cd

HSÜ WEI, 1521-93
Bamboo; 88d
Flowers and other plants; 81
Four seasons; 576d
Landscape with figures; 81
Peony, banana plant and rock; 615

HSÜEH-CH'UANG P'U-MING, 14th
century
Lingering fragrance from the nine
fields; 510
Lonely fragrance on the hanging
cliff; 510
Orchids; 615

HUA YEN, 1682-1765
An autumn scene; 88c
Autumn music and poetic thoughts;
188
Cloudsea at Mt. T'ai; 188
Giant bird; 188
The sound of autumn; 615

HUANG CHÜ-TS'AI, fl. 976-98
A pheasant and sparrows among
rocks and shrubs; 80

HUANG KUNG-WANG, 1269-1354
Dwelling in the Fu Ch'un Moun-
tains; 80c, 88d, 576, 615d
Rivers and hills before rain; 80
The stone cliff at the pond of
heaven; 80

HUANG SHEN, 1687-1768?
Landscape; 615
Ning Ch'i with his ox; 576

HUANG TING, 1660-1730
Snow clearing in the mountains; 88

HUBARD, William J., 1807-62
Calhoun, John C.; 399

HUBBARD, Calvin
Space adventure; 48c

HUBER, Jean, 1721-86
The artist painting a portrait of
Voltaire; 143

HUBER, Johann Rudolf, 1668-1748
Haller, Albrecht von; 143

HUBER, Wolfgang, 1480/90-1553
Lamentation; 576

HUBERT-SAUZEAU, J. Gabriel
Circus wrestlers; 354

HUCHTENBERG, Jan van, 1647-
1733
A battle; 282

HUDSON, Julie H., 1909-
The view; 23c

HUDSON, Thomas, 1701-79
Byng, Admiral John; 240, 587
Pole, Sir John and Lady; 587

HÜBNER, Carl W., 1814-79
The emigrants' farewell; 409

HUET, Jean Baptiste, 1745-1811
Spaniel attacking a turkey; 184

HUET, Paul, 1803-69
Flood at St. Cloud; 460, 576
The footbridge; 506c
Guardians' house in the forest of
Compiègne; 184
Rocks in the forest of Fontaine-
bleau; 480
View of Rouen; 409

HUGE, Jurgan Frederick, 1809-78
Bunkerhill; 528
Burroughs; 348c

HUGGINS, William John, 1781-1845
The Asia off Hong Kong; 421c
The East Indiaman Atlas off Prince
of Wales Island; 121c
First packet to Dublin: George IV
on board; 121
A pair of leopards; 604

HUGHES, Arthur, 1832-1915
Annunciation; 232
April love; 232c, 409, 576
The eve of St. Agnes; 232
Fair Rosamund; 232
Home from sea; 232, 434
The knight of the sun; 195c, 471c
The long engagement; 232, 471c,
605
Nativity; 232
Ophelia; 232c, 471c, 553, 604
Trist, Mrs. Harriet Susanna and
son; 195
The tryst; 232
The woodman's child; 232

Procession in Spain; 411c
Reflections; 411c
Rinds; 411c
River reflections; 411c
Rocky landscape; 411c
Ruins 1; 411c
Ruins 2; 411c
Sally; 411c
Scene at Cordes, France; 411c
Scene at Cuenca; 411c
Scene at St. Céré, France; 411c
Scene at Penne, France; 411c
Sedge fields; 411c
Self-portrait; 411c
Sharecropper; 411c
Sharecroppers; 411c
Snow hill; 411c
Smith, Annie; 411c
Spider lilies; 411c
Sponge diver--Tarpon Springs; 411c
The stable at Stafford Springs;
 411c
Tangle of lilies; 411c
Texas wildflowers; 411c
Thicket; 411c
Waterfall; 411c
Yellow bouquet; 411c
Yellow fog; 411c
Zinnias; 411c

HULME, Frederick William, 1816-
84
A lane near Ripley, Surrey; 604

HULTBERG, John P., 1922-
Spring's slow, explosion; 46
Surfdoom; 46c

HUMPHREY, Jack W., 1901-67
Charlotte; 234

HUMPHRY, Ozias, 1742-1810
Charlotte, Princess Royal; 382

HUNDERTWASSER, 1928-
Animal on feet; 261c
Arab geographer with satellite;
 261c
Bayer's, Konrad, death--Hana no
 Hana--the nose flower; 261c
The beard is the grass of the
 bald; 261c
Black, buried eye; 261c
The blind and crying car; 114c
Blind Venus inside Babel; 114c
Blood garden--houses with yellow
 smoke; 261c
Burning baldhead; 261c

Car with red raindrops; 261c
Cette fleur aura raison des hommes;
 449
Cockscomb; 261c
A corner of German earth; 261c
Devouring fishes and cyclists; 261c
Dreams of Doris; 261c
The end of Greece; 261c
The end of the Greeks--the Ostro-
 goths and the Visigoths; 261c
Eye scales IV; 261c
The feet of Kaorn; 261c
The five arms of gold over the
 four seas; 261c
Front view of steamer; 261c
The garden of the happy dead;
 261c
Garden with halo; 261c
Green spiral at home; 261c
Green towers in the sun; 261c
The hairdresser's heaven; 261c
Head with white windows; 261c
House of arcades and yellow tower;
 261c
Houses in the snow in silver rain;
 261c
The I don't know yet; 261c
The invasions; 261c
The island; 261c
Landscape by the silver river;
 261c
Lean picture of the fat of the gen-
 eral by Hans Neuffer; 261c
Magic cube; 261c
Man crying in spirals; 261c
Many transparent heads; 261c
Marta sees her friend; 114c
The neighbors II--spiral sun and
 moonhouse; 261c
On the high seas; 261c
Part of the steamer I; 261c
The political gardener; 114c
The rain; 261c
Roslyn; 261c
Run in the sun; 261c
Satisfied sun--the melting half-
 mountain; 261c
Shipwreck--the decline of Venice;
 261c
Sick window; 261c
Singing steamer III; 261c
Summerhouse framed with heads
 and a car; 261c
Sun and spiraloid epoch over the
 red sea; 549c
Sunset; 261c
Three hot water bottles window
 trees; 261c

Paul; 520c
Spanish girl; 521

JACKSON, Gilbert
Belasyse, Lord; 434, 550
Burton, Robert; 550
Hickman, William; 550

JACKSON, Henry
The Christ; 243

JACKSON, Samuel, 1794-1869
A mountain valley; 600c

JACOBELLO
Madonna with sleeping Child; 375
St. Anne with sleeping Virgin; 375

JACOBI, Otto R., 1812-1901
St. Anne River; 234

JACOBSEN, Antonio, 1849-1921
America's cup race in 1887; 13
Tug Gladiator; 158
Sidewheeler Shelter Island; 158
U. S. S. Constitution; 158

JACOBSZ, Dirk, 1500?-67
Occo, Pompejus; 583c

JACOVLEFF, Alexander, 1887-
1938
Madonna of the grotto; 553

JACQUE, Charles Emil, 1813-94
Garbagemen; 354
Landscape with sheep; 45
The large flock; 354
Shepherdess with her sheep; 45
The shepherd's rest; 553
Three sheep; 553

JACQUEMART Follower
Crucifixion; 375

JACQUET, Alain, 1939-
La source; 320

JÄRNEFELT, Earo
Fighting the forest fire; 354

JAGMAN, Ed., 1936-
Aspen flourish; 378c
Foot of Jones Pass; 378
The three of us; 378
Watching the hawk; 378

JAKUCHU, 1716-1800
Fowls and hydrangeas; 576

JAMES, David
Tide coming in, coast of Devon;
604

JAMES, George
Turner lying in state in his gal-
lery; 581

JAMES, William, 1882-1961
James, Henry; 281c

JAMESON, Kenneth
Above Llandre, Wales; 290c
Ripon Cathedral; 290
White flowers; 290

JAMESON, Norma
Dock leaves; 290
Farm; 290c
Lilies; 290
Red landscape; 290

JAMESONE, George, 1586-1644
Bruce, Robert; 550
Burnett, Sir Thomas, of Leys; 550
Campbell, Anne, Marchioness of
Huntly; 550
Campbell, Sir Robert, of Glen-
orchy; 550
Canmore, Malcolm; 550
Carnegie, Sir Alexander, of Bal-
namoon; 550
Carnegie, Sir David, 1st Earl of
Soutesk; 550
Carnegie, Sir John, 1st Earl of
Ethie and Northesk; 550
Colquhoun, Lady Marjory; 550
Douglas, Lady Margaret; 550
Douglas, Margaret, Marchioness of
Argyll; 550
Dun, Dr. Patrick; 550
Edmonstone, Lady Marjory; 550
Erskine, Col. Alexander, of Cam-
buskenneth; 550
Erskine, Anne, Countess of Rothes
with her daughters; 550
Erskine, Catherine, Lady Binning;
550
Erskine, John, of Otterstoun; 550
Erskine, John, 3rd Earl of Mar-
ischal; 550
Erskine, Mary, Countess Marisch-
al; 550c
Feritharis; 550
Forbes, Sir William, of Craigievar;
550
Forbes, Sir William, of Monymuk;
550

Egrets in cypress swamp; 293c
Fair and cold: Brant over dunes;
293c
Frigate birds in the Bahamas;
293c
Fuegian oyster catchers, Falkland
Sound; 293c
Geese sideslipping down; 293c
Golden twilight: Baldpates; 293c
Grappling eagles; 293c
Great horned owl on cedar: deep
forest; 293c
Helper at Hudson; 293c
Horses under cottonwood: Septem-
ber; 293c
Laughing gulls; 293c
Loons in canoe country; 293c
Moose in swamp; 293c
Morrissey ivory gull in Arctic;
293c
Mountains across the plains:
buffalo; 293c
The passing of the Old West; 293c
Pediunkers; 293c
Pronghorn antelope; 293c
Red Douglas quail; 293c
Red fox on Alaskan Peninsula;
293c
Redheads and ring-billed ducks
on the swell; 293c
Return of the voyageurs: picture
rocks in canoe country; 293c
Road after rain; 293c
The road west; 293c
Sanderlings; 293c
Shadow of the raven; 293c
Snipes at dusk; 293c
Swans over elm tops; 293c
Swans over tundra; 293c
Three frightened mallards; 293c
Three green-winged teal; 293c
Two Canada geese; 293c
White ibis in Florida; 293c
Wings across the sky; 293c
Wolf pack; 293c
Wood ducks and falling leaves;
293c
Wood ducks and silver water;
293c
The Zaca and tropic bird; 293c

JARDINE, Ellen A.
Green pastures; 23c

JARVIS, Charles W., fl. 1839-61
Jefferson, Thomas; 381

JARVIS, John Wesley, 1790-1839
Armstrong, John, Jr.; 178

Chase, Samuel; 178
Clay, Henry; 381c
Cooper, James Fenimore; 399
Paine, Thomas; 178
Perry, Oliver Hazard; 381c, 531
Poinsett, Joel Roberts; 381
Portrait of a gentleman; 381
Wilkinson, James; 178c

JASOKU, -1483
Landscapes with flowers and birds;
372

JAWLENSKY, Alexei von, 1864-
1941
Floating cloud; 503
Girl with peonies; 203c
Head; 449
House with trees; 147c
Infanta; 503c
Mediterranean coast; 283c
Nikita; 147
Olga--girl with a feathered hat;
576
Portrait of a woman; 271c
Sibyl; 503c
Spanish girl; 449
Spanish lady; 568c
Spanish woman; 503c
Still life; 449c
Still life with fruit; 568c
Still life with round table; 161
Variations on a human face; 203c
The white feather; 175c, 503
Young girl with peonies; 568c

JEANNIOT, Pierre Georges
The absinthe drinker; 354
Dinner at the Paris Ritz; 353
The introduction; 353
Polo at Bagatelle; 353

JEFFERSON, John
Tynemouth Priory; 105

JEFFERSON, Joseph IV, 1829-
1905
The old mill by the sea; 45

JEFFERYS, Charles William, 1869-
1951/52
Western sunlight, Lost Mountain
Lake; 234

JEN JEN-FA, 1254-1327
Fat and lean horses; 80
Feeding horses; 88c

JOUETT, Matthew Harris, 1787-1827
Clark, George Rogers; 178c, 399
Gratz, Mrs. Benjamin; 381
Shelby, Isaac; 381
Todd, Thomas; 381

JOULLIN, Amedee, 1862-1917
Indian woman with burden basket; 233c

JOURDAIN, Roger, 1845-
Monday; 354

JOUVENET, Jean B., 1644-1711/17
Deposition; 553

JOVAN, Bishop the Painter
Christ Pantocrator; 455

JOY, George William, 1844-1925
The Bayswater omnibus; 604, 605

JOY, Thomas Musgrove, 1812-66
The Charing Cross to Bank omnibus; 604, 605

JOY, William, 1803-67
Lifeboat going to a vessel in distress; 121

JOYCE, Marshall, 1912-
The doryman; 379c
The sea moss gatherer; 379c
Sintram; 379

JUANES, Juan de, 1500-79
Last Supper; 389

JUEL, Jens, 1745-1802
Inner Alster; 175

JUNCKER, Justus, 1703-67
The smoker; 51c

JUNGSTEDT, Axel
In the quarry, Switzerland; 354
The mines at Dannemora; 354

JUSTUS of GHENT, 5th century
Famous men; 559
Montefeltro, Federigo and Giudobaldo da; 375
Montefeltro, Federigo di, Duke of Urbino, with his son Guidobaldo, listening to a discourse; 382

JUTSUM, Henry, 1816-69
Landscape; 604

JUTZ, Carl the Elder, 1838-1916
Ducks at pond; 51
A gathering of fowl; 51

KABOTIE, Fred, 1900-
Germination; 67
Hopi ceremonial dance; 253c
Hopi masked dance; 415
Hopi snake dance; 415
The legend of the Snake Clan; 67
Snake dance; 67c, 415
Social dance; 67
Tsuku clown; 253
Woman's basket dance; 253c

KABOTIE, Mike, 1942-
Awatovi pottery elements; 67
Becoming a spirit; 67
The candidate; 67c
Ceremonial; 67
Ceremonial priest; 67c
The Christian kachina; 67c
Coming of the salako; 67
Coming of the water serpent; 67
Dark dawn blessing; 67c
Deer dancer; 67
Futurist Hopi; 67
Guardian of the waters; 67
Hawk and bee; 67
Hehe; 67
Homage to Hopi creativity; 67
Homage to Hopi overlay; 67
A Hopi dream; 67c
Hopi elements; 67c
Hopi lovers I; 67
Hopi lovers II; 67
Hopi warrior spirits; 67
Kachina faces; 67
Kachina lovers; 67
Kachina world; 67
Mother and child; 67
Music for fertility; 67
One horn with mana; 67
Portrait of a Big Horn; 67
Salako the Cloud Priest; 67c
Signatures from the past; 67
Sikyatki hand with bee; 67c
Spiritual migration; 67
Symbols of Bachavu; 67
Turquoise bird; 67
Warrior and water serpent; 67
Water serpent my father; 67

Baby girl; 311c
A bearded man; 311c
Ben; 311
Bernadette; 311c
Boys playing in the surf; 311c
Caro; 311c
A Crow chief; 311c
La familia; 311
Gina; 311c
Grampo; 311c
Inca market; 311c
Indian grandmother; 311c
Indian in blue shirt; 311
Indian Madonna; 311c
Kristina; 311c
Lea; 311c
Little Antonia; 311c
Little girl in shawl; 311c
Little girl with robe; 311c
Little Mack; 311
Little Mark; 311c
Little Stephanie; 311c
Littlest model; 311c
Market day, Mexico; 311c
Mexican farmer; 311
My mother; 311c
Nadine; 311c
Nude; 311
Old Navajo; 311c
An old timer; 311
Pañuelo azul; 311c
Pink lace and ribbon; 311
Prairie Wolf; 311c
Primping; 311c
El señor; 311
Silver bracelet; 311c
A Sioux type; 311c
Slim; 311c
Standing nude; 311c
Stephie; 311c
A Taos elder; 311c
Taos Indian; 311c
Taos, Joe Martinez de; 311c
A Taos type; 311c
Theo; 311
Trujillo, Grandfather; 311c

KELLOGG, Miner Kilbourne, 1814-89
Scott, Winfield; 381

KELLY, Ellsworth, 1923-
Atlantic; 283
Blue, black and red; 9c
Blue green red I; 387c
Blue, green, yellow, orange, red; 576
Chatham XI: blue yellow; 5c

City island; 22c
Green, blue, red; 3c
Orange and green; 449
Red blue; 348c
Red blue green; 472c
Two panels: black with red bar; 449
Two panels: yellow and black; 445c

KELLY, Sir Gerald, 1879-1972
Jane; 511

KELLY, Harold O., 1884-1955
Blacksmith and wagon shop; 296c
Coffee at the wagon; 296c
Congregation at Mt. Adams; 296c
Fourth of July races; 296c
Goats in corral; 296c
Hilltop dance hall; 296c
Hog killing time; 296c
More good people; 296c
October--first Monday; 296c
Ohio farm scene; 296c
A political rally; 296c
Ranney-Hand cows; 296c
River ferry crossing; 296c
Skinning deer; 296c
Star wagon yard; 296c
The street; 296c
Sunday morning; 296c

KELLY, Robert Talbot, 1861-1935
The flight of the Khalifa, Omdur-man, 1898; 605

KEMENY, Zoltan, 1907-65
Temps sur temps; 576

KEMP-WELCH, Lucy
Above the cove; 377
The afternoon ride; 377
An Alsatian dog; 377
Ambling home; 377c
Bay mare and foal at Bushey; 377
Bay tethered under a tree; 377
Behind the scenes; 377c
The blacksmith; 377
Bluebells in the New Forest; 377
Bringing up the guns; 377
Bushey Church and pond; 377
Carthorses on the track; 377
Chestnut horse exercising; 377
Circus ponies in their stalls; 377
Colt hunting in the New Forest; 377c
The cow byre; 377
A dapple grey in sunlight; 377

Hill valley, sunrise; 410
Lake George; 17, 333, 412, 530
Long Island Sound at Darien;
410c
Marine off Big Rock; 13, 410c,
412c, 531c
Mountain stream; 176
Reminiscences of the Catskill Moun-
tains; 410
River scene; 399
Shrewsbury River; 45, 399
Study for Trees on the Beverly
coast; 22c
Third Beach, Newport; 409
View from Cozzens' Hotel near
West Point; 17
Whirlpool, Niagara; 402
White Mountain scenery; 576

KENT, Germaine
Art ball; 23c
Lester; 23

KENT, Lester
Germaine; 23
Love story; 23c

KENT, Rockwell, 1882-1971
Azapardo River; 616
Down to the sea; 616c
Maine coast; 616
Neither snow, nor rain, nor ice
... Greenland; 616c
Polar expedition; 457
Road roller; 616
Shadows of evening; 616
The trapper; 616c
Wagner, Richard: 'Das Rhein-
gold,'' the entrance of the gods
into Valhalla; 22c

KENT, William, 1684/85-1748/58
Battle of Agincourt; 537, 538
Meeting between Henry V and
Queen of France; 537d, 538d
The quest begins; 538c

KERKAM, Earl C., 1891-1965
Self-portrait; 210

KERN, Hermann, 1839-1912
The fruit peddler; 51

KERNSTOK, Karoly
The agitator; 354

KERR, Cathy Bailey, 1928-
New home; 23

Pints, quarts and gallons; 23
Summer flowers; 23

KERSSENBROEK, Gisele von
Codex Gisele, initial P; 218

KERSTING, Georg F., 1785-1847
Couple at a window; 494c
Friedrich, Caspar David, in his
studio; 494c

KESSEL, Jan van
The temptations of St. Anthony in
a flower garland; 133

KESSEL, Jan van the Elder, 1626-
79
Vulcan, Venus and Cupid sur-
rounded by Vulcan's workshop
and exotic birds; 282c

KESU THE YOUNGER, 16th century
An episode in the Mahabharata; 71

KET, Dick H., 1902-40
Still life with bread rolls; 189

KETCHEN, Arthur W.
Farmyard #2; 23c

KETEL, Cornelius, 1548-1616
Elizabeth I; 434
Frobisher, Sir Martin; 434
Militia company of Captain Dirck
Jacobsz Roosecrans; 189
Unknown youth of 10; 507

KETTLE, Tilly, 1735-86
Young man in a fawn coat; 576

KEVER, Jacob S. H.
Mother and children; 553
Sisters; 553

KEYL, Friedrich Wilhelm, 1823-71
A gentleman with his horse and
dogs; 604

KEYSER, Nicasie de, 1813-87
Les grandes artists, Ecole du
XIXme siècle; 540

KEYSER, Thomas de, 1596/97-
1667
Huygens, Constantin; 104
Huygens, Constantin and his
clerk; 303, 323, 442c
Huygens, Constantin and his

Ad Parnassum; 225c
Airport; 199c
Angry moon; 315c
Arab song; 388
Architecture of the plane; 199
Arctic thaw; 475
Around the fish; 225c, 400
The artist at the window; 225c
Aspiring angel; 225c
At low wind; 315c
At night and hard; 315c
B. C. H. ; 199
Battle scene from the fantastic
 comic opera Sinbad the Sailor;
 449c
Before the snow; 475
La belle jardinière; 449c
Blossoming; 225c
Botanical theatre; 225c
Braced angles in two groups; 199
Calmly daring; 449
Carnival in the mountains; 199,
 225c
Castle; 315c
The castle mountain of S. ; 576
Castle to be built in a forest;
 225c
Cat and bird; 400
Ceramic--erotic--religious; 160
A child and the grotesque; 315c
City with the red dome; 199c
Clown; 225c, 260
Composition; 225c
Conqueror; 199c, 225c
Contemplating; 225c
Cosmic composition; 225c
The creator; 160
Crystal gradation; 199c, 225c
Dancer; 315c
Daringly poised; 199
Death and fire; 225c, 449
Demon above the ships; 64
Demon as pirate; 87
The departure of the boats; 475
Distillation of pears; 199c
Double bed; 315c
Double tent; 199c
Drawn one; 225c
Dwarf fairy-tale; 199
Eros; 199c
Fantastic plants; 273c
Female singer of comic opera;
 199
Figurative leaves; 315c
Fire in the evening; 199c, 225c,
 400
Fish magic; 225c, 283c
Florentine villa district; 199c

Flower face; 475
Flower in March; 315c
Flower path; 503
Föhn in Marc's garden; 568c
43; 199
Frau GL; 199
Fruit on red; 199
Fruits on blue; 449
Fruits on red; 225c
Fugue in red; 225c
The future man; 225c
Garden at night; 9c
Garden--city idyll; 3c
Garden still life with watering can;
 568c
Gate in the garden; 199c, 225c
Gifts for I; 400
Gladiolas--still life; 315c
Glass façade; 160
Goes shopping; 315c
Golden fish; 576, 588c
Goldfish wife; 64
Greeting; 199
Group: going home soon; 315c
Growth in an old garden; 225c
Gruesome experience; 315c
H. M. Idyll; 315c
Hands up; 315c
Harbor in bloom; 3c
Harbor of roses; 199
Head; 315c
Heads; 449c
Hermitage; 225c
Homage to Picasso; 449
House on the water; 199
House tree; 503
Houses in the night; 430
Hovering; 199
Idyll in a garden city; 294c
Impetus and direction; 199
In copula; 199
In the current six thresholds; 199
Individualized measurement of
 strata; 199, 210c
Insula dulcamara; 160c
Is stepping down; 315c
Jewels; 225c
Kettle drummer; 225c
Landscape with yellow birds; 260
Little fool in a trance; 199
Little jester in trance; 225c
Magic theatre; 199
Make believe; 199
Mask; 260
Mask for Falstaff; 199c
Matter, spirit and symbol of as-
 sault; 199
Moderate structure; 199

KOCH, Joseph Anton, 1768-1839
Dante Room, Villa Massimo,
Rome; 175
Heroic landscape with rainbow; 175
Italian vintage festival; 175
Italianate landscape with the
messengers from the Promised
Land; 409
Landscape with men returning from
the Promised Land; 494c
Landscape with rainbow; 494c
Schmadribach Falls; 262c, 494
Waterfall; 494c

KOCH, Pyke, 1901-
Extasé; 331c
Shooting gallery; 189

KOECHLIN, L.
Still life; 62

KOEDYCK, Isaak, 1616-77
Foot operation; 466
Girl peeling apples; 466
Old woman reading; 466

KÖHLER, Gustav, 1859-
The poacher; 51

KOEHLER, Robert, 1850-1917
In the park; 51
The strike; 257c, 354c

KOEKKOEK, Barend Cornelis,
1803-62
Mountainous landscape; 409
The old oak; 189

KÖNIG, Franz Niklaus, 1765-1832
The Staubbach Falls in the Bernese
Oberland; 143

KOERNER, W.H.D., 1878-1938
Trappers wintering near Monterey;
233c

KÖTHE, Fritz
Pardon; 320c

KOETSU
Landscape; 372

KOHLMEYER, Ida, 1912-
Tabulated; 390

KOJIMA TORAJIRO, 1881-1929
Begonia garden; 230

KOKOSCHKA, Oskar, 1886-1980
Autumn flowers; 553
Bride of the wind; 3c, 250
Brother and sister; 503
Bunch of autumn flowers; 203c
The coast at Dover; 210
Dent du Midi; 160c, 283c, 449c,
503
Forel, Auguste; 503, 576
Franzos, Mme.; 449
The knight errant; 503
Masaryk, Thomas Garrigue; 436c
Mrs. K.; 503
Portrait of a boy; 503
The power of music; 203c
Self-portrait with life size doll
made in the likeness of Alma
Mahler; 114c
The slave; 503c
The tempest; 87, 503c
Dr. Tietze and his wife; 503c
The tragedy of man; 430c
The trance player; 503
View of the Thames; 576
Walden, Nell; 203c
Woman in blue; 449c

KOLAR, Jiri, 1910-
Albers; 320
Klein Schmetterlinge; 320
Pramen; 320
Quelle; 320

KOLLER, Rudolf, 1828-1905
Oxen and ploughmen; 143c

KOMAR/MELAMID
Biography; 395
Buchumov, N., 1917; 395
Color is a mighty power; 395
Color writing: ideological abstrac-
tion No. 1; 395
Cut-off corner series, chemical
reaction; 395
Cut-off corner series KGB; 395
Cut-off corner series, not yet too
late; 395
Cut-off corner series, reproduction
from a picture on a subject from
Russian history; 395
Don't babble; 395
Double self-portrait; 395
Factory for the production of blue
smoke; 395
Glory to labor; 395
History of Russia; 395
History of the USSR; 395
Laika cigarette box; 395

KORZULKHIN, Alexei I., 1835-94
Funeral meal at the cemetery;
561
The monastery hospice; 96

KOSA, Emil, Jr., 1903-68
Summer time; 65

KOSHELEV, Nicolai, 1840-1918
Kramskoy with his wife; 561

KOSSAK, Julius F. von, 1824-99
The stud; 409

KOSSOF, Leon, 1926-
Children's swimming pool, autumn;
511
Man in a wheel chair; 576

KOSTOULAKOS, Peter
Captain's lamp; 23c

KOSUGI MISEI
Riverside village; 230

KOSUTH, Joseph, 1945-
Art as idea; 449

KOUDRIAVTSEFF, A. A.
The fishermen; 553

KOUNELLIS, Jannis, 1936-
Make it up on the spot; 449

KOVACIC, Mijo, 1935-
Bird of prey; 328c
Cowherd; 394c
Lunchtime in the field; 394c
Northern light; 394c
Old man and children; 394c
Singeing a pig; 289c
Winter scene; 328c

KOWALSKI-WIERUSZ, Alfred von
(Wierusz-Kowalski), 1849-1915
The landowner; 51
Over stock and stone; 353
Winter in Russia; 51

KOYAMA SHOTARO, 1857-1916
Cherry blossoms in Sendai; 230
Cowherd; 230
Kawakami Togai; 230

KOZLOFF, Joyce, 1942-
Temple of the sun, temple of the
moon; 316

KRAFFT, Barbara Steiner, 1764-
Portrait of a man; 218

KRAFFT, Johann P., 1780-1856
Emperor Franz I driving out after
a serious illness; 409

KRAMER, James, 1927-
Nevada City; 378
Summer in Salisbury; 378c
Westminster Abbey; 378

KRAMSKOY, Ivan Nikolayevich,
1837-87
Christ in the desert; 96c, 561
Forester; 561
Nekrasov at the time of his last
poems; 561
Temptation of Christ; 409
Unknown woman; 96

KRANS, Olof, 1838-1916
Harvesting grain; 243
Self-portrait; 243c
Women planting corn; 348c

KRASNER, Lee, 1908/11-
Abstract No. 2; 246, 259
Bluespot; 22c
Collage; 246
Continuum; 259
14th Street; 259
Gansevoort I; 259
Gansevoort II; 259
Hieroglyphs No. 4; 246
Imperative; 5c, 445c
Little image; 396
Lotus; 246, 472
Majuscule; 396
Noon; 259c
Nude study from life; 246
Peacock; 246
Polar stampede; 396
Prophecy; 396
Red, white, blue, yellow, black;
236
The seasons; 396
Seed No. 22; 246
Self-portrait; 396
Stretched yellow; 396
Sundial; 246

KRATOCHWIL, Siegfried, 1916-
The cabbage cutters; 289c

KRATZ, Mildred S.
Along the towpath; 378

KÜHN, Justus Engelhardt, fl. 1708-
 17
Darnall, Eleanor; 178, 399, 445c

KUHLER, Otto A., 1894-1977
Missouri River levee; 209c

KUHN, Walt, 1880-1949
Acrobat in white and blue; 4c
Adirondacks; 616
Amalgam; 4
American beauty; 4
Apples and pineapple; 4
Apple from Maine; 4
Apple in a wooden bucket; 4
Apples in the hay; 4
Apples on red cloth; 4c
Bananas; 4
Bar room fight; 4c
Bareback rider; 4c
Barry, Bobby, comedian; 4
Bathers on beach; 4c
Battle of New Orleans; 4
Beryl; 4
Black butterfly; 4c
Blue crown; 4c, 210, 576
Bread with knife; 4, 616
Brenda; 4
The camp cook; 4
Carnival girl; 4
Chico in silk hat; 4
The city; 4
Clown in his dressing room; 4
Clown with black wig; 4
Clown with drum; 4c
Clown with long nose; 390
Clown with mandolin; 4
Clown with red wig; 4
Clowns waiting; 4
The commissioners; 4c
Dancing clown; 4
Dressing room; 4, 472, 616
Dryad; 4
Elm; 4
Falls in Catskills; 4
Five clown heats; 4
Flower still life; 4c
Flowers and forms; 4
Four boats; 4
Fruit platter; 4
Girl from Madrid; 4
Girl in Pierrot's hat; 4
Girl in white chemise; 4
Green apples on blue cloth; 4c
Green apples with gray curtain; 4
Green apples with scoop; 4c
Green bananas; 4, 616
Green bananas and oranges; 4

Grenadier; 4c
The guide; 4, 616c
Hand balancer; 4
Hare and hunting boots; 4
Harlequin; 4c
Hat with blue ribbon; 4
Hydrangeas; 4c
Indian lore; 4
Indians and cavalry; 4
Island, Golden Gate Park; 4
Juggler; 4
Kansas; 4
Lahr, Bert; 4
Lancer; 4, 616c
Landscape with cows; 4
Lavender plumes; 4c
Loaf of bread; 4c
Man from Eden; 4
Man with ship model; 4
Mario; 4
Miss D; 4
Miss R; 4
Moist forest; 4
Morning; 4
Mountain stream; 4
Musical clown; 4, 616
Nocturnal landscape; 4
Oak; 4
Peaches; 4bc
Pending storm; 4
Pine on a knoll; 4
Polo game; 4c
Potatoes; 4
Pumpkins; 4
Reclining nude on striped blanket;
 4
Red and yellow roses; 4
Rehearsal; 4
Roberto; 4c
Rock formation; 4
Roses; 4
Sap bucket and apples; 4
Self-portrait; 4c
Show girl with plumes; 4
Sibyl; 4
Sleeping girl; 4
Still life, ducks; 4
Still life with apples; 4c
Summer interlude; 4
Tea party; 4
Teal; 4
Three apples; 4
Top man; 4c
Tragic comedians; 4c
Trees at noon; 4
Trees--Vermont; 4c, 313
Tricorne; 4c
Trio; 4c, 616c

Trout stream; 4
Trude; 4, 616
Vera reading by seashore; 4
Veteran acrobat; 4c
Veteran clown; 4c
Water butt; 4
White clown; 4c
Wild West No. 1; 4
Wisconsin; 4
Yeats, John Butler; 4
The young chief; 4
Zinnias; 4
Zinnias in black crock; 4

KUMASHIRO SHUKO
Willow and cormorant; 615

KUME KEIICHIRO, 1866-1934
Autumn landscape; 230
Kamo River; 230

KUN TS'AN, 1610-96
Winter landscape; 576
Wooded mountains at dusk; 88c

KUNG HSIEN, 1620?-89
Landscape; 88d, 576
Landscape in the style of Tung
Yüan and Chü-jan; 337
Landscapes; 188
Marshy landscape; 337
Mountains in mist; 539
A thousand peaks and a myriad
ravines; 539

KUNG K'AI, fl. 1260-80
Emaciated horse; 80

KUNISAWA SHINKURO, 1847-77
European lady; 230

KUNIYOSHI, Yasuo, 1893-1953
I'm tired; 472

KUNKEL, George
View from Jack's Cove; 47c

KUNSTLER, Morton, 1931-
The first American steam loco-
motive; 209c

KUO HSI, 1020?-1100?
Changing autumn sky over streams
and mountains; 179
Early spring; 80, 88, 179, 576
Landscape; 81
Landscape: early spring; 372
Woman and child in a garden; 81

KUPKA, Frantisek, 1871-1957
L'Âme du lotus; 525
Amorpha, chromatique chaude; 525
Amorpha, fugue in two colors;
438c, 525c
L'Archaïque; 525
L'Argent; 525
L'Autre rive; 525
La baigneuse; 525
Ballade/joies; 525
Le bibliomane; 525
La colorée; 525
Compliment; 438c
Conte de pistils et d'étamines I;
525
Couches de piano/Lac; 525
Creation; 525
Dans le Bois de Boulogne; 525
Defiance; 525
Deux danseuses; 525
Disks; 549c
Les disques de Newton; 525
Les disques de Newton: etude
pour la fugue en deux couleurs;
525
Etude pour amorpha, chromatique
chaude; 525
Etude pour amorpha, fugue en deux
coleurs; 525
Etude pour plans par coleurs; 525
Femme cueillant des fleurs; 525
La femme dans un miroir; 525
The first step; 449
The girl at Gallien; 147c
La grotte de Théoule; 525
Localisations des mobiles graph-
iques; 525
Meditation; 525
Le miroir ovale; 525
Newtonian color disks; 202c
Nocturne; 525
Ordonnance sur verticales; 525
Ordonnance sur verticales en
jaune; 525
Ovale animé; 525
La petite fille au baloon; 525
Plans par couleurs; 525
Plans par couleurs: Le grand nu;
525
Plans verticaux; 525
Plans verticaux I; 525
Plans verticaux III; 525c
Portrait de famille; 525
Le premier pas; 525
Le printemps cosmique I; 525
Le printemps cosmique II; 525
Self-portrait; 525
Soleil d'automne; 525

Maiko; 230c
Morning toilette; 230
Mt. Futago; 230
Reading; 230c
Snow in the woods; 230
The storyteller; 230
Taking a nap; 230
Turkey; 230
Woman with a mandolin; 230

KURTZ, Sadie
Two women; 243

KURZWEIL, Max, 1867-1916
Death of the dryad; 114c

KUWAYAMA, Tadaaki, 1932-
Red with chrome; 320

KUWAYAMA GHOKUSHU
Rock formation at Tamatsushima;
615

KUZELA, Miroslav
Mother, it is Toronto; 235c

KYLE, Joseph, 1815-63
Mott, Lucretia Coffin; 399

KYPRIOS, Johannes
Annunciation; 455

LABBE, Emile Charles
Kief on the Asiatic shore of the
Bosphorus at Constantinople;
302

LABILLE-GUIARD, Adélaïde, 1749-
1803
Bauffremont, Duc de; 236
Genlis, Mme. de; 236
Labille-Guiard, Mme., and her
pupils; 184
Pajou, The sculptor, modelling
the bust of J.B. Lemoyne; 218
Robespierre; 184
Self-portrait; 218
Self-portrait with two of her
pupils, Mlles. Capet and Rose-
mond; 218
Vincent, Francois André; 218c

LABRO, J. Llaverias
The future yachtsman; 353

LACKOVIC, Ivan, 1932-
Children's games; 394c

Desolate forest; 394c
Dry flowers; 394c
Flee, you people;
Flood; 328c
Red cows; 289c

LA CROIX, Charles F. Grenierde
A Mediterranean seaport; 553

LACY, Brenda
Architecture; 48c

LADBROOKE, John B., 1803-79
Lane scene; 363

LADBROOKE, Robert, 1770-1842
Foundry Bridge, Norwich; 363
Glymllffes Bridge, North Wales;
363
Landscape--the River Yare from
Postwich Grove; 363

LADELL, Edward, fl. 1856-86
Still life; 604

LADERMAN, Gabriel, 1929-
Lake shore Drive No. 2; 380
Little Falls; 380c
Portrait of Jeannette; 380
Portrait of Linda; 380
Still life No. 4; 126
Still life with large ceramic jar;
380c
View of Florence; 380
View of North Adams; 380

LAER, Pieter van see BAM-
BOCCIO, Il

LA FARGE, John, 1835-1910
Apple blossoms; 267
Berkeley's; 402
Bishop Berkeley's Rock, Newport;
45
Bowl of wild roses; 528c
Bridle path, Tahiti; 267c
Calla lily; 62
Clouds over sea: from Paradise
Rocks, Newport; 402
Evening sky; 45
The great bronze statue of Amida
Buddha at Kamakura; 131
Hollyhocks and corn; 62
Magnolia grandiflora; 62
Maus, our boatman; 409
Muse of painting; 176
Palms in a storm with rain,
Vaiala, Samoa; 267
Promise of immortality; 267

Bird, rock and camellias; 188
Bluejay on a branch; 188
Conversation with a priest; 337
Landscape in the style of Huang
 Kung-wang; 188
Landscapes after Sung and Yüan
 masters; 188bc
River landscape; 576
Winter landscape; 188d

LANCASTER, Mark, 1938-
Cambridge / red and green; 511c
Zapruder; 511

LANCE, George, 1802-64
Preparations for a banquet; 604

LANCRET, Nicolas, 1690-1743
Camargo, Mlle., dancing; 341c,
 576
The dance in the park; 553
A lady and a gentleman with two
 girls in a garden; 442c

LANDON----
Daedalus and Icarus; 184

LANDSEER, Charles, 1799-1878/79
Mary Queen of Scots renouncing
 the throne of Scotland; 604

LANDSEER, Sir Edwin, 1802-73
The Arab tent; 570c
The baptismal font; 382
The battle of Chevy Chase; 195
The challenge; 434
Dash; 382
Dignity and impudence; 409
Gibson, John; 195
The hunted stag; 195
Loch Avon and the Cairngorm
 Mountains; 195
Man proposes, God disposes; 195
Monarch of the glen; 604
The old shepherd's chief mourner;
 576
Osborne; 605d
Queen Victoria; 382
Queen Victoria, and Prince Albert
 at Windsor with the Princess
 Royal; 605d
Queen Victoria at Osborne; 382
Queen Victoria reviewing the Life
 Guards with the Duke of Well-
 ington, 28th September 1837;
 605
Queen Victoria, the Prince Con-
 sort, the Princess Royal at

Windsor; 195
Queen Victoria's favorite dogs and
 parrot; 384c
The sanctuary; 382
There's no place like home; 195
Windsor Castle in modern times:
 Queen Victoria, Prince Albert
 and Victoria, Princess Royal;
 382c
The young Queen Victoria review-
 ing her troops; 384
Zippin, a dog; 195

LANE, Fitz Hugh, 1804-65
Babson and Ellery houses; 17
Bear Island, northeast harbor; 17
Boston harbor at sunset; 412c
Brace's rock; 412
Brace's Rock, Brace's Cove; 412c
Brace's Rock, Eastern Point,
 Gloucester; 348c
Burning of the packet ship Boston;
 528
Christmas Cove, Me.; 402
Entrance of Soames Sound from
 southwest harbor, Mt. Desert;
 412
Gloucester harbor; 13
Gloucester harbor at sunset; 17,
 531
Harbor scene; 531c
New York harbor; 13, 17
Norman's Woe; 17
Owl's Head and Penobscot Bay,
 Me.; 17, 348, 402, 409, 412
Schooners before approaching
 storm; 412, 530
Ships in the ice off Ten Pound
 Island, Gloucester; 531
Southwest harbor, Me.; 399
Study for Brace's Rock, Eastern
 Point; 412
Sunrise through mist: Pigeon
 Cove, Gloucester; 412
Three-master on the Gloucester
 railway; 17
The western shore with Norman's
 Woe; 17, 412

LANE, Lois, 1948-
Mardi Gras; 367c

LANEUVILLE, Jean L., 1748?-
 1826
Vieuzac, Barère de; 184

LANFRANCO, Giovanni, 1582-1647
Annunciation; 291

Clipper barkentine; 334c
Cobwebs; 334c
Crucifixion; 334c
Derelict row boat on beach with
 moon over Alaska; 334c
Duck hunter; 334c
Early evening glow on Mt. Mc-
 Kinley; 334c
Evening glow; 334c
Evening--Seattle harbor; 334c
Fields of iris near Juneau; 334c
Food cache; 334c
Gastineau Channel; 334c
Going to the Potlatch; 334c
The golden north; 334c
Gulls along the storm cliffs; 334c
Halibut fisher; 334c
Ice bound; 334c
Indian fish cache; 334c
Indian home with totem; 334c
Indian woman and fish cache; 334c
Juneau, Alaska; 334c
Life on the Yukon; 334c
Lighthouse; 334c
Loading salmon, early morning;
 334c
Low water near Juneau; 334c
Lupine on the Richardson Highway;
 334c
Mendenhall Glacier; 334c
Mt. McKinley; 334c
Mt. Shuksan near Mt. Boker Na-
 tional Park; 334c
The northern lights; 334c
An old English landscape; 334c
Old sourdoughs house near Sleeping
 Indian Mountain; 334c
On the trail, Alaska winter; 334c
On to the potlatch; 334c
Outward bound from Venice; 334c
Pastoral landscape; 334c
Pearly dawn; 334c
Potlatch bound; 334c
Prince George war boat; 334c
Prospector's boat, stopping for
 lunch in Alaska; 334c
Ptarmigan in winter; 334c
Relic of the forgotten past; 334c
Road house on the Susitna; 334c
Rough sea; 334c
Rugged coast of Alaska; 334c
Sailing ship on the high seas of
 Alaska; 334c
Slough near Cook Inlet; 334c
Snow scene near Anchorage; 334c
Some old prospector's home; 334c
Squaw man; 334c
Steamer at Cannery; 334c

Storm clouds over Lake Otter,
 Alaska; 334c
Stormy sea coast; 334c
Summer at Mt. McKinley; 334c
Trading post on Whiskey Creek;
 334c
Tranquility; 334c
The trapper; 334c
Twilight on the Susitna River;
 334c
Venetian fishing boats; 334c
The Winnifred; 334c
Winter scene; 334c
Winter scene with cabin; 334c
Winter sunset in Alaska; 334c

LAURENCIN, Marie, 1885-1956
Acrobats; 553
Group of artists; 236
Two girls; 576
Woman with a hat; 271c
Woman with dove; 218c
Woman in the forest; 6c
Young girl; 99

LAURENS, Henri, 1885-1954
The guitarist; 449

LAURENS, Jean Paul, 1838-1921
Excommunication of Robert the
 Pious; 409

LAURENT, John L., 1921-
Beach--low tide; 46
Boon Island; 46
Green landscape; 46c

LAURI, Filippo, 1623-94
Martyrdom of St. Lawrence; 148
Martyrdom of St. Stephen; 148
St. Jerome; 556

LAURIE, Alexander, 1828-70
Lady writing in a parlor; 399

LAVAL, Charles
Self-portrait; 345
Self-portrait for van Gogh; 513

LAVALLEY, Louis, 1862-1927
Flora's wedding; 96

LAVERY, Sir John, 1856-1941
The chess players; 511
Cunninghame Graham, R. B.; 279
Hokusai and the butterfly; 231
Maidenhead regatta; 353
Moonlight, Tetuan, Morocco; 553

LEBER, Pierre, 1669-1707
Altar frontal; 235
Bourgeoys, Marguerite; 234, 235

LE BLANC, Louis
Bather; 48c

LEBOURG, Albert, 1849-1928
Snow scene, sunset; 506c

LE BOUTEUX, Jean Baptiste
 Michel
View of the camp of Mr. Law's
 concession at New Biloxi, coast
 of Louisiana; 528

LE BRUN, Charles, 1619-90
Entry of Alexander the Great into
 Babylon; 576
Séguier, The Chancellor; 610c
Crucifixion triptych; 576

LECCHI, Giacomo
Untitled mural; 40

LECK, Bart van der, 1876-1958
Composition; 189
Geometrical composition; 449
Geometric composition II; 197

LE CLERC, Jean
Adoration of the shepherds; 406d
A concert party; 406
The feast of Herod; 406
St. Francis in ecstasy; 406

LECOMTE----
Josephine at Lake Garda; 184

LECOMTE du NOÜY, Jean J. A.
 see NOÜY, Jean J. A. L. du

LECOMTE-VERNET, Charles
 Emile Hippolyte
A fellah woman; 302

LEDOUX, Jeanne Philiberte, 1767-
 1840
Portrait of a boy; 236

LEDUC, Ozias, 1864-1955
Le musicien; 234
Still life; 234

LEE, Arthur Tracy, -1879
Alamo, San Antonio; 336c
Brownsville, Tx.; 336c
Buffalo hunt; 336c

Canyon, Fort Davis, I; 336c
Canyon, Fort Davis, 2; 336c
Charley's kitchen, Fort Davis;
 336c
Chippewa camp, Minn.; 336
Chippewa, Minn.; 336
City of Mexico from Tuacubia; 336
Comanche lookout; 336c
Entrance to Wild Rose Pass; 336c
Falls of St. Anthony in 1848; 336
Fort Davis; 336c
Fort Davis scene I; 336c
Fort Davis scene 2; 336c
Fort Davis, Tx.; 336c
Fort Snelling, Upper Mississippi;
 336
Fort Riley (or Fort Leavenworth,
 Kan.); 336
Guadalupe Peak; 336c
Guadalupe River; 336c
Herd of deer; 336
In Wild Rose Pass; 336c
Indian burial place, Minnesota; 336
Indians hunting buffalo; 336
Lovers leap on Lake Pepin, Mis-
 sissippi River; 336
Maggie's kitchen, Fort Davis; 336c
Matamoros, Mexico; 336c
Military Plaza, San Antonio; 336
Minnehaha Falls; 336
Mississippi near Crow Wing River;
 336
Near Vera Cruz, Mexico; 336
Old Catholic Mission, Rio Grande;
 336c
Overland mail station; 336c
Plains of Colorado; 336
Rio Brazos, Tx.; 336c
Rio Grande City; 336c
Rocks above Fort Davis; 336c
Sanaho, a Comanche chief; 336c
San Antonio, Tx.; 336c
Sierra Prieta, Tx.; 336c
Sioux women gambling; 336
Upper Mississippi; 336
Upper Mississippi River scene;
 336
Upper Rio Grande; 336c
View near Fort Croghan; 336c
Western landscape; 336
Western scene; 336
Wolf Canyon; 336
Wolf Canyon, Tx.; 336c
Wolf Canyon water hole; 336c
Yellow Wolf; 336

LEE, Doris E., 1905-
Apple tree near the village; 246

April storm, Washington Square;
29
Country wedding; 246
Fisherman's wife; 246
The hunter; 246
Illinois River town; 246
Michigan cherry countryside; 246
The schoolhouse; 246
Thanksgiving; 29c, 246

LEE, Frederick Richard, 1799-
1879
Morning in the meadows; 604

LEE, John J., fl. 1850-60
Going to market; 604
Sweethearts and wives; 604

LEECH, John, 1817-64
Married for the money--the honey-
moon; 604

LEEMPUTTEN, Frans van, 1850-
1914
Distribution of bread at the vil-
lage; 354

LEES, Charles, 1800-80
The golfers; 605d
Skaters, a scene on Duddingston
Lock; 605
Sliding on Linlithgow Loch; 604

LE FAUCONNIER, Henri, 1881-
1946
L'Abondance; 217, 503
The huntsman; 449
The signal; 341c

LEFEVRE----
Guérin; 184
Mirabeau; 184

LEFFEL, David A., 1931-
Brett; 521c
Claudia; 521
Gibson, Jill; 521
Girl in turban; 521c
Lionel; 520d
Lizette; 521
Olshansky, Ludwig; 520c
Sara; 521
Self-portrait; 520c

LEFRANC, Jules, 1887-1972
The Eiffel Tower; 89c
Flowers; 328c
Le Metro Aérien; 328c

LEGA, Silvestro, 1826-95
The pergola; 409

LEGARE, Joseph, 1795-1855
Paysage au monument Wolfe; 234
Les ruines après l'incendie du
Faubourg St. Roch; 234

LEGER, Fernand, 1881-1955
The acrobat and his partner; 490c
Les acrobates dans le cirque; 217
The acrobats; 490c
Adam and Eve; 490c
Animated landscape; 490
L'Architecture; 217
Ball bearing; 481
Le baluster; 217c, 400
The barge; 490
The big barge; 490c
Big Julie; 490c
Bowl and book; 490
Bowl of pears; 3c
Branch on a black ground; 490c
The bridge; 480
Butterfly and flower; 326
Les campeurs; 490c
The cardplayers; 318, 490c
Le chaffeur nègre; 217
Le cirque médrano; 217
The city; 318, 326, 449c, 490c
Composition; 217c
Composition 7; 217
Composition à l'escalier; 217
Composition au poteau; 217
Composition aux 3 figures; 436c
Composition avec profil; 217
Composition for a mural painting;
490
Composition for the constructors;
490
Composition with leaf; 490c
Composition with three figures;
430
Composition with tree trunk; 128
Composition with two parrots;
490, 576
Le compotier; 217, 525
The constructors; 490c
Contrast of forms; 160c, 202c,
318, 490c
Contrastes de formes; 217c, 525
Contrastes de formes No. 2; 217
Contrastes de formes: nature
morte aux cylindres colorés;
525
Corsican village at sunset; 490
The country outing; 490c
La couseuse; 217, 525

LELEUX, Armand Emilie, 1818-
85
Private and confidential; 524

LELIE, Adriaan de, 1755-1820
Gildenmeester, The collection of
Jan; 189

LELONG, René
Sarah Bernhardt and the painter
Georges Clairin ascending over
Paris; 353

LELY, Peter, 1618-80
Blind harper; 587
Carnarvon, The family of the 2nd
Earl of; 587
Charles I and Duke of York; 587
Cleveland, Duchess of; 382c, 434,
537, 538
Compton, Sir William; 587
Cromwell, Oliver; 583c
Cymon and Iphigenia; 434
Dering, Lady; 587
The duet; 587
Edward, 1st Earl of Sandwich; 382
Fitzroy, Lady Barbara; 587
Gramont, Comtesse de; 576
Helmont, Francis Mercury van;
587
Hyde, Anne, Duchess of York;
434c
Portrait of a lady; 434
Lake, Two ladies of the, family;
583c
Northumberland, Elizabeth,
Countess of; 587
Sidney, Henry, later Earl of Rom-
ney; 587
Smith, Admiral Sir Jeremy; 587
Vane, Sir Henry; 537
The younger children of Charles
I; 587

LEMAIRE, Madeleine
Five o'clock tea; 353

LEMAN, Robert, 1799-1863
At Trowse; 363
The shepherd on the heath; 363

LEMIEUX, Jean Paul, 1904-
La fête au couvent; 234
Lazare; 234
The visit; 576

LEMMEN, Georges, 1865-1916
View of the Thames; 513

LEMOINE, Marie Victoire, 1754-
1820
Interior of the atelier of a woman
painter; 236
Self-portrait with Elisabeth Vigée-
Le Brun; 218

LEMOS, Julia
Chicago fire; 122c

LE NAIN, Antoine, 1588?-1648
The village piper; 373

LE NAIN, Louis, 1593?-1648
La famille de paysans dans un in-
térieur; 217
The farm wagon; 576
La halte du cavalier; 373
The milkmaid's family; 341c
Peasant family; 576
Rest of the horsemen; 229
A visit to grandmother; 341

LE NAIN, Mathieu, 1607?-77
The family dinner; 553
The young gamblers; 382

LE NAIN Brothers
The forge; 610c
Peasant family; 610c

LENBACH, Franz Seraph von,
1836-1904
Bavarian peasant girl; 51c
Emperor Wilhelm I; 409
Portrait of a girl; 51
Portrait of a man; 51
The red umbrella; 175

LENDENSTREICH, Valentin
Wülersleben triptych; 553

LENNOX, Shirley A., 1931-
Adirondack autumn; 23c
Stonybrook; 23c

LENTZ, Stanislaw
Group portrait of the scientific
circle of Warsaw; 96

LENZ, Maximilian
Marionettes; 114

LENZ, Wolfgang, 1925-
The widow; 331c

LEONARDO da VINCI, 1452-1519
Adoration of the Magi; 26c, 42d,
61, 205, 213, 223, 239, 567c,

LESLIE, George Dunlop, 1835-
1921
Pot pourri; 604
Rose time; 96

LESSING, Carl Friedrich, 1808-80
Castle Eltz; 51
Hussite prayer; 409
Hussite sermon; 175

LE SUEUR, Eustache, 1616/17-55
Annunciation; 553c
Death of St. Bruno; 576
Nero with the ashes of Germanicus;
382

LETHIERE----
Philoctetes at Lemnos; 184

LEU, Hans the Elder, 1465?-1507
View of Zurich, right bank of the
Limmat; 143

LEU, Hans, 1490?-1531
Orpheus and the animals; 567c
Orpheus charming the animals;
143c

LEUTZE, Emanuel, 1816-68
Cathedral ruins; 267, 528
Ferdinand removing the chains from
Columbus; 266c
Hawthorne, Nathaniel; 381
Leutze, Juliane Lottner; 381
Longacre, Eliza Stiles; 381
Lottner, Ferdinand; 381
Lottner, Oberst; 381
Lottner, Frau Oberst; 381
Seward, William; 381
Taney, Chief Justice Roger B.;
381
Washington crossing the Delaware;
122c, 266, 409, 531
Whittredge, Worthington; 381

LEVECQ, Jacob, 1634-75
Portrait of an unknown man; 608c

LEVI, Julian E., 1900-
Fisherman's family; 29
Orpheus in the studio; 64c

LEVIN, Phoebus, fl. 1836-78
Covent Garden Market; 605
The dancing platform at Cremorne
Gardens; 604, 605

LEVINE, David, 1926-
Coney Island bathing; 210

LEVINE, Jack, 1915-
Bandwagon; 313c
The feast of pure reason; 370c,
449
Gangster funeral; 472, 576
Jocasta; 313c
The mourner; 528
Potentates; 313c
Street scene No. 1; 29
Street Scene No. 2; 29
The three Graces; 445c
Welcome home; 210

LEVINE, Les, 1935/36-
Light works; 320

LEVITAN, Isaak, 1860-1900
Eternal peace; 262
Spring waters; 409

LEVY, Paul
Nut and bolt; 167c

LEVY, Rudolf, 1875-1944
At the Seine in Paris; 147

LEVY-DHURMER, Lucien, 1865-
1953
Loti, Pierre; 302
Mosque at Rabat; 302c
Nocturne; 462
Rodenbach, Georges; 100c
Silence; 331c

LEWIS, Charles James, 1830-92
Hurley, Berkshire; 604

LEWIS, Frederick Christian, 1779-
1856
Halt at the sanctuary of Ganesh; 302

LEWIS, Henry, 1819-1904
Street in St. Louis; 399

LEWIS, John Frederick, 1805-76
The Alhambra; 600
Cairo, a street scene near the
Bab El Luk; 570c
La Cava, 1840; 105
A Frank encampment in the desert
of Mt. Sinai; 600bc
Girl in an interior; 600
The halt of the Duke of Northum-
berland in the Sinai Desert; 302
The harem; 570c, 576c
Harem life--Constantinople; 570c,
600
In the Bey's garden; 204c
Indoor gossip; 600

Indoor gossip, Cairo; 570c
Lilium auratum; 409, 604
An old mill; 600c
Prince Hassan and his servant;
570c
The siesta; 96, 195, 302c, 570c
A storyteller in Cairo; 302
The street and mosque of the
Ghoreyah, Cairo; 384
Study for The proclamation of
Don Carlos; 600
Study of a jaguar; 600c

LEWIS, Percy Wyndham, 1882-
1957
Abstract composition; 434
A battery shelled; 478
Composition in blue; 434
The crowd; 3c, 511
Red duet; 511c
Roman actors; 449
Sitwell, Edith; 478, 576
La suerte; 511
Workshop; 418, 511

LEWIS, Tom E., 1909-
Three fish in a pan; 65

LEYDEN, Aertgen van
St. Jerome; 406

LEYDEN, Lucas van, 1494-1533
Dance around the golden calf;
189
Last Judgment; 205c, 576
A man aged 38; 189, 442
The worship of the golden calf;
314

LEYS, Henri, 1815-69
The declaration of love; 96
Faust and Marguerite; 409

LEYSTER, Judith, 1606-60
Boy and girl with cat and eel; 218c
A boy playing a flute; 608c
The flute player; 74c
The gay cavaliers; 236
The jolly companions; 218
The merry young man; 524
The offer refused; 466
The proposition; 236c
The rejected offer; 303
Self-portrait; 99
Still life; 218
Still life with tankard, basket of
fruit and Roemer; 236
Young man encouraging a girl to
smoke and drink; 524

LHERMITE, Leon A., 1844-1925
The apple market, Landerneau;
354
Christ visiting the poor; 479
The gleaners; 354
Les Halles de Paris; 354
Harvest; 409
The harvesters' payday; 354
Rest during the harvest; 553
The vintage; 45
Washerwoman; 354
The wheatfield: noonday rest; 443c

LHOTE, André, 1885-1962
Landscape in the Drôme; 66
Nude: flute player; 449

LI CH'ENG, 919-67
Buddhist temple in the hills; 361
Fishing on a wintry river; 88
Temple in the hills after rain; 179

LI CH'ÜEH, fl. 1250
Pu-tai; 372
Zen Master Feng Kan; 372

LI KAN, 1245-1320
Bamboo; 80

LI K'O-JAN, 1907-54
Boy musician; 88c
Our mighty army, a million strong,
has crossed the Yangtse; 539

LI KUNG-LIN, 1045-1106
The classic of filial piety; 576d
Five horses and grooms; 80
Five tribute horses; 188d

LI LIU-FANG, 1575-1629
Thin forest and distant mountains;
188, 337

LI SHAN, 1670-1754
Colors of spring; 615

LI SHIH-CHO, fl. 1741-65
Landscape with waterfall; 337

LI SHIH-HSING, 1282-1328
Old trees by a cool spring; 337

LI SUNG, fl. 1190-1220
The Hangchow Bore by moonlight;
539

LI SUNG, fl. 1210-30
Knick-knack pedlar; 88c

LIER, Adolf H., 1826-82
The Theresienwiese, Munich; 409

LIEVENS, Jan, 1607-74
Huygens, Constantijn; 303, 608
Job in misery; 303
The raising of Lazarus; 608c
Samson and Delilah; 303
Self-portrait; 576

LIEZEN-MAYER, Sándor, 1839-98
St. Elizabeth; 96

LII CHI
Cranes by a rushing stream; 81

LII WEN-YING
River village in a rainstorm; 81

LIJN, Liliane, 1939-
Cosmic flare; 320

LIMBACH, Russell, 1904-
Kiss that flag; 29

LIMBOURG, Jean de
St. Jerome hearing a lecture on
Plato; 375
St. Jerome scourged; 375

LIMBOURG, Pol de, 15th century
Adoration of the Magi; 239
February; 291c
Meeting of the Magi; 239

LIMBOURG Brothers
Annunciation; 375
May; 576c
Très riches heures du Jean, Duc
de Berry; 283cd

LIMOGES MASTER
Aeneas and the god of the Tiber;
421c

LIN KUANG
Spring mountain; 81

LIN LIANG, fl. 1488-1505
A pair of peacocks; 337
Phoenix; 81, 615

LINARD, Jacques, 1600?-45
Vase of lilies, roses and poppies
on a wooden box; 204c

LINCK, Jean Antoine, 1766-1843
View of Mt. Blanc from the top
of the Brévent; 143

LINDENSCHMIT, Wilhelm von
The fisherman and siren; 417

LINDLAR, Johann Wilhelm, 1816-
96
Waterfall; 51

LINDMARK, Arne, 1929-
Side street, Seville; 492
Spain; 492

LINDNER, Richard, 1901-78
And Eve; 319c
Arturo Ui; 319c
L'As de Trèfle; 319c
The child's dream; 319
Circus, circus; 319c
Clouds; 319c
The corset; 319
The couple; 319c
Couple I; 319c
Couple II; 319c
East 69th St.; 319c
Fifth Avenue; 319c
First Avenue; 319c
Fun city; 319c
The gift; 319c
Girl; 319c
Girl with bird; 319c
Girl with green hair; 319c
Girl with hoop; 319c
The heart; 319c
Hello; 319c
How it all began; 319c
Ice; 9c, 319
Kiss; 319c
Kiss No. 2; 319c
Lollipop; 319c
Man with a sword; 319c
A man's best friend; 319c
The meeting; 319c
Miss American Indian; 319c
New York men; 319c
No. 5; 319
On; 319c
Out of towners; 319c
Partners; 319c
Pillow and almost a circle; 319c
Poet; 319c
Profile; 319c
Proust, Marcel; 319
Rear window; 319c
Room for rent; 319c
Shoot; 319c
Shoot I; 319c
Shoot II; 319c
Shoot III; 319c
Solitaire; 319c
Spinoza, Benedict; 22c

LOIR, Marie Anne, 1715?-69?
Châtelet, Gabrielle-Emilie le
Tonnebier de Breteuil, Mar-
quise du; 218, 236

LOISEAU, Gustave, 1865-1935
The banks of the Eure; 553

LOMAHEMA, Milland, 1941-
Abstract of whipper; 67
Ahula, the germinator; 67c
Antelope priest; 67
Awatovi motifs of the kachina clan;
67
Bear and kachina migrations pat-
tern; 67
Chaquina I; 67
Chaquina II; 67
Cloud kachina symbol; 67
Corn maidens; 67c, 415
Cornfield; 67
Emergence; 67c
Faces of kachinas; 67
Female warrior; 67
Frog, sun, flute player and bird;
67
The home dance; 67
Hopi chief in his field; 67
Journey to the underworld; 67
Kachina kivas on San Francisco
Peaks; 67
Kikimongwi; 67
Long hair kachina; 67
Long hair kachina and rainbow;
67c
Mudheads; 67c
The old one--the village chief; 67
One horn priest; 67
Rain corn clan priests; 67
Sculpture maiden; 67
Se Pa Po Nah; 67
Social dance maiden; 67
Stylized eagle; 67
Sun and rain spirits over corn
plants; 67
Symbols of home dance; 67c
Symbols of the Bear Clan; 67
Turtle design; 67
The village chiefs; 67

LOMAX, John Arthur
The connoisseurs; 604

LOMAYEUSA, Louis
Kachina; 67

LOMBARDO, Sergio, 1939-
Super-quadro; 320

LOMBARDOS, Emmanuel
Noli me tangere; 455
St. John the Evangelist and Pro-
coros; 455
Virgin and Child; 455

LONEY, William Glenworth, 1877-
1956
Pheasants; 235

LONG, Edwin, 1829-91
The Babylonian marriage market;
604
Love's labor lost; 570c

LONG, Richard A., 1945-
Connemara, Ireland; 449

LONGHI, Alessandro, 1733-1813/
16
Casanova, Giacomo; 553
Widmann, Count Carlo Aurelio;
398

LONGHI, Barbara, 1552-1619
Madonna and Child with St. John
the Baptist; 236
Mary and the Child Jesus in the
act of crowning a saint; 524
Mary with Christ and John the
Baptist; 218

LONGHI, Pietro, 1707-85
Blind man's buff; 382
The dancing master; 576
Exhibition of a rhinoceros at Venice;
442
The letter; 398
The meeting; 398
Temptation; 398
The visit; 398

LOO, Charles Amedée Philippe
van, 1719-90/95
A sultana dressing; 302

LOO, Jean Baptiste van, 1684-
1745
Diana and Endymion; 576

LOO, Louis Michel van, 1707-71
Family of Philip V; 346

LOONEY, Ben Earl
Abrams Falls; 351c
Arkansas cows and barns; 351c
Arkansas Territorial restoration;
351c

Madonna and Child with Sts.
Nicholas and Anthony Abbot;
522
Madonna and Child with Sts. Dona-
tus, John the Evangelist, John
the Baptist, and Matthew
polyptych; 592
Madonna between St. Francis and
St. John the Evangelist; 592
Madonna with Child and angels;
592
Madonna with John the Baptist
and donor; 375
Massacre of the Innocents; 592
Nativity of the Virgin triptych;
592
Polyptych; 522
St. Humilitas of Faenza with scenes
from her legend; 592

LORENZETTI, Pietro, School
Half figure of the Madonna with
Child; 592
Last Supper; 592

LORRAINE, Claude Gellée, 1600-
82
Archangel Raphael and Tobias;
294c
Ascanius shooting the stag of
Sylvia; 284c, 610c
The Bay of Baiae; 341bc
Embarkation from Ostia; 294c
Embarkation of St. Paula; 610c
Hagar and the angel; 190, 576c,
581
A harbor scene; 382
The herdsman; 39c
Jacob and Laban; 240
Landscape; 17
Landscape: David at the cave
of Adullam; 442
Landscape: Hagar and the angel;
248, 442, 546, 580
Landscape: Narcissus; 546
Landscape with a goatherd and
goats; 580
Landscape with a mill; 412
Landscape with Jacob and Laban;
248
Landscape with nymph; 284c
Landscape with nymph and satyr
dancing; 553
Landscape with sacrificial pro-
cession; 98c
Marriage of Isaac and Rebekah;
442c
Midday; 341

The mill; 581
Moses saved from the bulrushes;
294c
Rape of Europa; 382c
Seaport: the embarkation of the
Queen of Sheba; 442, 581
The Tiber above Rome; 576
View of the Campo Vaccino; 283c
Village in the Roman campagna;
294c
Village festival; 2
Village fete; 294c, 610c

LOS ANGELES FINE ARTS SQUAD
The Beverly Hills siddhartha;
167c
The black submarine: Robert E.
LeRoi; 167c
Brooks Street; 167c
Brooks Street scene; 107
Ghost town; 167c
Hippie knowhow; 167c
The Isle of California; 167c
Venice in the snow; 167c

LO SAVIO, Francesco
Dynamic--filter--variation in in-
tensity spacelight; 449
Filtro luce; 320
Metallo nero opaco uniforme; 320
Spazio luce; 320

LO SPADA (Pietro Marescalchi),
1520-84
Pozzo, Dr. Zaccaria dal, at 102
years of age; 432c

LOTHROP, George F.
The Muses; 243

LOTTO, Lorenzo, 1480-1556
Annunciation; 576
Belo, Brother Gregorio, of Vicen-
za; 398, 432c
Christ taking leave of his mother;
205
A lady as Lucretia; 442c
Legend of St. Lucy; 375
Madonna and Child with Sts. James
and Anthony of Padua; 432c
Madonna and Child with two donors;
432c
The maiden's dream; 223c, 462
Odoni, Andrea; 223, 382, 459c
Portrait of a goldsmith in three
positions; 382
Sleeping Apollo; 375
Young man in his study; 583c

stream: landscape after Ni
Tsan; 337

LU HSIN-CHUNG, fl. 1300
Arhat; 372

LUARD, John Dalbiac, 1830-60
The welcome arrival; 605

LUBIN, Désiré
Back home; 354
Judicial inquest at the village; 354

LUC, FRERE, 1614-85
L'Assomption de la Vierge; 234
Un Hospitalière soignant Notre
seigneur dans la personne
d'un malade; 234

LUCA di TOMME, 1339-89
Crucifixion; 592d
Madonna and Child with St. Anna
and other saints polyptych; 592

LUCAS, Albert Durer, 1828-
Ferns and heathers; 604

LUCAS, Edward George Handel
Dust crowns all; 604

LUCAS, Eugenio, 1824-70
Capea; 38
The defense of Saragossa; 409
The Inquisition; 38

LUCAS, Georg Friedrich August,
1803-63
Landscape near Rome; 494c

LUCAS, John Seymour, 1849-1923
Flirtation; 604

LUCAS, Marie Seymour
We are but little children weak,
nor born to any high estate;
524

LUCAS-ROBIQUET, Mme. ----
Bébé et Zizon; 524

LUCASSEN, Reinier, 1939-
A cosy corner; 189

LUCE, Maximilien, 1858-1941
The church at Gisors; 513c
Cross, Henri-Edmond; 513
Industrial valley of the Sambre;
124

Landscape with willow trees; 513
Outskirts of Montmartre; 513
La rue Mouffetard, Paris; 513
Sewing; 513
View of the Seine toward the Pont-
Neuf; 124

LUCEBERT----, 1924-
The flagon; 189

LUCHS, Michael, 1938-
Rabbit; 22c

LUCIANI, Ascanio, -1670
Architectural ruins with figures;
458

LUCIONI, Luigi
Trees and mountains; 457
Vermont pastoral; 242

LUDWIG, Wolfgang, 1923-
Kinematische scheibe IX; 320
Kinematische scheibe X; 320
Kinematische scheibe XI; 320

LÜTHI, Hanny, 1919-
Christmas in Bern; 289c
The pleasures of country life; 289c

LUINI, Bernardino, 1481/82-1532
Madonna and Child with Sts. Sebas-
tian and Roche; 556c
Madonna del Roseto; 570c
Passion choir screen; 143

LUKIN, Sven, 1934-
Bride; 472

LUKS, George Benjamin, 1867-
1933
Brady, Nora; 616
The breaker boy; 616
The butcher cart; 14c, 616c
Central Park Lake; 390
A clown; 616
Gamley, Mrs.; 348c
Hester Street; 257, 283c, 399
Higgins, Eugene; 616
Holiday on the Hudson; 14c
The little milliner; 616
London bus driver; 616c
The miner; 445c
My garden, Berk Hills; 528c
Roundhouses at Highbridge; 472,
616c
Sassafras; 616
Schreecher, Lake Rossignol; 267c

Mother vine; 356c
Of the sea; 356c
On the beach; 356c
Overhaul; 356c
Piers at Colington; 356c
Portsmouth residence; 356c
Reflections; 356c
Refuge; 356c
St. Andrew's by the sea; 356c
Sea holly; 356c
Semper paratus; 356c
Sport fishing boats; 356c
Two sentries; 356c
The vacant place; 356c
Wright Brothers' bare necessities;
 356c

McARDLE, Harvey Arthur
Battle of San Jacinto; 122c

McAULIFFE, James J., 1848-1921
Wood, Mayor Fernando, driving
 Rose Medium and Janesville;
 399

MACBETH, Ann
Elspeth; 524

MACBETH, Robert Walker, 1848-
 1910
The ballad seller; 604

MacBRYDE, Robert, 1913-66
Emotional Cornish woman; 449
Performing clown; 511
Still life with cucumbers; 553

McCALL, Robert T., 1919-
Battleship row; 122c

McCALLUM, Andrew, 1821-1902
The first tints of autumn; 604

MacCAMERON, Robert L., 1866-
 1912
Taft, William Howard; 122

McCANCE, W.
Conflict; 231
Mediterranean hill town; 231

McCARTHY, Frank C., 1924-
After the blue northers; 535c
After the storm; 535c
Along the Beaver stream; 535c
Apache horse thieves; 535c
Apache trackers; 535c
Arizona patrol; 535c

The attack; 535c
Attacking the iron horse; 535c
The attempt on the stage; 535c
Before the charge; 535c
Bleak dawn; 535c
The breakaway bull; 535c
The circle; 535c
Circle of savage splendor; 535c
Coming in from the roundup; 535c
A cry of vengeance; 535c
The decoys; 535c
Down from the high country; 535c
The drags; 535c
An early start; 535c
East meets West; 122c
Forward by twos; 535c
The fugitive; 535c
He saw the hawk in its restless
 arc of watch flight; 353c
In search of new grass; 535c
The last crossing; 535c
The lone sentinel; 535c
The long trail west; 535c
The lookout; 535c
Mountain men's trek; 535c
Moving on; 535c
Night wind; 535c
An old time mountain man; 535c
Packing in; 535c
The prayer; 535c
The raiders; 535c
Return from the raid; 535c
Running battle; 535c
The savage taunt; 535c
Smoke was their ally; 535c
Starting his gather; 535c
Under attack; 535c
The war party; 535c
Water leaves no trail; 535c
When his first shot was his last;
 535c

McCARTHY, Justin, 1892-
Gardner, Ava; 243
Toronto Maple Leaves; 243c

McCLANAHAN, Preston
Eyes; 167c

McCLOSKEY, William John, fl.
 1879-91
Still life with mandarin oranges;
 267

McCOMBS, Solomon, 1913-
Fasting; 415

McCONCHIE, Mary Ann
Windsong; 23

McGEHEE, Paul, 1960-
Barges on the Neckar River--
Heidelberg, Germany; 23c
City Park--Dinkelsbuhl, Germany;
23c
Engine #90--Strasburg Railroad;
23c
Hudson River departure--1963; 23c
Preparing to refuel; 23c
St. Mark's Tower--Rothenburg,
Germany; 23c
Yard patrol boats--Annapolis,
Md.; 23c

McGRADY, John
Swing low, sweet chariot; 242c

McGRATH, Clarence, 1938-
Silk and velvet; 233c

MACGREGOR, Jessie
The reign of terror; 524

MacGREGOR, Robert
Great expectations; 231

MacGREGOR, William York, 1855-
1923
The vegetable stall; 231c, 279

McGREW, Ralph B., 1916-
Afternoon light; 360c
Aht-ed Holtsoie; 360c
Anna; 360c
Aubade; 360c
Badahni, Hasti-in tah; 360
Becky's Dior; 360c
Bekis, Tsegi Nellie; 360c
Bessie blesses the children; 360c
Bessie, the happy one; 360c
Big Thumb; 360c
Blooming ironwood; 360c
Canticle of June; 360
Canyon colors; 360c
Cha-t-cluei; 360c
Chuhongnona, Lincoln; 360c
Co-cag-how-neuma; 360c
Death Valley; 360c
Delight; 360c
Desert foliage; 360c
The dinneh; 360c
Dolce Far Niente, Navajo style;
360c
Duggai, Hasti-in; 360c
Duggai, Sherman; 360c
Entahl: in the cookshade; 360c
Evening of Bessie's girlhood; 360c
Family group; 360

A favorite; 360c
Fourth position; 360
Frybread time; 360c
Full many a time; 360c
Furcap in the hogan; 360c
Gail, a quick sketch; 360
Going on a visit; 360c
Hasti-inspeck; 360c
Holtsoie girl; 360c
Idyll; 360c
Im Das Herzen's Frühlingskeit;
360c
In a desert canyon; 360c
In Percy Shootinglady's hogan;
360c
In the Datil hills; 360c
In the smoketrees; 360c
In the spring; 360c
In the valley; 360c
In the wagon; 360c
The inlet; 360
Jewels of winter; 360c
Julia in the Cha-ha-oh; 360c
Julius; 360c
The Navajo, Duggai Keith; 360c
Kewantwytewa, Jimmy; 360c
Kyushvehma; 360c
Kin-nahl-day, evening; 360
Late in June; 360c
Lily pads, Olympia Peninsula; 360c
Lure of the canyon; 360c
Man from Moenavi; 360c
Mattinata; 360c
Mesa chieftain; 360c
Navajo boy; 360c
Navajo encampment; 360
Navajo girl, Aht-ed Pete; 360c
The Navajo, Jeh Alkath; 360c
Navajo princess; 360c
The Navajo, Sleep in Jesus; 360c
Navajo women and child; 360
Navajos at mealtime; 360c
Neskai Yassie Beyih; 360c
The newcomer; 360
Off to the trading post; 360c
Offussatara gets gussied up; 360c
Old ones talking; 360c
Old road, Olympic Peninsula; 360c
Pah-nim-tewa, Hopi Powamu chief;
360c
Painted Canyon, wall detail; 360c
Pause on the way to the sing; 360
Profile; 360
The race; 360c
Rainy afternoon, Grand Tetons;
360c
Rock colors, Painted Canyon; 360c
Saturday morning; 360c

Anemones; 49c
An antique relief; 49
At the edge of the wood; 49
Aubretia, Walberswick; 49
The Baptistry, Siena Cathedral;
49c
A basket of flowers; 49, 231
Begonias; 49c
Blanc Antoine; 49c
Borage, Walberswick; 49c
The boulders; 49
Boultenère; 49c
Bugloss, Holy Island; 49
Cabbages in an orchard; 49
Cactus flower, Walberswick; 49c
Campanile Martorana, Palermo;
49
Centairea, Withyham; 49
Chicory, Walberswick; 49
The church of La Lagonne; 49
Church tower; 49
Cloisters, Monreale; 49c
Collioure, Pyrénées, Orientales--
summer palace of the Queens
of Aragon; 49c
Cowslip, Chiddingstone; 49
Cuckoo flower, Chiddingstone; 49
The descent of night; 49c, 462
The down, Worth Matravers; 49
Faded roses; 49c
Fairies; 49
Fetges; 49
Fig leaf, Chelsea; 49
The fort; 49c
Le Fort Maillert; 49c
Le Fort Mauresque; 49
Fritillaria, Walberswick; 49
Gorse, Walberswick; 49
Green hellebore, Walberswick; 49
The grey iris; 49c
The harvest moon; 49c, 279
Héré de Mallet, Ile sur Têt; 49c
A hill town in southern France;
49c
Hound's tongue, Holy Island; 49
In fairyland; 49c
Iris seed, Walberswick; 49
Ivy geranium, St. Mary's Scilly;
49
Japonica, Chiddingstone; 49
Larkspur, Walberswick; 49
Leycesteria, Walberswick; 49
The Lido, Venice; 49
The little bay, Port Vendres; 49c
Men unloading a steamer at quay-
side; 49
Mimosa, Amélie-les-Bains; 49
Mixed flowers, Mont Louis; 49

Mont Alba; 49c
Mont Louis--flower study; 49c
Mountain landscape; 49
Mountain village; 49
Orvieto Cathedral; 49c
A palace of timber; 49
Palalda, Pyrénées--Orientales; 49c
Palazzo Ca d'Oro, Venice; 49
The Palazzo Publico, Siena; 49
Palm grove shadows; 49c
Part seen, imagined part; 49
Peonies; 49
Pimpernel, Holy Island; 49
Pine cone and needles, Walbers-
wick; 49
Pine, Walberswick; 49
Pinks; 49
The poor man's village; 49
Porlock Weir; 49c
Port Vendres; 49c
Port Vendres, la ville; 49
Reflections; 49
The road through the rocks; 49
The rocks; 49c
Rosemary, Walberswick; 49
La Rue du Soleil; 9
La Rue du Soleil, Port Vendres;
49c
Scabious and toalflax, Blakeney; 49
Sea pink, Holy Island; 49
The shadow; 49c
Ships; 49
Slate roofs; 49c
Sorrel, Walberswick; 49
A southern farm; 49c
A southern port; 49
A southern town; 49c
A Spanish farm; 49
Spurge, Withyham; 49
Steamer at the quayside; 49
Steamer moored at the quayside
with two gendarmes standing
on the quay; 49
Stylised plant form; 49
Summer in the south; 49c
Tacsonia, Cintra, Portugal; 49
Tobacco flower, Bowling; 49
Tomb, Elgin; 49c
The tree of influence; 49c
The tree on personal effort; 49c
Venetian palace, Blackshore on the
Blyth; 49c
Veronica, Walberswick; 49
Village in the mountains; 49
The village of La Lagonne; 49c,
434
The village, Worth Matravers; 49
Walberswick; 49

Wareham; 49c
The wassail; 49c
White roses; 49c
White tulips; 49c
Winter; 49
Woody nightshade, St. Mary's
Scilly; 49
Yellow clover, Holy Island; 49
Yellow tulips; 49c

MACKNIGHT, Dodge, 1860-1950
First snow--winter landscape; 492
A lane through an orange grove,
Orikuela; 267c
Towering castles, Grand Canyon;
281c

McLAUGHLIN, John, 1898-1976
Number 14, 1970; 22c

McLEAN, Mary Ann
Queen Victoria; 235

McLEAN, Richard T., 1934-
All American standard miss; 320
Rustler charger; 320

McLEARY, Kindred, 1901-
Lower East side; 29

MACLISE, Daniel, 1806-70
Alfred the Saxon long disguised
as a minstrel in the tent of
Guthrum the Dane; 537, 538
Dickens, Charles; 195
An interview between Charles I
and Oliver Cromwell; 537c,
538c
Marriage of the Princess Aoife
of Leinster with Richard de
Clare, Earl of Pembroke; 409
The meeting of Wellington and
Blücher; 195
Noah's sacrifice; 604
The play scene in Hamlet; 384
A scene from Undine; 382
The spirit of chivalry; 576
The standard bearer; 553

McMAHAN, Saran
Taos aspens; 23c
Woman and child; 23

MacNEE, Sir Daniel, 1806-82
Lochart, Elsie Ann; 604
McCulloch, Horatio; 279

MACNEE, Sir David
Lady in grey; 231

McNEILLEDGE, Alexander M.,
1791-1874
The ship Fanny; 235

MacNUTT, Glenn G., 1906-
Cobbler's Cove; 492

MacRAE, Anthony
Torn and cut paper collage; 129c

McRAE, John
Raising the Liberty Pole; 122c

McREYNOLDS, Cliff, 1933-
The arrival; 575c
The creation; 575c
Landscape with bird and boy; 575c
Landscape with hand grenade; 575c
Portrait of heaven; 575c
Soon; 575c

M'TAGGART----
Spring; 73
The wave; 73

McTAGGART, William, 1835-1910
The coming of St. Columba; 231
The emigrants; 121
Grandmother's pet; 279
Harvest at Broomieknowe; 279
Herring fishers at noon, Kilbrennan
Sound; 279
A north wind, Kilbrennan Sound;
604
The old pathway; 231
On the white sands; 279
The sailing of the emigrant ship;
231c
Spring; 195, 231c
Study for the storm; 231

McVEIGH, Miriam T.
Dancers; 23
Past this way; 23

MacWHIRTER, John, 1893-1911
June in the Austrian Tyrol; 604
Night--most glorious night, thou
wert not made for slumber;
279
The track of the hurricane; 384

MADDOX, Conroy, 1912-
Passage de l'Opéra; 511c

MADHU the ELDER, 16th century
The call to prayer at night; 71

MADOU, Jean Baptiste, 1796-
1877
Feast at the chateau; 409

MADRAZO, Raymond de, 1841-
1920
Female nude; 96
Hervey, The Marquise d', as
Diana; 96c

MADRAZO y KUNTZ, Federico,
1851-94
The Marquess de Montelo; 576

MAENTEL, Jacob, 1763-1863
Brenzier, Mr., Lancaster Co.
Pa.; 158
Boy with rooster; 158

MAES, Nicolaes, 1634-93
At the fountain; 553
The blessing; 74c
Christ blessing children; 303
The daydreamer; 608c
The happy child; 553
The idle servant; 303
Interior with listening servant; 40
The intruder; 608c
Mother with her child in a cot;
608c
Nursery scene; 466
Old woman praying; 466
Portrait of a lady; 436c
Portrait of a man; 553
Vegetable market; 466
Woman at prayer; 576
Woman giving alms to a boy; 466
Woman selling fish; 466
Woman selling milk; 466
Woman selling vegetables; 466

MAES, Nicolaes, Follower
Old man giving alms to a boy;
466
Woman cleaning fish; 466

MAESTRO dei CASSONI JARVES
History of Alatiel; 421cd

MAGAFAN, Ethel, 1916-
Across the meadow; 47c
Beside a mountain stream; 46c

MAGDA ANDRADE----
Lagoon; 553

MAGDALEN MASTER, fl. 1270
Madonna enthroned between Sts.

Peter and Leonard; 87c
St. Mary Magdalen and scenes
from her life; 522

MAGGIOTTO, 1713-94
Joseph sold by his brethren; 398

MAGGS, John Charles
A mail coach departing; 604

MAGNASCO, Alessandro, 1667/81-
1747/49
A bacchanal; 556
Bacchanalian scene; 341c
The monks' refectory; 576
Vagrants in a ruin; 556

MAGNELLI, Alberto, 1888-1971
Composition No. 6; 449
Ronda océanique; 438c
Sonorous border; 549c

MAGRITTE, René, 1898-1967
Act of violence; 557
Afternoon of a faun; 557
The air and the song; 227
Aladdin's lamp; 557
The alarm clock; 557
Alice in Wonderland; 557
Allais, Homage to Alphonse; 557c
Alphabet of revelations; 557
The amorous perspective; 227, 557c
Anne Judith; 557
The anniversary; 557c
Annunciation; 449, 557c
Arch of Triumph; 407c, 557c
Archimedes' principle; 557
The art of conversation; 557
The art of living; 227c, 557c
The automaton; 557
The backfire; 557
The balcony; 407c
The banquet; 557c
Le bataille de l'Argonne; 362
The bather; 557c
The battle of the Argonne; 557
The beautiful realities; 557c
The beautiful relations; 557c
The beautiful truths; 407c
The beautiful world; 557c
La belle captive; 362
The bell's other chime; 557
The beyond; 557
The birth of the idol; 227c
The black flag; 227c
The black flag II; 557
Black magic; 227c, 407c, 557
The blow to the heart; 557

The window; 227
Woman; 407c
The world's blood; 227c
The wrath of the gods; 557
Young woman; 557c

MAHLER, Lucy
Let a people loving freedom come
to growth; 107

MAHMUD MUZAHIB
Bahram Gur in the turquoise
pavilion on Wednesday; 87c

MAIGNAN, Albert, 1845-1908
The meeting of Dante and Matilda;
96

MAILLOL, Aristide, 1861-1944
Woman with a sunshade; 506c

MAINARDI, Sebastiano, fl. 1493-
1513
Madonna and Child with St. John
and three angels; 556

MAINO, Juan Bautista, 1578-
1649
Resurrection; 526

MAIONE, Robert, 1932-
The barns, Anticoli Corrado; 379
East Anglian farm; 379
English village; 379c
July, Umbria; 379
Oaks and haystacks; 379
Trees; 379c
The view from Agello; 379c

MAISTRE, Roy de, 1894-1968
Crucifixion; 478
Marriage; 511
Seated figure; 478
Vegetable still life; 576

MAKARIOS of GALATISTA
Virgin suckling; 547c

MAKARIOS the PAINTER
Virgin Pelagonitissa; 455

MAKART, Hans, 1840-84
Death of Cleopatra; 114c, 302,
409c
Wolter, Charlotte, as Messalina;
115

MAKOVSKY, Konstantin E., 1839-
1915

The return of the holy carpet to
Cairo; 302
The Holy Carpet being transferred
from Mecca to Cairo; 96

MAKOVSKY, Vladimir E., 1846-1920
An evening gathering; 561
An evening with friends; 96
In the doctor's waiting room; 409
A rendezvous; 561

MAKSIMOV, Vassily M., (MAXI-
MOV) 1844-1911
All in the past; 561
The death bed; 354
The family apportionment; 96
Family division; 561

MALBONE, Edward Greene, 1777-
1807
Allston, Washington; 381

MALCZEWSKI, Jan
On their way to Siberia; 354
A step nearer Siberia; 354

MALDARELLI, Federico, 1826-93
The Pompeiian girl; 96

MALDONADO, Estuardo
Estructura modular No. 25; 37c

MALEVICH, Kasimir, 1878-1935
Eight red rectangles; 438c, 430
The guardsman; 202c
Suprematist composition; 449c,
576
Suprematist composition: black
square and red square; 576
Suprematist composition: white on
white; 3c, 250
Suprematist painting: black rec-
tangle, blue triangle; 250
Supreme; 549c
Supremus No. 50; 84, 438c
Taking in the harvest; 418
White on white; 320
Woman with water pails; 449
The woodcutter; 202c

MALHOA, José, 1855-1933
The fado; 96
The painter and his model; 285c

MALIN, Suzie
The Jacobs; 9c

MALINA, Frank Joseph, 1912-
Circles within circles II; 320

MALLET----
The bathing of the infant St. John
the Baptist; 184
Gothic bath; 184

MALLORY, Ronald, 1933-
Organa; 320

MALOUEL, Jean, -1419
Martyrdom of St. Denis; 576

MALTON, Thomas the Younger,
1748-1804
King's Mews, Charing Cross; 600
St. Paul's Church, Covent Garden;
247

MAMMEN, Jeanne, 1896-1975
The Kaschemme bar; 400

MAN, Alfred Young
George Catlin--Fritz Scholder--
Indian rip-off; 253
Peyote vision; 253
Six whites--one Indian; 253

MAN, Cornelis de, 1621-1706
The little mistress; 282c

MAN, L. D.
The Royal Caroline and the
Katherine at sea in a gale;
121
The Royal Sovereign; 121

MANCINI, Antonio, 1852-1930
Gardner, John Lowell; 281c
Return from Piedigrotta; 409
Standard bearer of the harvest
festival; 281

MANDER, Karel van, the Elder,
1548-1606
Adoration of the shepherds; 303

MANDER, William Henry
On the Mawddach, Wales; 604

MANESSIER, Alfred, 1911-
Night; 449c
Rural festival; 438c
The sixth hour; 549c

MANET, Edouard, 1823-83
The absinthe drinker; 55, 197,
229c
Amazon; 229
Ambre, Emilie, as Carmen; 229

Argenteuil; 55c, 124c, 512c
Astruc, Zacharie; 55c, 229, 373,
506
At Père Lathuille's; 512c
At the cafe; 55, 197, 229, 512c
Autumn; 229, 512c
Le Bal de l'Opera; 310c
Le balcon; 373
The balcony; 138c, 197, 229,
283c, 512c
Ballet Espagñol; 197
The bar at the Folies-Bergère;
55c, 197, 229c, 373, 409, 506c,
512c, 576c
Barque of Dante; 229
Battle between the Kearsage and
the Alabama; 197, 229
Blonde nude; 197, 229
Blue Venice; 229
Boating; 55c, 87c, 138c, 229,
512c
Boats; 229
Le bon bock; 55, 229, 506
Boy blowing soap bubbles; 512c
The boy with the sword; 229
Les bulles de Savon; 373
Bunch of violets; 452
Le buveur d'absinthe; 373
Café, Place du Théâtre-Français;
55c
Callais, Nina de: the woman with
the fans; 229
Carnations and clematis in a vase;
97
Chez le Père Lathuille; 197
Chez Tortoni; 281c
Child with cherries; 506c
Le Christ aux anges; 373
Christ mocked; 98c, 229
Christ scourged; 452
Clemenceau; 197, 229
Un coin du café concert; 373
Combat de taureaux; 373
Concert in the Tuileries; 55c,
229c, 506
The conservatory; 229c
Dead Christ with angels; 229, 512c
Dead Christ with two angels; 197
Dead soldier; 229
The dead toreador; 197, 229,
310c, 512c
Le dejeuner dans l'atelier; 373
Déjeuner sur l'herbe; 9c, 55c,
97, 124, 197, 229, 285c, 373,
430c, 452, 506c, 576
The departure of the Folkestone
boat; 229c, 512c
Desboutin; 506

The Seine at Argenteuil; 512c
Self-portrait; 373
Self-portrait with palette; 55c,
 156, 197
Skating; 229, 512c
Sortie du Port de Boulogne; 197
The Spanish ballet; 55c, 229
The Spanish singer; 197, 229
Spray of white peonies; 506
Stalk of asparagus; 229
Still life with a hat; 229
Still life with carp; 98c, 229
Still life with melon and peaches;
 229
Still life with salmon; 55c
Still life with salmon and pike;
 229
Street pavers in the Rue Mosnier;
 55c
The street singer; 55c, 512c
Study for Le Déjeuner sur l'herbe;
 97
Le suicide; 373
Surprised nymph; 229
Le torero mort; 373
Two peonies and secateurs; 512c
Valence, Lola de; 124c, 229,
 460, 506c, 512c
Vase of peonies; 506c
Venus of Urbino; 229
La vieux musicien; 373
View of the Paris World's Fair;
 55
View of the Universal Exhibition
 of 1867; 229
The waitress; 55c, 156c, 442,
 512c
The water drinker; 229
Woman with a parrot; 138c, 197,
 506, 512c
Women at the races; 512c
Young woman; 229
Young woman reclining in Spanish
 costume; 197, 229c, 452
Zola, Emile; 55c, 124, 138c,
 162, 197, 229, 373, 452, 460c,
 506, 512c, 566, 583c

MANETTI, Rutilio, 1571-1639
Samson and Delilah; 526

MANFREDI, Bartolomeo, 1587?-
 1620/21
Chastisement of Cupid; 526
Christ disputing with the doctors
 in the Temple; 526
Denial of St. Peter; 526
The tribute money; 526

MANGOLD, Robert P., 1937-
Circle in and out of a polygon II;
 472
Incomplete circle No. 2; 449
$\frac{1}{2}$ gray-green curved area; 320
1/3 gray-green curved area; 320
Two quarter circles within a
 square; 126
Untitled; 5c

MANGOLD, Sylvia Plimack, 1938-
Cornfield, tapes and measures; 5c

MANGUIN, Henri Charles, 1874-
 1949
Bathers; 147
The corn oaks; 147c, 161
The 14th of July at St. Tropez;
 147
The 14th of July at St. Tropez,
 the harbor, left side; 161
The gypsy in the studio; 147c
Model resting; 147c
Morning; 341c
Nude in the studio; 161
Puy, Jean; 147
Self-portrait; 147
The sleeping girl; 161
The vale, St. Tropez; 161c

MANN, Joshua Hargrave, fl. 1849-
 84
The child's grave; 605

MANNLICH, Johann Christian von,
 1741-1822
The tribunal of folly; 346

MANOHAR, 17th century
Processional scene at the court of
 Jahangir; 71c

MANSON, George, 1850-76
The cottage door; 231
What is it?; 231

MANSUR, 17th century
Peafowl; 71
Pheasant; 71

MANTEGNA, Andrea, 1431-1506
Adoration of the shepherds; 294c,
 339
Agony in the garden; 72c, 223,
 442, 459c, 533c
The Apostles Peter and Paul; 177
Archers shooting St. Christopher;
 177c

Courtyard of the Royal residence
 in Munich; 341c
Halt for rest on the edge of the
 wood; 175
The Hesperides; 175, 430d
Horsehandler and nymph; 175
In the loggia; 576
The oarsmen; 175
The orange grove; 175c
The pergola; 175
Roman vineyard; 175
St. George; 593
Self-portrait; 175
Three horsemen; 503

MARFFY, Odon
Nude; 147

MARGAZIUS, Giorgios
Last Judgment; 455

MARGITAY, Tihaner von
The honeymoon; 353

MARIENTHAL, Jeffrey C., 1949-
Album design; 23
Evening star; 23
Flying canvas; 23c
P-38; 23c

MARILHAT, Prosper, 1811-47
The Erechtheum at Athens; 409
Ruins of the El Hakem Mosque
 in Cairo; 302c

MARIN, John, 1870-1953
Baybridge Brooklyn; 16
Big Wood Island; 13
Boat fantasy, Deer Isle, Me.; 16c
Boat movement, Cape Split; 267c
Boat off Deer Isle; 87c, 449c
Breakers, Maine coast; 528, 617c
Buoy, Maine; 402
Camden Mountain across the bay;
 402
Cape Split; 267
Clouds and mountains at Kufstein;
 528
Deer Isle; 16c
Deer Isle, Me.; 9c
Echo Lake, Franconia Notch,
 White Mountains; 16c
Echo Lake, Monroe Co., Pa.,
 Delaware Country; 16
Fantasy, Small Point, Me.; 16
Fell Plummer's Wharf; 16
From the ocean; 617c
Impression; 617c

Landscape with trees and rain;
 492
Lower Manhattan; 16, 313c, 400,
 430c
Lower Manhattan from the river;
 64
Maine islands; 267c, 576c
Maine series No. 3, movement,
 boat off Deer Isle; 16
Mt. Chocorua; 267
Mountain and clouds, Tyrol series;
 16c
Movement: boats and objects, blue
 and gray sky; 3c
Movement, Fifth Avenue; 210, 267
Movement in brown with sun; 348c
Off Stonington; 445c, 617c
Palisades No. 2; 617c
Palisades, Hudson River; 402
Pertaining to Stonington Harbor,
 Me.; 267
Red sun; 617c
The red sun--Brooklyn Bridge;
 528c
Region of Brooklyn Bridge fantasy;
 9c, 267c, 472c
Sailboat in harbor; 617c
Schooner at rest; 313c
Seaside, an interpretation; 617c
The Seine, Paris; 16
Ship, sea and sky forms, an im-
 pression; 617c
The Singer Building; 87c
Small Point, Me.; 16c
Storm over Taos; 267c
Street in Normandy; 16
Study of the sea; 402
A study on Sand Island; 13
Sunset; 313c
Sunset, Maine coast; 617c
Taos Canyon No. 2, N.M.; 16
Trees, West Point, Me.; 16
Tyrolean Mountains; 617c
View from Deer Isle; 16
View from Devil's Island; 16c

MARINARI, Onirio, 1627-1715
A young martyr; 556

MARINO da PERUGIA
Madonna and Child with Sts. Paul
 and Benedict; 522

MARINOT, Maurice, 1882-1959
Interior; 147c

MARIS, Jacob, 1836/38-97/99
Allotments near The Hague; 189

The knighting of St. Martin; 205
Madonna and Child with four saints;
 281c
Madonna between St. Lucy and
 St. Catherine; 592
Madonna enthroned with saints; 592
Madonna from the Annunciation;
 341c
Maestà; 205, 522
The obsequies of St. Martin; 522,
 592
Passion polyptych; 559
Polyptych; 522
Polyptych of 1320; 592
Procession to Calvary; 522c
Return of the young Christ to his
 parents; 522
St. Ambrose falls asleep during
 Mass and dreams that he is
 present at the obsequies of
 St. Martin; 592
St. Louis; 533c
St. Louis altarpiece; 522
St. Louis of Toulouse crowning
 King Robert of Naples; 205,
 576, 583c, 592
St. Martin knighted by the Em-
 peror Julian; 592
St. Martin renouncing the sword;
St. Mary Magdalen and St.
 Catherine; 592
Sant' Agostino Novello with scenes
 from his legend; 592
Virgil frontispiece; 522

MARTINO, Antonio P., 1902-
Four houses; 457
Wilde Street, Manayunk; 457

MARTONE, Lucia
Rhododendron; 23
A word from the boss; 23c

MARTORELL, Bernardo (Mortorell),
 1427-53
St. George and the dragon; 205, 576

MARUCELLI, Germana
Abito; 320

MARUYAMA OKYO, 1733-95
Hozu River; 278d

MARX, Gustave
The visit to the estate; 353

MASACCIO, Tomaso di, 1401-28
Adam and Eve being expelled

from Paradise; 223d
Adoration of the Magi; 375, 533c
The banishment from the Garden
 of Eden; 283c
Crucifixion; 72c
Crucifixion of St. Peter; 469
The expulsion of Adam and Eve
 from Paradise; 205, 459c,
 505c, 576
Holy Trinity; 40
Holy Trinity with St. John and St.
 Mary; 291c
Holy Trinity with the Virgin and
 St. John the Evangelist, adored
 by the donor and his wife; 223
Madonna and Child with angels;
 113
Martyrdom of St. Peter; 375
Miracle of the shadow; 205
Pisa polyptych; 559
St. Peter giving alms; 375d
St. Peter raising the prefect's son;
 375
Tribute money; 39, 87c, 205, 223,
 239d, 375, 576c
Trinity; 205, 533c
Virgin and Child; 442
Virgin and Child enthroned; 459c
Virgin and Child with St. Anne;
 223
Virgin, Child and St. Anne; 533c
A young man in a scarlet turban;
 281c

MASACCIO Circle
Penitant St. Jerome; 375

MASANOBU, 1686-1764
Crane; 576
Oiran and Kamuro; 576
Sage looking at lotus; 263

MASIP, Vicente
Martyrdom of St. Agnes; 389

MASO di BANCO, 1341/50-
The donor and the last trump; 522
St. Silvester quelling the dragon;
 522
St. Sylvester restoring life to the
 victims of a dragon; 205c
St. Sylvester subdues the dragon
 and brings to life the two sor-
 cerers; 113

MASOLINO da PANICALE, 1383-
 1440/47
Assumption of the Virgin; 533c

Baptism of Christ; 576
The martyrdom of St. John the
Baptist; 205
Sts. John the Baptist and Jerome;
442
The temptation; 223
Temptation of Adam and Eve; 205c
Virgin, Child and St. Anne; 533c

MASON, Alice T., 1904-71
The beehive; 126
L'Hasard; 236c

MASON, George Hemming, 1818-
72
The evening hymn; 604

MASON, Roy, 1886-1972
Admiralty inlet; 233c

MASRIERA, Francisco, 1842-1902
A melody of Schubert; 353
Young girl resting; 96

MASSEY, William W.
Model's artist; 23c
Two women and a letter; 23c

MASSON, André, 1896-
Battle of fishes; 579
The bird hunt; 283c
Genesis I; 549c
The harbor near St. Mark's,
Venice; 553
Iroquois landscape; 449c
Le jet au sang; 576
The Sioux cemetery; 449

MASSYS, Cornelis (Metsys),
1508?-50
Landscape with the judgment of
Paris; 553

MASSYS, Jan (Metsys), 1509?-75
The payment of taxes; 406

MASSYS, Quentin (Metsys), 1466-
1530
Banker and his wife; 205c, 576
Burial of Christ triptych; 72c
Christ presented to the people;
72c
Deposition from the cross; 205
Flora; 284c, 285c
Holy Family with Elizabeth and
St. John; 436c
Holy kindred; 576
Man with a pink; 98c

A money changer and his wife;
250
Portrait of a lady; 210
Portrait of a man; 424c
St. Anne triptych; 294c
Virgin and Child enthroned with
four angels; 442

MASTER BERTRAM (Bertram of
Minden), 1340-1415
Grabow altarpiece; 576d
Kiss of Judas; 205

MASTER FRANCKE, 15th century
Adoration of the Magi; 576
Flagellation of Christ; 469
St. Barbara betrayed; 205

MASTER JOHN
Mary I; 434

MASTER of AMIENS
Scene from the life of Christ;
610c

MASTER of AMIENS School, 15th
century
Ascension; 98c

MASTER of AVILA
Adoration of the Magi; 553

MASTER of BASEL
Hieronymous Tschekkenbürlin; 583c

MASTER of BOHEMIA
Christ between two thieves; 72c

MASTER of CELL 2
Baptism of Christ; 440
Christ carrying the Cross; 440
Christ in Limbo; 440
Christ on the Cross with the Virgin
and St. John; 440
Coronation of the Virgin; 440
Lamentation over the dead Christ;
440
The Maries at the Sepulchre; 440
Nativity; 440

MASTER of CELL 31
Madonna and Child enthroned with
angels between Sts. Peter and
Paul; 440
Sermon on the Mount; 440

MASTER of CELL 36
Christ nailed to the Cross; 440

MASTER of 1518
Christ in the house of Simon; 576

MASTER of FLEMALLE
Annunciation; 205, 375
Betrothal of the Virgin; 205
Christ on the Cross; 72c
Descent from the Cross; 205d
Madonna; 375
Virgin and Child and saints in a
 garden; 294c
Virgin of the fire screen; 205

MASTER of 1402
Marcia painting a self-portrait;
 304
Thamar in her studio; 304

MASTER of 1417
Two scenes from the legend of a
 holy hermit; 440

MASTER of GERIA
Retable of St. Andrew; 553

MASTER of HELSINUS
Madonna and Child with St. James
 the Less and St. Lucy; 398

MASTER of JATIVA
Adoration of the Magi; 553

MASTER of LIESBORN
Presentation in the Temple; 442

MASTER of MARY of BURGUNDY
Coronation of the Virgin; 40c
Madonna and saints framed by
 a window scene; 205
St. Anthony Abbot in the desert;
 40c
St. Catherine of Alexandria and
 the Hermit; 40c
Virgin visiting St. Elizabeth; 40c

MASTER of MESSKIRCH
St. Benedict; 576

MASTER of MOULINS, fl. 1500
Annunciation; 98c
Bourbon, Charles de; 610c
Bourbon triptych; 559
Dauphin Charles Orleans; 583c,
 610c
Moulins triptych; 576d
Nativity with Cardinal Rolin; 205
Virgin adored by the angels; 610c
A young princess; 291

MASTER of PEDRET, 12th century
Virgin and Child enthroned; 87

MASTER of ST. CECILIA
Martyrdom of St. Margaret; 205

MASTER of ST. FRANCIS
Crucifix; 72c
Crucifixion; 522, 547c
St. Francis; 522

MASTER of ST. FRANCIS LEGEND
 Follower
Crucifixion; 87

MASTER of ST. GILES, fl. 1500
Mass of St. Giles; 576

MASTER of ST. ILDEFONSO
The investiture of St. Ildefonso;
 576

MASTER of ST. SEVERIN, fl.
 1480-1510
Stigmatization of St. Francis; 576

MASTER of ST. VERONICA, 15th
 century
Man of pity; 72c
St. Veronica; 72c, 576
St. Veronica with the sudarium;
 442

MASTER of the AIX ANNUNCIA-
 TION, 15th century
Annunciation; 205, 576

MASTER of the AVIGNON PIETA
Avignon Pietà; 610c

MASTER of the BARBERINI
 PANELS, fl. 1450-70
Annunciation; 223

MASTER of the BERLIN MADONNA
Madonna and Child; 375

MASTER of the CAMPOSANTO
 CRUCIFIXION
Crucifixion; 522

MASTER of the COUNTESS of
 WARWICK
Brooke, William, 10th Lord Cob-
 ham and his family; 434

MASTER of the EPÊTRE d'OTHEA
Temperance and clock; 375

MASTER of the FEMALE HALF-
LENGTHS, 16th century
Virgin and Child; 341bc

MASTER of the FOGG PIETA
Pietà; 522

MASTER of the FORTIES
Portrait of a young man; 436c

MASTER of the FRANKFURT
GARDEN of PARADISE
Garden of Paradise; 205

MASTER of the JUDGMENT of
SOLOMON
Judgment of Solomon; 526

MASTER of the LAST JUDGMENT
Sts. James and Philip; 553

MASTER of the LATHROP TONDO,
late 15th century
Assumption of the Virgin with St.
Thomas; 556

MASTER of the LEGEND of ST.
LUCY
Madonna and Child with musical
angels; 436c

MASTER of the LIFE of MARY,
fl. 1460-90
Visitation; 205

MASTER of the LIFE of the
VIRGIN
Conversion of St. Hubert; 442c
Presentation in the Temple; 576

MASTER of the LOW COUNTRIES
Calvary of Hendrix van Rijn;
72c

MASTER of the MADONNA of
BADIA a ISOLA
Madonna enthroned with the Child
and angels; 592

MASTER of the MADONNA of
CITTA di CASTELLO
Madonna from San Michele in
Crevole; 592

MASTER of the MORRISON
TRIPTYCH
Morrison triptych; 553
The Virgin and Child with angels;
553c

MASTER of the OBSEQUIES of
ST. FRANCIS
Death and ascension of St. Francis;
522
St. Francis mourned by St. Clare;
522c
Verification of the stigmata; 522
Vision of the ascension of St.
Francis; 522

MASTER of the ODYSSEY LAND-
SCAPES
The ships of Odysseus are de-
stroyed by the Laestrygones;
421c

MASTER of the PANZANO TRIP-
TYCH, fl. 1365-80
St. Anthony of Padua; 553

MASTER of the RAJHRAD ALTAR
Crucifixion; 72c

MASTER of the ST. BARTHOLO-
MEW ALTARPIECE, 15-16th
centuries
Doubting Thomas; 576

MASTER of the STRAUS MADONNA
Crucifixion; 436c
Madonna and Child; 436c

MASTER of the THUISON ALTAR-
PIECE
Entry into Jerusalem; 341bc

MASTER of the TRIUMPH of
DEATH
Last Judgment and the Inferno; 522
Triumph of Death; 522

MASTER of the TUCHER ALTAR-
PIECE, 15th century
Tucher altarpiece; 576

MASTER of the VIRGIN AMONG
VIRGINS, fl. 1470-1500
Madonna surrounded by four female
saints; 189

MASTER of the VISION of ST.
JOHN
Adoration of the Magi; 553

MASTER of the WOLFEGG
LEDGER
Lamentation; 72c

MASTER of TREBON
Entombment; 72c

MASTER of VYSSI BROD
Crucifixion; 72c

MASTER THEODORIC
St. Matthew; 205c

MATEJKO, Jan, 1838-93
The artist's wife in wedding dress;
96
Batory, Stephen, at Pskov; 409c

MATHEWS, Arthur F., 1860-
1945
The wave; 13, 531

MATHEWS, Charles James, 1803-
78
Ruins of the abbey at Ashby de la
Zouche; 105

MATHIEU, Georges, 1921-
Acognition; 447c
Athys; 447c
The battle of Bouvines; 447cd
The battle of Gilboa; 447c
The battle of Hastings; 447c
Birth of Osiris; 447c
Black megalopolis; 447c
Black spot; 447
Blue and red; 447c
Blue, violet and black; 576
Capetians everywhere; 430c, 447
Les Capétiens partout; 387c
Caput III; 447
Dana; 447c
De cura episcoprum; 447c
Disintegration; 447c
Drawing and quartering of Fran-
cois Ravaillac; 447cd
Du mu; 447
Dynasty; 447
Egregis; 447c
Election of Charles V; 447c
Evanescence; 447c
Evil; 447
Fourth Avenue; 447c
The good Duke Philip appeased by
his son; 447
Homage to death; 447
Homage to Delalande; 447c
Homage to General Hideyoshi; 447c
Homage to Jean Tassin; 447c
Homage to M. de Vauban; 447c
Homage to Philidor; 447c
Inception; 447c

Jossigny; 447c
Locronan; 447c
Maisons--Lafitte; 447
Marie of Brabant; 447c
Marly; 447c
Matheiu painting the battle of
Hakata; 447c
Miramas; 447
Oliver decapitated; 438c
Orange plaid; 447c
Painting; 449
Paris, Capital of the arts; 447cd
Pealed; 447
Quentin; 447c
Qui reges deponerem, regesque
ordinarem; 447c
Red decadence; 447c
Red flamence; 447c
Red, yellow and black; 447c
Règne blanc; 447
Small celebration for Iris; 447c
Souneon III; 447c
Stridence; 447c
Survival; 447c
The taking of Berg op Zoom; 447c
Taverny; 447c
Upside down; 447c
The victory of Denain; 447c
Voulizic; 447c
Zorastre; 447

MATISSE, Henri, 1867-1954
Académie bleue; 215
L'Algérienne; 97c
Apples; 98c
Après le bain; 215
Arbre près de l'étang de Trivaux;
215
The artist and his model; 286c
L'Artiste et son modèle; 215
The artist's family; 341c
Asia; 286
L'Asphodèle; 147
L'Atelier de Gustave Moreau; 215
L'Atelier, Quai St. Michel; 215
The attic studio; 286c
Baignade; 215
Baigneuse; 215
Baigneuses; 215
Baigneuses à la tortue; 215
Bathers by a river; 98c, 285c,
286c
Bathers with a turtle; 579
Beasts of the sea; 87c
Bevilaqua; 215
Blue nude; 161, 449, 480, 579
Blue nude, souvenir de Biskra;
286

Still life in Venetian red; 161
Still life with apples on pink cloth; 286c
Still life with Aubergines; 286c
Still life with goldfish; 449c
Still life with oysters; 3c
Studies for Dance I; 286c
Studio, Quai St. Michel; 210, 286
Le studio rouge; 215c
Study for Luxe, calme, et volupté; 161
Sunlight in the forest; 286c
Tea; 286
The terrace, St. Tropez; 161, 281c
La terrasse; 215
Le thé; 215
Three sisters; 286
Les toits de Collioure; 215c
Une vue de Notre Dame; 215
Vase and pomegranates; 449
View from Belle Ile; 147
View of Collioure; 341c
View of Collioure with the church; 161
View of Notre Dame; 286
Vue de St. Tropez; 215
The window; 64
Window in Tahita; 286c
Woman before the window; 161
Woman in a purple coat; 271c
Woman reading; 286c
Woman with a hat; 147c, 161
Woman with a veil; 286c
Woman with the parasol; 161
Yellow Odalisque; 286c
Les yeux bleus; 215
The young sailor II; 161c
Zorah debout; 215
Zorah on the terrace; 215c, 286c
Zulma; 215

MATKOV, Franko
Virgin and Child, Sts. Stephen and John the Baptist; 455

MATSUOKA HISAHI, 1862-1944
Arc de triomphe; 230
An Italian soldier; 230

MATTA, Roberto, 1912-
Listen to living; 576
To give painless light; 449c
The vertigo of Eros; 449

MATTEO di GIOVANNI, 1443?-95
St. Sebastian; 442

MATTEO GIOVANETTI di VITERBO
Hunting scene; 576

MATTESON, Tompkins H., 1813-84
The Bible lesson; 266
Caught in the act; 257
Jacobs, The trail for witchcraft of George; 122c
Justice's court in the backwoods; 257
Now or never; 257
Palmer, Erastus Dow, in his studio; 266
Sugaring off; 257, 436c
The turkey shoot; 420

MATTHEUER, Wolfgang
Landscape with road; 273

MATTHEWS, Gene E., 1931-
Hill; 492

MATTHEWS, Sharon Ann
Ghetto; 48c

MATTHIEU, Rosina Christina
Peter III of Russia with Catherine II and her son Paul; 218

MATULKA, Jan, 1890-1972
Cubist nudes; 342
Indian dancers; 342c

MATVEEV, John
Annunciation; 455

MAUDUIT, Louise Marie Jeanne, 1784-1862
Bonaparte, Pauline; 218

MAULPERTSCH, Franz A., 1724-96
Baptism of the eunuch; 341c
Self-portrait; 114

MAUPEOU, Caroline von
A girl of Bohemia; 524

MAURER, Alfred H., 1868-1932
Abstraction; 342
Apples and nuts; 528
Autumn; 472
Green striped bowl; 472
Landscape; 342, 436c
Portrait of a girl with green background; 617c
Self-portrait with hat; 617c

Smoker at the fireside; 466
Smoker lighting his pipe; 466
Still life with dead bird; 466
Still life with tankard and herring;
466
Tavern scene; 466
Three people before an inn; 466
Two men with a sleeping woman;
466
Usurer; 466
Vegetable market at Amsterdam;
466
Venus and Amor in the smith of
Vulcan; 466
Visit to the nursery; 466
Weeping woman in blacksmith's
shop; 466
The widow's mite; 466
Woman at her toilet with a servant;
466
Woman at the virginal; 466
Woman cleaning fish; 466
Woman giving alms to a boy; 466
Woman in a blue satin dress; 466
Woman peeling an apple; 466
Woman playing the viola da Gam-
ba; 466
Woman reading a letter; 466
Woman scouring pots and pans
in a niche; 466
Woman selling fish; 466
Woman selling fish and fruit; 466
Woman selling poultry; 466
Woman washing in a tub; 466
Woman with a jug and a man with
a pipe; 466
Woman with glass and tankard;
466
Woman with sewing in a niche;
466
Young lady at her toilet; 466
Young lady drawing; 466
Young lady with a parrot; 466
Young man with pipe and jug; 466
Young woman and young man
smoking; 466
Young woman at her toilet; 466
Young woman giving fish to a cat;
466
Young woman making lace; 466
Young woman reading; 466
Young woman reading a letter; 466
Young woman seated at a table;
466
Young woman selling poultry; 466
Young woman spooling thread; 466
Young woman with a dog; 466
Young woman writing a letter; 466

METZ, Frank R., 1925-
County Mayo; 380c
Low tide, Bay of Fundy; 380c
Sea loch; 380
Sea marsh; 380
Sheltered cove; 380c

METZINGER, Jean, 1883-1957
Appolinaire, Guillaume; 361
Dancer at the cafe; 449
Le goûter; 525
Landscape; 449c
Nu; 525
Tea time; 576
Woman with guitar; 202c

MEULEN, Adam Frans van der,
1632-90
Philippe Francois d'Arenberg
saluted by the leader of a troop
of horsemen; 282

MEULEN, Pieter ter, 1602-54
Gelderland pastures; 553

MEULEN, Steven van der, 1527?-
63?
Petrie, Sir William; 434
Sidney, Frances, Countess of Sus-
sex; 434

MEUNIER, Constantin E., 1831-
1904/05
The return of the miners; 409

MEUNIER, Georgette, 1859-
Study of a heron; 524

MEURON, Maximilien de, 1785-
1868
View of the Great Eiger from the
Wengern Alp in the Bernese
Oberland; 143c

MEYER, Conrad, 1618-89
Orell, Joseph; 143

MEYER, Jeremiah, 1735-89
Frederick, Duke of York; 382

MEYER, Johann Georg (Meyer von
Bremen), 1813-86
Family gathering; 51
Girl reading; 51
Girl with knitting; 51
Grandmother and child; 51
Siesta; 51
Sitting girl; 51

MILTON, David
Afternoon in Juarez; 23
Backyard in Santa Cruz; 23

MINAMI KUZO, 1883-1950
A day in June; 230
Portrait of a European lady; 230

MINARDI, Tommaso, 1787-1871
The rosary around the neck of
the Lamb; 409

MINCHO, 1352-1431
Cottage by a mountain stream;
372
Daido Osho; 372
Shoichi Kokushi; 372
White-robed kannon; 372

MINOR, Robert Crannell, 1839-
1904
A hillside pasture; 45
October; 45, 308

MINTCHINE, Abraham, 1898-1931
Market, Place d'Alleray, Paris;
553

MINTON, John, 1917-57
Stormy day, Cornwall; 511

MIR HASHIM, 17th century
Portrait of a nobleman; 71

MIR SAYYID ALI, 16th century
The story of Laila and Majnun; 71

MIRALLES, José
Curtain seamstresses; 354

MIRANDA, Juan Carreño de, 1614-
85
Clothed monster; 346
Naked monster; 346

MIRO, Joan, 1893-
A beautiful bird flying through the
gentle light of the moon at
dawn; 250
Canvas; 389
The carbide lamp; 400
The check; 97
Circus horse; 160
Dancer; 259
Dutch interior; 3c, 400
Figures and dog in front of the
sun; 3c
Figures in a white rectangle;

549c
The garden; 389
Glove and newspaper; 449
Hand catching a bird; 283c
The hare; 449
Harliquinade; 449c
Harlequin's carnival; 291c, 576
The hunter; 259, 579
Maternity; 449c
Obrador, Juanita; 98c
Painting; 430
Painting 1933; 64
The passage of the divine bird;
430
Person throwing a stone at a bird;
400
Personnages with the star; 3c
Queen Louise of Prussia; 128,
436c
Red sun; 187c
Seated woman II; 472
Still life with old shoe; 168
The table; 160c
Triptych; 576
Woman and kite among the con-
stellations; 326
Woman, bird by moonlight; 307

MITCHELL, Joan, 1926-
They never appeared with the white;
5c
To the harbormaster; 449

MITCHELL, Max
Blue on red; 316

MITCHELL, Philip, 1814-96
The virtuous lady mine; 105

MITCHELL, Vernell
Rape of Europa; 243

MITELLI, Agostino, 1609-60
Triumph of Alexander; 40

MITFORD, Mary Russell, fl. 1768-
70
Milbrooke Church with a view of
Southampton; 105

MITROFANOVIC, George
Annunciation; 455d

MITSUOKI, 1617-91
Quail; 576

MITSUTANI KUNISHIRO, 1874-1936
The rickshaw man's family; 230

Guillaume, Paul; 187, 553
Gypsy woman with baby; 64, 335c, 576c
Hebuterne, Jeanne; 430
Italian woman; 449c
Landscape in Provence; 66
Lipchitz, Jacques, and his wife; 583c
The little girl in blue; 283c
Nude; 505c
Portrait of a student; 449
Portrait of a young woman; 128
Seated nude; 285c, 290
Self-portrait; 595
Soutine, Chaim; 110, 595
Standing nude; 160
Varvogli, Mario; 160
Woman of the people; 6c
Zborowska, Anna; 210
Zborowsky, Léopold; 271c

MOESLE, Robert, 1932-
Azay-le-Rideau; 378
Chateau Chissay; 378
Polperro; 378c
St. Pierre de Cheville; 378

MOGFORD, John, 1821-85
Cadgwith Cove, Cornwall; 604

MOHEDANO, Antonio, 1561-1625
Annunciation; 70

MOHOLY-NAGY, László, 1895-1946
A II; 449, 549c
Colored lattice No. 1, 430c
Composition A XX; 438c
Construction; 400
Z II; 400

MOILLON, Louise, 1610-96
At the greengrocer; 236
Basket of apricots; 236c
Nectarines; 352
Still life with asparagus; 218c
Still life with cherries, straw-
 berries, and gooseberries; 610c
Still life with grapes and vine
 leaves; 236

MOISE, Theodore Sydney, 1806-83
Clay, Henry; 399

MOKUAN REIEN, fl. 1323-45
The four sleepers; 263, 372c, 510, 615
Hotei; 263, 510

MOLA, Pietro Francesco, 1612-66/68
Portrait of a young man; 556
The prophet Elisha and the rich
 woman of Shunem; 556
The prophet Elijah and the widow
 of Zaraphath; 556c
St. John the Baptist preaching in
 the wilderness; 442
Socrates teaching; 143

MOLENAER, Jan Miense, 1609/10-68
Allegory of vanity; 553
Interior with a lady at the vir-
 ginals; 608c

MOLIJN, Pieter de (Molyn), 1595-1661
Landscape with cottages; 189
Landscape with peasants; 282
Landscape with traveling figures; 608c
Sandy road; 303
The surroundings of a village; 74c

MOLINARI, Luis
Gran herdagano; 37c
Templo de la Monjas-Uxmal; 37

MOLL, Carl, 1861-1945
View of Vienna from Eichelhof in
 Nussdorf; 409

MOLL, Oscar, 1875-1947
Cote d'Azur, 147

MOLLER, Hans, 1905-
Pines against the sea; 46c

MOMADAY, Alfred M., 1913-81
Buffalo medicine man; 415

MOMPOU, Joseph, 1888-
The shore; 553

MONACO, Lorenzo, 1370/71-1422/26
Adoration of the Magi; 205c
Coronation of the Virgin; 205
Crucifixion; 72c
Madonna and Child; 553
Madonna and Child and saints; 576
Penitent St. Jerome; 375

MONACO, Lorenzo Workshop
Madonna and Child; 553

Summer breeze in the Channel;
121
Women bathing a child; 105

MOORE, Herbert
The prodigal son; 437

MOORE, John, 1941-
Basic days; 380c
The letter; 380c
Red snapper soup; 380c
Three L. A. pinks; 380
View of New Haven; 380c

MOORE, Mary, 17th century
Essex, Thomas, Cromwell, Earl
of; 218

MOORE, Robert Eric, 1927-
Tide in; 46
Trio of windbirds; 46

MOORE, Theophilus
Family; 48c

MOORE, Willie
5th Ward neighborhood; 48c

MOOTZKA, Waldo, 1903-41
Allegorical bird in cloud hemis-
phere; 67
Fertilization; 67
Kachina; 67
Mythical bird; 67
Pollination of the corn; 415c
Squash dance; 67

MOPOPE, Stephen, 1900-74
Apache Ben; 415
Dancer; 415
Indian with pipe; 415
Portrait; 253c

MOR, Anthonis see MORO,
Antonio

MORA, Francis Luis, 1874-1940
Ball at the Art Students League;
266
Navajo family; 233c

MORAIS, Crisaldo d'Assuncão,
1932-
Woman on horseback; 289c

MORALES, Luis de, 1509-86
Ecce homo; 576
Madonna and Child; 335c

Pietà; 205
Virgin de la Piedad; 389

MORALT, Willy, 1884-1931
Visit to the hermit; 51

MORAN, Edward, 1829-1901
The brig Armstrong engaging the
British fleet in the harbor of
Fayal; 496
Casco Bay, coast of Maine; 496
The city and harbor of New York;
496
The commerce of nations paying
homage to Liberty; 496
The Constitution entering Boston
Harbor; 496
Foggy afternoon, New York Bay;
496
French peasants at rest; 496
Halfway up Mt. Washington; 496
Hudson, Henry, entering New York
Bay; 496
Jacques in the Forest of Arden;
496
The Life Saving Patrol, New Jer-
sey coast; 496
The Livonia and the Sappho; 496
Lost at sea; 496
New York Bay from the Battery;
496
New York harbor; 496
The ocean--highway of all nations;
496
On the Brandywine; 496
The relief ship entering Le Havre;
496
The sea; 496
A shipwreck; 390, 490
Standing out; 496
The storm; 496
The unveiling of the Statue of
Liberty; 496
Valley in the sea off the coast of
Great Britain; 496
The Wabash leaving New York for
the seat of the war; 496
The windmill; 496

MORAN, Mary Nimmo, 1842-99
View of Newark from the meadows;
45

MORAN, Thomas, 1837-1926
Barnard Castle; 528
Calatouche, N. C.; 410c
The chasm of the Colorado; 402c,
412

The balcony; 124c
Boursier, Mme., and daughter;
236c
Cache-cache; 124
The cradle; 55, 138c, 283c, 335c,
409
Eté; 124
Girl in a boat with geese; 236
Girl with a cage; 506c
Givaudan, Marthe; 210
Gobillard, Paule; 6c
The harbor at Lorient; 310c, 560
In the dining room; 187, 310c,
460c
In the garden at Maurecourt; 553
The jetty--an outdoor impression;
524
Lady with a muff; 128
Little girls in the garden; 271c
Manet, Eugène, on the Isle of
Wight; 124c
The mother and sister of the
artist; 310c
On the lake; 124
Paris seen from the Trocadero; 236
Pontillon, The artist's sister,
Mme., seated on the grass;
460
Portrait of a young woman seated;
524
Seascape, Isle of Wight; 218c
The sisters; 236
Summer day; 506c
White flowers in a bowl; 236, 443c
Woman and child on a terrace at
the seaside; 548
Young woman in a party dress;
124c
Young woman sewing in a garden;
506

MORLAND, George, 1763-1804
The sale house door; 576
Approaching storm; 341c
The fruits of early industry and
economy; 194
A gypsy encampment; 247
Inside a stable; 434
Quarry scene; 247
The tavern door; 587

MORLEY, Malcolm
Amsterdam in front of Rotterdam;
320
Colombo, Cristoforo; 11
Race track; 320c
School of Athens; 320
United States with New York sky-
line; 320
Vermeer--portrait of the artist in
his studio; 320

MORO, Antonio (Anthonis Mor),
1517/21-76/77
Anne of Austria, Queen of Spain;
576
Granvelle, Cardinal; 189
Queen Mary Tudor; 205, 281c,
389, 434, 583c, 587
Pejeron, The buffoon; 304

MORONI, Giovanni Battista, 1525-
78
A bearded man in black; 281c
Benvenuti, Mario; 556
Portrait of a gentleman; 223
Portrait of a man; 459c
The tailor; 205

MORRICE, James Wilson, 1865-
1924
Ice bridge over the St. Lawrence;
576
On shipboard; 234
The woodpile, Ste. Anne; 234

MORRIS, Carl, 1911-
Brown painting; 449
Monoliths; 46
Wind path; 46

MORRIS, George L. K., 1905/06-
75
Nautical composition; 29
New England church; 29

MORRIS, Philip Richard, 1838-
The return of the hostage; 604

MORRIS, Roger D., 1947-
Soldier; 23

MORRIS, William, 1834-96
Queen Guinevere; 232, 405, 471c
Self-portrait; 576

MORRISSEAU, Norval, 1932-
Adam and Eve and the serpent;
518c
Ancestors performing the ritual of
the shaking tent; 518c
Ancestral figure with spiritual
helpers; 518c
Ancestral portrait; 518c
Angry thunderbird; 518c
Animal unity; 518c

A vision; 462
The voice; 401c, 475, 513c
Wharf, the ship is dismantled; 500c
White night; 500c
Winter landscape; 500c
Winter landscape in Kragerö; 203c
Winter landscape near Krageroe;
 500c
Winter night; 160c, 401c
Woman in three stages; 500c

MUNKACZY, Mihaly von, 1844-
 1900/09
Arrest of the night tramps; 354
Charpie makers; 354
Christ before Pilate; 96
Last day of the condemned man;
 409
Parisian interior; 96c
The pawnbroker; 354
The presentation by the nurse;
 353c
The rivals; 51

MUNN, Paul Sandby, 1773-1845
Near Durham; 105
Tan-y-Bwlch; 600

MUNNINGS, Alfred, 1878-1959
Epsom Downs and city and sub-
 urban day; 576

MUNNS, Henry Turner, 1832-98
Danby, Francis; 2

MUR-A-MUR Squad
Ribbons; 167c

MURCH, Walter, 1907-67
Chemical industry; 22c
Transformer; 210

MURILLO, Bartolomé E., 1617-82
Abraham and the three angels;
 70
Adoration of the Magi; 553
Annunciation; 70
The Aranjeuz Immaculata; 389
Ascension; 341c
Boy with a dog; 341
Charity of St. John of God; 70
Christ healing the paralytic; 70,
 442c
Crucifixion; 70
Feeding of the five thousand; 70
Girls at a window; 389
Holy family with a little bird; 283c
Immaculate Conception; 576

Liberation of St. Peter; 70
Moses sweetening the waters of
 Mara; 70
A peasant boy leaning on a sill;
 442
Peasant boys; 576
Portrait of the artist; 382
Return of the prodigal son; 70
St. Elizabeth of Hungary healing
 the sick; 70
San Diego de Alcala in ecstasy be-
 fore the Cross; 69
Self-portrait; 442

MURILLO Follower
St. John the Baptist; 240

MURPHY, Denis Brownell, 1755?-
 1842
Crome, John; 208, 363

MURPHY, Gerald, 1888-1964
Boat deck; 481
Cocktail; 481
Doves; 481
Engine room; 481
Library; 481
Portrait; 481
Razor; 348c, 481
Wasp and pear; 400, 472, 481
Watch; 481

MURPHY, John Francis, 1853-
 1921
Path to the village; 45
The sprout lot; 45
Under gray skies; 45
The willow pond; 528

MURRAY, Charles Fairfax, 1849-
 1919
The violin player; 604

MURRAY, Sir David, 1849-1933
A Highland loch; 604

MURRAY, John H.
Buoys; 492
Cranberry Island, Me.; 492

MURREY, Richard F., 1950-
Chief Dignity; 23

MUSCHAMP, Sydney, fl. 1870-1903
Scarborough Spa at night; 605

MUSSCHER, Michel van, 1645-1705
Cook; 466

NARDONE, Vincent J., 1937-
Diptych in land and water; 23c

NARIO, José
History of Mexican American
 workers; 107cd

NARJOT, Ernest, 1826/27-98
The grandchildren; 233c
Leland Stanford's picnic, Fountain
 Grove, Palo Alto, Cal.; 266

NASAKA, Juko
Untitled; 320

NASH, John, 1893-
The cornfield; 511
The moat, Grange Farm, Kimble;
 478
Winter afternoon; 478

NASH, Joseph, 1808-78
The corridor, Windsor Castle; 382
The Queen's sitting room, Windsor
 Castle; 382
The Van Dyck room, Windsor
 Castle; 382

NASH, Paul, 1889-1946
Eclipse of the sunflower; 607
Encounter in the afternoon; 511
Equivalents for the megaliths;
 511c
Event of the downs; 449
French farm; 553
Landscape from a dream; 576
Landscape of the megaliths; 478
Landscape of the vernal equinox;
 382c, 478, 511
Meadow with copse: Tower Ham-
 lets District; 478
Night landscape; 434c
Oxfordshire landscape; 9c
Pillar and moon; 3c, 294c
The raider on the shore; 9c
Totes meer; 475
We are making a new world; 511
Winter sea; 478

NASH, Willard, 1898-1943
Landscape No. 2; 233c

NASMYTH, Alexander, 1758-1840
Almondell Bridge; 279
Edinburgh Castle; 279
Edinburgh from the east; 105
Perth, Sarah Clementina, Lady,
 with her daughter Clementina;

279
Rocky wooded landscape with ruined
 castle by a lock; 247
Tantallon Castle; 279
View of the Ponte Molle on the
 Sylvan side of Rome; 279
Windings of the Forth; 576

NASMYTH, Charlotte
A wooded landscape with travelers
 on a path; 218

NASMYTH, Jane, 1778-1866
Furness Abbey with a distant view
 of Morecambe Bay; 218

NASMYTH, Patrick, 1786-1831
Near Tonbridge; 105
A view in Leigh Woods, Bristol;
 279
A view of Teviotdale; 604

NATTIER, Jean Marc, 1685-1766
Balletti, Manon; 442
Portrait of a lady as Diana; 576
Rohan, Princesse de; 553

NAUEN, Heinrich, 1880-1941
Pietà; 503

NAUMAN, Bruce, 1941-
Study for the hologram; 472
The true artist helps the world;
 449
Window or wall sign; 320

NAUMOVSKI, Vangel, 1924-
The grief and the flowers grown
 from tears; 394c

NAVARRE, Mlle. ----, 18th cen-
 tury
Portrait; 218

NAVARRETE, Juan Fernández de,
 1526?-79
Martyrdom of St. James; 389

NAVEZ, François J., 1787-1869
Hemptinne family; 409

NAY, Ernst W., 1902-68
Alpha; 449c
Receding ochre; 549c
Retreating ochre; 438c

NEAGLE, John, 1796-1865
Choncape and Shairtarish; 572

Clay, Henry; 381
Haviland, John; 399
Lyon, Pat, at the forge; 14c, 599, 445c
Stuart, Gilbert; 399
View on the Schuylkill; 399

NEAL, Harold M., 1930-
King, Martin Luther, Jr.; 122c

NEALE, John Preston, 1780-1847
Northumberland House, Charing Cross; 105

NEDYALKO of LOVEC
Old Testament Trinity; 455

NEEFS, Pieter I, 1578-1656/61
Interior of Antwerp Cathedral; 576
Interior of the Church of the Dominicans in Antwerp; 41

NEEL, Alice, 1900-
Arce, Georgie; 396
Crehan, Hub; 396
Cruz, Harold; 396
Curtis, Jackie, and Rita Red; 396
Futility of effort; 396
Geldzahler, Henry; 396
Gould, Joe; 396
The Gruen family; 396
Hartley; 396
Hurd, Hugh; 396
Julie and Algis; 396
Nancy and the twins; 396
Neel, Richard; 396
Perreault, John; 396
TB case, Harlem; 396
T.B., Harlem; 236
Warhol, Andy; 5c
Well baby clinic; 396

NEEP, Victor
Clown; 129

NEER, Aert van der, 1603?-77
Approaching the bridge; 553
Arrival of the guests; 553
Burning church; 189
Canal scene by moonlight; 303
City burning by moonlight; 282c
Frozen river; 74cd
A frozen river by a town at evening; 576
River scene by moonlight; 608c
Summer evening landscape; 282
Winter scene with skaters; 608c

NEER, Eglon H. van der, 1634?-1703
Boudoir scene; 466
Boys playing with a bird's nest in a landscape; 608c
Card players; 466
Guiscardo and Guismonda; 282c
Lady with a lute; 466

NEERVOORT, Leonardus A. J., 1908-
The fairground musician; 289c

NEGRETE, Ezequeil
Mexican herdsmen; 262

NEGUS, Caroline, 1814-67
Page, Mrs. James; 381

NEHLIG, Victor, 1830-1909
Pocahontas and John Smith; 233c

NEHUS, Jonee
Polly's piano; 492

NELLI, Suor Plautilla
Last Supper; 218

NELSON, Arthur, fl. 1756-90
Near Canterbury; 105

NERI da RIMINI, fl. 1300-19
Crucifixion; 522

NERI di BICCI
Madonna with sleeping Child, 975

NERLY, Friedrich, 1807-78
View of the Volsker Mountains near Olevano; 175

NEROCCIO
St. Bernard preaching in the Piazza del Campo; 576

NESBITT, Lowell B., 1933-
Iris; 320
Willenbecher's, John, atelier; 320c

NESTEROV, Mikhail Vassilievich, 1862-1942
A vision of the young Bartholomew; 96

NETSCHER, Caspar, 1636?-84
Boy in a niche; 466
Boy with a jug in a niche; 466
The lace maker; 576, 608c

OHMAN, Richard M. , 1946-
Coil series No. 1; 316

OHNO, Masuho
Untitled; 320

OKADA, Alan
Chi Lai-arriba--rise up!; 107c
Chinatown today; 107
History of Chinese immigration to
the U. S. ; 107d

OKADA BEISANJIN, 1744-1820
Autumn landscape; 615
The landscape, an elder brother;
371
Lion-dog and peonies; 615
Scholars under a pine tree; 615

OKADA HANKO, 1802-46
Crows rising in spring mist; 615bc
The farewell gift; 371

OKADA SABUROSUKE, 1869-1939
Portrait of a lady; 230c
Portrait of a woman; 230
Reading; 230
Upper Seine; 230

OKADA, Kenzo, 1902-
Compatability; 22c
Plum tree; 187
Solstice; 449

O'KEEFFE, Georgia, 1887-
Abstraction; 246, 617c
Abstraction--white rose III; 414c
Another church, Hernandez, N. M. ;
22c
Banana flowers; 246
Barn with snow; 414c
Black abstraction; 414c
Black and white; 414c
Black bird series; 414c
A black bird with snow-covered
red hills; 414c
Black cross, New Mexico; 98c,
246, 348c, 402, 414c, 445c,
617
Black hollyhock, blue larkspur;
414c
Black iris; 414c, 430c, 576,
617c
Black place III; 414c
Black rock with blue III; 414c
Black rock with blue sky and white
clouds; 414c
Black spot, No. 2; 472

Black spot III; 414c
Bleeding heart; 414c
Blue No. 2; 236, 267, 414c, 617c
Blue No. 1; 236
Blue No. 3; 236
Blue No. 4; 236
Blue and green music; 617c
Blue lines; 414c
Canyon with crows; 414c
Cebolla church; 414c
City night; 414c
Cliffs beyond Abiquiu; 414c
Cliffs beyond Abiquiu--dry water-
fall; 414c
Closed clam shell; 414c
Corn, dark; 414c
Cow's skull: red, white and blue;
131, 414c, 617c
Cross by the sea, Canada; 414c,
475
Cross with red heart; 414c
Dark abstraction; 414c, 617c
Dead tree with pink hill; 414c
East River from the Shelton; 414c
East River from the 30th story of
the Shelton Hotel, New York;
122c, 186
Evening star III; 402, 414c, 475
Evening star IV; 414c
Evening star V; 414c
Evening star VI; 414c
Fifty-ninth street studio; 414c
The flagpole; 414
Flagpole with white house; 414c
A fragment of the Ranchos de Taos
Church; 414c
From a day with Juan No. IV; 5c
From the faraway nearby; 414c,
617c
From the plains I; 414c, 342
From the plains II; 414c
Gate of adobe church; 313c
Gerald's tree I; 414c
Green-gray abstraction; 414c
The grey hills; 414c
Grey hills II; 414c
Hills and mesa to the west; 402
In the patio I; 414c
In the patio IV; 414c
It was yellow and pink III; 414c
Jack-in-the-pulpit II; 414c
Jack-in-the-pulpit III; 414c
Jack-in-the-pulpit IV; 414c
Jack-in-the-pulpit V; 414c
Jack in the pulpit VI; 414c
Ladder to the moon; 414c
Lake George barns; 236, 414c
Lake George window; 246, 400,

414c, 617c
Lake George with crows; 414c
The Lawrence tree; 414c
Light coming on the plains II;
 9c, 414c, 475, 617c
Music--pink and blue I; 414c
Nature forms, Gaspé; 414c
Near Abiquiu, N.M.; 414c
New York night; 414c, 472
New York rooftops; 528
New York with moon; 414c
Open clam shell; 414c
Orange and red streak; 402c, 414c
An orchid; 414c, 528
Painting No. 21; 414c
Patio with black door; 414c
Patio with cloud; 246
Pedernal; 414c
Pedernal and red hills; 414c
Pelvis III; 414c
Pelvis series, red with yellow;
 414c
Pelvis with moon; 246, 414c
Portrait W, No. II; 472c
Radiator Building--night, New
 York; 414c
Ram's head with hollyhock; 414c
Ranchos Church; 236, 242c, 414c
Red and orange hills; 414c
Red and yellow cliffs; 414c
Red canvas; 528c
Red hills and bones; 414c, 475
Red hills and sky; 414c, 475
Red poppy; 414c
Road past the view II; 414c
The shanty; 414c
Shell I; 414c
Shell and old shingle I; 414c
Shell and old shingle II; 414c
Shell and old shingle III; 414c
Shell and old shingle IV; 414c
Shell and old shingle VI; 414c
Shell and old shingle VII; 414c
Shell on red; 414c
The Shelton with sunspots; 414c
Single alligator pear; 414c
Sky above clouds IV; 414c
Stables; 414c
Starlight night; 414c
Stump in red hills; 414c
Summer days; 402, 414c
Sunflower for Maggie; 414c
Two calla lilies on pink; 414c
Two jimson weeds; 414c
Wave, night; 414c
White birch; 414c
White Canadian barn II; 414c
The white flower; 64, 246

White patio with red door; 414c
The white place in shadow; 414c
The white trumpet flower; 414c
The winter road; 414c

OKYO, 1733-95
Pine trees in snow; 576

OLAH, Susan R., 1947-
Berci; 23
The native; 23

OLDACH, Julius, 1804-30
Oldach, Catharina Maria, the art-
 ist's mother; 175

OLDENBURG, Claes, 1929-
Bacon and eggs; 370c

OLDFIELD, John Edwin, fl. 1826-
 54
Landscape; 105

OLITSKI, Jules, 1922-
Born in Snovsk; 92
4th stride; 97
High A yellow; 387c, 445c
Intimacy; 92
Line passage I; 5c
Mojo working; 92
Prince Patutsky command; 472c
Seventh loosha; 388c, 472

OLIVER, Isaac, 1568-1617
Donne, John; 382c
Dorset, Third Earl of; 587
Elizabeth, Queen of Bohemia; 382c
Henry, Prince of Wales; 382c,
 434
Herbert, Lord, of Cherbury; 434
Portrait of an unknown man; 382c
Self-portrait; 576

OLIVER, Isaac, Style
Dorset, Third Earl of; 587
Essex, Frances, Countess of; 587

OLIVER, Kermit
Fire fighters; 48c
Post-Civil War, Texas black legis-
 lators; 48

OLIVER, Peter, 1594-1648
Charles I; 382
Charles I when Prince of Wales;
 434c
School of love; 214

Christ enthroned among saints;
205c
Christ rescuing the disciples;
205
St. Matthew altarpiece; 522
Strozzi altarpiece; 113, 522
Triumph of death; 38, 522d, 576d

ORCAGNA, Jacopo di Cione,
1868-98
St. Matthew altarpiece; 522

ORCAGNA Workshop
St. Michael; 375

ORCHARDSON, Sir William Q.,
1835-1910
The first cloud; 353, 409
Hamlet and Ophelia; 231c
Her mother's voice; 353
The last dance; 231c
Mariage de convenance I; 605d
Mariage de convenance: after;
279, 605
The marriage of convenience;
96, 195, 231, 576, 604
Master baby; 279
On the lagoons; 231
Queen of the swords; 384
A social eddy; left by the tide;
279
Solitude; 231

ORD, Joseph Blaya
Déjeuner à la Fourchette; 62

ORDAHL, Stafford
Untitled; 23

ORELLI, Giuseppe Antonio Felice,
1706-76
Selene and Endymion; 143c

ORLANDI, Deodato, fl. 1288-1308
Crucifix; 113, 522
Scenes from the lives of Sts.
Peter and Paul; 522

ORLEY, Bernard, 1488-1541/42
Job's afflictions; 205
The ruin of the children of Job;
576

ORLEY, Bernard van Studio
Charles V; 382

ORLOWSKI, Alexander O., 1777-
1832
Battle scene; 409

ORMANI, Maria
Breviarium cum calendario; 218

OROZCO, Jose Clemente, 1883-
1949
The coming of Quetzalcoatl; 200
The departure of Quetzalcoatl; 200
Law and justice; 87
Mother and child; 335c
Prometheus; 576c
Zapatistas; 242

ORPEN, William, 1878-1931/38
Dead Germans in a trench; 511
Hommage à Manet; 478
The play scene in Hamlet; 478

ORROCK, James, 1829-1919
Glen Capel on the Nith; 105

ORTMAN, George E., 1926-
Seasons; 320

OS, Georgius Johannes Jacobus,
1782-1861
Still life with fruit and flowers;
409

OSBORN, Emily Mary, fl. 1851-93
For the last time; 605
Nameless and friendless; 218, 604
Sturgis, Mrs. and children; 236c

OSBORNE, Walter Frederick,
1859-1903
In St. Stephen's Green; 604

OSHITA TOJIRO, 1870-1912
Foot of Mt. Hodaka; 230
Oze Pond; 230

OSONA, Rodrigo de the Elder, fl.
1746-84
Crucifixion; 576
Madonna of the Knight of Montesa,
with Sts. Benito and Bernard;
389

OSTADE, Adriaen van, 1610-85
An alchemist at work; 303
Carousing peasants; 189
Family of peasants in an interior;
74c
The fish seller; 608c
Interior of a peasant's cottage;
157c
Interior of an alehouse; 608c
Landscape with an oak; 74c
The painter in his studio; 374

Hilly scene; 462
In a Shoreham garden; 9c, 576
The lonely tower; 600
The magic apple tree; 409, 462c
Moonlit landscape; 475
Pastoral with horsechestnut; 475
Pear tree blossoming in a walled
 garden; 475
Pistyll Mawdach, North Wales;
 105
Portrait of the artist as Christ;
 475
The rest on the flight; 195, 475
Self-portrait; 475
Sepham barn; 600
A valley thick with corn; 434
View of Tivoli; 506c

PALMER, Sutton, 1854-1933
A lock on a river; 105

PALMER, William C., 1906-
Dust, draught and destruction;
 242c
A soft day--Connemara; 46c

P'AN TZ'U
Plum blossoms; 615

PANERAI, Giuseppe
Going to the meet; 353

PANGALOS, Maria
Pastorale; 23

PANKO, William, 1892-1948
Blue birds of happiness; 235c
Drumheller, Alberta; 235
Rodeo; 235
Round-up; 234

PANNINI, Giovanni Paolo, 1692-
 1765/68
Architectural fantasy with a con-
 cert party; 553
Circe entertains Odysseus at a
 banquet; 556
Hermes appears to Calypso; 556
Ruins with St. Paul; 576
Ruins with the Farnese Hercules;
 553
St. Peter's Square, Rome; 553
Visit of the Cardinal of York to
 San Paolo fuori le mura; 522

PANTOJA de la CRUZ, Juan,
 1553-1608
Margaret, Queen of Spain; 382
Villamayor, Diego de; 341

PAOLINI, Giulio, 1940-
The lining; 449

PAOLINI, Pietro, 1603-81
An allegory; 526
A concert; 526

PAOLINO, Fra
Coronation of the Madonna with
 saints; 61

PAOLOZZI, Eduardo, 1924-
Evadne in green dimension; 449
Head I; 449
I was a rich man's plaything; 511c

PAPE, Abraham de, 1620-66
Old woman plucking a hen; 466

PARADISE, Phil, 1905-
Corral; 65

PARET, Luis, 1746-99
Charles III dining before his court;
 389
Charles III at luncheon attended by
 his court; 576

PARK, J. Stuart
A gypsy maid; 231c
Roses; 231c

PARK, Linton, 1826-1906
Flax scutching bee; 122c, 370

PARKER, Edgar, 1840-
Adams, John; 122

PARKER, Henry H., 1858-
Harvest time; 604

PARKER, Henry Perlee, 1795-
 1873
Smugglers playing cards; 604

PARKER, Joseph
Anticipated moment; 575c
Dawn of the Aquarian age; 575c
The path; 575c
Rise of the spiritual sun; 575c
Sunrise in blue; 575c

PARKER, Judith R.
Carrie; 23c

PARKER, Ray, 1922-
Untitled; 472

PA-TA SHAN-JEN see CHU TA

PATCH, Thomas, 1725-82
A distant view of Florence; 194
A group in Florence; 166

PATER, Jean Baptiste, 1695-
1736
The bathing party; 553
Fête galante; 576

PATERSON, James
Moniaive; 231

PATINIR, Joachim, 1490-1524
Baptism of Christ; 283c
Charon crossing the Styx; 576
Charon's boat; 294c
Flight into Egypt; 205
Landscape with St. Jerome; 576
Penitence of St. Jerome; 294c
St. Jerome in a rocky landscape;
424c, 442c

PATLAN, Ray
Hay cultura en nuestra comunidad;
107d
History of Mexican American work-
ers; 107cd
Salón de la raza; 107cd
Sun of justice; 107d

PATON, Sir Joseph, Noel, 1821-
1901
The Bluidie Tryste; 279
Dante's dream; 195
Dawn: Luther at Erfurt; 231
Ezekiel; 279
The fairy raid; 604
The fairy raid--carrying off a
changeling--Midsummer Eve;
231
In memoriam; 605
The quarrel of Oberon and Titania;
231c
The reconciliation of Oberon and
Titania; 279
The soldier's return; 382

PATON, Waller Hugh, 1828-95
Holy Island, Aran, from above
Lamlash; 604

PATROON PAINTER, De Peyster
Manner, fl. 1715-30
Levy, Moses; 158

PAULSEN, Brian O., 1941-
Roadside Indian area; 153

PAVLOVETZ, Nikita
King of kings; 455
Virgin in the enclosed garden; 455
Virgin's festivals; 455

PAXTON, William McGregor, 1869-
1941
The figurine; 176
The new necklace; 257c
Tea leaves; 257, 353
Woman combing her hair; 257

PAYMAL-AMOROUX, Blanche
A holiday at Sosthène; 524

PAYNE, William, 1760-1830?
Moonlight landscape; 105

PAYZANT, Charles
Unknown ship owner; 235

PEACOCK, Ralph
The plea for mercy; 604

PEAKE, Robert, 1580-1626
A military commander; 434
Henry, Prince of Wales, in the
hunting field; 434

PEALE, Anna Claypoole, 1791-
1878
Biddle, Nicholas; 381

PEALE, Charles Willson, 1741-
1827
Arbuckle, Mrs. James, and son;
17, 178
The artist in his museum; 17, 29,
178c, 270c, 409
Belfield and Germantown; 17
Belfield Garden; 17
Dickinson, John; 287
Exhuming the mastodon; 266, 348c,
399
Family group; 62d
Franklin, Benjamin; 178c
Gates, Horatio; 178
Gelston, Mrs. David, and daughter;
178
Green, Mrs. Jonas; 178c
Laming, Benjamin and Eleanor
Ridgely; 17
Little girl with a toy horse; 17
Morris, Gouverneur and Robert,
in the Office of Finance; 178
Moultrie, William; 178
Noah and his ark; 266
The Peale family; 17, 87c
Portrait of a lady; 399

PECK, Sheldon, 1797-1868
Crane, Anna Gould, and grand-
 daughter, Jennette; 32, 348c
Crane, David Crane and Catharine
 Stolp; 32c
Flint, Mr.; 32
Girl with rose and landscape; 32
Man holding Bible; 32c
Man with newspaper and landscape;
 32
Mother and son; 32c
Murray, Mrs.; 32
Peck, Captain Alanson; 32c
Peck, Jacob and Elizabeth Gibbs;
 32
Peck, Mary Parker; 32c
Portrait of a boy; 32
Tyler, Elmer; 32
Vaughan, Mr. S.; 32
Vaughan, Mr. and Mrs. William;
 32c
Wagner, John J., family; 32
Welch, Phebe; 32
Welch, William W.; 32
Woman holding book with chest
 and bowl of fruit; 32
Woman in a chair; 32

PEDERSEN, Carl Henning, 1913-
Ochre phoenix bird, a legend;
 436c

PEEL, James, 1811-1906
Carting timber in the Lledr Valley;
 604

PEELE, John Thomas, 1822-97
The pet; 176
A prayer for health; 604, 605

PEETERS, Bonaventura, 1614-52
French man-of-war on a rough
 sea; 421c

PEETERS, Catharina, 1615-76
Sea battle; 218

PEETERS, Clara, 1594-1657
Flowers in a glass vase; 236c
Still life; 218c
Still life with a vase of flowers,
 goblets and shells; 236
Still life with cheese, bread
 and pretzels; 236
Still life with fish; 236
Still life with flowers, a goblet,
 dried fruit and pretzels; 236

PEETERS, Geertje, 17th century
Flowers; 218

PEIRCE, Waldo, 1884-1970
After the show; 242

PELHAM, Henry, 1749-1806
Babcock, Adam; 381

PELHAM, Peter, 1684-1751
Mather, Rev. Cotton; 399

PELIZZA de VOLPEDA see
 VOLPEDO, Giuseppe P. da

PELLAN, Alfred, 1906-
Femme d'une pomme; 234
Floraison; 576
Maisons de Charlevoix; 234

PELLEGRINI, Giovanni Antonio,
 1675-1741
Allegory of the marriage of the
 Elector Palatine; 442
Entombment; 556
The musicians' balcony; 434, 587
Painting; 284c
Sophonisba receiving the cup of
 poison; 553

PELLEW, John C., 1903-
Above Empire; 423c
Above the cliff; 423c
Above the Rio Grande; 423c
At Ocean Point; 423c
Autumn; 423c
The barens; 378
Barn interior; 423
Beth painting; 423c
Betty sketching; 423c
Clear day, cold breeze; 423c
Colorado evening; 423
Copeland Lake; 423c
Cornwall; 423c
December afternoon; 423c
Down East; 378
Ducks in Stonybrook; 423
Farington's pines; 423c
First snow; 423c
Fisherman's chapel, Ericeira;
 423c
Five Mile River; 423c
Florida waterfront; 378
Forest interior; 423c
Fresh snow; 423c
A gray day; 423
Gulls at bass rocks; 423c

604
The gambler's victim; 231
Hunted down; 279
A state secret; 195
Treason; 279
Two strings to her bow; 279
The world went very well then;
 231

PETTIT, William
Buff; 348

PETTITT, Joseph Paul
A mountain path in Wales; 604

PEVSNER, Antoine, 1884-1962
Abstract forms; 449
Grey scales; 438c

PEYRON, Jean F. P., 1744-1814
Belisarius; 184
Death of General Valhubert; 184
Hagar and the angel; 184
Time and Minerva; 184

PEYRONNET, Dominique, 1072-
1943
L'Annonce du garde-champêtre;
 328c
La mer; 328c
Woman reclining; 331c

PFAHL, Charles
Afternoon nap; 519
Afternoon rest; 519c
Artist and model; 519c
Artist at work on self-portrait;
 519c
Backbone; 519c
Backlight; 519c
Black lace; 519c
Charlotte with patterns; 519c
Cleaning; 519
Conversation; 519
Depressed; 519c
Despair; 519c
Despondent; 519c
Diego; 519c, 520c
Early morning; 519
Hall mirror; 519
Head in profile; 519c, 520c
Interior; 519c
Jay; 519, 521c
Keener, Ward; 520c
Mirrored image; 519
Model at rest; 519
The monk; 520
The naturalist; 519c

Night light; 519
Nude; 519
Nude on carpet; 519
Nude on quilt; 519c
Portrait against Oriental rug; 519
Reclining figure; 519c
Reflection; 519
Resting model; 519
Sea urchin; 519c
Self-portrait; 520
Self-portrait in progress; 519c
Self-portrait with monk's cowl;
 519c
Sharon with nightcap; 519
Still life: flowers and fruit; 519c
Still life: rabbit; 519c
Still life with plants; 519
Study in light; 519
Summer evening; 519c
Sunday morning; 519
Sunday Times; 519c
Watering plants; 519c

PFORR, Franz, 1788-1812
Emperor Rudolf's entry into Basle;
 409
Entry of the Emperor Rudolf of
 Habsburg into Basle; 175

PHILIPP, Robert, 1895-
At sea; 520
Self-Portrait; 520c

PHILIPSON, Robin, 1916-
Ascension and Crucifixion; 347
Brenda: spring portrait; 347
The burning; 347
Byzantine interior; 347c
Cathedral interior; 347c
Cock crowing; 347
Cockfight, prelude; 347c
Cockfight, the kill; 347
Cockfight, yellow; 347
Crucifixion; 347
Defenders of the realm; 347
Equestrian king; 347
Fruit; 347
High summer, No. 3; 347
The hunt; 347c
Kind, No. 1; 347
Never mind; 347c
Night II; 347
Rose window in darkening interior;
 347
The screen No. 3; 347
Self-portrait; 347
The soldier and the village; 347
Soldier and village study; 347

PICKEN, George, 1898-1971
Strike; 29

PICKENS, Alton, 1917-
Carnival; 370

PICKERING, Evelyn
Flora; 524

PICKERSGILL, Frederick Richard,
1820-1900
The burial of Harold; 537, 538
Two Venetian girls on a balcony;
604

PICKET, Sarah T.
The steamship Sarah; 235c

PICKETT, Joseph, 1848-1918
Coryells ferry; 243c
Lehigh Canal, New York; 328c
Manchester Valley; 64, 89c, 348c,
370

PICOT, François E. , 1786-1868
Cupid fleeing Psyche; 409

PIEN WEN-CHIN, fl. 1413-27
Bird on a prunus branch; 337
Two cranes and small birds with
bamboo and blossoming plum;
81
White cranes; 88d

PIENEMAN, Jan Willem, 1779-
1853
The battle of Waterloo; 189

PIEPHO, Carl
At the edge of the wood; 593

PIERCE, Bruce
Gothic north: St. Nikolai of Ham-
burg; 378
Gothic window; 378
Reflections of a gothic god; 378
Up a gothic stair; 378
Winter rose; 378c

PIERO della FRANCESCA, 1410-92
Altarpiece; 375
Annunciation; 576
An Apostle; 375
Baptism; 205
Baptism of Christ; 84d, 223, 294c,
442c, 459c
Battle of Constantine; 291cd
Christ on the Cross with the Vir-

gin and St. John the Evangelist;
223
Death of Adam; 87c, 205
Discovery of the True Cross; 84,
87c
Federigo and Battista riding on
triumphal chariots; 223
Flagellation; 205, 223, 533c
Hercules; 281c
Madonna; 375
Madonna and Child with saints and
angels adored by Federigo da
Montefeltro; 87c
Madonna and saints; 375
Madonna del Parto; 335c
Madonna of mercy; 87c
Madonna pointing to her pregnant
womb; 223c
Meeting of Solomon and Sheba;
84d
Montefeltro, Duke Federigo da;
43, 283c, 576, 583c
Montefeltro, Federigo da, Duke of
Urbino and his wife Battista
Sforza; 223, 533
Nativity; 9c, 307, 335c, 442, 576
Proof of the True Cross; 87c
Queen of Sheba visiting Solomon;
375
Resurrection; 205, 223d, 576c
St. Augustine; 375
St. Jerome and a donor; 375
St. Michael; 375, 442c
St. Nicholas of Tolentino; 375
Sforza, Battista, Duchess of Ur-
bino; 583c
Story of the Queen of Sheba; 205cd
Two children of Adam; 223
The victory of the East Roman
Emperor Heraclius over the
Persian King Chosroes; 223
Virgin and Child with angels and
saints; 533c
Virgin and Child with angels and
saints, adored by Federigo da
Montefeltro, Duke of Urbino; 223

PIERO DI COSIMO, 1462?-1521
Adoration of the Child; 553
The building of a palace; 556c
Discovery of honey; 205c, 291c
A forest fire; 459c, 567c
Immaculate Conception; 61
Madonna and Child with four saints;
61
Mars and Venus; 223
Mythological scene; 284c
A mythological subject; 442, 533c

Mykonos Church; 433c
My studio; 433c
Netherlands; 433c
Night market, Guatemala; 433
Old bridge, Toledo, Spain; 433c
Old list; 433
Opera house at Sydney Harbor,
 Australia; 433c
Overlook Mountain; 433c
Perrine's Bridges; 433c
Rainy tryst; 433c
Rondout Creek; 433c
Round Top Church, New York;
 433c
Shooting fish on the Rio Carrao,
 Venezuela; 433c
Sinbad's Roc foot; 433c
Snow cascades; 433c
Snowshoes; 433c
Snowball cart, Spanish town; 433
Summer woodland; 433c
Town in Cork; 433c
Troubadour's rest stop; 433c
Unfinished project, Savannah; 433c
Untouched forest; 433c
Venice, Mother and chicks; 433c
Wash-up time; 433c
West Indian Beach; 433c
Woods--late winter; 433c
You can't get there from here;
 433c

PILOTY, Karl Theodor von, 1826-
 86
Seni before the body of Wallen-
 stein; 86, 176, 576
Thusnelda in the triumphal pro-
 cession of Germanicus; 409

PILS, Isidore A., 1813-75
Rouget de l'Isle singing the Mar-
 seillaise at the house of
 Deitreich, Mayor of Stras-
 bourg;

PINE, Robert Edge, 1730?-88
Warren, Earl, making reply to
 the writ commonly called Quo
 Warranto in the reign of Ed-
 ward I, 1278; 537, 538

PINELLI, Bartolomeo, 1781-1835
The mandolin player in the cam-
 pagna; 409

PINNEY, Eunice, 1770-1849
Two women; 218

PINSON, Isabelle
Family group; 218

PINTORICCHIO, Bernardino di,
 1454-1513
Aeneas Piccolomini setting out for
 the Council of Basilea; 576
Crucifixion with Sts. Jerome and
 John; 72c
The departure of Enea Silvio
 Piccolomini for the Council of
 Basel; 43
Madonna and Child; 281c
The return of Odysseus; 421c

PINWELL, George John, 1842-75
The strolling players; 604

PIOMBO, Sebastiano del, 1485-
 1547
Columbus, Christopher; 398
Death of Adonis; 576
Juno; 375
Madonna and Child with Sts.
 Joseph, John the Baptist and a
 donor; 442
Pietà; 205
Polyphemus; 375
Portrait of a man in armor; 432c
Raising of Lazarus; 43
St. Louis of Toulouse; 432c
Salviati, Cardinal Giovanni; 556

PIPER, John, 1903-
Castle Howard; 478
Construction; 511
Gordale Scar; 511
Monument, Waldershare; 478
River landscape; 105
Rock valley, north Wales; 553
St. Mary le Port, Bristol; 576
Somerset Place, Bath; 434, 607

PIPPIN, Horace, 1888-1946/47
Brown, John, going to his hanging;
 89c, 122c, 243c, 328c
Family in the kitchen; 243c

PISA School
Crucifix; 72c
Crucifix with episodes from the
 Passion; 72cd
Crucifix with stories of the Pas-
 sion; 547c
Crucifix with Virgin and St. John;
 547c

RAFFAËLI

A little girl holding flowers; 279
Macdonell, Col. Alastair, of
Glengarry; 195
McMurdo, Lt. Col. Bryce; 409
The McNab; 434c
Robison, Professor John; 279
Sinclair, Sir John; 576
Spens, Dr. Nathaniel; 279
Tait, John and his grandson; 194
Thomson, Christina; 553
Traill, Lady Janet; 553
Walker, The Rev. Robert, skating
on Duddingston Loch; 194

RAFFAËLI, Jean François, 1850-
1924
At the bronze foundry; 354
Guests waiting for the wedding;
409

RAFFAEL, Joseph, 1933-
Autumn leaves; 320
Island lilies II; 46
Muir creek I; 46c

RAFFET, Denis A.M., 1804-60
The retreat from Russia; 409

RAFFLER, Max, 1902-
The fifth day of creation; 289c
A sledging party with King Ludwig
II of Bavaria; 289c

RAFFO, Steve
La casa de Dios; 457
City sunset; 187

RAGAN, Leslie, 1897-
Empire State Express; 209
Leaders of the great steel fleet;
209c
Twilight on the Hudson River;
209c

RAGINI, Mayrurika
The peacock melody; 273c

RAGNONI, Sr. Barbara, 15th
century
Adoration of the shepherds; 218,
524

RAHL, Carl, 1812-65
Persecution of the Christians in
the Roman catacombs; 409

RAI SAN'YO
Landscape; 615bc

RAINALDI, Francesco, 1770-1816
Princess Mashim Oudh; 302

RAINER, Arnulf, 1929-
Self-portrait; 114c

RALEIGH, Charles S., 1830-1925
Western Star; 158

RAMOS, Melvin, 1935-
A.C. Annie; 103
Aardvark; 103c
Aquagirl; 103
Aquaman in danger; 103
The atom; 103
Baby Ruth; 103
Badger; 103
Banting; 103c
The bath; 103
Batman; 103
Batmobile; 103c
Beaver shot; 103
Bison; 103
Black Hawk; 103
Blue coat; 103c
Browned bare; 103
Camilla; 103
Camilla No. 2; 103
Candy; 103c
Captain Midnight; 103c
Cave girl; 103
Checkered dress; 103
Chic; 103
Chiquita; 103c
Civet cat; 103c
Clouded leopard; 103
Cool; 103
Crime buster; 103c
Cute; 103
Dare Devil; 103
David's duo; 103c, 320
Devil Doll; 103
Dr. Midnight; 103c
Doll; 103
Elephant seal; 103
Fantomah; 103
The flash; 103
Futura; 103
Gale Allen--girl squadron leader;
103
Gardol Gertie; 103
Georgia Peach; 103
Giant panda; 103c
Gloria Gardol; 103c
Glory Forbes vigilante; 103
Gorilla; 103c
The green lantern; 103
Guenon; 103

La muta; 43c, 361
Oath of Leo II; 43
Parnassus; 43c, 205
Pietà; 281c
Pope Julius II; 223, 442
Pope Leo X; 567c
Portrait of a woman; 223
Portrait of a young cardinal; 43cd
Portrait of two men; 43
Prophet Isaiah; 43
Sacrifice at Lystra; 287, 382
St. Catherine of Alexandria; 43, 442
St. Cecilia altarpiece; 43c
St. George and the dragon; 39c, 43c, 187, 382
St. Michael; 567c
St. Michael and the dragon; 43c
St. Michael vanquishing the Devil; 43c
St. Paul preaching in Athens; 205
St. Peter freed from prison; 205
St. Sebastian; 43
School of Athens; 43c, 87c, 205, 223bc, 239, 361d, 373, 459c, 533c
Sibyls; 43d
Sistine Madonna; 43c, 223
Small Cowper Madonna; 39c
Strength, Prudence, and Temperance; 43
Tempi Madonna; 567c
Theological virtues; 43c
Three Graces; 43c, 176, 205, 505c, 567c
Tolentino, Niccolò da, altarpiece; 43c
Transfiguration; 43c, 87c, 205, 533c, 576
Venus and Adonis; 43
Virgin and Child; 223
Vision of Ezekiel; 43c
The way to Calvary; 43c
Young woman with a unicorn; 583c

RAPHAEL, School
La Fornarina; 97

RAPHAEL, William, 1833-1914
Bonsecours market; 234

RASIC, Milan
Springtime; 328c
Summer; 394c

RATCLIFFE, William, 1870-1955
The coffee house, East Finchley; 511

RATERRON, Jean Jacques
The tree; 23

RATGEB, Jörg, 1480?-1526
Flagellation; 205, 576

RATNER, David M., 1922-
Blue Steel interior; 210

RATTNER, Abraham, 1895-1978
Afternoon in August; 338
Air raid; 338
Apocalipsion; 338
April showers; 338c
Bacchanali; 338
Bedwell, Bettina; 338
Black angels; 338
The bride; 338
The butcher; 338c
The carnival; 338c
Christ and two soldiers; 338
Church near Galdardon; 338c
The city No. 2; 338
City life; 338
City man; 338
Clown; 338
The clown No. 4; 338c
Composition, city people; 338
Composition--five figures; 338
Composition in blue No. 1; 338c
Composition with three figures; 338c
Costume figure with mask; 338
Crucifixion; 338
Crucifixion in blue; 338
Dark rain; 338
Darkness fell over the land; 338c
The descent; 338
Descent from the Cross; 338c
Design for the memory; 338
Deux personnages; 338c
Don Quixote with horse; 338c
The emperor; 338c
Ezekiel in the Valley of Dry Bones; 338
Family wedding day portrait; 338
Farm still life; 338
La fête; 338
Figure and fruit in blue; 338
Figure and mask; 338
Figure--blue and red; 338
Figure in a white turban; 338
Figure in flames; 338
Figure in the market; 338
Figure with flowers and table still life; 338
Figure with wings and mask; 338c
Figures in farmscape; 338bc

Figures waiting; 338
Fisherboy; 338bc
Flagellation; 338
Flower girls; 338
Flying trapeze; 338
1492; 338c
The game of cards; 338
Gargoyle in flames; 338c
Gargoyles No. 1; 338
Girl with hoop; 338c
Green table still life; 338c
Guitar player; 338
Hallucination; 338
Hands ascending No. 2; 338
Happy birthday No. 1; 338
Happy birthday No. 2; 338
Hommage à Goya--composition in
 red with three figures; 338c
Job; 338
Job No. 2; 338
Job No. 4; 338
The judges; 338c
Juggler; 338
Kings and clowns; 338c
Lake landscape; 338
Lamentation; 338
Last Judgment triptych; 338c
Laughing girl; 338
Man and birds; 338
The market No. 3; 338
Martyr; 338
Mask composition No. 4; 338
Masks; 338c
Meat cutter; 338
Miller, Henry; 338
Moses; 338
Moses and the Tablets of the Law;
 338c
Moses composition No. 2; 338c
Moses ... "I am"; 338c
Mother and child; 338c
Nude and sailor; 338
Old gray shoes; 338
Old shoes; 338
The painter; 338
Panic; 338
Parade; 338
People on Sixth Avenue; 338c
The pier at Santa Barbara; 338c
Pietà; 338c
A place called Golgotha; 338
Place of darkness; 338c
La plage; 338c
Portrait of Don Quixote; 338
Portrait of Esther; 338
Potato farmscape; 338
Potato picker; 338c
Pourquoi; 338

Prairie landscape; 338
Prairie sky No. 3; 338
Prairie sky No. 6; 338
Procession; 338
Rearing horse; 338
The red carpet; 338
Red tapestry chair; 338c
Rocco del Capo Sea storm No. V;
 338
Rocco del Capo sea storm No.
 VII; 338
Rome No. 1; 338c
Rome No. 3; 338
Rooftops; 338
Row of masks; 338c
Sag Harbor figure; 338c
St. Francis; 338
Saturday night; 338
Seashore fantasy; 338c
Self-portrait; 338c
Shekina Amelek; 338
Six million No. 2; 338
Song of Esther; 338c
Still life; 338c
Still life with mirror; 338
Still life with shoes; 338
Storm composition No. 4; 338
The sun; 338
Sunday afternoon; 338
The survivors; 338
Table by the window; 338
Table still life; 338
Three bathers; 338
Trancendence; 338c
Trois personnages; 338
Two figures with masks; 338c
Up from the wilderness; 338
Valley of dried bones; 338c
Victory--Jerusalem the Golden;
 338bc
Vision of Ezekiel; 338
We the people; 338
Who shall bear the guilt; 338
Window cleaner; 338
Window cleaner No. 3; 338
Window composition; 338c
Winter composition; 338
Woman cutting bread; 338c

RAUSCHENBERG, Robert, 1925-
Almanac; 387c
Ammo; 316
Bed; 413c, 449c
Buffalo II; 472
Canyon; 348c
Charlene; 413c, 445c
First landing jump; 3c
Gallinipper circus; 5c

Small blue nude; 369c
Small café; 55c
La sortie du Conservatoire; 506
Spring bouquet; 82, 204c
Standing bather; 130
Still life with bouquet; 82, 597
Still life with cup and sugar bowl;
 130c, 369c
Still life with melon and vase of
 flowers; 128
Still life with onions; 82
Still life with peaches; 82
Still life with peaches and grapes;
 130
Summer; 130c
Summertime; 369c
The swing; 55c, 82, 130c, 369c,
 506c
The theater box; 156
Three bathers with a crab; 130
La toilette; 124c
Torso of a woman in the sun;
 138c
Torso of a young woman in the
 sunlight; 285c
Two girls at the piano; 156c
Two girls reading; 6c, 156
Two little circus girls; 82, 98c
The two sisters; 130
The umbrellas; 82, 156, 260,
 409c, 460, 506c
The valet of Paul Bérard; 130
Vase with chrysanthemums; 369c
Venice, fog; 130c
Venice, mist; 369c
Venice, St. Mark's; 130c
Venice: the Doge's Palace; 82
Venus and Cupid; 130
Vesuvius, the port of Naples; 82
View of Laudun; 130
Vollard, Ambroise; 82, 506
Vollard, Ambroise, dressed as
 a toreador; 130
Vollard, Ambroise, holding a
 Maillol statuette; 55
Wagner, Richard; 130, 506
The walk; 130
Walk on the seashore; 369c
Washerwomen at Cagnes; 130c,
 369c
Woman arranging her blouse; 130
Woman by a fence; 560
Woman combing her hair; 128
Woman emerging from bathing;
 505c
Woman in a boat; 55c
Woman in a park; 560
Woman in the sun; 506

Woman playing the guitar; 369c
Woman reading; 124
Woman standing by a tree; 560
Woman with a black hat; 130
Woman with a bodice of chantilly
 lace; 130
Woman with a cat; 310c
Woman with a parasol in a garden;
 156c
Woman with a parrot; 369c
Woman's torso in sunlight; 82c
Young bather; 283c
Young girl reading; 560
Young girl seated in a field near
 Chatou; 156c
Young girl with a dog; 369c
Young woman bathing; 130
Young woman with a dog; 55c
Young woman with a muff; 55
Young woman with a swan; 82

REPIN, Ilya, 1844-1930
Arrest of the revolutionary; 354
The Cossacks defying Sultan Mah-
 mud IV; 302
Iskul, Baroness Varvara Ivanovna;
 96
Ivan the Terrible; 33d
Peasant with an evil eye; 561
Procession; 354, 430c
Protodiakon; 561
Refusal of confession; 561
They did not expect him; 409, 576
They had given up waiting for him;
 96c
Volga boatmen; 33d
Zaporozhets Cossacks write to the
 Sultan; 96

REPTON, Humphrey, 1752-1818
Chester rows; 105

RESNICK, Milton, 1917-
Untitled; 5c

RETH, Alfred, 1884-1966
Corner of the studio; 449
Monk by the corpse of Henry IV;
 175
Nemesis; 341
Otto III's visit to Charlemagne's
 vault; 175

REVERE, Paul, 1735-1818
A westerly view of the colleges in
 Cambridge, New England; 14c,
 122c

Duns Scotus; 382
The flaying of Marsyas; 284c
Martyrdom of St. Bartholomew;
 389
A prophet; 458
Prophet Elijah; 458
St. Andrew; 389
St. Jerome; 526
St. Sebastian; 458
Sense of sight; 526
A sense of taste; 526
Sense of touch; 526
Trabaci, Giovanni Maria, choir
 master, Court of Naples; 553

RIBERA, Romera
Art in misery; 354

RIBERA-CICERA, Roman
Leaving the ball; 353

RIBOT, Théodule, 1823-91
La Charbonnière; 506
The seamstress; 409

RICCI, Marco, 1676/80-1730
Landscape; 118
Landscape with Boaz and Rutk;
 556
Landscape with Tobias and the
 angel; 556
Roman ruins; 118
A ruin caprice; 382

RICCI, Sebastiano, 1659-1734
Bacchus and Ariadne; 442, 576
Christ and the woman of Samaria;
 553
Finding of Moses; 382c
St. Paul preaching; 553
San Gaetano comforting a moribund
 sinner; 346

RICHARD, Fleury, 1777-1852
Deference of St. Louis to his
 mother; 184
Mme. Elisabeth de France dis-
 tributing milk; 184

RICHARD, Jim, 1943-
Fish and greasy hair; 153c

RICHARDS, Albert, 1919-45
The landing: H hour minus 6.
 In the distance glow of the
 Lancasters bombing battery
 to be attacked; 511

RICHARDS, Ceri, 1903-71
Blue vortex in the primaries; 449
La cathédrale engloutie; 576
Do not go gentle into that good
 night; 478
Music room; 553
The sculptor and his model; 434
Two females; 478
The variable costerwoman; 511

RICHARDS, John Inigo, 1720-1810
Chepstow Castle; 247

RICHARDS, Walter, 1907-
Inauguration in Air Force One;
 122c

RICHARDS, William, 1784?-1811
A southeast view of Albany Fac-
 tory; 235

RICHARDS, William Trost, 1833-
1905
Atlantic City--beach dunes and
 grass; 531
Commercial England, London; 172
Conservatory; 172
Cove on Conanicut Island; 172
East Hampton Beach; 267
February; 172
Ferns in a glade; 172
The Franconia Mountains, from
 Compton, N.H.; 267c
In the Adirondack Mountains; 172
In the Adirondacks; 172
June day; 172
June woods; 172
Lake Squam from Red Hill; 172
Landscape; 172, 402
The league long breakers thunder-
 ing on the reef; 13bc, 172
Lighthouse; 172
Moonlight on Mt. Lafayette, N.H.;
 172, 528
Mt. Vernon; 172
Mythical England, Stonehenge; 172
Near Florence; 172
Newport coast; 172
The old fort, Conanicut Island;
 172
Old orchards at Newport; 172
On the coast of New Jersey; 172
An orange sunset waning low; 172
Red clover, butter-and-eggs, and
 ground ivy; 172
A rough surf; 172
St. John's Head, Orkney Islands;
 172

The Sakonnet River; 172
Seascape; 172
Shipwreck; 172
Sketches of the sea; 172
Sleive League, Donegal, Ireland;
531c
Stolzenfels; 172
Thunderheads, at sea: the pearl;
172
Tintagel coast; 172
Valley of Wyoming; 172
A view in the Adirondacks; 172
Woods; 172

RICHARDSON, Edward, 1810-74
Tynemouth Priory; 245
Victoria; 234

RICHARDSON, Jonathan
Cowper, Lord Chancellor; 587
Daines, Sir William; 434
Vertue, George; 587

RICHARDSON, Thomas Miles, Sr.,
1784-1848
Newcastle-upon-Tyne; 604

RICHARDSON, Thomas Miles,
Jr., 1813-90
Angelsey; 105
Durham; 600

RICHETERRE, Michel Dessailliant
de
Ex-voto de l'Ange gardien; 234

RICHMOND, George, 1809-96
Christ and the woman of Samaria;
576
The creation of light; 475
The eve of separation; 195
Portrait of a gentleman; 604

RICHMOND, J. C.
Taranaki farm; 86

RICHMOND, Leonard
Boulogne market, France; 457c
The bridge, Charmouth, Dorset;
457c
Burnham beeches; 457c
The Canadian Rockies; 457c
The Dolomites; 457c
The Luxembourg Gardens, Paris;
457c
Near Le Puy, France; 457c
Old houses, Rouen; 457c
Pas-de-Calais, France; 457c

A scene in Bruges, Belgium; 457c
The shore, Lyme Regis; 457c
Still life; 457c
A street in Etaples, France; 457c
A street in Rouen, France; 457c

RICHMOND, Thomas, Jr., 1802-
74
Portrait of a lady; 604

RICHMOND, Sir William Blake,
1842-1921
McRobin, Mrs.; 604
Venus and Anchises; 523cd

RICHTER----
I Carmini, in a fanciful setting;
118

RICHTER, Adrian Ludwig, 1803-
84
Crossing the Elbe at Schreckenstein
near Aussig; 175
Genoveva; 409
The little lake; 409c
Morning in Pelestrina in the Apen-
nines; 494
Spring evening; 175

RICHTER, Gerhard, 1932-
Ema; 320
Evening landscape; 475
Liebespaar; 320
Ohne Titel, Grün; 320c
Window; 449

RICHTER, Giovanni, 1665-1745
Piazza San Marco towards San
Marco; 556
Piazza San Marco towards the
Piazzetta; 556
S. Giorgio Maggiore, in a fanciful
setting; 118
Sta Lucia and the Scalzi, in a
fanciful setting; 118
The Spirito Santo and the Zattere,
in a fanciful setting; 118

RICKERT, Paul
Burning off; 378
Chestnut Hill; 378
Expecting; 378
In her sagacity; 378c
Mill inn; 378

RICKETTS, Charles, 1866-1931
The death of Don Juan; 100c
Heliodorus driven from the Temple;
604

RICKSON, Gary A. , 1942-
Africa is the beginning; 107
Segregation, A. D. ; 107

RIDDELL, Robert Andrew, fl.
1793-99
Travelers on a hill in Cheshire;
105

RIDDLES, Leonard, 1918-
Picking persimmons; 415

RIDLEY, Matthew White, 1837-
88
The Pool of London; 604

RIEDEL, G. T.
Trompe l'oeil; 40c

RIEFSTAHL, Wilhelm Ludwig
Friedrich, 1827-88
Wedding procession in the Tyrol;
51

RIEGER, Federigo von, 1903-
Ice skating in Franconia; 328c

RIEMENSCHNEIDER, Tilman,
1460-1531
St. Mary Magdalen altarpiece;
559

RIESENER, Henri François, 1767-
1828
Quay, Maurice; 344

RIGAUD, Hyacinthe, 1659-1743
Gueidan, Marquis Gaspard de,
playing the bagpipes; 576
Louis XIV; 346, 583c, 610c
Villars, Marquis Jean Octave de;
553

RIGAUD, John F. , 1742-1810
The first interview of King Edgar
and Elfrida; 537, 538
Grey, Lady Elizabeth, petitioning
King Edward IV for her hus-
band's lands; 537, 538

RIGBY, Elizabeth, 1809-93
Burgh Castle, Suffolk; 105

RIGGS, Robert, 1896-
Ford, Henry, in his shop; 122c

RILEY, Bridget, 1931-
Arrest I; 449

Cataract 5; 9c
Crest; 9c, 320, 511
Current; 430c
Drift No. 2; 210
Exposure; 320
Fall; 387c, 478
Late morning; 387c
Movement in squares; 478

RILEY, John, 1646-91
Holmes, Bridget; 587
Lauderdale, Duke of; 587
The scullion; 587

RIMBERT, Rene, 1896-
Paysage de banlieue; 328c

RIMINESE PAINTER
Last Judgment; 522d
Young St. Nicholas with Maestri
Angelo; 522

RIMINI, Guiliano da
Madonna and Child with Sts. Fran-
cis, Clare and other saints;
281c

RIMMER, William, 1816-79
Evening; 131
Flight and pursuit; 131c, 266,
348c, 409

RIN JUKKO
Konoha Tengu; 615

RINALDO, Karen A.
Nantucket waterfront; 23
Westward; 23
Woods Hole waterfront; 23c

RINDISBACHER, Peter, 1806-34
Bulger, Captain, Governor of As-
siniboia and the chiefs and war-
riors of the Chippewa Tribe at
Red Lake; 234
Keokuk; 381
Winnesheek, Isaac; 381

RIOPELLE, A. G.
A Quebec church; 235

RIOPELLE, Jean Paul, 1922/23-
Encounter; 449c
Knight watch; 234, 576
Painting; 438c
Purple track; 449

RIOS, Michael
Bank of America mural; 107d

waterfall and three figures in
the foreground; 556
A river with landscape with Apollo
and the Sibyl; 576
Self-portrait; 442
L'Umana fragilita; 187
Witches' Sabbath; 346

ROSA, Salvator, Style
Hagar and the angel; 553

ROSAI, Ottone, 1895-1957
Decomposition of a street; 18
Landscape; 18

ROSALES, Eduardo, 1836-73
Isabella the Catholic's last will
and testament; 389

ROSAM, Walter
View of the Seine; 147

ROSE, Albert A.
West, James E.; 256c

ROSE, David, 1910-
Mountain landscape; 9c

ROSE, Sheila
Cosmic illusion; 575c
Egg I--cosmic egg; 575c
Egg II--resurrection; 575c
Egg shell; 575c
Light; 575c
Manifestation; 575c
Stars; 575c
Transmigration of souls in blue;
575c

ROSENBERG, Charles G.
Wall Street, half past 2 o'clock,
October 13, 1857; 122c

ROSENQUIST, James, 1933-
Brandeis, Louis Dembitz; 22c
Broom Street truck; 3c, 387c
Early in the morning; 472
F-111; 87bc
Front lawn; 320
Gears; 5c
Horse blinders; 445cd
The light that won't fail I; 348c
Monroe, Marilyn, I; 11, 320
Study for Expo 67; 449
Terrarium; 97

ROSENSTAND, Vilhelm, 1850-1938
Outside the A Porto cafe; 354

ROSETSU, 1745-90
Bull and puppy; 576

ROSLIN----
Daubenton; 184

ROSLIN, Marie S. G. see
GIROUST-ROSLIN, Suzanne

ROSLIN, Marie Suzanne Giroust
see GIROUST-ROSLIN,
Suzanne

ROSS, Alexander, 1908-
Jewels in my garden; 47c

ROSS, Charles, 1937-
Reading by lamplight; 48

ROSS, James
The block, 5th Ward; 48c

ROSS, Richard R. , 1937-
Eve; 23

ROSS, Robert Thorburn, 1816-76
The fisherman's home; 604

ROSS, William Charles, 1794/95-
1860
Prince Albert; 382
Princess Feodora of Hohenlohe-
Langenburg; 382

ROSSE, Susan Penelope, 1652?-
1700
Gwyne, Eleanor; 236
Self-portrait; 236
Wignall, Robert; 236

ROSSELLI, Cosimo, 1439-1507
Adoration of the Magi; 239

ROSSELLINO, Antonio, 1427-79
Nativity; 61, 339

ROSSET-GRANGER, Edouard
The sugar crushing machine; 354

ROSSETTI, Dante Gabriel, 1828-82
Angels watching over the crown of
thorns; 405
Annunciation; 434c, 405
Arthur's tomb; 405c
Astarte Syriaca; 100c, 232c, 405,
434, 462
Baciata, Bocca; 405
Beata Beatrix; 100c, 405c, 430c,

599
Two musicians; 599c
Victory bouquet; 599
Walkowitz, Abraham; 599
Washing of the hands; 599
White bouquet; 599
White horses in Caesarea; 599c
White lilacs; 599c
White roses; 599c
Woman with pomegranate; 599
Woman with wheat; 599
Yemenite boy; 599
Yemenite bride; 599c
Young David playing the harp; 599c

RUBLYOV, Andrey (Rublev),
 1360/70-1430
Ascension; 455
Cathedral of the Assumption
 iconostasis; 559
Christ in glory; 455
Four figures from a 15 figure
 deesis tier; 455
Last Judgment; 576d
Old Testament Trinity; 455
The Saviour Archangel Michael,
 and St. Paul; 455
Virgin of Vladimir; 455

RUBLYOV and CHORNY Workshop
Annunciation; 455

RUDA, Edwin, 1922-
Mad Ludwig; 316

RUDE, Sophis Fremiet, 1797-
 1867
Self-portrait; 524

RUELLAN, Andree, 1905-
Docks at roundaut; 457

RUGGERI, Piero, 1930-
Figure; 553

RUISDAEL, Jacob van, 1628/30
 82
A bleach ground; 546
The cornfield; 189
Cornfields; 294c
The distant view of Haarlem
 from the northwest; 608c
An extensive landscape with a
 ruined castle and a village
 church; 157c, 303, 576
Forest of oaks beside a lake; 74c
Forest scene; 39c, 189
Hill with trees; 74c

The Jewish cemetery; 74, 294c,
 303, 608c
Jewish graveyard; 291
A landscape with a ruined castle
 and church; 442c
Landscape with dunes and mule-
 driver; 273
Landscape with waterfall; 553
The large forest; 74c
The marsh; 341c
The mill at Wijk bij Duurstede;
 189, 303
The quay at Amsterdam; 303
Rocky landscape; 303
Ruins of Egmond; 98c
The shore at Egmond-aan-zee;
 121, 210, 282
View of Haarlem; 189
A view of Rhenen from the west;
 442
View on the Amstel looking towards
 Amsterdam; 608
A waterfall; 442
Wheatfields; 87, 303
The windmill at Wijk bij Duurstede;
 576, 608c

RUMMELHOFF, John
Apollo 10; 320

RUNCIMAN, Alexander, 1736-85
Agrippina landing at Brundisium
 with the ashes of Germanicus;
 279
David returning victorious after
 slaying Goliath; 587
King Lear in the storm; 279
Landscape from Milton's L'Alle-
 gro; 279
Orestes pursued by the Furies;
 279
Ossian singing; 279
Self-portrait with John Brown; 279
The tomb of the Horatii on the
 Appian Way; 279

RUNCIMAN, John, 1744-1868/76
Christ and the three Maries at
 the tomb; 279
King Lear in the storm; 434, 587

RUNDLE, Joseph Sparkhall, 1815-
 80
Sultan's residence, Aden; 105

RUNGE, Philipp Otto, 1777-1810
The artist's parents; 175, 475,
 494cd

SANDYS, Frederick, 1829-1904
Bulwer, Rev. James; 576
Gentle spring; 604
Medea; 523c
Morgan-le-Fay; 471c

SANGUIGNI----
Mourning Virgin; 440
St. John the Evangelist; 440

SAN MARCO School
Holy Family with infant St. John;
 61
Madonna and Child with six saints;
 61

SANO di PIETRO, 1406-81
Apparition of the Virgin to Pope
 Calixtus; 576

SANRAKU, 1559-1635
Plum and pheasant; 576

SANT, James, 1820-1916
Cardigan, Lord, relating the
 story of the cavalry charge of
 Balaclava to the Prince Con-
 sort and the royal children at
 Windsor; 604
Waiting; 96

SANTI, Raphael see RAPHAEL

SANTOMASO, Giuseppe, 1907-
Reds and yellow of harvest time;
 449c
Wedding in Venice; 449

SAPP, Allan
Abandoned cabin and sled; 484
After the funeral; 484c
After the party; 484c
Baby is sleeping; 484
Baby was crying; 484c
Baking bannock; 484
Bear's, John, horses; 484
Before the bar-b-q on Red
 Pheasant Reserve; 484
Behind my old home; 484c
Big load of hay; 484
Blowing snow; 484
Bringing hay home; 484
Bringing their mother for sew-
 ing; 484
Broken wheel on reserve; 484c
Chasing a coyote; 484c
Chopping some wood; 484c
Coming from hunting; 484

Cooking potatoes; 484
Cooking supper; 484
The cowboy; 484c
Cutting a stick; 484
Dance hall at Little Pine Reserve;
 484
Drawing my grandmother; 484c
Eating on the floor; 484
Filling the barrel; 484
Fixing up a cousin's house; 484
Four people on a sleigh; 484c
Getting wood for a fence post;
 484c
Giving chickens a drink; 484
Going to have a drink; 484
Going to visit their neighbor at
 Sweetgrass Reserve; 484
He is going home; 484
Holding her baby; 484
Horses eating; 484c
Indoor pow-wow at Sweetgrass
 Reserve a long time ago; 484c
Inside my old home a long time
 ago; 484
Lady washing the floor; 484c
Looking for a log; 484c
Making a crazy blanket; 484
Making a fire; 484
Making double trees; 484
Making rabbit soup; 484c
Man in barn; 484
The man is still working; 484
A man smoking a long stemmed
 pipe; 484
Moving to a different place; 484
My friend's place on Red Pheasant
 Reserve; 484
My friend's place at Red Pheasant
 Reserve a long time ago; 484
My grandfather's ranch a long
 time ago; 484c
My grandmother cooking choke-
 berries and deer meat; 484
My home; 484
My old place a long time ago;
 484c
Near my old home at Red Pheasant
 Reserve; 484c
Nicotine getting his horses; 484
Nicotine, Mary, and her little
 dog; 484
Nobody home; 484
Nobody lives here anymore; 484
Nothing much to do; 484
Old church at Red Pheasant Re-
 serve; 484c
Old fashioned hand game; 484
An old man died; 484c

SAVAGE 556

SAVAGE, Edward, 1761-1817
Congress voting independence; 287
Huger, John; 381
Savage, Mrs. Edward; 381
Savage, Sarah Seaver; 531
The Washington family; 399

SAVAGE, Eugene Francis, 1883-
Arbor Day; 176
The four seasons; 176

SAVAGE, Jerry, 1936-
Empathy; 153

SAVERY, Roelandt, 1576-1639
Flowers in a niche with lizards
and insects; 204c
Landscape with birds; 74c
Orpheus; 282

SAVIN, Istom
Miracle of the blind man; 455
Origin of the wood of the True
Cross; 455
A triptych of the Bogolyubovo
Virgin and selected saints;
455

SAVIN, Nazary
King of Kings; 455
Petrov Virgin; 455

SAVITSKY, Jack, 1910-
The miner's week; 243c
Train in coal town; 243c

SAVITSKY, K. D.
Brigands of the Volga; 354

SAVOLDO, Girolamo, 1480-1548?
St. Mary Magdalen approaching
the sepulchre; 205
St. Matthew; 205c
Portrait of a soldier; 223
Sleeping nude; 375

SAVRASOV, Alexis, 1830-97
The rooks have come; 561
Rural scene; 561

SAWYER, Amy, fl. 1887-1908
Panel of a screen; 524

SAWYIER, Natalie
South entrance to the covered
bridge; 298

SAWYIER, Paul, 1865-1917
Benson Creek shallows; 298c

Bull, Mayme, in a canoe; 298c
Bull, Samuel Corbin; 298
Bull, Mrs. Samuel Corbin; 298c
Carnival time, Jamaica Bay; 298c
Catskill Highlands; 298c
Catskill Mountains near Highmount;
298c
Catskill stream; 298c
Corner of Wapping and Washington
Streets; 298c
Creek scene; 298c
Dix River; 298c
Drinking fountain in front of post
office; 298c
Elkhorn Creek; 298c
The fading day; 298c
Frankfort Bridge; 298c
Frankfort cityscape with old
fountain; 298c
Frankfort on the Kentucky; 298c
Harbor scene; 298c
Hemp breaking; 298
High Bridge, Ky.; 298c
High Bridge Towers; 298c
Horse and buggy; 298c
The ice harvest; 298c
Jamaica Bay; 298c
Kentucky arsenal; 298c
Kentucky River scene with cliffs;
298c
Kentucky River with High Bridge
in background; 298c
Lake Switzerland in Fleischmanns,
N. Y.; 298c
Lindsey, Henry; 298c
The Murphy Ford; 298c
New York harbor; 298c
Old Capital Hotel; 298c
Old Capital Hotel on rainy day;
298c
Old covered bridge across the
Kentucky River; 298
Old Crow distillery; 298c
Old Elks' Club in Frankfort; 298c
Old Iron Bridge in Frankfort in
the rain; 298c
One of the gates to the walled city
of Manila; 298c
Pathway in Central Park; 298c
Prospect Park; 298c
Prospect Park, New York; 298c
Punch Bowl on Benson Creek; 298c
Railroad station in Catskills; 298c
A rainy day at the bridge; 298
Road at Fleischmanns, N. Y.; 298c
Roadway scene; 298c
The rock breaker; 298c
Sailboats on the water; 298c

SCHJERFBECK, Hélène, 1862-
1946
At work; 524
The convalescent; 524

SCHLABITZ, Adolf
Church choir in the Tyrol; 354

SCHLEICH, Eduard the Elder,
1821-74
Lake Chiem; 51c
Lake Starnberg; 409
Seashore; 175

SCHLEICH, Robert the Younger,
1845-1934
Cattle market on a meadow in
Upper Bavaria; 51
Haymaking in Upper Bavaria;
51

SCHLEMM, Betty L., 1934-
Bass rocks, Gloucester; 489
Caleb's lane; 489
Clearing; 489
Drifting in; 489
Gott Street, Rockport; 489
Jeffersonville winter; 489
Jennifer's bicycle; 489
Jenny's arrangement; 489
Maple sugaring; 489
March 1, Rockport; 489
Rocky Neck; 489
Roses at Old Garden Beach, Rock-
port; 489
Sunday at Sandy Bay, Rockport;
489
Sunday sail; 489
There is a time; 489

SCHLEMMER, Oskar, 1888-1943
Bauhaus stairway; 449
Concentric group; 576
Series of women; 3c

SCHLESINGER, Felix, 1833-
Bavarian inn; 51
Children with rabbits; 51

SCHLITT, Henrich, 1849-
Gnomes transporting frogs; 51

SCHMALZ, Carl N., 1926-
The anchorage; 492
Beinn Tangaval, Barra; 492c
Detail; 492
Ebbing tide, Kennebunkport; 492c
Enclosed garden; 492c

El Escorial; 378
Figures in the Forum, Rome; 378
Fisherman's morning; 492
Flop; 492d
Fort River, fall; 492c
Gentle surf; 492
Government wharf; 492
July 6, 1976; 492c
Maine still life; 492c
Meditation, Warwick Long Bay;
492c
Indian Point; 492c
John Smith's beach; 492
Kitchen ell; 492
Maine morning; 492
Mexican bus; 492
Morning fog; 492
Overcast island; 492
Roman prospect; 378c
Rural fire station; 492
Salt marsh, June; 492c
Sea-Belle, Falmouth; 492
Shack at Biddeford Pool; 492
Small Point, Me.; 492
Stonehenge; 378, 492
Temple of Apollo, Rome; 378
Tuna flags; 492
12:15, Cape Porpoise; 492c
West Point; 492
Westerly; 492
Winter's work; 492c

SCHMALZ, Herbert Gustave
Clorinda; 604

SCHMAROFF, Pavel D., 1874?-
Lady in the carriage; 553

SCHMID, Richard A., 1934-
American victorian; 493
The bridge; 493
Bridge at South Kent; 493c
Bull's Bridge; 493c
Caribbean house; 493c
Cataloochie Creek; 493
Christmas Cove; 493
Clapboard house; 493
Comogli Street; 493
Cottonwoods; 493c
Dogwood; 493c
Dooryard milkweed; 493
Everglades; 493
Fajardo Street; 493c
Farmhouse; 493c
Firehole River; 493
Guyaquil Street; 493c
Happy's forest; 493
Housatonic River; 493

Sonz, Ben; 520c
Thea; 521
Toddy; 521c
Williams, Frank; 520c

SEYMOUR, James, 1702-52
Fagge, Sir Robert, and the gypsy;
 166
Famous hunters belonging to HRH,
 The Duke of York; 166
A kill at Ashdown Park; 194

SEYMOUR, Samuel, 1775-
View near the base of the Rocky
 Mountains; 412

SHADBOLT, Jack L. , 1909-
Dark fruition; 234

SHAHN, Ben, 1898-1969
Ave; 449c
The Bowery clothing store; 29
Crowd listening; 29
The defaced portrait; 449
Dust; 29
East Side soap box; 29
Existentialists; 267
Grain harvesting; 29
Handball; 370
Jesus exhalted in song; 29
The jury box; 313c
Liberation; 210
Mine disaster; 3c
Miners' wives; 370, 445c
Mural in the community center,
 Roosevelt, N.J.; 29
Pacific landscape; 294c, 370
Passion of Sacco and Vanzetti;
 64, 87, 122c, 348, 370, 472,
 576
Peter and the wolf; 430c
Prisoners milking cows; 29
The red stairway; 348c
Sacco and Vanzetti; 29
Sacco and Vanzetti: in the court-
 room cage; 370c
Steel mill; 29
Three men; 29
Vacant lot; 29c
Vanzetti, Bartolomeo and Nicola
 Sacco; 370
The voting booths; 22c
Welders; 290

SHAH-NAMA
Bahram Gur slays a wolf; 576

SHALON de SAFED (Shalom
 Moskovitz), 1892-
Stories from the Bible: Moses

preparing the feast of Pass-
 over; 289c

SHANG HSI, 16th century
Lao-tzu passing the barrier; 81

SHANNON, Charles Haslewood,
 1863-1937
The pearl fishers; 604

SHANNON, Sir James Jebusa,
 1862-1923
Portrait of a girl with a cat; 604

SHAO MI, fl. 1620-60
Landscape; 88c

SHARER, Bill, 1934-
Butterfly kachina dancers, Gallup
 ceremony; 233c

SHARON, Mary Bruce, 1878-
All the transportation in my child-
 hood; 508c
The Arkansas traveler; 508c
Christmas dinner; 508c
Coming out of church in New York
 City; 508c
Fishing with grandpa; 508c
Grandpa's escape; 508c
Grandpa's kitchen; 508c
I go to the circus; 508c
I visit Sitting Bull; 508c
Mama; 508c
My Aunt Pauline; 508c
My doll and I at Grandma's; 508c
My doll's washtub; 508c
My father's house in Washington,
 Ky. ; 508c
My first pony; 508c
My first visit to the Kentucky
 Derby; 508c
My first visit to the Metropolitan
 Museum; 508c
Myself; 508c
Over the Rhine on Grandpa's bridge;
 508c

SHARPLES, James
Washington, George; 528

SHARPLES, Rolinda, 1794-1838
Sharples, Rolinda and her mother;
 218

SHATTUCK, Aaron Draper, 1832-
 1928
Landscape, river and cattle; 176
Peaks Island Beach--across Casco
 Bay to Portland Light; 531

Whitehead Cliffs--Monhegan Island,
Me. ; 531

SHAVER, A. N.
Branner, John Roper; 381
Branner, Mrs. John R. ; 381
The Roper family; 381

SHAVER, Samuel M. , 1816?-78
Nelson, Thomas Amis Rogers;
381

SHAW, John Byam, 1872-1919
Blessed damozel; 534c, 604
The Boer War; 471c

SHAW, Joshua, 1776/77-1860
After the storm; 531c
The deluge; 434

SHAYER, William, 1788-1879
Travelers near Netley Abbey;
604

SHEDD, George
Maine gables; 492

SHEE, Martin Archer, 1769-1850
The infant Bacchus; 576

SHEELER, Charles R. , 1883-
1965
Abstraction: tree form; 342c
Aerial gyrations; 186c
Against the sky a web was spun;
186
American city interior; 370
American interior; 186c, 472
American landscape; 186, 545
Americana; 186c
Amoskeag Canal; 186
Amoskeag Mills; 186
Apples on a pewter plate; 186
Architectural cadences; 186c
Architectural planes; 186
The artist looks at nature; 3c,
186c, 545
Ballardvale; 186c
Ballardvale revisited; 186c
Begonias; 186c
Boneyard; 62
Bucks county barn; 186c, 528,
545
Buildings at Lebanon; 186c
Cactus; 62, 186c
California industrial; 186
Catwalk; 186c
Chrysanthemums; 186c, 472

Church Street El; 186c
City interior; 186c, 545
City interior No. 2; 186
Classic landscape; 186, 472
Classic still life; 267
Companions; 186
Composition around white; 186
Conduit; 186
Conference No. 1; 186
Connecticut barn and landscape;
186
Continuity; 186
Continuity No. 2; 186
Convergence; 186
Conversation--sky and earth; 186
Convolutions; 186
Family group; 186c
Fisherman's Wharf, San Francis-
co; 186
Fissures; 186
Flower forms; 186c
Fugue; 186c
General Motors research; 186
Geraniums, pots, spaces; 186
The great tree; 186
Hallway; 186c
Hex signs; 186
Home, sweet home; 186c
House with trees; 186c
Improvisations on a mill town;
186
Incantation; 186c
Interior; 186c
It's a small world; 186
Kitchen, Williamsburg; 186c
Landscape; 186c
Manchester; 186c
The mandarin; 186
Midwest; 186c, 576
My Egypt; 186
New England irrelevancies; 186
New York No. 2; 186c
New Haven; 186
Objects on a table; 186c
Offices; 186c
On a Shaker theme; 186c
Ore into iron; 186
Panama Canal; 22c
Pertaining to yachts and yachting;
186c
Plums on a plate; 186
Power house with trees; 186c
Powerhouse; 186
River Rouge plant; 186
Rolling power; 62, 186c, 370c
Rouge River Industrial plant; 186,
267c
San Francisco; 186c

Boat from Mykonos, No. 1; 517c
Boat from Mykonos, No. 2; 517c
Bougainvillea; 517c
The boutique; 517c
Boy and target; 517c
Boy climbing a staircase; 517c
A boy, wall; 517c
Café by night; 517c
Café; 517c
Café des Flores; 517c
Café in St. Germain des Près; 517c
Calabrian women; 517c
Carcass on a beach; 517c
Carrozzelle; 517c
Castelfusano; 517c
Chairs by the sea; 517c
Colors, patio; 517c
Côte d'Azur; 517c
Courtyard in Torcello; 517c
Damp sand; 517c
Dancing rock; 517c
The decor of Paris; 517c
Dusty white; 517c
Evening in Gaeta; 517c
The falcon; 517c
The fight; 517c
Figure, beach; 517c
Figures, breakwater; 517c
Figures, reds; 517c
Fishing hut; 517c
Fishing pier; 517c
Fiumicino; 517c
Fiumicino, storm; 517c
Five o'clock; 517c
The flower; 517c
Foceverde; 517c
Foceverde, hut; 517c
A garden; 517c
The gate; 517c
Girl and wall; 517c
Girl at a bus stop; 517c
A girl called Marina; 517c
Girl in the sun; 517c
Girls, interior; 517c
Girls, motos; 517c
A glass of absinthe; 517c
The gold bedroom; 517c
The green sea; 517c
Gypsy camp; 517c
Gypsy camp in white; 517c
Hot sands; 517c
In Calabria; 517c
In Procida; 517c
In St. Germain des Près; 517c
In the Marais; 517c
Inside a room, Bari; 517c
Interior, girl; 517c

Ischia, two girls; 517c
Lacerated posters; 517c
Landscape in blue; 517c
Luna Park by the sea, cicadas; 517c
Maratea; 517c
Marinara; 517c
Market; 517c
Market in Parione; 517c
Mezzogiorno; 517c
My atelier; 517c
My model; 517c
Naples, market; 517c
Neapolitan beach; 517c
Near Blvd. St. Michel; 517c
Near Tindari; 517c
Noon in Posillipo; 517c
On the boulevard; 517c
On the sand; 517c
On the Viale; 517c
Palermitana; 517c
La palisade; 517c
Paris, fall; 517c
Paris, Rue St André des Artes; 517c
Paulette; 517c
The Periferia; 517c
The piazzetta; 517c
Posters; 517c
Pozzuoli; 517c
Procession; 517c
Purple and blues; 517c
Rain; 517c
Rainbow jacket; 517c
Red, gold interior; 517c
The reds and blues of Naples; 517c
Reds, blues, Paris; 517c
Rocks by the sea; 517c
Roman fountain; 517c
A room, wallpaper; 517c
Rue Bonaparte; 517c
Rue de Buci; 517c
Rue de Ponthieu; 517c
Rue de Rennes; 517c
Rue de Seine; 517c
Rue Dufour; 517c
Rue Royale; 517c
Sail, pink, breeze; 517c
St. Eufemia; 517c
St. Germain des Près; 517c
Sea wall; 517c
The Seine; 517c
She was wearing a pink hat; 517c
Sicilian landscape; 517c
Sidewalk; 517c
Siesta; 517c
Silent beach; 517c

nolles; 109c
View from the Canal St. Martin;
109c
View of Montmartre; 55c
Village on the Seine; 341c
Village on the shore of the Marne;
436c
Village street in Marlotte; 109c
Voisins village; 109c
Washerwomen near the bridge at
Moret; 109c
The waterworks at Marly; 443c
Wheatfields near Argenteuil; 109c
Wooden bridge at Argenteuil; 409

SISSON, Laurence, 1928-
The osprey nest; 492

SISTER A.
Adoration of the shepherds; 524
Madonna and Child with St.
Catherine and other saints;
524

SISTER B.
Holy Family with John the Bap-
tist; 524

SITWELL, Lady Susan Tait, fl.
1820
Rome and Mt. Aventine from the
Palace of the Caesars; 105

SKARBINA, Franz
Smoking the fish; 354

SKELTON, Jonathan, 1730?-59
Scene at Blackheath with Van-
brugh's Castle; 600

SKELTON, Peter H., Jr.
Hemis figures; 67

SKIPPE, John, 1741-1811/12
Travelers in a landscape; 105

SKIPWORTH, Frank Markham
Portrait sketch of a young lady;
604

SKOKEI TEN'YU
Small scene of lake and moun-
tains; 510

SKOVGAARD, Peter C. T., 1817-
75
Landscape near Kongens Moller;
409

SKURJENI, Matija, 1898-
The acrobats; 89c
Cathedral Park; 394c
Cherries; 394c
A city on a river; 289c
Female nude; 394c
Gypsy love in moonlight; 89c
I dreamt I was in Marseilles;
89c, 394c
My dream of a visit to Mar-
seilles; 394c
The women of Trnje; 394c

SKYLLAS, Drossos P., 1900-75
Lake in the hill and icicles; 89c
Three sisters; 89c

SKYNNER, T.
Portrait of a woman; 370

SLABBAERT, Karel, 1618-54
Boy with a bird in a niche; 466

SLAFTER, Alonzo, 1801-64
Parker, Amine; 381

SLATER, Joseph
An archery competition; 105

SLEEP, Joseph, 1914-
Cat; 89c

SLEIGH, Sylvia
Court of Pan; 320
Golup, Philip, reclining; 320
October, Felicity Rainine and Paul
Rosano; 320

SLEVOGT, Max, 1868-1932
The black d'Andrade; 175
Corner of a garden in the sun;
506c
Hunter on a hillside; 506
Rigardo, Portrait of the dancer
Marietta di; 175
Two camel riders in the Libyan
desert; 262c
Uniforms; 503
The victor; 409
View of a forest; 506

SLINGELAND, Pieter van, 1640-
91
Children blowing soap bubbles;
373
Couple with a dog; 466
Girl with a pail, in a niche; 466
Old couple in a kitchen; 466
Two women with a dead hen; 466

SLOAN, Diane
Carapace 3; 320c

SLOAN, John, 1871-1951
Angna enters; 497
Arachne; 497
Backyards, Greenwich Village;
 14c, 616
Battle of Bunker Hill; 497
Bleecker Street, Saturday night;
 497
Blonde nude and flowers; 497c
Blonde nude with orange, blue
 couch; 497c
Brunette nude, striped blanket;
 497
Carmine Theater; 497
Chama running red; 497c
Charlotte in red coat; 497
Chinese restaurant; 497c
Cienega from the hills; 497c
The city from Greenwich Village;
 242c, 497c, 616c
The coffee line; 497
Colored girl with gold and silver;
 497c
The cot; 210, 472, 497c
Dance at Cochiti Pueblo; 497
Davis, Stuart; 497
Deep blue sea; 497c
Dock street market; 497
Dolly in white, rocks and sea;
 497
Dolly with a black bow; 497, 616
Dubinsky, Jeanne; 497c
Duncan, Isadora; 497
The dust storm, Fifth Avenue;
 399, 497c
Eagles of Tesuque; 497c, 616c
East entrance, City Hall, Pa.;
 497
Easter Eve; 497
Election night in Herald Square;
 140, 497
Eve of St. Francis, Santa Fe;
 616
Exploring the unsold; 497
The first mail arrives at Bronx-
 ville, 1846; 497
Girl, back to the piano; 497c
Girl in feather hat; 497
Glackens, William; 497
Gloucester harbor; 13, 497
Gloucester trolley; 497
Gray and brass; 257
The green dance dress; 497
Green's cats; 497
Hairdresser's window; 257, 472,

497c
The haymarket; 497, 616c
Helen at the easel; 497
Helen in green suit; 497c
Hudson sky; 497
Independence Square, Philadel-
 phia; 497c
Indian art by the highway; 497
Italian church procession, New
 York; 122c, 242
Jefferson Market, Sixth Avenue;
 497
Juanita; 497c
Koshare; 497
Lady and cat; 497
Lady and Rembrandt; 497
Large white nude; 497
Looking out on Washington Square;
 497
McSorley's bar; 242, 283c, 399,
 497
McSorley's cats; 497c
McSorley's at home; 497
Mink Brook; 497
Miscationary; 497
Model in dressing room; 497
Monument in the Plaza; 497c
My wife in blue; 497c
Navajo necklace; 497
The new blue dress; 497c
Nude, four senses; 497c
Nude glancing back; 497
Nude on Navajo blanket; 497
Nude, red hair, standing; 497c
Nude resting, striped blanket; 497
Nude, terra cotta; 497c
Nude with booklet; 497
Nude with red hand mirror; 497c
The old Haymarket; 399
Our corner of the studio; 497
The picnic grounds; 257c, 497,
 616c
Pigeons; 497c, 616
Portrait of Pete; 497
Professional nurse; 497c
Rainbow, New York City; 497c
Range and the burro; 497
The rathskeller, Philadelphia; 497
The red lane; 497
Red rocks and quiet sea; 497
Reddy on the rocks; 497
Reuterdahl, Mrs. Henry; 497
Rio Grande Canyon; 233c
Rosette; 497c
Sally, Sarah, and Sadie, Peter
 and Paul; 497
Santa Fe siesta; 497c
Sea food; 497

The bibliophile; 38
Birds; 38
The blind balladeer; 38
Bodégon; 38
Bodégon of Saints' Day; 38
Bodégon of the Cantabric; 38
Bodégon with hens; 38
Bodégon with sea bream; 38
Bodégon with turkey; 38
The boxers; 38
Brother and sister; 38
Bullfight; 38
Bullfight in Chinchón; 38
Bullfight in Ronda; 38
Bullfight in Sepúlveda; 38
Bullfight in Turégano; 38
Burial of the sardine; 38c
Burning town; 38
Calatayud; 38
Capes in the bullring of Las
 Ventas; 38
Carnival; 38
Carnival in Las Ventas; 38
Carvings; 38
The cheap barber shop; 38
Children with lantern; 38
Children's nativity; 38
Chinese and vases; 38
Chinese glazed pottery; 38
The Chinese table; 38
Chorus masquerade in the suburb;
 38
The chorus women; 38
Christ of Burgos; 38
Chulos; 38
Chulos and Chulas; 38c
The church; 38
The circus; 38
The clowns; 38c
The coterie at the drugstore; 38
Death of Marat; 38
Disciplinants; 38
The drunken Bota; 38
Eating room at the Alms House;
 38
The end of the word; 38c
Excursion to Mt. Sanctuary; 38
The fallen; 38c
Florencio; 38
The fortuneteller; 38
Four masks; 38
Giants and large-heads; 38
Girl asleep; 38
The girls at Claudia's; 38
Glass bottles; 38
The glass cases; 38
The hairdresser; 38
Heads and masks; 38

The hermit; 38
The hermits; 38
Holy Week procession; 38
The house of the suburb; 38
The hunters; 38
Huts in the Alhóndiga; 38
The Indianos; 38
Isabelline vase; 38
The kiss of Judas; 38
The last masks; 38
Last Supper; 38
El Lechuga; 38
El Lechuga and his assistants; 38
Maker of masks; 38
Mannequins; 38
Mask; 38
The mask and the doctors; 38
Masks; 38
Masks in the snow; 38
Masks of the blowing-fan; 38c
Masks of the hill; 38
Masks of the Red Devil; 38
Masquerade; 38
The meat cart; 38
Men laying asphalt; 38
The merchant sea captain; 38
The miraculous Christ; 38
The miraculous Christ of Huesca;
 38
The mirror of death; 38c
Model; 38
Mountain spinners; 38
Mountain village; 38
Las mulillas; 38
Mummers; 38
Musical still life; 38
New Year's Eve; 38
Nude; 38
Nude with a mirror; 38
The old anatomy professor; 38
The old bridge of Las Ventas; 38
The old shipowner; 38
Ossuary; 38
Our Lady of Sorrows; 38
The outcasts; 38
El Pelele; 38
The physicist; 38
The Plaza Mayor; 38
Procession; 38
Procession at night; 38
Procession in Castile; 38
Procession in Cuenca; 38
Procession in Holy Week; 38
Procession in Pancorbo; 38
Procession in Toro; 38
The procession of death; 38c
Procession of scapulaires; 38
The quack; 38

Flowers in red vase; 154c
Flowers on black ground; 154c
Football players; 154c
Football players in the park of
 the prince; 438c
The Fort d'Antibes; 154c, 449c
The gulls; 154c
Les Indes Galontes; 154c
Landscape; 154c
Landscape--Agrigento; 154c
Landscape, La Ciotat; 154c
Le lavandou; 154c, 430c, 438c
Light fragments; 154c
Marathon; 154c, 387c
Martigues; 154c, 449
Musicians; 210
The musicians, souvenir de
 Sidney Bechet; 154c
Nice; 154c
Nocturne; 154c
The park at Sceaux; 154c
Parc des Princes; 154c
Portrait of Anne; 154c
Portrait of Jeannine; 154c
Red boats; 154c
Red horseman; 154c
Red sky; 154c
Rue Gauget; 64, 154c
Seascape; 154c
La Seine; 210
Sicilian harbor; 154c
Standing nude; 154c
Still life with red pot; 154c
Study at Ciotat; 3c, 154c, 576
The sunset; 154c
Three pears; 154c
Trapped rocks; 154c
Vase of flowers; 154c
White flowers in a black vase;
 553

STALCUP, Marie
The colors of autumn; 23c

STAMOS, Theodoros, 1922-
Abstraction; 439
Aegean sun-box; 439cb
Aegean sun-box No. 1; 439
Ahab for R. J. H. ; 439c
Altar; 259, 439
Ancestral flower; 259, 439
Ancestral myth; 439
Ancestral worship; 439c
Archaic construction; 439
Archaic release; 439
Archaic sentinel; 11, 259, 439
Azalea Japonica; 439
Berkshire morning; 439

Berkshires No. 10; 439
Beyond the mountains, No. 1; 439c
Beyond the mountains No. 3; 439
Black sun-box; 439
Brown-gray; 439
Capadossia; 439
Cassandra; 439c
Cheops sun-box No. 1; 439c
Cheops sun-box No. 2; 439c
Cheops sun-box, Transparent blue;
 439c
Classic sun-box; 439c
The cleft; 439
Composition with braided ropes;
 439
Conversation piece; 439
Corinth No. 3; 439
Corinthian sun-box No. 10; 439c
Cornish sun-box; 439
Cosmological battle; 439
Coventry sun-box; 439c
Coventry sun-box No. 2; 439c
A day; 439
Day of the two suns; 439c
Death of the anarchist, Spain; 439
Delphi; 439c
Delphic sun-box No. 2; 439
Divining rod; 439
Double Aegean sun-box; 439c
Double orange sun-box; 439
Double white sun-box; 439
Drawing; 439
Echo; 439c
Edge of sun; 439c
Egypt; 439
Egypt No. 2; 439
The emperor plows the field; 439
The emperor sees the mountains;
 439
The emperor sees the mountains,
 No. 2; 439
The fallen fig; 402, 439c
Field No. 3; 439c
Flower eruption; 439
Forming sun-box; 439
Fountain; 439c
Good Friday II; 439
Good Friday massacre; 439
Grand blue sun-box; 439c
Gray divide; 439
Gray ungrounded; 439
Greek Easter; 439
Greek orison; 439c
Green sun-box; 439
Hagia zone sun-box; 439
Hardhack for Edna St. Vincent
 Millay; 439
Heart of Norway spruce; 439

Heart of Norway spruce No. 1;
439
The heartbeat; 439
Hibernation; 439
High snow--low sun; 439
High snow--low sun III; 439
High snow--low sun IV; 439
High snow--low sun No. 8; 439c
Homage to Mark Rothko sun-
box; 439c
Homage to Milton Avery sun-
box; 439
Hovering yellow sun-box; 439
The iconoclast; 439
Impulse of remembrance; 439
Irish haystack; 439
Kaaba; 439
Landscape; 439
Legend of dwelling; 439
Levant No. 5; 439
Levant for E. W. R. ; 439c
Lights on the Seine; 439
Listen; 439
Low sun; 439c
Low sun--black bar II; 439c
Lupine; 439c
Mandrake echo; 439
Mandrake root; 439
Mistra; 439
Monolith; 439
Monument for sailors; 439
Moon chalice; 439
Moon flower and surf; 259, 439
Movement of planets; 259c, 439c
Mycenae sun-box No. 2; 439c
The new farm; 439
October field; 439
Of the underworld; 439
Olympia sun-box; 439
The omen; 439
Orient winter; 439
Pandora sun-box; 439c
Pass of Thermopylae; 439
The phoenix is a sun-box; 439c
Pink sun-box; 439c
Poet's column for Stanley Kunitz;
439
Potato bug; 439
Prehistoric phase; 439
Red mound No. 1; 439c
Red Sea terrace; 439c
Red Sea terrace No. 2; 439
Reflective sun-box; 439
Reflective sun-box No. 2; 439c
The reward; 439
Road to Sparta; 439
Rose sun-box No. 2; 439c
The sacrifice; 259, 439

The sacrifice of Chronos; 439
Scar thread; 439
Screen door; 439
Seedling; 439
Shofar in the stone; 439
Soundings No. 2; 439
Soundings III; 439
Sounds in the rock; 439
Spartan sun-box; 439c
Still life on beach; 439
Stirling II; 439
Stirling III; 439
Stirling VII; 439
Sun-box; 439
Sun-box field; 439
Sun games No. 1; 439
Sun games No. 3; 439
Sun-moon chalice II; 439c
Sunlocked; 439
Swamp forest; 439c
Teahouse No. 1; 439
Teahouse No. 5; 439
Teahouse VII; 22c, 439c
Teahouse, Berkshires; 439
Thaw; 439
Thaw II; 439
Transparent green sun-box; 439c
Transparent sun-box No. 1; 439c
Undersea fantasy; 439c
Vale of Sparta; 439
Very low sun; 439
Very low sun-box; 439
A walk in the poppies; 439c
Waterway; 439
Wave; 439
Waves of the night; 439
The wedding; 439
What the wind does; 439
White echo; 439c
White field; 439
White field VII; 439c
White spring; 439
White sun-box; 439
World tablet; 439, 449

STANCZAK, Julian, 1928-
Summer light; 320

STANFIELD, George Clarkson,
1828-78
At Bellagio on Lake Como; 604

STANFIELD, William Clarkson,
1793-1867
The battle of Roveredo; 195
The bridge at Avignon; 604
Cavalrymen near a beached ship,
with a fort in the distance; 600

Entrance to the Zuyder Zee,
Texel Island; 121
Off the Dogger Bank; 409
On the Dogger Bank; 121c
On the Scheldt; 121
Sketch for the Battle of Trafalgar,
and the victory of Lord Nelson
over the combined French and
Spanish fleets, 21 October,
1805; 121
Study for London Bridge; 105

STANHOPE, John Roddam
Spencer, 1829-1908
Eve tempted; 195
Love and maiden; 523
Thoughts of the past; 604

STANLEY, Caleb Robert, 1795-
1868
Honfleur, Normandy; 105
A view on the Thames--Lambeth
Palace beyond; 604

STANLEY, John Mix, 1814-72
The Osage war dance; 266

STANLEY, Robert, 1932-
Crash; 320

STANNARD, Alfred, 1806-89
Landscape; 604
Yarmouth jetty; 363

STANNARD, Eloise Harriet, 1829-
1915
Fruit; 363
Still life with a hare; 363

STANNARD, Joseph, 1797-1830
Thorpe water frolic; 363

STANTON, Rose Emily, 1838-1908
Barn owlets; 105c

STANWOOD, F.
Morning in the White Mountains;
399

STANZIONE, Massimo, 1585-
1656
Bacchanale; 458
Banquet of Herod; 458
Deposition from the Cross; 458
The healing of the sick by a
miraculous stream; 458
Jesus shown to the people; 458
Lot and his daughters; 458

Marriage in Cana; 458
A martyr; 458
Rest on the flight into Egypt; 556
St. Agatha; 458
St. Bruno healing a sick woman; 458
Susanna bathing; 458
The Virgin and St. Peter bring
comfort to the Carthusians; 458
Virgin with Sts. John the Evange-
list and Andrew Corsini; 576

STAPLES, Sir Robert Ponsonby
On the beach--a view of Hastings;
604

STARK, Arthur James, 1831-1902
A showery day; 363

STARK, David D.
Moonlite elk; 23

STARK, James, 1794-1859
Windsor Castle; 363
A wooded river landscape with a
fisherman and his dog in the
foreground; 604

STARK, Jeffrey
Luncheon party; 243

STARNINA, Gherardo, 1354?-1408?
St. Benedict; 522
Thebaid; 205

STARR, Louisa (Canziana)
Sintram and his mother; 524

STEARNS, E.
King Capital forbids the rising
tight of the poor [sic]; 243

STEBERL, Ondrej, 1897-
Nude woman in a mountain land-
scape; 289c

STEELE, Gordon
Trestle; 457

STEELE, Jeffrey, 1931-
Ignis fatuus; 387c
Lavolta; 387c

STEELINK, Willem
Sheep in pasture; 553

STEEN, Jan, 1625?-79
Adoration of the shepherds; 314
The angel Raphael casting out the

Study of rocks I; 67
Study of rocks II; 67
Two hearts II; 67c
Two hearts III; 67c
Two hearts going to feast; 67

TALLANT, Richard, 1853-1934
Sierra Blanca; 233c

TAM, Reuben, 1916-
Dark tide zone; 46
Eclipse of the moon; 64

TAMAYO, Rufino, 1899-
Acrobats; 544
Afternoon sun; 200
America; 200
Animals; 200, 449, 544
Arid landscape; 200
The astronomer; 200c, 544c
Ball player; 200
The bird charmer; 544
The birth of nationality; 200c
Black Venus; 200c, 544
Blue bird; 200
The blue chair; 544
Bowl of fruit with watermelon;
 200
Boy at window; 200
Boy in blue; 544
The burning man; 544
Carnival; 544c
Cataclysm; 200c
Chair with fruit; 200
Children playing; 544
Claustrophobia, 200c
Comedians; 544
Commemorative bust; 200c
Composition; 544
Composition with two figures; 200
Cosmic terror; 544
Couple; 200c, 544
Couple in black; 200c
Couple in the garden; 200
Couple in white; 200
Cow swatting flies; 544
Crescent moon; 544
The cry; 544
Dancer; 544
Dancer in the night; 200, 544
Dancers; 200c, 544
Dancers over the sea; 544
The devil; 200
Dialogue; 200c
Dialogue at the window; 200
Disks; 200
Dog howling at the moon; 544c
Duality; 200c

Dubuffet; 200c
Dynamic torso; 200
Empty fruit bowl; 544
Encuentro; 544
Energy; 200
Eroded landscape; 200, 544
Factory; 200c
The family; 544
Family playing; 544
Family portrait; 200
Figure; 200c
Figure in movement; 200c
Figure in white; 544
Figure on a white background; 544
Figures; 544
Figures in white; 200
Fishmongers; 200c
The flute player; 544
The fountain; 544, 576
Fruit vendors; 544
The great galaxy; 544
Head; 200c
Head with red; 200
Heads in white; 200
Hippie; 200
Homage to Juárez; 544
Homage to the race; 544
Homage to Zapata; 544
Image in the mirror; 200c
Insomnia; 544
The juggler; 544
Leader; 200c
Lion and horse; 544
Lollipop; 544c
Lovers in a landscape; 544
Man, 200
A man and a woman; 200
Man and his shadow; 200c
Man and woman; 200c
Man at the door; 200
Man before picture; 200
Man close to the window; 544
Man confronting infinity; 200c
Man glowing with happiness; 544
Man in red; 200c, 544
Man in red and green; 544
Man looking at the firmament; 200
Man pouring out his heart; 544
Man radiant with happiness; 200c
Man sticking out his tongue; 544
Man with a globe; 200
Man with cigar; 544
Man with crossed arms; 544
Man with flower; 544
Man with guitar; 544
Man with red hand; 544
Man with red hat; 544
Man with stick; 200

TAYLOR, Henry Fitch, 1853-
1925
Abstraction; 342
Guitar series; 472
The parade--abstracted figures;
342

TAYLOR, Jane
A room in Montparnasse; 607c

TCHELITCHEW, Pave, 1898-
1957
Glover, Mrs. R. A.; 576
The green man; 400
Hide and seek; 449

TCHENG, John T. L., 1918-
Mighty power; 23c

TEAGUE, Donald, 1897-
The last leg; 233c

TEDICE, Enrico de
Crucifix; 522

TEERLINC, Levina, 1520?-76
Portrait of a young woman; 236

TEGELBERG, Cornelis
Landscape; 454

TELLER, Grif
Crossroads of commerce; 209c
Horseshoe curve; 209c
On time; 209c
The steel king; 209c

TEMPLETOWN, Viscountess,
Lady Mary Montagu, -1824
Woodscene; 218

TENIERS, David I., 1582-1649
Armida in battle; 133
Charles and Ubald searching for
Rinaldo; 133
Charles and Ubald tempted by
nymphs; 133
The dream of Oradine; 133
A scene in Godfrey's camp; 133

TENIERS, David, the Younger
(II), 1610-90
The alchemist; 133c
The archduke Leopold William in
his picture gallery in Brussels;
304
Archduke Leopold Wilhelm's
gallery; 424c

Armida in battle; 133
Assumption of the Virgin; 133
Brussels gallery I; 304
Brussels gallery I; the Archducal
gallery with the royal portraits;
304
Charles and Ubald searching for
Rinaldo; 133
Charles and Ubald tempted by
nymphs; 133
Christ on the Mt. of Olives; 133
The deliverance of St. Peter; 133
The denial of St. Peter; 133
Le départ pour le marché; 133
Dream of Oradine; 133
Fat kitchen; 133
The gallery of the Archduke Leo-
pold Wilhelm; 157c
Good Samaritan; 133
The guardroom; 341c
Incantation scene; 133
Kitchen interior; 133c
Landscape with Christ and the pil-
grims to Emmaus; 133
Landscape with cows; 341
Landscape with woodcutters; 133
Latona and the Lycian peasants;
133
Lot and his daughters; 133
Madonna of the cherries; 133
A man holding a glass and an old
woman lighting a pipe; 282
The Nativity; 133
Peasants feasting and dancing;
382
Peasants outside a country inn;
382
Peasants playing bowls; 576c
The prodigal son with the prosti-
tutes; 133
St. Anthony in a landscape; 133c
A scene in Godfrey's camp; 133
The seven acts of mercy; 133c
Shepherds with their flocks; 553
The smoker; 133
Still life; 133c
The storm; 282c
Le tambour battant; 382c
The temptations of St. Anthony;
133
The temptations of St. Anthony in
a flower garland; 133
A view of Het Sterckshof near
Antwerp; 157c
Weert, Blessed Jan van, in a
flower garland; 133
The witch; 133c

UGOLINO, Raniero di
Madonna and Child with scenes
from the lives of the Virgin
and her parents; 522

UGOLINO da SIENA, fl. 1317-27
Predella of Santa Croce, Florence;
592
St. Peter and St. Paul; 592
The way to Calvary; 576

UGOLINO di NERIO, 1317-49
Crucifixion; 522
Deposition; 442

UHDE, Fritz Karl H. von, 1848-
1911
Jesus with the peasants; 506
Mother and child; 175
The nursery; 96, 353
The orphanage; 354
Three models; 409
Young girls in the garden; 506c

UITEWALL see WTEWAEL

ULANOV, Kiril
Theodosia the Blessed; 455

ULFT, Jacob van de, 1621-89
A Moscovite delegation at Gorin-
chem; 157

ULRICH, Carl
Ferry at St. Ignace; 209c
Making lamp bulbs; 354c

ULRICH, Charles Frederick, 1858-
1908
In the land of promise--Castle
Garden; 257
The village print shop; 257, 266

ULRICH, Johann Jakob, 1798-
1877
Lake of Lucerne with the Uri-
Rotstock; 143

UMEHARA RYUZABURO, 1888-
Narcissus; 230
Necklace; 230

UNKOKU TOGAN, 1547-1618
Crows on a plum branch; 372cd
Landscape; 151d
Landscape and figures; 151
Landscape with figures; 372
Noble characters; 151

Plum tree and crows; 151
Wild geese and reeds; 151

UOTA----
Evangeliarium; 218

URAGAMI GYOKUDO, 1745-1820
Album of mist and clouds; 615cd
Cleansing wind through the pines;
615
Clear streams and wonderful
caves; 615
Frozen clouds and whirling snow;
372
Frozen clouds sifting powdery
snow; 615
Green pines and russet valleys;
615
Many houses seen from on high;
615
Mountains stained by red leaves;
615c
Mountains wrapped in rain; 615
The silence of sky and mountain;
615
Village at the foot of a mountain;
615

USAMI, Keiji, 1940-
Laser beam; 320c

USHAKOV, Simon
Annunciation; 455
Old Testament Trinity; 455
St. Sergius of Radonezh; 455
Veronica; 455

UTRECHT, Jacob C. van
Arents, Barbara, called Spierinck;
41c
Rubens, Bartholomeus; 41c

UTRILLO, Maurice, 1883-1955
La Caserne; 390
L'Impasse Cottin; 576
Landscape, Pierrefitte; 560
Maison Mimi; 64
An old street in Villefrance-sur-
Mer; 140
Residential street; 294c
Row of houses at Pierrefitte; 560
Rue des Poissonniers; 283c
Street in Montmartre; 271c, 553

UTTENHEIM MASTER
St. Augustine altarpiece; 469d
Uttenheim Lady altar; 559

Iris; 140
Italian farmyard; 140
January; 140c
July 15th, summer landscape;
 140
Latin Quarter, Square in Paris;
 140
Leaning trees; 140
Life study, Académie Julien,
 Paris, the spotted man; 140
Long's Peak from Loch Vale,
 Estes Park, Col. ; 140
Looking for wigglers; 140
Midsummer, cowpath; 140
Misty day, Fountain of the Ob-
 servatory; 140
Near sundown; 140c
New road; 140c, 242
Nude bather; 140
Oil sketch of house for American
 gothic; 140
The old J. G. Cherry Plant,
 Cedar Rapids; 140
Old sexton's place; 140
Old stone barn; 140
Overmantel painting; 140c
The painter; 140
Pantheon; 140
Paris street scene, church of Ste.
 Geneviève; 140
Paris street scene with café;
 140
Paris street scene with green
 bus; 140c
Pigs behind fence, feeding time;
 140 ·
Plaid sweater; 140c
Port du Clocher, St. Emilion; 140
Portal with blue door, Italy; 140
Portrait of Nan; 140c
Pyle, Arnold comes of age, por-
 trait of Arnold; 140
Quivering aspen; 140
Red bedding; 140
Retrospection; 140
Return from Bohemia; 140
Revere, Midnight ride of Paul;
 29, 140c
Road to Florence; 140
Ruins, Pérignueux; 140
The runners, Luxembourgh Gar-
 dens; 140c
Self-portrait; 140
Sentimental ballad; 242
Shadows; 140
Shaffer, Mary Van Vechten; 140
Shaffer, Susan Angevine; 140
Sheltered shop, Kenwood; 140

The shop inspector; 140
Spring in town; 29c, 140c, 242c
Spring plowing; 140
Spring: the four seasons lunettes;
 140
Spring turning; 140c
Stamats, Sally; 140
Stone City; 140c, 242c, 370c, 472
Storm on the Bay of Naples; 140c
Street of the dragon, Paris; 140
Street scene through gate, Roman
 Arch; 140
Summer: the four seasons lun-
 ettes; 140
Sunflower with zinnias; 140
Sunlit corner, No. 5 Turner Alley;
 140c
Ten tons of accuracy; 140
Tree planting; 242
Trees and fields; 242
Trees and hill, oaks; 140
Truck gardens, Moret; 140c
Tuileries Gate and Obelisk, Paris;
 140
Turner, John B. . pioneer; 140
Turret lathe operator; 140, 242
Victorian survival; 29, 140
View of Mary's Lake in Estes
 Park, Col. ; 140
Ville d'Avray; 140
Weems', Parson, fable; 29, 140c
Winter tree over Indian Creek;
 140
Woman with plants; 29, 140c, 242c
Yellow doorway, St. Emilion; 140c
Yellow house, Munich; 140
Yellow shed and leaning tree; 140c
Young artist on Kenwood Hills;
 140
Young corn; 29, 140c

WOOD, Robert E. , 1926-
Beach figure; 606c
Beached boat; 606
Before the storm; 606
Boats and nets, Honfleur; 606
Cabin on the shore; 606
California coast; 606
Dead end wharf; 606
Deep creek; 606c
Dunn's River falls; 606c
Empty rendezvous; 606c
Ferry boat, Sausalito; 606
Figures in the trees; 606
Flame at the top; 606
Full painting explorations; 606c
Golden sunset; 606
Gray wharf; 606